JEWISH SYMBOLS

IN THE GRECO-ROMAN PERIOD

ABRIDGED EDITION

MYTHOS: *The Princeton/Bollingen Series in World Mythology*

ERWIN R. GOODENOUGH

JEWISH SYMBOLS
in the
Greco-Roman Period

ABRIDGED EDITION

Edited, with a Foreword, by Jacob Neusner

BOLLINGEN SERIES

PRINCETON UNIVERSITY PRESS

PUBLISHED BY PRINCETON UNIVERSITY PRESS
41 WILLIAM STREET, PRINCETON, NEW JERSEY 08540
IN THE UNITED KINGDOM:
PRINCETON UNIVERSITY PRESS, OXFORD
COPYRIGHT © 1953, 1954, 1956, 1958, 1964, 1965, 1968
BY PRINCETON UNIVERSITY PRESS
FOREWORD AND ABRIDGMENT COPYRIGHT © 1988
BY PRINCETON UNIVERSITY PRESS

LIBRARY OF CONGRESS CATALOGING IN PUBLICATION
DATA WILL BE FOUND ON THE PAGE FOLLOWING THE
INDEX. THIS IS A ONE-VOLUME ABRIDGMENT OF "JEWISH SYMBOLS
IN THE GRECO-ROMAN PERIOD," BOLLINGEN SERIES XXXVII,
ORIGINALLY PUBLISHED BETWEEN 1953 AND 1968

LCC 88–5857
ISBN 0–691–09967–7
ISBN 0–691–01922–3 (PBK.)

PRINCETON UNIVERSITY PRESS BOOKS
ARE PRINTED ON ACID-FREE PAPER, AND MEET
THE GUIDELINES FOR PERMANENCE AND DURABILITY
OF THE COMMITTEE ON PRODUCTION GUIDELINES
FOR BOOK LONGEVITY OF THE COUNCIL
ON LIBRARY RESOURCES

SECOND PRINTING, FOR THE MYTHOS
PAPERBACK EDITION, 1992

10 9 8 7 6 5 4 3 2

PRINTED IN THE UNITED STATES OF AMERICA

CONTENTS

PART III. THE SYNAGOGUE
AT DURA-EUROPOS

(*from Volumes IX–XII*)

THIS ABRIDGMENT presents to a new generation of readers some of the more important parts of Goodenough's now-classic *Jewish Symbols in the Greco-Roman Period* (I–XIII). Goodenough took as his problem the interpretation of symbols of art and archeology in the study of religion. In his monumental work, published between 1953 and 1968, he developed a method for explaining, without recourse to literary testimony and evidence, the meaning and use of symbols. In this synopsis I mean to provide a clear picture of Goodenough's method and how it works in substantial examples of his results. Let me first briefly explain the structure of this book, then proceed to an account of Goodenough and his principal ideas.

In Part I we go straight to Goodenough's statement of the problem he proposes to solve in this study, then to the method he uses to work out his answer. In Parts II and III we then review Goodenough's discussions of specific problems and give a brief summary as he provided it. How does this abridgment relate to Goodenough's *Jewish Symbols*?

The original work was set out in thirteen volumes:

VOLUMES I–III	The Archeological Evidence from Palestine and the Diaspora VOL. III: 1209 illustrations
VOLUME IV	The Problem of Method; Symbols from Jewish Cult 117 illustrations
VOLUMES V–VI	Fish, Bread, and Wine 455 illustrations
VOLUMES VII–VIII	Pagan Symbols in Judaism 459 illustrations
VOLUMES IX–XI	Symbolism in the Dura Synagogue VOL. XI: 354 illustrations, 21 color plates
VOLUME XII	Summary and Conclusions 5 text figures
VOLUME XIII	Indexes and Maps

Goodenough's massive conception encompasses three separate issues. First, he describes the archeological evidence for Judaism in Greco-Roman times, in Volumes I to III. I do not reproduce that part of his work because, while accurate for its time, it is now dated by recent discoveries. I believe, moreover, that the current generation will find more interesting Goodenough's method and results than the archeological finds he surveyed.

Second, in Volume IV, Part V, he takes up the interpretation of specific

symbols, and from Volume IV, Part VI, through Volume VIII, he considers various symbols, individually. These he divides into two groups: those originating in distinctively Jewish settings and those deriving from "pagan" or non-Jewish provenance. The former he rightly identifies as distinctively Jewish because they originate in the cult of the Jewish Temple in Jerusalem. The latter do not. Of the former group I have selected the *shofar*, of the latter, astrological symbols.

Third, in Volumes IX to XI Goodenough proceeds to analyze a particular archeological site—one that, all parties concur, employs symbols symbolically—to address the difficult question of how to deal as a whole and in one place with the entire symbolic vocabulary he had traced item by item. Because I regard the Dura study as the climax of Goodenough's work on Jewish symbols, I have included three major essays on Dura: first, Goodenough's statement of method in interpreting the synagogue-art at Dura, second, his discussion of "cosmic Judaism," and third, his description of "the Judaism of immaterial reality." These seem to me his most systematic statements of results.

Volume XII, published after Goodenough's death, summarized his main results. Out of this volume I present Goodenough's concluding chapter. Volume XIII included an index, compiled by Delight Ansley, a list of corrections and reconsiderations, and maps drawn by Liam Dunne, with research assistance by Irene J. Winter. The corrections and reconsiderations are incorporated in this abridged edition.

In addition to selecting what I believe to be representative and important chapters, I also have edited the selections and omitted some materials of the chapters presented here. This I did only for the sake of brevity. I urge readers to go to the original and review for themselves the whole of Goodenough's grand conception and presentation.

ERWIN R. GOODENOUGH, 1893–1965

Erwin Ramsdell Goodenough was the greatest historian of religion America ever produced, and *Jewish Symbols* is his major work. He was born in Brooklyn, New York, was raised in a family devoted to Methodist fundamentalism, and studied at Hamilton College, Drew Theological Seminary, and Garrett Biblical Institute, from which he received his bachelor's degree in theology in 1917. He then spent three years studying at Harvard University with George Foot Moore, the first important historian of religion in America, and another three years at Oxford University. He received his D. Phil. from Oxford in 1923, and in the same year became instructor in history at Yale University. He spent his entire teaching career at Yale, being named Professor of the History of Religion in 1934 and John A. Hoober Professor of Religion in 1959. He retired in 1962 and spent a post-retirement year at Brandeis Univer-

sity. The complete bibliography of his writings, by A. Thomas Kraabel, appears in J. Neusner, ed., *Religions in Antiquity. Essays in Memory of Erwin Ramsdell Goodenough* (Leiden, 1968).

Because *Jewish Symbols in the Greco-Roman Period* comprised twelve volumes of text and pictures and a thirteenth volume of index, only specialists worked their way through the whole. The work reached its audience principally through the reports of reviewers. While not all of the reviews proved hopelessly unsympathetic and supercilious, enough of them were so that Goodenough's achievement scarcely registered in his own day, and twenty years after his death, his work has lost access to that large world of literate readers interested in symbolism and the definition and meaning of religion that Goodenough proposed to address. Goodenough deserves a general audience because, through the specific case of the symbolism of ancient Judaism and the problems in its interpretation, he raises a pressing general question: how to make sense of the ways in which people use art to express their deepest yearnings, and how we are to make sense of that expression in the study of the people who speak—without resort to words—through it.

The importance of Goodenough's work lies in his power to make the particular into something exemplary and suggestive, to show that, in a detail, we confront the whole of human experience in some critical aspects. Goodenough asks when a symbol is symbolic. He wants to know how visual symbols speak beyond words and despite words. We find ourselves surrounded by messages that reach us without words, that speak to and even for us beyond verbal explanation. Goodenough studied ancient Jewish symbols because he wanted to explain how that happens and what we learn about the human imagination from the power of symbols. It is difficult to point to a more engaging and critical problem in the study of humanity than the one Goodenough took for himself. That is why, twenty years after the conclusion of his research, a new generation will find fresh and important the research and reflection of this extraordinary man.

GOODENOUGH'S ESSENTIAL CONTRIBUTION

WHEN IN 1963 I had originally collected some of the ideas presented (after much revision) in what is to follow, I reviewed them with Goodenough. He asked me what I thought he had contributed. I turned the question on him. I recall my surprise at how he understated his contribution. Goodenough was a great man, one of the few truly great human beings I have known in scholarship. The modesty of his assessment of his own work strikes me as evidence of that fact. At the same time, let it now be said that he had a sense of not having been adequately appreciated in his day. Even when he lay dying, Goodenough expressed a sense of disappointment and hurt. Academic life sometimes turns

paranoia into understatement. But Goodenough's continuing influence, the keen interest in his work two decades after his death, surely vindicates him and marks him as one of the giants of his age.

In any event, let us now consider the essential contribution made by *Jewish Symbols*. Why are these books so important that they deserve careful study? Here is Goodenough's own view: First, a great deficiency in earlier scholarship on the archeology of this period has been the failure of most investigators to reckon openmindedly with the implications for classical Judaism of the relics of a supposedly aniconic faith which consistently used plastic symbols of all shapes, sizes, and significations. Whether one holds that decoration is "mere ornament" or not, one cannot lightly dismiss, as many have done, the astonishing appearance of pagan ornament in Jewish settings.

To this I would add one comment. Such offhand dismissal represents an act of faith in prevailing presuppositions that no scholar can afford to make. The eagle, the vine, the human and divine figures, including the head of Zeus, and the wreath all warrant serious consideration in the context of the art in which they generally were found, namely pagan art, as well as the unexpected places in which they turned up, on Jewish synagogues and ossuaries. By simply reviewing the finds in such a way, Goodenough has forced a reconsideration of their meaning. By proposing an explanation of them, he has forced the scholarly world to a thoughtful reappraisal of its earlier position: and he has rightly insisted that if *his* theses are rejected, others must be proposed in their place. In this way, a deficiency in earlier treatment of Jewish symbols in the Greco-Roman period has been addressed.

Second, Goodenough's essential contribution, I believe he would say, is to be measured by evaluating not his "proof" of any of these theses, but rather his method and its *cumulative* consequences. Goodenough forced some of us to take seriously the question posed by the Jewish symbolic vocabulary yielded by ancient synagogues and sarcophagi.

Goodenough does not claim to "prove" anything, for if by proof one means certain and final establishment of a fact, there can be no proof in the context of evidence such as this. The stones are silent. Goodenough reports what he understands about them, attempting to accomplish what the evidence as it now stands permits: the gradual accumulation of likely and recurrent explanations derived from systematic study of a mass of evidence, and the growing awareness that these explanations point to a highly probable conclusion. That is not a "demonstration" in the sense that a geometrical proposition can be demonstrated, and for good reason are the strictly literal (and, therefore, philological) scholars uncomfortable at Goodenough's results. But all who have worked as historians, even with literary evidence, must share Goodenough's underlying assumption, that although nothing in the endeavor to recover historical truth is in the end truly demonstrable or positive, nonetheless significant statements about history may be made.

Third, Goodenough would claim that he has clearly indicated his method in his words, "a substantial probability recurrently emerging from this mass of evidence." If the cumulative evidence is inspected as cautiously as possible, it can hardly yield a statement other than the following: At the period between the first and sixth centuries, the manifestations of the Jewish religion were varied and complex, far more varied, indeed, than the extant Talmudic literature would have led us to believe.

Besides the groups known from this literature, we have evidence that "there were widespread groups of loyal Jews who built synagogues and buried their dead in a manner strikingly different from that which the men represented by extant literature would have probably approved, and in a manner motivated by myths older than those held by these men." The content of these myths may never be known with any great precision, but clearly they comprehended a Hellenistic-Jewish mystic mythology far closer to the Qabbalah than to Talmudic Judaism. In a fairly limited time before the advent of Islam, these groups dissolved. This is the plain sense of the evidence brought by Goodenough, not in any sense a summary of his discoveries, hypotheses, suggestions, or reconstruction of the evidence into a historical statement. Such a summary would not be possible, since Goodenough's central interest is the material and the method by which it may be dealt with, grave by grave, and symbol by symbol. But the summary he does present is a very substantial contribution to scholarship indeed, the great significance of which should impel many readers to turn to the evidence itself for closer study.

Through the present work Goodenough attained the rank of premier American historian of religion of the twentieth century, a status achieved, among native Americans, only by George Foot Moore. No other works have so decisively defined the problem of how to study religion in general, and, by way of example, Judaism in particular, as have Moore's *Judaism* and Goodenough's *Jewish Symbols*. Goodenough worked on archeological and artistic evidence, so he took as his task the description of Judaism out of its symbolic system and vocabulary. Moore worked on literary evidence, so he described Judaism as a systematic theological structure. Together they placed the systematic study of Judaism in the forefront of the academic study of religion and dictated the future of the history of religion in the West to encompass not only the religions of nonliterate and unfamiliar peoples, but also of literate and familiar ones. In all, Moore and Goodenough have left a legacy of remarkable power and intellectual weight.

The Archeological Evidence

THE FIRST THREE VOLUMES collect the Jewish regalia uncovered by archeologists working in various parts of the Mediterranean basin. Goodenough's interest in these artifacts began, he reports, with the question of how it was pos-

sible, within so brief a span as fifty years, that the teachings of Jesus could have
been so completely accommodated to the Hellenistic world. Not only central
ideas, but even widespread symbols of early Christianity appear in retrospect
to have been appropriated from an environment alien to Jewish Palestine.
"For Judaism and Christianity to keep their integrity, any appropriations from
paganism had to be very gradual" (I, 4). Yet within half a century of Jesus'
death, Christian churches were well established in Hellenistic cities, and Chris-
tian teachings were within the realm of their citizens' discourse. If the "fusion"
with Hellenistic culture occurred as quickly as it did, then it seems best ex-
plained by reference to an antecedent and concurrent form of Hellenistic Ju-
daism that had successfully and naturally achieved a comfortable accommo-
dation with Hellenism. Why so? Goodenough maintains that the Judaism
known from the writings of the ancient rabbis, hence, "rabbinical Judaism,"
could not accommodate itself to Hellenism. Goodenough's main point follows:
"While rabbinical Judaism can adjust itself to mystic rites . . . it would never
have originated them" (I, 27).

That is to say, we would look vainly in the circles where Talmudic litera-
ture developed for the origins of the symbols and ideas of Hellenistic Judaism.
It follows that evidences of the use of the pagan inheritance of ancient civili-
zation for the specifically Jewish purposes derives from Jews whose legacy is
not recorded in the pages of the Talmud. So Goodenough's first question is, if
the rabbis whose writings we possess did not lead people to use the symbols at
hand, then who did? If, as Goodenough contends, not all Jews (perhaps, not
even many Jews) were under the hegemony of the rabbis of the Talmud, then
what shall we think if we discover substantial, identifiably Jewish uses of forms
we should expect in a pagan setting? To these two questions the first eight vol-
umes are devoted, for substantial Jewish iconic remains have been uncovered
from Tunisia to Dura, from Rome to the Galilee, and at many places in be-
tween, and these remains are surprising from the viewpoint of Talmudic law.

One conclusion would render these finds insignificant. While illegal, sym-
bolic representations of lions, eagles, masks, and victory wreaths, not to men-
tion the Zodiac and other astral symbols, were made for merely ornamental
purposes, "the rabbis" may not have approved of them, but finding it neces-
sary to "reckon with reality," may have "accepted" them. That view was com-
monly expressed but never demonstrated. For his part Goodenough repeats
again and again, symbol by symbol and volume by volume, that it is difficult to
see how the handful of symbolic objects so carefully chosen from a great vari-
ety of available symbols, so frequently repeated at Dura, Randanini, Bet Al-
pha, Hammam Lif, and elsewhere, selected to the exclusion of many other
symbols and so sloppily drawn that no ornamental artist could have done
them, could have constituted mere decoration. Furthermore, it begs the ques-
tion to say that these symbols were "merely" ornamental: why specifically these
symbols and *no others*? Why in these settings?

Two extreme positions present themselves. One maintains that a "symbol" is perpetually symbolic, retaining its emotive value forever and everywhere. The other contends that symbols (in this sense, representations of real things) are never more than "mere" ornament. What do people mean by "mere ornament"? What other instances of wholly meaningless decoration attached to other places of worship and burial, which in antiquity were normally adorned with meaningful and evocative designs, do we have? Those who reject Goodenough's insistence that symbols ordinarily bear meaning do not trouble themselves with such questions as these. Rather, Goodenough's critics asked how we know that a symbol is symbolic, as though Goodenough himself did not address that question.

Goodenough attempts to uncover the meaning of various symbols discovered in substantial quantities throughout the Jewish world of antiquity. His procedure is, first, to present the finds *in situ*, second, to expound a method capable of making sense of them, and, third, to study each extant symbol with the guidance of this method. He presents a majestic array of photographs and discussion, for the first time assembling in one place the material needed to give a portrait of Jewish art in antiquity, a portrait as magnificent as will ever appear. The Bollingen Foundation deserves credit for making possible Goodenough's remarkable edition. Nothing like it has been done in the thirty years since the first three volumes made their appearance.

In his survey Goodenough begins with the art of the Jewish tombs in Palestine and their contents, studying the remains by chronological periods, and thus indicating the great changes in funerary art that developed after A.D. 70. He proceeds (I, ch. 5) to the synagogues of Palestine, their inscriptions and contents, describing (sometimes briefly) more than four dozen sites. He concludes:

> In these synagogues certainly was a type of ornament, using animals, human figures, and even pagan deities, in the round, in deep relief, or in mosaic, which was in sharp distinction to what was considered proper for Judaism. . . . The ornament we are studying is an interim ornament, used only after the fall of Jerusalem, and before the completion, or reception, of the Talmud. The return to the old standards, apparently a return to the halachic Judaism that the rabbis advocated, is dramatically attested by the destruction, obviously by Jews themselves, of the decorative abominations, and only of the abominations, in these synagogues. Only when a synagogue was abandoned as at Dura . . . are the original effects preserved, or the devastations indiscriminate. (I, 264)

The decoration in these synagogues must have seemed more than merely decorative to those who destroyed them so discriminatingly.

Goodenough turns (II, chs. 1–5) to the archeological evidence from the diaspora. Here he presents the remains of the Roman Jewish catacombs, as well as symbols used with burials outside Rome, synagogues of the diaspora,

small objects such as lamps and glass remnants, the evidence of the inscriptions, and charms and amulets. Every student of the Talmud is aware, of course, that amulets and charms were part of the setting of rabbinic Judaism as well, but most dismiss such matters as evidence of the superstition of the ignorant masses.

Goodenough argues that distinction between fetishistic magic and religion is generally subjective, and imposed from without by the embarrassed investigator. He points out (II, 156) that magical characteristics, such as the effort to achieve material benefits by fundamentally compulsive devices, are common (whether we recognize them as such or not) in the "higher" religions. It is certainly difficult to point to any religious group that did not quite openly expect religion to produce some beneficial consequence, and if that consequence was to take place after death, it was no less real. Hence Goodenough concludes that "magic is a term of judgment," and thus the relevance of charms and amulets is secured. Goodenough summarizes the consequences of his evidence as follows:

> The picture we have got of this Judaism is that of a group still intensely loyal to Yao Sabaoth, a group which buried its dead and built its synagogues with a marked sense that it was a peculiar people in the eyes of God, but which accepted the best of paganism (including its most potent charms) as focusing in, finding its meaning in, the supreme Yao Sabaoth. In contrast to this, the Judaism of the rabbis was a Judaism which rejected all of the pagan religious world (all that it could). . . . Theirs was the method of exclusion, not inclusion. (II, 295)

The problem then was how to establish a methodology by which material amassed in the first three volumes might be studied and interpreted.

Goodenough's Method of Interpreting Symbols

THE SIMPLEST METHOD Goodenough might have used would have been to interpret the archeological evidence on the basis of written documents of the period. As we shall see when we come to the Dura synagogue, that is the approach taken by Kraeling. Goodenough argues, however, that the written documents, particularly the Talmudic ones, do not suffice to interpret symbols so utterly alien to their spirit and, in any case, so rarely discussed in them. Furthermore, even where some of the same symbols are mentioned in the Bible or Talmud and inscribed on graves or synagogues, it is not always obvious that the biblical antecedents or Talmudic references engage the mind of the artist. Why not? Because the artists follow the conventions of Hellenistic art, and not only Hellenistic art, but the conventions of the artists who decorated cultic objects and places in the same locale in which the symbols have turned up in the Jewish settings.

Goodenough asks for a general theory to make sense of all the evidence, something no one gives, and asks: "Where are we to find the moving cause in the taking over of images, and with what objective were they taken over? It seems to me that the motive for borrowing pagan art and integrating it into Judaism throughout the Roman world can be discovered only by analyzing the art itself" (IV, 10). An interpretive method is needed. Goodenough succinctly defines this method:

> The first step . . . must be to assemble . . . the great body of evidence available . . . which, when viewed as a whole, demands interpretation as a whole, since it is so amazingly homogeneous for all parts of the Empire. The second step is to recognize that we must first determine what this art means in itself, before we begin to apply to it as proof texts any possibly quite unrelated statements of the Bible or the Talmud. That these artifacts are unrelated to proof texts is a statement which one can no more make at the outset than one can begin with the assumption of most of my predecessors, that if the symbols had meaning for Jews, that meaning must be found by correlating them with talmudic and biblical phrases. . . . The art has rarely, and then only in details, been studied for its possible meaning in itself; this is the task of these volumes. (IV, 10–11)

Goodenough's method is presented in Volume IV, ch. 2. If the succeeding volumes exhibit a monotonous quality, as one symbol after another comes under discussion and produces an interpretation very close to the ones already given, it is because of the tenacious use of a method clearly thought through, clearly articulated, and clearly applied throughout.

What is this method? The problem here is to explain how Goodenough determines what this art means in itself. He begins by asking: "Admitting that the Jews would not have remained Jews if they had used these images in pagan ways and with pagan explanations, do the remains indicate a symbolic adaptation of pagan figures to Judaism or merely an urge to decoration?" (IV, 27).

Goodenough defines a symbol as "an image or design with a significance, to the one who uses it, quite beyond its manifest content . . . an object or a pattern which, whatever the reason may be, operates upon men, and causes effect in them, beyond mere recognition of what is literally presented in the given form." Goodenough emphasizes that most important thought is in "this world of the suggestive connotative meaning of words, objects, sounds, and forms." He adds that in religion, a symbol conveys not only meaning, but also "power or value" (IV, 33). Further, some symbols move from religion to religion, preserving the same "value" while acquiring a new explanation. In the long history of Judaism religious "symbols" in the form of actions or prohibitions certainly endure through many, varied settings, all the while acquiring new explanations and discarding old ones, and perpetually retaining religious "force" or value or (in more modern terms) "meaning." Hence, Goodenough writes:

> Indeed when the religious symbols borrowed by Jews in those years are put to-
> gether, it becomes clear that the ensemble is not merely a "picture book without
> text," but reflects a lingua franca that had been taken into most of the religions
> of the day, for the same symbols were used in association with Dionysus,
> Mithra, Osiris, the Etruscan gods, Sabazius, Attis, and a host of others, as well
> as by Christianity later. It was a symbolic language, a direct language of values,
> however, not a language of denotation. (IV, 36)

Goodenough is far from suggesting the presence of a pervasive syncretism.
Rather, he points to what he regards as pervasive religious values applied quite
parochially by various groups, including some Jews, to the worship of their
particular "Most High God." These values, while connotative and not denota-
tive, may, nonetheless, be recovered and articulated in some measure by the
historian who makes use of the insights of recent students of psychology and
symbolism.

> The hypothesis on which I am working . . . is that in taking over the symbols,
> while discarding the myths and explanations of the pagans, Jews and Christians
> admitted, indeed confirmed, a continuity of religious experience which it is
> most important to be able to identify . . . for an understanding of man, the phe-
> nomenon of a continuity of religious experience or values would have much
> more significance than that of discontinuous explanations. (IV, 42)

At this point Goodenough argues that the symbols under consideration were
more than merely space-fillers. Since this matter is crucial to his argument, let
me give his reasons with appropriate emphasis:

> first, they were all *living* symbols in surrounding culture;
>
> second, the vocabulary of symbols is extremely limited—on all the artifacts not
> more than a score of designs appear in sum—and thus highly selected;
>
> third, the symbols are frequently not the work of an ornamental artist at all;
>
> fourth, the Jewish and "pagan" symbols are mixed on the same graves, so that
> if the menorah is accepted as "having value," then the peacock or the wreath
> of victory ought also to have "value";
>
> fifth, the symbols are found in highly public places, such as synagogues and
> cemeteries, and not merely on the private and personal possessions of indi-
> viduals, such as amulets or charms.

Goodenough therefore must state carefully where and how each symbol
occurs, thus establishing its commonplace quality; he must then show the
meaning that the symbol may have had *universally*, indicating its specific
denotative value in the respective cultures that used it. He considers its
broader connotative value, as it recurs in each culture, because a symbol evokes
in man, not only in specific groups of men, a broader, psychologically oriented
meaning. Goodenough notes that the formal state religions of Athens, Rome,

and Jerusalem had a quite different basis and had little (if any) use for the sym-
bols at hand. These symbols, he holds, were of use "only in religions that en-
gendered deep emotion, ecstasy, religions directly and consciously centered in
the renewing of life and the granting of immortality, in the giving to the dev-
otee of a portion of the divine spirit of life substance."

> These symbols appear to indicate a type of Judaism in which, as in Philonic Ju-
> daism, the basic elements of "mystery" were superimposed upon Jewish legal-
> ism. The Judaism of the rabbis has always offered essentially a path through
> this present life, the Father's code of instructions as to how we may please him
> while we are alive. To this, the symbols seem to say, was now added from the
> mystery religions, or from Gnosticism, the burning desire to leave this life al-
> together, to renounce the flesh and go up into the richness of divine existence,
> to appropriate God's life to oneself.

> These ideas have as little place in normative, rabbinic Judaism as do the pic-
> tures and symbols and gods that Jews borrowed to suggest them. . . . That such
> ideas were borrowed by Jews was no surprise to me after years of studying
> Philo.

What is perplexing is how Jews fitted such conceptions into, or harmonized
them with, the teachings of the Bible.

Interpreting Symbols One by One:
Symbols from the Jewish Cult and Pagan Symbols used by Jews

IN VOLUMES IV THROUGH VIII Goodenough turns back to the symbols
whose existence he traced in Volumes I to III. Now he attempts a systematic
interpretation according to the method outlined in Volume IV, Part V. In his
discussion of symbols from the Jewish cult, Goodenough attempts to explain
what these symbols—specifically, the Menorah, the Torah shrine, *lulab* and
etrog, *shofar*, and incense shovel—may have meant when reproduced in the
noncultic settings of synagogue and grave. (In our abridgment, we consider
only the *shofar*.) These symbols are, of course, definitely Jewish. But they seem
to have been transformed into symbols (IV, 67) "used in devotion, to have
taken on personal, direct value," to mean not simply that the deceased was a
Jew but to express a "meaning in connection with the death and life of those
buried behind them." It would be simple to assign the meaning of these sym-
bols to their biblical or cultic origins, except that they are often represented
with less obviously Jewish, or biblical, symbols, such as birds eating grapes, and
the like. Rather, Goodenough holds that these devices may have been thought
to be of some direct help in achieving immortality for the deceased; specifically
"the menorah seems to have become a symbol of God, of his streaming Light
and Law . . . the astral path to God. . . . The lulab and ethrog carried on the as-

sociation with Tabernacles as a festival of rain and light, but took on mystical overtones, to become a eucharist of escape from evil and of the passing into justice as the immaterial Light comes to men." He concludes: "They could take a host of pagan symbols which appeared to them to have in paganism the values they wanted from their Judaism, and blend them with Jewish symbols as freely as Philo blended the language of Greek metaphysics with the language of the Bible" (IV, 212).

In Volumes V and VI, *Fish, Bread, and Wine*, Goodenough begins by discussing the Jewish and pagan representations of creatures of the sea, reviews these usages in Egypt, Mesopotamia, Syria, Greece, and Rome (a recurrent inquiry in the latter section), then turns to the symbolic value in Judaism of the fish, and finally, of bread. The representations of "bread" often look merely like "round objects," however, and if it were not for the occasional representation of baskets of bread, one would scarcely be convinced that these "round objects" signify anything in particular. The section on wine is the high point of these volumes, both for its daring and for its comprehensive treatment of the "divine fluid" and all sorts of effulgences from the godhead, from Babylonia and Assyria, Egypt (in various periods), Greece, and Dionysiac cults in Syria and Egypt, as well as in the late syncretistic religions. Goodenough finds considerable evidence of these symbols in Jewish cult and observance, but insists that fish, bread, and wine rites came into Jewish practice during and not before the Hellenistic period, and hence must be explained by contemporary ideas. Wine, in particular, was widely regarded as a source of fertility, but its mystic value was an expression of the "craving for sacramental access to Life."

Pagan symbols used in Jewish contexts include the bull, the lion, the tree, the crown, various rosettes and other wheels (demonstrably not used in paganism for purely decorative purposes), masks, the gorgoneum, cupids, birds, sheep, the hare, the shell, cornucopias, the centaur, psychopomps, and astronomical symbols. (Among these I present the important section on astrological symbols in Judaism.) Goodenough treats this body of symbols last because while some may have had biblical referents, the symbolic value of all these forms seems to him to be discovered in the later period. Of the collection, Goodenough writes:

> They have all turned into life symbols, and could have been, as I believe they were, interpreted in a great many ways. For those who believed in immortality they could point to immortality, give man specific hopes. To those who found the larger life in a mysticism that looked, through death, to a final dissolution of the individual into the All . . . these symbols could have given great power and a vivid sense of appropriation. . . .
>
> The invasion of pagan symbols into either Judaism or Christianity . . . involved a modification of the original faith but by no means its abandonment. Symbolism is itself a language, and affected the original faith much as does

adopting a new language in which to express its tenets. Both Christians and Jews in these years read their Scriptures, and prayed in words that had been consecrated to pagan deities. The very idea of a God, discussion of the values of the Christian or Jewish God, could be conveyed only by using the old pagan *theos*; salvation by the word *sōtēria*; immortality by *athanasia*. The eagle, the crown, the zodiac, and the like spoke just as direct, just as complicated a language. The Christian or Jew had by no means the same conception of heaven or immortality as the pagan, but all had enough in common to make the same symbols, as well as the same words, expressive and meaningful. Yet the words and symbols borrowed did bring in something new. (VIII, 220–21)

Goodenough continues: "When Jews adopted the same lingua franca of symbols they must . . . have taken over the constant values in the symbols" (VIII, 224).

Finally, Goodenough reviews the lessons of the evidence. We learn that the Jews used images of their cultic objects in a new way, in the pagan manner, for just as the pagans were putting the mythological and cultic emblems of their religions on their tombs to show their hope in the world to come, so too did the Jews. From fish, bread, and wine, we learn that the Jews were thus partaking of immortal nature. In reference to the symbols that had no cultic origins (VII and VIII) and, on the face of it, slight Jewish origins (apart from the bull, the tree, the lion, and possibly the crown, which served in biblical times), Goodenough proposes that the value of these objects, though not their verbal explanations, was borrowed because the Jew found in them "new depths for his ideas of . . . his own Jewish deity, and his hope of salvation or immortality."

Interpreting a Set of Symbols: The Synagogue at Dura-Europos

WHEN THE PAINTED walls of the synagogue at Dura-Europos emerged into the light of day in November 1932, the modern perspective on the character of Judaism in Greco-Roman times had to be radically refocused. Until that time it was possible to ignore the growing evidence, turned up for decades by archeologists, of a kind of Judaism substantially different from that described in Jewish literary remains of the period. Those remains specifically contained in the Talmud and Midrash were understood to describe an aniconic, ethically and socially oriented religion, in which the ideas of Hellenistic religions, particularly mystery religions, played little or no part. Talmudic Judaism had, by then, been authoritatively described in such works as George Foot Moore's *Judaism*, and no one had reason to expect that within what was called "normative Judaism" one would uncover phenomena that might, in other settings, be interpreted as "gnostic" or mystical or eschatological in orientation. It is true

that archeological discoveries had long before revealed in the synagogues and graves of Jews in the Hellenistic world substantial evidences of religious syncretism, and of the use of pagan symbols in identifiably Jewish settings. But before the Dura synagogue these evidences remained discrete and made little impact. They were not explained—they were explained away.

After the preliminary report, the Dura synagogue was widely discussed, and a considerable literature, mostly on specific problems of the art but partly on the interpretation of the art, developed. In the main, the Dura synagogue was studied by art historians and not, with notable exceptions, by historians of religion or of Judaism. But from 1932 to 1956 Goodenough was prevented from discussing the finds at Dura. In 1956, Carl H. Kraeling published *The Synagogue* (A. R. Bellinger, F. E. Brown, A. Perkins, and C. B. Welles, eds., *The Excavations at Dura Europos Conducted by Yale University and the French Academy of Inscriptions and Letters. Final Report.* VIII, 1. *The Synagogue*, by Carl H. Kraeling, with contributions by C. C. Torrey, C. B. Welles, and B. Geiger, Yale University Press). Then the issue could be fairly joined. In no way can Goodenough's volumes IX to XI be considered in isolation from the other and quite opposite approach to the same problem. So as we take up Goodenough on the Dura synagogue, we deal with Goodenough in the context of the debate with Kraeling.

Let me state the issue in a general way. Under debate is how we make use of literary evidence in interpreting the use of symbols, and, further, which evidence we consider. Goodenough looks at the symbols in their artistic context, hence in other settings besides the Jewish one, and he invokes literary evidence only as a second step in interpretation. Kraeling starts with literary evidence and emphasizes the Jewish meanings imputed in literary sources to symbols found in Jewish settings. This he does to the near exclusion of the use and meaning of those same symbols in non-Jewish settings in the same town, indeed on the same street. Goodenough reads Hellenistic Jewish writings at his second stage, Kraeling reads rabbinic and related writings at his first stage.

In looking at the walls of the synagogue, Kraeling argued that the paintings must be interpreted for the most part by reference to the so-called rabbinic literature of the period, and he used the Talmudic, Midrashic, and Targumic writings for that purpose. He writes, "The Haggadic tradition embodied in the Dura synagogue paintings was, broadly speaking, distinct from the one that was normative for Philo and for that part of the ancient Jewish world that he presents. . . . This particular cycle [of paintings] as it is known to us at Dura moves within a definable orbit of the Haggadic tradition, . . . this orbit has Palestinian-Babylonian rather than Egyptian relations" (pp. 353, 354). In Volumes IX to XI, Goodenough took the opposite position. Characteristically, he starts with a systematic statement of method, only then proceeding to the artifacts demanding interpretation.

THE DEBATE ON METHOD IN INTERPRETING
THE JUDAISM OF DURA

Kraeling argues that the biblical references of the Dura paintings are so obvious that one may begin by reading the Bible, and proceed by reading the paintings in the light of the Bible and its Midrashic interpretation in the Talmudic period. He says, "Any community decorating its House of Assembly with material so chosen and so orientated cannot be said to have regarded itself remote from religious life and observance of the Judaism that we know from the Bible and the Mishnah. . . . It would appear that there is a considerable number of instances in which Targum and Midrash have influenced the pictures" (pp. 351–52). Kraeling provides numerous examples of such influence. He qualifies his argument, however, by saying that the use of Midrashic and Targumic material is "illustrative rather than definitive." While he makes reference, from time to time, to comparative materials, Kraeling does not in the main feel it necessary to examine the broad iconographic traditions operating in Dura in general, and most manifestly in the synagogue art: whatever conventions of pagan art may appear, the meaning of the synagogue art is wholly separated from such conventions and can best, and probably only, be understood within the context of the Judaism known to us from literary sources.

Goodenough's argument in the earlier volumes, repeated in the later ones, is that literary traditions would not have led us to expect any such art as this. We may find statements in Talmudic literature that are relevant to the art, but after assembling the material we must in any case determine

> what this art means in itself, before we begin to apply to it as proof texts any possibly quite unrelated statements of the Bible or the Talmud. That these artifacts are unrelated to proof texts is a statement which one can no more make at the outset than one can begin with the assumption of most of my predecessors, that if the symbols had meaning for Jews, that meaning must be found by correlating them with talmudic and biblical phrases. (IV, 10)

Even though the art of the Dura synagogue may at first glance seem to be related to Midrashic ideas, and even be found in a few cases to reflect Midrashic accounts of biblical events, nonetheless one is still not freed from the obligation to consider what that art meant to a contemporary Jew, pagan, or Christian who was familiar with other art of the age. Since both the architectural and the artistic conventions of the Dura synagogue are demonstrably those of the place and age, and not in any way borrowed from preexistent "rabbinic" artistic conventions—because there were none—one must give serious thought to the meaning and value of those conventions elsewhere and assess, so far as one can, how nearly that value and meaning were preserved in the Jewish setting.

Both Kraeling and Goodenough agree that there was a plan to the art of

the synagogue. All concur that biblical scenes are portrayed not only as mere ornament or decoration but as a means of conveying important religious ideas, so that the walls of the sanctuary might, in truth, yield sermons. So we may turn away from the argument that symbols are not always symbolic. *These* symbols were symbolic.

One may say that the use of pagan art is wholly conventional, just as the critics of Goodenough's earlier interpretations repeat that the symbols from graves and synagogues were "mere ornament" and imply nothing more than a desire to decorate, but surely no one can say this of Dura, and no one has, for the meaningful character of Dura synagogue art is so self-evident as to obviate the need to argue it. And by asserting that pagan art has lost its value and become, in a Jewish setting, wholly conventional, we have hardly solved many problems, nor explained *why* pagan conventions were useful for decoration.

Goodenough's basic thesis alleges that when Jews borrowed the artistic and religious conventions of their neighbors, the value, though obviously not the verbal explanation, these conventions bore for the pagans continued to retain meaning for Jews. So the argument reverts, even at Dura, to the claim that symbols are symbolic. But at Dura Goodenough stands on firm ground. That is why, in this condensation, I present a large sample of his systematic analysis of the Dura art and its Judaism.

General Points of Difference in Interpretation

HERE LET the two scholars speak for themselves, first, on the general meaning that emerges from the paintings as a whole and, second, on the nature of Judaism at Dura. While both scholars interpret the pictures in detail, each provides a summary of the meaning of the art as a whole. Kraeling's is as follows:

> A closer examination of the treatment of Israel's sacred history as presented in the Synagogue painting leads to a number of inferences that will help to appraise the community's religious outlook. . . . These include the following:
>
> a. There is a very real sense in which the paintings testify to an interest in the actual continuity of the historical process to which the sacred record testifies. This is evidenced by the fact that they do not illustrate interest in the Covenant relationship by a combination of scenes chosen from some one segment of sacred history, but provide instead a well-organized progression of scenes from the period of the Patriarchs and Moses and Aaron, from the early days of the monarchy, through the prophetic period, the exile, the post-exile period, to the expected Messianic age as visualized by prophecy. . . .
>
> b. There is a very real sense in which the history portrayed in the paintings involves not only certain individuals, but concretely the nation as a whole, and in which the course of events in time and space are for the individuals and the

nation a full and completely satisfactory expression of their religious aspirations and ideals. . . .

c. There is a very real sense in which the piety exhibited in, and inculcated by, the paintings finds a full expression in the literal observance of the Law. This comes to light in the effort to provide the historical documentation for the origin of the religious festivals . . . in the attention paid to the cult and its sacra, including the sacrifices: and in the opposition to idolatry.

d. Because they have this interest in the historical process, in the people of Israel, and in the literal observance of the Law, the paintings can and do properly include scenes showing how those nations and individuals that oppose God's purposes and His people are set at naught or destroyed. . . .

In other words, the religious problem which the synagogue paintings reflect is not that of the individual's search for participation in true being by the escape of the rational soul from the irrational desires to a higher level of mystical experience, but rather that of faithful participation in the nation's inherited Covenant responsibilities as a means of meriting the fulfillment of the divine promises and of making explicit in history its divinely determined purpose. (pp. 350–51)

Since the west wall contains the bulk of the surviving fresco, we turn to Goodenough's interpretation of that wall:

The west wall of the synagogue as a whole is indeed coming to express a profoundly consistent Judaism. On the left side a miraculous baby is given by Elijah, but he ties in with the temporal hopes of Israel, exemplified when Persian rulership was humiliated by Esther and Mordecai. Divine intervention brings this about, but, here, brought only this. Above [we shall consider Goodenough's complete chapter on the cosmic Judaism involved here] is the cosmic interpretation of the Temple sacrifice of Aaron, and Moses making the twelve tribes into the zodiac itself.

On the right, just as consistently, the immaterial, metaphysical values of Judaism are presented. [We shall consider Goodenough's chapter on the Judaism of immaterial reality.] Moses is the divine baby here, with the three Nymphs and Anahita-Aphrodite. Kingship, as shown in the anointing of David by Samuel, is not temporal royalty, but initiation into the hieratic seven. Above these, the gods of local paganism collapse before the Ark of the Covenant, the symbol of metaphysical reality in Judaism, which the three men beside the ark also represented, while that reality is presented in a temple with seven walls and closed inner sanctuary, and with symbols from the creation myth of Iran. At the top, Moses leads the people out to true spiritual Victory.

In the four portraits, an incident from the life of Moses is made the culmination of each of these progressions. He goes out as the cosmic leader to the heavenly bodies alongside the cosmic worship of Aaron, the menorah, and the zodiac. He reads the mystic law like the priest of Isis alongside the Closed Temple and the all-conquering Ark. He receives the Law from God on Sinai beside a Solomon scene which we cannot reconstruct: but he stands at the

> Burning Bush, receiving the supreme revelation of God as Being, beside the
> migrating Israelites, who move, presumably, to a comparable, if not the same,
> goal. (X, 137–38)

The reader must be struck by the obvious fact that, in the main, both scholars
agree on the substance of the paintings, though they disagree on both their
interpretation and their implications for the kind of religion characteristic of
this particular synagogue.

Concerning Dura Judaism, Kraeling argues that the Jews of Dura had
fallen back "visibly" upon the biblical sources of religious life (p. 351). Kraeling
says throughout that the Jews in Dura were, for the most part, good, "norma-
tive," rabbinic Jews:

> If our understanding of the pictures is correct, they reveal on the part of those
> who commissioned them an intense, well-informed devotion to the established
> traditions of Judaism, close contact with both the Palestinian and the Babylo-
> nian centers of Jewish religious thought, and a very real understanding of the
> peculiar problems and needs of a community living in a strongly competitive
> religious environment, and in an exposed political position. (p. 353)

Goodenough, in his description of Judaism at Dura (X, 196–209), holds that
these Jews were not participants in the "established traditions of Judaism," and
that they did not have close contact with Babylonian or Palestinian Judaism.
He follows the general view of Babylonian Judaism as "rabbinic," which I shall
question below. The walls of the synagogue are not, he argues, representations
of biblical scenes, but *allegorizations* of them (as in the specific instances cited
above). The biblical scenes show an acceptance of mystic ideas which were sug-
gested by the symbolic vocabulary of Jews elsewhere in the Greco-Roman
world, studied in the first eight volumes.

> While the theme of the synagogue as a whole might be called the celebration of
> the glory and power of Judaism and its God, and was conceived and planned
> by men intensely loyal to the Torah, those people who designed it did not un-
> derstand the Torah as did the rabbis in general. Scraps stand here which also
> appear in rabbinic haggadah, to be sure. . . . But in general the artist seems to
> have chosen biblical scenes not to represent them but, by allegorizing them, to
> make them say much not remotely implicit in the texts. . . . On the other hand,
> the paintings can by no means be spelled out from the pages of Philo's allego-
> ries, for especially in glorifying temporal Israel they often depart from him al-
> together. Kraeling astutely indicated . . . that we have no trace of the creation
> stories, or indeed of any biblical passages before the sacrifice of Isaac, sections
> of the Bible to which Philo paid almost major attention. This must not blind us,
> however, to the fact that the artist, like Philo, presumed that the Old Testament
> text is to be understood not only through its Greek translation, but through its
> re-evaluation in terms of Greek philosophy and religion. Again, unlike Philo in
> detail but like him in spirit, the artists have interpreted biblical tradition by us-

ing Iranian costumes and such scenes as the duel between the white and black
horsemen. . . . The Jews here, while utterly devoted to their traditions and
Torah, had to express what this meant to them in a building designed to copy
the inner shrine of a pagan temple, filled with images of human beings and
Greek and Iranian divinities, and carefully designed to interpret the Torah in
a way profoundly mystical. (X, 206)

Both Goodenough and Kraeling accept the conventional view of Babylo-
nian Judaism. It is normally portrayed as a wholly isolated legalistic and law-
abiding religion, deeply engaged by its own interests and traditional concerns,
and wholly divorced from the surrounding culture. Goodenough describes
Babylonian Jewry as an island, a cultural ghetto (IX, 8–10), where the Jews
occupied themselves in the study of the law in its most halakhic sense, while the
Dura community, "engulfed" by the pagan world, was far more deeply influ-
enced by pagan culture. Kraeling, likewise, views Babylonian Jewry as living in
towns predominantly Jewish (p. 325) and generally loyal to the halakhah as it
was later recorded. The conventional view is based on a conflation of all in-
formation, early or late, into a static and one-dimensional portrait. What we
know about the Jews in Babylonia before 226 does not support this view. It
contradicts it.

A Judgment on the Matter of Dura

GOODENOUGH'S APPROACH, if not demonstrably correct in every detail,
takes account of the realities of Dura, a cosmopolitan and diverse town in
which many different groups lived side by side. He takes account of the high
probability that, under such circumstances, Jews learned from their neighbors
and commented, in a way they found appropriate, on their neighbors' reli-
gions. Kraeling's approach rests on the premise that a group of Jews lived
quite separate from the world around them. So far as we know, there was no
ghetto in Dura: neither physical nor cultural isolation characterized the Jews'
community there. They assuredly spoke the same language as others, and they
knew what was going on. The notion, moreover, of an "Orthodoxy," surely ap-
plies to the third century a conception invented in the nineteenth, and that
anachronism has confused many, not only Kraeling, in reading the artistic and
literary sources at hand. There was no single Judaism then, there was never an
Orthodoxy, any more than today there is a single Judaism, Orthodox or other-
wise. That conception is a conceit of Orthodoxy.

Indeed, throughout Babylonia (present day Iraq) Jews lived in the same
many-splendored world, in which there were diverse languages and groups
worshipped different gods. And Jews themselves prove diverse: there were
many Judaisms. The evidence is that the Jews in Babylonia lived in relatively
close contact, both physical and cultural, with their neighbors. Their main cen-

ter, Nehardea, was not far from the great Hellenistic city, Seleucia, on the Tigris. Greeks, Babylonians, pagan Semites, Jews, and Parthians inhabited the narrow strip of fertile land around the Royal Canal, which later historians so generously assigned to the Jews alone. We know, for example, that in the first century, when the Jewish barony of Anileus and Asineus was established, the local Greeks and Babylonians opposed it and eventually succeeded in gaining Parthian support to destroy it. For a time, the two brothers ruled *both* Jewish *and* Hellenistic and Babylonian populations, all in a relatively small area around Nehardea itself. And there were Greeks in Nehardea. It should be emphasized, therefore, that the Jews were only one minority in the region, and they were not the most numerous. Furthermore, the Greek city of Seleucia contained a Hellenized Jewish population.

Thus the evidence points to extensive Jewish participation in Parthian affairs. Participation in political, commercial, and possibly military affairs could not have been carried on by people "wholly isolated" from the culture of the government. One should expect to find among them substantial knowledge of the surrounding culture. Not the least of the contacts of the Jewish masses with that culture would have been through the coinage, which certainly yielded some information on the pagan religion of the Iranian Empire, and on the local Semitic and Hellenistic cults as well. It is too much to conclude that political, commercial, and military contacts had led to the utter assimilation of Babylonian Jewry into Parthian culture. But one ought not to be surprised to find traces of Parthian (and hence Parthian-Hellenistic) influence on Babylonian Jewry. We should certainly expect to see similar influences in Dura, a town held by Parthia until *circa* A.D. 160, and should be astonished to find no knowledge of Iranian culture half a century later in such a place. With this in mind, I find it difficult to question the importance ascribed by Goodenough to Greco-Parthian culture in Dura. We should have expected to find some kind of syncretistic, mystical tradition in the synagogue at Dura and something approximating the Judaism discerned by Goodenough, specifically a kind of Judaism in which Ezekiel plays a very important role and in which the mystical speculations associated in part with his writings are represented.

The original paintings in the synagogue were covered over in a great redecoration, the results of which have survived. How may we understand that great redecoration of the Dura synagogue, which took place *circa* A.D. 245? In the context of the state of religions generally in early Sasanid Iran, the redecoration of the synagogue represents an act of tremendous religious creativity. It expresses the reflection of an extraordinary mind, a response to the Jewish tradition, whether to the rabbinic tradition alone (Kraeling) or to the tradition as modulated by current ideas and attitudes (Goodenough). What stimulated that mind to rethink the meaning of Israel's life and history, with a focus on the question of salvation at the end of time, as the biblical story foretells it?

From the answer—Israel will be saved by God, who rules history—we may discern the question. That question derived from the stunning success of the Iranian Sasanian dynasty, which in a brief time overthrew the Iranian Parthian one, after a rule of four hundred years.

Yet the political change tells only part of the story of why, at just this time, in just this place, a crisis of the age provoked deep reflection on the meaning of history. No era in the history of religions was more diverse or creative than the early middle third century. No place ever exhibited greater variety or vitality than Mesopotamia. In the small region, a parallelogram of no more than two hundred miles in length and fifty in breadth, we find the following extraordinary signs of creativity and vitality:

first, and most important, the resurgence of a conquering, proselytizing Mazdeism, propagated by the state under Ardashir and established (if in a tolerant manner) as the state religion under Shahpuhr with its exponent, Kartir;

second, the development of an Iranian gnostic syncretism by the prophet Mani, who, at the time of the redecoration of the Dura synagogue, proclaimed a new religion and in the next decades attracted a wide following in Iran, and in the Roman Empire as well;

third, the advance of Christianity (Mani's father was probably a Christian, and Jesus played a part in his theology) into the Mesopotamian valley from Edessa, where by 201, it had become well established;

fourth, the great expansion of cults within the Iranian idiom, in particular Mithraism, in both Iran and the Roman Empire, to the point where Mithraism was perhaps the single most popular religion on the Roman side of the frontier;

fifth, and by no means least, the beginnings of a revolution in Babylonian Judaism, which transformed the earlier indigenous religion into a fair representation of the ideas of the Palestinian Tannaim (this much we may say, but obviously no more), and which must have created a tremendous upheaval in Babylonian Jewry.

These events, each of them of lasting importance in the religious life of Mesopotamia, took place within a brief period; one may say that from *circa* 220 to *circa* 250 in Babylonia Manichaeism, Rabbinic Judaism, and Mazdeism were all taking form. To such events, Dura's Jewish philosopher may well have responded, as Goodenough says he did, by a series of symbolic comments on the religions of the day. He made the statement that the God of Israel, known through the pages of the Hebrew Scripture, ruled over all humanity and determined the course of all nations. The power of Goodenough's reading of Dura derives from the simple fact that the premise is sound: there was no ghetto, and Judaism lived out its life in the affairs of a Jewish community at one with the world.

A FINAL JUDGMENT

Dura is hardly the end of the matter. Indeed, rereading Goodenough after three decades or so reminds us that he began much but concluded nothing. That marks the measure of his greatness. Obviously, this abridgment serves only to call attention to the magisterial work at hand. Goodenough wanted nothing more than to insist that art matters. So if the present work serves Goodenough's name and memory well, it will bring a new generation once more to ask Goodenough's questions. People may or may not agree with his answers, but they will have to work along lines dictated by his premises and to follow his methods, in whole or in part. He was the greatest historian of religion of his generation, and, as a premier scholar, he cared not so much for conclusions as for process, not so much for scoring points as for the reasoned conduct of argument and inquiry. He leaves a legacy of learning and of a great life, lived for illumination.

THE CRITICAL RESPONSE TO GOODENOUGH'S READING OF JEWISH SYMBOLS

No account of Goodenough's monumental work can ignore the critical debate that he precipitated. Anyone with an interest in symbolism will follow that debate as a first step beyond this encounter with Goodenough's work. A mark of the success of scholarship, particularly in a massive exercise of interpretation such as the one at hand, derives from how a scholar has defined issues. Did Goodenough succeed in framing the program of inquiry? Indeed he did. Nearly all critics now concede the premise of his work, which, when he began, provoked intense controversy. So the judgment of time vindicated Goodenough in his principal point: that the Jewish symbols be taken seriously, and not be dismissed as mere decoration. That view formed the foundation of his work. Goodenough's greatness begins in his power to reframe the issues of his chosen field. In his day few scholars in his area of research enjoyed equivalent influence, and, in our day, none.

But that fact should not obscure differences of opinion, both in detail and in general conclusions. Goodenough would not have wanted matters any other way. Readers will find useful an account of two interesting approaches to the criticism of Goodenough's *Jewish Symbols*, as well as a list of the more important reviews of his work. These readings will pave the way to further study not only of Goodenough's work, but also of symbolism and, by way of example, of the symbolism of Judaism.

Arthur Darby Nock (1902–1963)

In *Gnomon* 27 (1955), 29 (1957), and 32 (1960), Nock presented a systematic critique of Goodenough, Volumes I–VIII, under the title, "Religious Symbols

and Symbolism." Now reprinted in Zeph Stewart, ed., *Arthur Darby Nock. Essays on Religion and the Ancient World* (Oxford, 1972), II, pp. 877–918. Nock first summarizes the main lines of Goodenough's approach to the interpretation of symbols. He then expresses his agreement with what I regard as the principal implication of Goodenough's work for the study of Judaism (pp. 880–82, pass.):

> G[oodenough] has made a good case against any strong central control of Judaism: it was a congregational religion and the local group or, in a large city such as Rome, any given local group seems to have been largely free to follow its own preferences. Again, in art as in other things, Judaism seems to have been now more and now less sensitive on questions of what was permissible. From time to time there was a stiffening and then a relaxing: down into modern times mysticism and enthusiasm have been recurrent phenomena; so has the "vertical path" as distinct from the "horizontal path." To speak even more generally, from the earliest times known to us there has been a persistent quality of religious lyricism breaking out now here, now there among the Jews.

The point conceded by Nock is central to Goodenough's thesis: that Judaism yielded diversity and not uniformity. Again, since Goodenough repeatedly turns to Philo for explanation of symbols, it is important to note that Nock concedes how Philo may represent a world beyond himself:

> So again, in all probability, Philo's attitude was not unique and, deeply personal as was the warmth of his piety and his sense of religious experience, we need not credit him with much original thinking. The ideas which he used did not disappear from Judaism after 70 or even after 135. Typological and allegorical interpretation of the Old Testament continued to be common. G.'s discussion of the sacrifice of Isaac is particularly instructive; so are his remarks on the fixity and ubiquity of some of the Jewish symbols and (4.145 ff.) on lulab and ethrog in relation to the feast of Tabernacles, "the culminating festival of the year" with all that it suggested to religious imagination.
>
> Menorah, lulab, ethrog, Ark and incense-shovel were associated with the Temple and as such could remain emblems of religious and national devotion after its destruction; the details of the old observances were discussed with passionate zeal for centuries after their disuse. G. has indeed made a strong case for the view that, as presented in art, they refer to the contemporary worship of the synagogue (as he has produced serious arguments for some use of incense in this). It may well be that they suggested both Temple and synagogue.

But Nock provided extensive and important criticism, of Goodenough's ideas. He expresses his reservations on detail:

> The improbability of many of G.'s suggestions on points of detail does not affect his main theses, but those theses do themselves call for very substantial reservations. Thus the analogy between Isis and Sophia is more superficial than real, and so is that between allegorical explanations of the two types of religious vestments used by Egyptians and the two used by the High Priest. Now these

are not minor matters; the first is one of the foundations of what is said about the 'saving female principle' and the second is made to support the supposition of Lesser and Greater Mysteries of Judaism.

The crucial question is: was there a widespread and long continuing Judaism such as G. infers, with something in the nature of a mystery worship? Before we attack this we may consider (a) certain iconographic features regarded by G. as Hellenistic symbols—in particular Victories with crowns, Seasons, the Sun, and the zodiac; (b) the cup, the vine and other motifs which G. thinks Dionysiac; (c) the architectural features which he interprets as consecratory. (pp. 882–83)

The important point to observe is how Nock calls into question not only detail but the general approach: the main results. But Nock concludes: "Once more such points do not destroy the essential value of the work. I have tried to indicate . . . what seem to be the major gains for knowledge which it brings and naturally there are also valuable details" (p. 918).

In the balance, Nock's systematic critique confirms Goodenough's standing as the scholar to insist that the symbols matter. More than that Goodenough could not have asked. More than that Nock did not concede.

Morton Smith (1915–)

SMITH's "Goodenough's Jewish Symbols in Retrospect" (*Journal of Biblical Literature* 86 [1967]: 53–68, and note also Goodenough, XIII, 229–30) provides a list of reviews of Goodenough's work, which he compiled from *L'Année philologique*, and which I have appended to this foreword, as well as a systematic reconsideration of the work as a whole. This essay stands as the definitive account of Smith's own viewpoint on Goodenough's work.

Smith first calls attention to the insistence on distinguishing the value of a symbol from its verbal explanation:

> The fundamental point in Goodenough's argument is his concept of the "value" of a symbol as distinct from the "interpretation." He defined the "value" as "simply emotional impact." But he also equated "value" with "meaning" and discovered as the "meaning" of his symbols a complex mystical theology. Now certain shapes may be subconsciously associated with certain objects or, like certain colors, may appeal particularly to persons of certain temperaments. This sort of symbolism may be rooted in human physiology and almost unchanging. But such "values" as these do not carry the theological implications Goodenough discovered. (p. 55)

The premise of a psychic unity of humanity, on which Goodenough's insistence on the distinction at hand must rest, certainly awaits more adequate demonstration. Smith proceeds:

After this definition of "value," the next step in Goodenough's argument is the claim that each symbol always has one and the same "value."

Goodenough's position can be defended only by making the one constant value something so deep in the subconscious and so ambivalent as to be compatible with contradictory "interpretations." In that event it will also be compatible with both mystical and legalistic religion. In that event the essential argument, that the use of these symbols necessarily indicates a mystical religion, is not valid. (pp. 55–56)

So much for the basic theory of symbolism. Smith proceeds to the specific symbolism at hand:

The lingua franca of Greco-Roman symbolism, predominantly Dionysiac, expressed hope for salvation by participation in the life of a deity which gave itself to be eaten in a sacramental meal. This oversimplifies Goodenough's interpretations of pagan symbolism; he recognized variety which cannot be discussed here for lack of space. But his thesis was his main concern, and drew objections from several reviewers, notably from Nock, who was the one most familiar with the classical material.

It must be admitted that Goodenough's support of this contention was utterly inadequate. What had to be established was a probability that the symbols, as commonly used in the Roman empire, expressed this hope of salvation by communion. If they did not *commonly* do so *at this time*, then one cannot conclude that the Jews, who at this time took them over, had a similar hope. But Goodenough only picked out a scattering of examples in which the symbols could plausibly be given the significance his thesis required; he passed over the bulk of the Greco-Roman material and barely mentioned a few of the examples in which the same symbols were said, by those who used them, to have other significance. These latter examples, he declared, represented superficial "interpretations" of the symbols, while the uses which agreed with his theory expressed the symbols' permanent "values." The facts of the matter, however, were stated by Nock: "Sacramental sacrifice is attested only for Dionysus and even in his cult this hardly remained a living conception"; there is no substantial evidence that the worshipers of Dionysus commonly thought they received "his divine nature in the cup." So much for the significance of the lingua franca of Greco-Roman Dionysiac symbolism. (p. 57)

Smith then points out that Goodenough "ruled out the inscriptional and literary evidence which did not agree with his theories." He maintains that Goodenough substituted his own intuition, quoting the following: "The study of these symbols has brought out their value for my own psyche." By contrast, Smith concurs with Goodenough's insistence on the hope for the future life as a principal theme of the symbols.

Still, Smith maintains that Goodenough failed "to demonstrate the prevalence of a belief in sacramental salvation" (p. 58). In Smith's view, therefore, "the main structure of his argument was ruined." Smith makes a long sequence

of *ad hominem* points about Goodenough's background, upbringing, religious beliefs, and the like—for example, "He is the rebellious son of G. F. Moore" (p. 65). In this way he treats scholarship as an expression of personal idiosyncracy—for instance, of background and upbringing—dismissing Goodenough's learning. He leaves in the form of questions a series of, to him "self-evident," claims against Goodenough's views. These claims in their form as rhetorical questions Smith regards as unanswerable and beyond all argument. For example: "But the difficulties in the supposition of a *widespread, uniform* mystical Judaism are formidable [italics Smith's]. How did it happen that such a system and practice disappeared without leaving a trace in either Jewish or Christian polemics? We may therefore turn from the main argument to incidental questions" (p. 59). Those three sentences constitute Smith's stated reason for dismissing Goodenough's principal positions and turning to minor matters. Goodenough, for his part, had worked out the answers to these questions, which he recognized on his own. Still, Smith's criticism cannot be dismissed, nor should we wish to ignore his positive assessment:

> Goodenough's supposition that the Jews gave their own interpretations to the symbols they borrowed is plausible and has been commonly accepted. His reconstructions of their interpretations, however, being based on Philo, drew objections that Philo was an upper-class intellectual whose interpretations were undreamt of by the average Jew. These, however, missed Goodenough's claim: Philo was merely one example of mystical Judaism, of which other examples, from other social and intellectual classes, were attested by the monuments. For this reason also, objections that Goodenough misinterpreted Philo on particular points did not seriously damage his argument; it was sufficient for him to show that Philo used expressions suggestive of a mystical and sacramental interpretation of Jewish stories and ceremonies. The monuments could then show analogous developments independent of Philo. Some did, but most did not. (p. 61)

The single most important comment of Smith is as follows:

> Goodenough's theory falsifies the situation by substituting a single, anti-rabbinic, mystical Judaism for the enormous variety of personal, doctrinal, political, and cultural divergencies which the rabbinic and other evidence reveals, and by supposing a sharp division between rabbinic and anti-rabbinic Judaism, whereas actually there seems to have been a confused gradation. (p. 65)

Declaring Goodenough to have failed, Smith concludes, "Columbus failed too. But his failure revealed a new world, and so did Goodenough's" (p. 66). For more than that no scholar can hope. For learning is a progressive, an on-going process, an active verb in the continuing, present tense.

The More Important Reviews (Smith, pp. 66–67)

Albright, W., *Bulletin of the ASOR*, 139, pp. 32 f., on Goodenough, I–III.

Avi-Yonah, M., *Israel Exploration Journal*, 6 (1956), pp. 194 ff., on I–IV.

Barb, A., *Antiquaries' Journal*, 36 (1956), pp. 229 ff., on I–IV; 38 (1958), pp. 117 f., on V–VI; 39 (1959), p. 301, on VII–VIII.

Baron, S., *Journal of Biblical Literature* [hereinafter: *JBL*], 74 (1955), pp. 196–99, on I–III.

Bickerman, E., *L'Antiquité classique*, 25 (1956), pp. 246 ff., on I–IV; 26 (1957), pp. 532 f., on V–VI; 28 (1959), pp. 517 f., on VII–VIII; "Symbolism in the Dura Synagogue," *Harvard Theological Review*, 58 (1965), pp. 127 ff., on IX–XI.

den Boer, W., *Mnemosyne*, Ser. 4, 12 (1959), pp. 85 ff., on V–VI; 14 (1961), pp. 66 ff., on VII–VIII.

Botterweck, D., *Theologische Quartalschrift*, 137 (1957), pp. 210 f., on I–VI.

Buck, F., *Catholic Biblical Quarterly*, 27 (1965), p. 191, on IX–XI.

Couroyer, B., *Revue biblique*, 67 (1960), pp. 107 ff., on VII and VIII; 72 (1965), pp. 310 ff., on IX–XI.

Daniélou, J., *Recherches de science religieuse*, 45 (1957), pp. 471 ff., on I–VI; 48 (1960), pp. 598 ff., on VII and VIII.

Delvoye, C., *Latomus*, 14 (1955), pp. 494 ff., on I–IV; 18 (1959), pp. 484 ff., on V–VIII.

Ehrlich, E., *Zeitschrift für Religionsgeschichte*, 9 (1957), pp. 277 ff., on I–VI; 12 (1960), pp. 92–94, on VII–VIII.

Ferrua, A., *Rivista di Archeologia Cristiana*, 30 (1954), pp. 237 ff., on I–III.

Galling, K., *Zeitschrift des deutschen Palaestina-Vereins*, 70 (1954), pp. 182 f., on I–III.

Gaster, T., "Pagan Ideas and the Jewish Mind," *Commentary*, 17 (1954), pp. 185 ff., on I–III.

Goossens, G., *Revue belge d'archéologie*, 22 (1953), pp. 268 f., on I–III; 24 (1955), pp. 125 f., on IV; 25 (1956), pp. 251 f., on V–VI; 27 (1958), pp. 231 f., on VII–VIII.

Grant, F., *JBL*, 79 (1960), pp. 61 ff., on VII–VIII; 83 (1964), pp. 418 ff., on IX–XI.

Grant, R., *Church History*, 23 (1954), pp. 183 ff., on I–III; 24 (1955), pp. 279 f., on IV; 26 (1957), pp. 292 ff., on V–VI; 29 (1960), pp. 94 ff., on VII–VIII.

Guillaumont, A., *Revue des études anciennes*, 59 (1957), pp. 482 ff., on I–VI; 62 (1950), pp. 542 ff., on VII–VIII.

Gusinde, M., *Anthropos*, 49 (1954), pp. 1145 ff., on I–IV; 52 (1957), pp. 311 ff., on V–VI; 54 (1959), pp. 1012 ff., on VII–VIII.

Gutmann, J., *Studies in Bibliography and Booklore*, 3 (1957), pp. 33 ff., on V–VI; *The Reconstructionist*, 31 (1965), pp. 20 ff., on IX–XI.

Hart, H., *Journal of Theological Studies*, 7 (1956), pp. 92 ff., on I–IV.

Hooke, S., *Journal of Theological Studies*, 9 (1958), pp. 117 ff., on V–VI; 11 (1960), pp. 371 ff., on VII–VIII.

Jeremias, J., *Theologische Literaturzeitung*, 83 (1958), cols. 502–5, on I–VI; 87 (1962), p. 922, on VII–VIII.

Kayser, S., *Review of Religion*, 21 (1956), pp. 54 ff., on I–IV.

Landsberger, F., *American Journal of Philology*, 76 (1955), pp. 422 ff., on I–IV; 78 (1957), p. 450, on VI–VII; 81 (1960), pp. 198 f., on VIII–IX.

Leon, H., *Archaeology*, 7 (1954), p. 261 f., on I–III; 9 (1956), p. 154, on IV; 11 (1958), pp. 135 f., on V–VI; 13 (1960), p. 155, on VI–VIII.

Leroy, J., *Cahiers Sioniens*, 9 (1955), pp. 157 ff.

MacKenzie, R., *Catholic Biblical Quarterly*, 16 (1954), pp. 489 ff., on I–III; 17 (1955), pp. 629-31, on IV; 20 (1958), pp. 264 ff., on V–VI.

Marcus, R., *Classical Philology*, 52 (1957), pp. 43 ff., on I–III; pp. 182 ff., on IV.

Momigliano, A., *Athenaeum*, n.s. 34 (1956), pp. 237 ff., on I–IV.

Mouterde, R., *Mélanges de l'Université Saint-Joseph*, 31 (1954), pp. 341 ff., on I–IV; 34 (1957), pp. 262 ff., on V–VI.

Musurillo, H., *Theological Studies*, 15 (1954), pp. 295 ff., on I–III; 25 (1964), pp. 437 ff., on IX–XI.

Neusner, J., "Jewish Use of Pagan Symbols after 70," *Journal of Religion*, 33 (1965), pp. 285–294.

———, "Notes on Goodenough's Jewish Symbols," *Conservative Judaism*, 17 (1963), pp. 77 ff., on I–VIII.

Nober, P., *Biblica*, 36 (1955), pp. 549 ff., on I–III; 38 (1957), pp. 364 ff., on V–VI; 41 (1960), pp. 430 ff., on VII–VIII; 46 (1965), pp. 96 ff., on IX–XI.

Nock, A., *Gnomon*, 27 (1955), pp. 558 ff., on I–IV; 29 (1957), pp. 524 ff., on V–VI; 32 (1960), pp. 728 ff., on VII–VIII.

North, R., *Orientalia*, n.s. 25 (1956), pp. 310 ff., on I–IV; 26 (1957), pp. 180 f., on V–VI; 35 (1966), pp. 201 ff., on IX–XI.

van Puyvelde, C., *Recherches de théologie ancienne et médiévale*, 21 (1954), pp. 324 ff., on I–IV; 24 (1957), pp. 375 ff., on V–VI.

Rosenau, H., *Journal of Jewish Studies*, 8 (1957), pp. 253 ff.

Roth, C., *Judaism*, 3 (1954), pp. 179 ff., on I–III.

Sandmel, S., *JBL*, 77 (1958), pp. 380 ff., on V–VI.

Sed-Rajna, G., *Revue des études juives*, 3 (1964), pp. 533 f.

Segert, S., *Archiv Orientalni*, 23 (1955), pp. 256 ff., on I–III; 24 (1956), pp. 157 ff., on IV; 26 (1958), pp. 322 ff., on V–VI; 28 (1960), pp. 704 ff., on VII–VIII.

Smith, M., *Anglican Theological Review*, 36 (1954), pp. 218 ff., on I–III; 37 (1955), pp. 81 ff., on IV; 39 (1957), pp. 261 ff., on V–VI; 42 (1960), pp. 171 ff., on VII–VIII; *Classical World*, 59 (1965–6), p. 13, on IX–XI.

———, "The Image of God," *Bulletin of the John Rylands Library*, 40 (1958), pp. 473 ff.

Strauss, H., *Judaism*, 7 (1958), pp. 178 f., on IV–VI; 8 (1959), pp. 374 f., on VII–VIII.

Thelen, M., *Journal of Bible and Religion* [later: *Journal of the American Academy of Religion*], 32 (1964), pp. 361 ff., on IX–XI.

Vincent, L., *Revue biblique*, 62 (1955), pp. 104 ff., on I–III; pp. 428 ff., on IV; 64 (1957), pp. 593 ff., on V–VI.

Willoughby, H., *Journal of Near Eastern Studies*, 15 (1956), pp. 121 ff., on I–IV; 17 (1958), pp. 158 f., on V–VI; 20 (1961), pp. 260 ff., on VII–VIII.

ABBREVIATIONS

AA,AZ. *Archäologischer Anzeiger zur Archäologischen Zeitung.*

AA,JDAI. *Archäologischer Anzeiger, Beiblatt zum Jahrbuch des Kaiserlich Deutschen Archäologischen Instituts.*

AAL,M. *Atti della R. Accademia dei Lincei, Memorie della Classe di Scienze Morali, Storiche e Filologiche,* Rome.

AAL,N. *Atti della R. Accademia dei Lincei, Notizie degli scavi di antichità della Classe di Scienze Morali, Storiche e Filologiche,* Rome.

AASOR. *Annual of the American School of Oriental Research in Jerusalem.*

Abrahams, *Jewish Life.* Israel Abrahams, *Jewish Life in the Middle Ages,* London, 1932.

AJA. *American Journal of Archaeology.*

AJP. *American Journal of Philology.*

AJSL. *American Journal of Semitic Languages and Literatures.*

ARW. *Archiv für Religionswissenschaft.*

AZ. *Archäologische Zeitung.*

BA. *Bollettino d'arte del Ministero della Pubblica Istruzione.*

Babelon, *Guide illustré.* E. Babelon, *Guide illustré au Cabinet des Médailles,* Paris, 1900.

BAC. *Bullettino di archeologia cristiana.*

Baron, *History.* Salo Wittmayer Baron, *A Social and Religious History of the Jews,* New York, 1937.

BASOR. *Bulletin of the American Schools of Oriental Research.*

BCH. *Bulletin de correspondance hellénique.*

Berliner, *Juden in Rom.* A. Berliner, *Geschichte der Juden in Rom,* Frankfort, 1893.

Beyer and Lietzmann, *Torlonia.* H. W. Beyer and Hans Lietzmann, *Jüdische Denkmäler,* I: *Die jüdische Katakombe der Villa Torlonia in Rom,* Berlin-Leipzig, 1930 (Studien zur spätantiken Kunstgeschichte, IV).

BICA. *Bullettino dell'Istituto di Corrispondenza Archeologica,* Rome, 1829–1885. Continued by publications of Archäologisches Institut des Deutschen Reichs in Rome.

Billiard, *La Vigne.* Raymond Billiard, *La Vigne dans l'antiquité,* Lyons, 1913.

BJPES. *Bulletin of the Jewish Palestine Exploration Society.*

BMW, *Excavations.* Frederick Jones Bliss, R. A. Stewart Macalister, and Dr. Wünsch, *Excavations in Palestine during the Years 1898–1900,* London, 1902.

Bonner, *Amulets.* Campbell Bonner, *Studies in Magical Amulets, Chiefly Graeco-Egyptian,* Ann Arbor, 1950.

Bonner, *BM.* Campbell Bonner, "Amulets Chiefly in the British Museum," *Hesperia,* XX (1951), 301–345.

Bousset, *Religion.* Wilhelm Bousset, *Die Religion des Judentums im späthellenistischen Zeitalter,* 3d ed., Tübingen, 1926 (Handbuch zum Neuen Testament, XXI).

BT. Babylonian Talmud, with references to the various treatises. ET refers to the English translations made by various scholars under the general editorship of I. Epstein, London, Soncino Press, 1935 et seq. Similarly, GT refers to the German translation of Lazarus Goldschmidt, pub. with the Hebrew text, Berlin, 1897; rev. ed. (German transl. only), Berlin, 1929.

Bullet. Commiss. Archeol. *Bullettino della Commissione Archeologica Comunale di Roma.*

Bulletin, Rabinowitz. *Bulletin,* Louis M. Rabinowitz Fund for the Exploration of Ancient Synagogues, Museum of Jewish Antiquities, Hebrew University, Jerusalem, Israel.

Butler, *Architecture, 1899.* Howard C. Butler, *Architecture and Other Arts,* New

York, 1903 (Publications of an American Archeological Expedition to Syria in 1899–1900, II).

Butler, *Architecture, 1904–5.* *Syria: Publications of the Princeton University Archaeological Expeditions to Syria in 1904–5 and 1909.* Div. II, *Architecture,* by Howard C. Butler: Sec. *A,* "Southern Syria"; Sec. *B,* "Northern Syria." Leyden, 1919–1920.

By Light, Light. See Goodenough.

Caylus, *Rec. d'ant.* A.-C.-P. Caylus, *Recueil d'antiquités égyptiennes, étrusques, grecques et romaines,* VI, Paris, 1764.

C-G, *Arch. Res.* Charles Clermont-Ganneau, *Archaeological Researches in Palestine during the Years 1873–1874,* London, 1899.

Chabouillet, *Cat. gén.* M. Chabouillet, *Catalogue général et raisonné des camées et pierres gravées exposées dans le Cabinet des Médailles,* Paris, 1858.

Charles, *Apoc. and Pseud.* R. H. Charles, *The Apocrypha and Pseudepigraphica of the Old Testament in English, with Introductions and Critical and Explanatory Notes to the Several Books,* Oxford, 1913.

CIG. *Corpus inscriptionum Graecarum.*

CIJ. See Frey.

CIL. *Corpus inscriptionum Latinarum.*

CL. *Dictionnaire d'archéologie chrétienne et de liturgie,* ed. by Fernand Cabrol and H. Leclercq, Paris, 1907 et seq.

Cohn-Wiener. Ernst Cohn-Wiener, *Die jüdische Kunst, ihre Geschichte von den Anfängen bis zur Gegenwart,* Berlin-Leipzig, 1929.

Coll. De Clercq. A. de Ridder, *Collection De Clercq: Catalogue,* VII, ii, *Les Pierres gravées,* Paris, 1911.

Cook, *Zeus.* Arthur B. Cook, *Zeus: A Study in Ancient Religion,* Cambridge, 1914 et seq.

CR,AIB. Académie des Inscriptions et Belles-Lettres, *Comptes rendus des séances de l'année.*

CSEL. *Corpus scriptorum ecclesiasticorum Latinorum,* Vienna, 1866 et seq.

Cumont, *After Life.* Franz Cumont, *After Life in Roman Paganism,* New Haven, 1922.

Cumont, "Sarcophage judéo-païen." Franz Cumont, "Un Fragment de sarcophage judéo-païen," *RA,* Ser. V, Vol. IV (1916), 1–16. Revised and reprinted in idem, *Symbolisme,* 484–498.

Cumont, *Symbolisme.* Franz Cumont, *Recherches sur le symbolisme funéraire des Romains,* Paris. 1942 (Bibliothèque archéologique et historique, XXXV).

Danby, *Mishnah.* Herbert Danby, *The Mishnah, Translated from the Hebrew with Introduction and Brief Explanatory Notes,* Oxford, 1933.

Dölger, *Ichthys.* Franz Joseph Dölger, *Das Fisch-Symbol in frühchristlicher Zeit,* ΙΧΘΥC als Kürzung der Namen Jesu, IHCOYC ΧΡΙCTOC ΘΕΟΥ ΥΙΟC CΩTHP, 2d ed., Münster, 1928 et seq.

DS. *Dictionnaire des antiquités grecques et romaines d'après les textes et les monuments,* ed. by C. Daremberg and E. Saglio, Paris, 1873 et seq.

Du Mesnil, *Peintures.* Comte du Mesnil du Buisson, *Les Peintures de la synagogue de Doura-Europos, 275–256 après J.-C.,* Rome, 1939.

Du Molinet, *Cabinet.* Claude du Molinet, *Le Cabinet de la Bibliothèque de Sainte Geneviève,* Paris, 1692.

Dussaud. *Monuments.* René Dussaud, *Les Monuments palestiniens et judaïques,* Paris, 1912.

EB. *Encyclopaedia biblica,* ed. by T. L. Cheyne and J. S. Black, New York and London, 1899–1903.

Eisler, *Orph.-dion.* Robert Eisler, *Orphisch-dionysische Mysteriengedanken in der christlichen Antike,* Leipzig-Berlin, 1925 (Vorträge der Bibliothek Warburg, II, 1922–1923, ii).

Eisler, *Orpheus the Fisher.* Robert Eisler, *Orpheus the Fisher: Comparative Studies in Orphic and Early Christian Cult Symbolism,* London, 1921.

EJ. *Encyclopaedia Judaica: Das Judentum in Geschichte und Gegenwart,* Berlin, 1928 et seq.

Erman, *Relig. Ägypt.* Adolf Erman, *Die Religion der Ägypter,* Berlin-Leipzig, 1934.

Farnell, *Cults.* Lewis R. Farnell, *The Cults of the Greek States*, Oxford, 1896 et seq.

Frey, *CIJ.* Jean-Baptiste Frey, *Corpus inscriptionum Iudaicarum, Recueil des inscriptions juives qui vont du IIIe siècle avant Jésus-Christ au VIIe siècle de notre ère*, Rome, 1936, I: *Europe.*

Galling, "Nekropole." Kurt Galling, "Die Nekropole von Jerusalem," *PJ*, XXXII (1936), 73–101.

Garrucci, *Arte cristiana.* Raffaele Garrucci, *Storia della arte cristiana nei primi otto secoli della chiesa*, Prato, 1872–1880. References, unless otherwise stated, are to the Jewish material in Vol. VI, 1880.

GCS. *Die griechischen christlichen Schriftsteller der ersten drei Jahrhunderte*, pub. by Kirchenväter Commission der Preussischen Akademie der Wissenschaften, Leipzig.

Ginzberg, *Legends.* Louis Ginzberg, *The Legends of the Jews*, Philadelphia, 1909 et seq.

Goodenough, *By Light, Light.* Erwin R. Goodenough, *By Light, Light: The Mystic Gospel of Hellenistic Judaism*, New Haven, 1935.

Goodenough, *Introduction.* Erwin R. Goodenough, *An Introduction to Philo Judaeus*, New Haven, 1940.

Gori, *Thes. Gem.* A. F. Gori, *Thesaurus gemmarum antiquarum*, Florence, 1750.

Gorlaeus, *Dactyl.* Abraham Gorlaeus, *Dactyliotheca*, Leyden, 1695. (2 vols.)

Gressmann, *AOTB.* Hugo Gressmann, *Altorientalische Texte und Bilder zum Alten Testament*, 2d ed., Berlin-Leipzig, 1926–1927.

Gressmann, "Jewish Life." Hugo Gressmann, "Jewish Life in Ancient Rome," *Jewish Studies in Memory of Israel Abrahams*, New York, 1927, 170–191.

Hamburger, *RE.* J. Hamburger, *Real-Encyclopädie für Bibel und Talmud, Wörterbuch zum Handgebrauch für Bibelfreunde, Theologen, Juristen, Gemeinde- und Schulvorsteher, Lehrer*, etc., 2d ed., Strelitz, 1883 et seq.

Hanfmann, *Seasons.* George M. A. Hanfmann, *The Season Sarcophagus at Dum-*

barton Oaks, Cambridge, Mass., 1951 (Dumbarton Oaks Studies, II).

Harris, *Fragments.* J. Rendel Harris, *Fragments of Philo Judaeus*, Cambridge, 1886.

Harrison, *Prolegomena.* Jane E. Harrison, *Prolegomena to the Study of Greek Religion*, 3d ed., Cambridge, 1922.

HDB. James Hastings, *A Dictionary of the Bible*, New York, 1898–1904.

HERE. James Hastings, *Encyclopaedia of Religion and Ethics*, 1908 et seq.

Hopfner, *Fontes.* Theodor Hopfner, *Fontes historiae religionis Aegyptiacae*, Bonn, 1922 (Fontes historiae religionum ex auctoribus Graecis et Latinis collecti, II, i).

Hopfner, *Zauber.* Theodor Hopfner, *Griechisch-ägyptischer Offenbarungszauber*, Leipzig, I, 1921, II, 1924 (Studien zur Palaeographie und Papyruskunde, XXI, XXIII).

HTR. *Harvard Theological Review.*

HUCA. *Hebrew Union College Annual.*

ICC. *International Critical Commentary.*

Ichthys. See Dölger.

IG. *Inscriptiones Graecae.*

JAOS. *Journal of the American Oriental Society.*

JBL. *Journal of Biblical Literature.*

JDAI. *Jahrbuch des Kaiserlich Deutschen Archäologischen Instituts.*

JE. *Jewish Encyclopedia: A Descriptive Record of the History, Religion, Literature, and Customs of the Jewish People from the Earliest Times to the Present Day*, ed. by Isidore Singer, New York, 1901 et seq.

JHS. *Journal of Hellenic Studies.*

JJPES. KOVATZ, *Journal of the Jewish Palestine Exploration Society* (in Hebrew).

JÖAI. *Jahreshefte des Österreichischen Archäologischen Instituts in Wien.*

JPOS. *Journal of the Palestine Oriental Society.*

JQR. *Jewish Quarterly Review.*

JRS. *Journal of Roman Studies.*

JT. Jerusalem Talmud, with references to the various treatises. FT refers to French translation of Moïse Schwab, Paris, 1871 et seq.

Juster, *Juifs.* Jean Juster, *Les Juifs dans*

l'empire romain, leur condition juridique, économique et sociale, Paris, 1914.

King, *Gnostics.* C. W. King, *The Gnostics and Their Remains*, London, 1887.

Kircher, *Oedip.* Athanasius Kircher, *Oedipus Aegyptiacus*, II, ii, Rome, 1653.

Klein, *Corp. inscr.* Samuel Klein, *Jüdisch-palästinisches Corpus inscriptionum (Ossuar-, Grab- u. Synagogeninschriften)*, Vienna-Berlin, 1920.

Kopp, *Pal. crit.* U. F. Kopp, *Palaeographia critica*, Mannheim, 1817 et seq. (4 vols.)

Kraeling, *Synagogue.* Carl H. Kraeling, *The Synagogue*, New Haven, 1956 (The Excavations at Dura-Europos, Conducted by Yale University and the French Academy of Inscriptions and Letters. Final Report, VIII, ed. by A. R. Bellinger, F. E. Brown, A. Perkins, and C. B. Welles).

Krauss, *Synag. Altert.* Samuel Krauss, *Synagogale Altertümer*, Berlin-Vienna, 1922.

Kropp. Angelicus M. Kropp, O.P., *Ausgewählte koptische Zaubertexte*, Brussels, 1930–1931. (3 vols.) Some pages of Vol. III were published separately as *Liturgie in koptischen Zaubertexten*, Diss., Bonn, 1930. All references are to the larger work.

KW. Heinrich Kohl and Carl Watzinger, *Antike Synagogen in Galilaea*, Leipzig, 1916 (Wissenschaftliche Veröffentlichung der Deutschen Orient-Gesellschaft, XXIX).

Lanzone, *Dizionario.* R. V. Lanzone, *Dizionario di mitologia egizia*, Turin, 1881 et seq.

Leclercq, *Manuel.* H. Leclercq, *Manuel d'archéologie chrétienne depuis les origines jusqu'au VIIIe siècle*, Paris, 1907.

Leisegang, *Index.* Hans Leisegang, *Indices ad Philonis Alexandrini opera*, Berlin, 1926 (L. Cohn and P. Wendland, *Philonis Alexandrini opera quae supersunt*, VII).

Levy, *Wörterbuch.* Jacob Levy, *Wörterbuch über die Talmudim und Midrashim*, 2d ed., Berlin-Vienna, 1924.

LS. Henry Liddell and Robert Scott, *A Greek-English Lexicon*. New ed. of H. S. Jones, Oxford, 1925 et seq.

Macalister, *Gezer.* R. A. Stewart Macalister, *The Excavation of Gezer, 1902–1905 and 1907–1909*, London, 1912.

Macarius, *Abraxas.* Joannes Macarius, *Abraxas seu Apistopistus*, Antwerp, 1657. (I have not distinguished beween the contributions of Macarius and Chiflet.)

Maisler, *Beth She'arim.* Benjamin Maisler, *Beth She'arim: Report on the Excavations during 1936–1940*, I, Jerusalem, 1944. English Summary, Jerusalem, 1950.

Matter, *Excurs. gnost.* J. Matter, *Une Excursion gnostique en Italie*, Paris, 1852.

Matter, *Hist. crit.* J. Matter, *Histoire critique du gnosticisme*, Paris, 1928.

MDAI,Ath. *Mitteilungen des Kaiserlich Deutschen Archäologischen Instituts, Athenische Abteilung.*

MDAI,Röm. *Mitteilungen des Kaiserlich Deutschen Archäologischen Instituts, Römische Abteilung.*

MDPV. *Mitteilungen und Nachrichten des Deutschen Palästina-Vereins.*

Mém.,AIB. *Académie des Inscriptions et Belles-Lettres, Mémoires presentés par divers savants.*

MGWJ. *Monatschrift für Geschichte und Wissenschaft des Judentums.*

Middleton, *Lewis Coll.* J. Henry Middleton, *The Lewis Collection of Gems and Rings in the Possession of Corpus Christi College, Cambridge*, London, 1892.

Mon. Ant. *Monumenti antichi, pubblicati per cura della R. Accademia Nazionale dei Lincei.*

Montfaucon, *Ant. Expl.* Bernard de Montfaucon, *Antiquity Explained and Represented in Sculptures*, II, Engl. transl. of D. Humphreys, London, 1721.

Monuments. See Dussaud.

Moore, *Judaism.* George Foot Moore, *Judaism in the First Centuries of the Christian Era, the Age of the Tannaim*, Cambridge, 1927.

MR. Midrash Rabbah, with references to the various treatises. ET refers to the English translation made by various scholars under the general editorship of I. Epstein, London, Soncino Press, 1939 et seq.

Müller-Bees. Nikolaus Müller and Nikos Bees, *Die Inschriften der jüdischen Kata-*

kombe am Monteverde zu Rom, Leipzig, 1919.

Müller, *Monteverde.* Nikolaus Müller, *Die jüdische Katakombe am Monteverde zu Rom, der älteste bisher bekannt gewordene jüdische Friedhof des Abendlandes*, Leipzig, 1912. (Pub. in Italian in *Dissertazioni della Pontificia Accademia Romana di Archeologia*, Ser. II, Vol. XII [1915], 205–318.)

Naményi, *L'Esprit.* Ernest Naményi, *L'Esprit de l'art juif*, 1957 (Bibliothèque juive).

NBAC. Nuovo bullettino di archeologia cristiana.

NSA. See *AAL,N.*

Oehler. Johann Oehler, "Epigraphische Beiträge zur Geschichte des Judentums," *MGWJ*, LIII (1909), 292–302 (nos. 1–96), 443–452 (nos. 97–234), 525–538 (nos. 235–268, with Suppl.).

Osborne, *Engraved Gems.* Duffield Osborne, *Engraved Gems*, New York, 1912.

Osten, *Newell.* H. H. von der Osten, *Ancient Oriental Seals in the Collection of Mr. Edward T. Newell*, Chicago, 1934 (University of Chicago Oriental Institute Publications, XXII).

PEF,An. Palestine Exploration Fund, *Annual.*

PEF,QS. Palestine Exploration Fund, *Quarterly Statement*. After 1938 called *Palestine Exploration Quarterly* (abbr., *PEQ*).

PEQ. See *PEF,QS.*

Pfuhl, *Malerei.* Ernst Pfuhl, *Malerei und Zeichnung der Griechen*, Munich, 1923.

PG. Migne, *Patrologia Graeca.*

PGM. See Preisendanz.

Pirke Eliezer. *Pirkê de Rabbi Eliezer* (*The Chapters of Rabbi Eliezer the Great*) *according to the Text of the Manuscript Belonging to Abraham Epstein of Vienna*, transl. and annot. by Gerald Friedlander, London, 1916.

PJ. Palästinajahrbuch des Deutschen Evangelischen Instituts für Altertumswissenschaft des Heiligen Landes zu Jerusalem.

PL. Migne, *Patrologia Latina.*

Preisendanz, *PGM.* Karl Preisendanz, *Papyri Graecae magicae: Die griechischen Zauberpapyri*, Leipzig-Berlin, I, 1928; II, 1931.

PSBA. Proceedings of the Society of Biblical Archaeology.

PT, *Painted Tombs.* John P. Peters and Hermann Thiersch, *Painted Tombs in the Necropolis of Marissa* (*Marêshah*), London, 1905.

PW. Paulys *Real-Encyclopädie der classischen Altertumswissenschaft*, ed. by G. Wissowa, Stuttgart, 1894 et seq.

QDAP. Quarterly of the Department of Antiquities in Palestine.

RA. Revue archéologique.

RAC. Rivista di archeologia cristiana, Pontificia Commissione di Archeologia Sacra, Rome.

Radin, *Jews.* Max Radin, *The Jews among the Greeks and Romans*, Philadelphia, 1915.

RB. Revue biblique.

RE. See Hamburger.

REG. Revue des études grecques.

Reifenberg, *Coins.* Adolf Reifenberg, *Ancient Jewish Coins*, Jerusalem, 1940. Reprinted from *JPOS*, XIX (1939–1940), 59–81, 286–318.

Reifenberg, *Denkmäler.* Adolf Reifenberg, *Denkmäler der jüdischen Antike*, Berlin, 1937.

Reifenberg, *Kleinkunst.* Adolf Reifenberg, *Palästinensische Kleinkunst*, Berlin, 1927 (Bibliothek für Kunst und Antiquitäten-Sammler, XXXI).

Reinach, *Peintures.* S. Reinach, *Répertoire de peintures grecques et romaines*, Paris, 1922.

Reinach, *Pierres.* Solomon Reinach, *Pierres gravées des collections Marlborough et d'Orléans, des recueils d'Eckhel, Gori, Lévesque de Gravelle, Mariette, Millin, Stosch*, Paris, 1895.

REJ. Revue des études juives.

RHR. Revue de l'histoire des religions.

Robert, *Sarkophag-Reliefs.* Carl Robert, *Die antiken Sarkophag-Reliefs im Auftrage des Kaiserlich Deutschen Archäologischen Instituts*, Berlin, 1890 et seq.

Roscher, *Lex. Myth.* Ausführliches Lexikon der griechischen und römischen Mythologie, ed. by W. H. Roscher, Leipzig, 1884 et seq.

Rostovtzeff, *Dura-Europos.* The Excava-

tions at Dura-Europos, Conducted by Yale University and the French Academy of Inscriptions and Letters, ed. by M. I. Rostovtzeff et al. *Preliminary Reports*, New Haven, 1928 et seq.

RQ. Römische Quartalschrift für christliche Alterthumskunde und für Kirchengeschichte.

Salmasius, *Ann. clim.* C. Salmasius, *De annis climactericis*, 1648.

Scholem, *Jewish Mysticism.* Gershom G. Scholem, *Major Trends in Jewish Mysticism*, Jerusalem, 1941 (Hilda Stroock Lectures, delivered at the Jewish Institute of Religion, New York, 1938).

Schürer, *Jüd. Volk.* Emil Schürer, *Geschichte des jüdischen Volkes im Zeitalter Jesu Christi*, 4th ed., Leipzig, 1901 et seq. ET refers to Engl. transl. of J. Macpherson, S. Taylor, and P. Christie, *A History of the Jewish People in the Time of Jesus Christ*, New York, 1891.

Shulchan Aruch. Joseph Karo, *Shulchan Aruch*, cited in transl. by Heinrich G. F. Löwe, *Schulchan Aruch, oder die vier jüdischen Gesetzbücher*, 2d ed., Vienna, 1896.

Simon, *Verus Israel.* Marcel Simon, *Verus Israel: Etude sur les relations entre Chrétiens et Juifs dans l'empire romain*, Paris, 1948 (Bibliothèque des Ecoles Françaises d'Athènes et de Rome, CLXVI).

Singer, *Prayer Book.* S. Singer, *The Standard Prayer Book*, New York, 1928. (Reprinted many times in England and in the United States.)

Southesk Coll. Lady Helena Carnegie, *Catalogue of the Collection of Antique Gems Formed by James, Ninth Earl of Southesk, K. T.*, London, 1908.

Spon, *Misc. erud.* Jacob Spon, *Miscellanea eruditae antiquitatis*, Lyons, 1679–1685.

Stephani, *Compte rendu.* *Compte rendu de la Commission Impériale Archéologique*, St. Petersburg, 1860–1880.

Strack-Bill. Hermann L. Strack and Paul Billerbeck, *Kommentar zum Neuen Testament aus Talmud und Midrasch*, Munich, 1922–1928.

Strack, *Intro.* Hermann L. Strack, *Introduction to the Talmud and Midrash*, Philadelphia, 1931.

Sukenik, *Beth Alpha.* Eleazar L. Sukenik, *The Ancient Synagogue of Beth Alpha*, London, 1932.

Sukenik, *El-Hammeh.* E. L. Sukenik, *The Ancient Synagogue of el-Ḥammeh (Ḥammath-by-Gadara), an Account of the Excavations Conducted on Behalf of the Hebrew University, Jerusalem*, Jerusalem, 1935.

Sukenik, *Synagogues.* E. L. Sukenik, *Ancient Synagogues in Palestine and Greece*, London, 1934 (Sweich Lectures of the British Academy, 1930).

SWP, Jerusalem. Charles Warren and Claude Reignier Conder, *The Survey of Western Palestine, Jerusalem*, London, 1884.

SWP, Memoirs. C. R. Conder and H. H. Kitchener, *The Survey of Western Palestine, Memoirs of the Topography, Orography, Hydrography and Archaeology*, London, 1881–1883.

SWP, Special Papers. Charles Wilson and Charles Warren, *The Survey of Western Palestine, Special Papers on Topography, Archaeology, Manners and Customs*, etc., London, 1881.

Toelken, *Erklärendes Verzeichnis.* E. H. Toelken, *Erklärendes Verzeichniss der antiken vertieft geschnittenen Steine der königlich preussischen Gemmensammlung*, Berlin, 1835.

Torlonia. See Beyer and Lietzmann.

Trachtenberg, *Magic.* Joshua Trachtenberg, *Jewish Magic and Superstition*, New York, 1939.

TSBA. Transactions of the Society of Biblical Archaeology.

UJE. Universal Jewish Encyclopedia, ed. by Isaac Landman, New York, 1939–1943.

Walters, *Engraved Gems.* H. B. Walters, *Catalogue of the Engraved Gems and Cameos, Greek, Etruscan and Roman, in the British Museum*, London, 1926.

Ward, *Seal Cylinders.* William Hayes Ward, *The Seal Cylinders of Western Asia*, Washington, 1910.

Watzinger, *Denkmäler.* Carl Watzinger, *Denkmäler Palästinas*, Leipzig, I, 1933; II, 1935.

Weitzmann, *Joshua.* Kurt Weitzmann, *The Joshua Roll*, Princeton, 1948.

Weitzmann, *Roll and Codex.* Kurt Weitz-
mann, *Illustrations in Roll and Codex: A
Study of the Origin and Method of Text Illus-
tration,* Princeton, 1947 (Studies in Man-
uscript Illumination, II).

Wilamowitz, *Glaube.* Ulrich von Wilamo-
witz-Moellendorff, *Der Glaube der Helle-
nen,* Berlin, 1931–1932.

Wilpert, *Mosaiken und Malereien.* Josef
Wilpert, *Die römischen Mosaiken und Ma-
lereien der kirchlichen Bauten vom IV. bis
XIII. Jahrhundert,* 2d ed., Freiburg im
Breisgau, 1917.

Wilpert, *Pitture.* Josef Wilpert, *Roma sot-
terranea: Le pitture delle catacombe romane,*
Rome, 1903.

Wolfson, *Philo.* Harry Austryn Wolfson,
*Philo: Foundations of Religious Philosophy
in Judaism, Christianity and Islam,* Cam-
bridge, 1947.

Zaehner, *Zurvan.* R. C. Zaehner, *Zurvan,
A Zoroastrian Dilemma,* Oxford, 1955.

ZaeS. *Zeitschrift für ägyptische Sprache und
Alterthumskunde.*

Zauber. See Hopfner.

Zaubertexte. See Kropp.

ZAW. *Zeitschrift für die alttestamentliche
Wissenschaft.*

ZDPV. *Zeitschrift des Deutschen Palästina-
Vereins.*

ZNW. *Zeitschrift für die neutestamentliche
Wissenschaft.*

Zohar. *The Zohar.* ET refers to Engl.
transl. of Harry Sperling and Maurice
Simon, London, Soncino Press, 1931 et
seq. FT refers to Fr. transl. of J. de Pauly,
rev. by E. Lafuma-Giraud, Paris, 1906 et
seq.

ZWT. *Zeitschrift für wissenschaftliche Theo-
logie.*

EXTANT TREATISES ATTRIBUTED TO PHILO

The English titles are those of Colson and Whitaker in the Loeb
edition of the works of Philo. Roman numerals in italics refer to
the number of the volume of that series in which the given trea-
tise appears. Ralph Marcus' translation, for the Loeb series, of
the works of Philo surviving in Armenian was not published in
time to be used.

Abr. *De Abrahamo.* On Abraham (*VI*).

Aet. *De aeternitate mundi.* On the Eternity
of the World (*IX*).

Agr. *De agricultura.* On Husbandry (*III*).

Animal. *Alexander, sive de eo quod rationem
habeant bruta animalia.* Alexander, or
That Dumb Animals Have Reason. (Ac-
cessible only in Armenian and in Auch-
er's Latin transl.)

Antiq. *Liber antiquitatum biblicarum.* (Pseu-
do Philo, ed. by Guido Kisch, 1949,
transl. by M. R. James, 1917.)

Cher. *De cherubim.* On the Cherubim, and
the Flaming Sword, and Cain the First
Man Created out of Man (*II*).

Conf. *De confusione linguarum.* On the
Confusion of Tongues (*IV*).

Congr. *De congressu eruditionis gratia.* On
Mating with the Preliminary Studies
(*IV*).

Cont. *De vita contemplativa.* On the Con-
templative Life (*IX*).

Decal. *De decalogo.* On the Decalogue
(*VII*).

Deo. *De deo.* On God. (Accessible only in
Armenian and in Aucher's Latin transl.)

Det. *Quod deterius potiori insidiari soleat.*
That the Worse Is Wont to Attack the
Better (*II*).

Ebr. *De ebrietate.* On Drunkenness (*III*).

Flac. *In Flaccum.* Against Flaccus (*IX*).

Fug. *De fuga et inventione.* On Flight and
Finding (*V*).

Gig. *De gigantibus.* On the Giants (*II*).

Heres. *Quis rerum divinarum heres.* Who Is
the Heir of Divine Things (*IV*).

Hyp. *Apologia pro Judaeis.* Hypothetica
(*IX*).

Immut. *Quod deus sit immutabilis.* On the
Unchangeableness of God (*III*).

Jona. *De Jona.* On Jonah. (Accessible only in Armenian and in Aucher's Latin transl.)

Jos. *De Josepho.* On Joseph (*VI*).

LA. *Legum allegoria.* Allegorical Interpretation of Genesis (*I*).

Legat. *Legatio ad Gaium.* Legation to Gaius (*X*).

Migr. *De migratione Abrahami.* On the Migration of Abraham (*IV*).

Mos. *De vita Mosis.* Moses (*VI*).

Mund. *De mundo.* On the World.

Mut. *De mutatione nominum.* On the Change of Names (*V*).

Opif. *De opificio mundi.* On the Account of the World's Creation Given by Moses (*I*).

Plant. *De plantatione.* Concerning Noah's Work as a Planter (*III*).

Post. *De posteritate Caini.* On the Posterity of Cain and His Exile (*II*).

Praem. *De praemiis et poenis.* On Rewards and Punishments (*VIII*).

Prob. *Quod omnis probus liber sit.* That Every Virtuous Man Is Free (*IX*).

Provid. *De Providentia.* On Providence (*IX*).

QE. *Quaestiones et solutiones in Exodum.* Questions and Answers on Exodus. (Accessible only in Armenian and in Aucher's Latin transl.)

QG. *Quaestiones et solutiones in Genesim.* Questions and Answers on Genesis. (Accessible only in Armenian and in the Aucher transl.; bks. i–iii transl. from Aucher's Latin by Yonge.)

Sacr. *De sacrificiis Abelis et Caini.* On the Birth of Abel and the Sacrifices Offered by Him and His Brother Cain (*II*).

Samp. *Sine praeparatione de Sampsone* [*sermo*]. On Samson. (Accessible only in Armenian and in Aucher's Latin transl.)

Sobr. *De sobrietate.* On the Prayers and Curses Uttered by Noah When He Became Sober (*III*).

Som. *De somniis.* On Dreams, that They Are God-sent (*V*).

Spec. *De specialibus legibus.* On the Special Laws (*VII, VIII*).

Virt. *De virtutibus.* On Virtues Which together with Others Were Described by Moses; or on Courage and Piety and Humanity and Repentance (*VIII*).

PART I

THE QUESTION, THE METHOD

The Problem

THE PROBLEM in the origin of Christianity to which this study hopes to contribute is that of its rapid hellenization. Christianity began, as far as we know, with a simple Galilean peasant, who, like Amos of old, spoke moving words to an audience which as a whole little understood or liked his message. As to details of Jesus' message we are in almost constant difficulty, but his way of thinking seems to have been so genuinely a product of the Judaism of his environment that strongly as he denounced aspects of that Judaism, any real departure from it has usually seemed foreign to his mind. The Fourth Gospel has been taken to be an interpretation of Jesus in terms recognizably hellenistic: but how could such a transformation of Jesus' teaching so early have begun in the Christian community, so early indeed that the documents most generally dated as the earliest, that is the letters of Paul, seem to me completely oriented to Hellenism? Could Paul have met Peter and James and Andrew and Bartholomew, have heard their burning messianism as he led them and their followers to persecution, and then, miraculously converted, have looked about him to borrow this from Platonism, that from Mithra, the other from Isis, so as to construct a new religion of salvation about the risen Lord? Or did someone else do so, and Paul follow him? One has to admit such possibilities, but deny categorically their remote probability. It seems incredible that early Christianity could ever out of hand have borrowed the sacred cup from Dionysus, the Virgin Mother from any one of a dozen stories of the miraculous impregnation of a human mother by the god to produce the saving infant, baptismal regeneration from, again, one of a number of sources, and a Savior who had conquered death from the hellenized Egyptian-Roman-Syrian world in general, while it continued its Jewish detestation of all these religions, and its refusal, at the price of martyrdom, to have any truck with them whatever. Paul himself certainly did not "found" such a hellenized Christianity, for subsequent but early hellenized documents of Christianity use surprisingly little the phrases which distinguish Paul's own thought.

How then could Christianity so early and quickly have been hellenized? Only two answers to the problem are possible. The first is the traditional position of the Church, that divine revelation continued throughout the Apostolic

Age and was institutionalized by God himself in the Church. So Jesus himself founded the Eucharist and the Church; Paul, "John," and the author of the Letter to the Hebrews got by direct revelation from God himself the theology of original sin, baptismal regeneration, the theory of atonement, and the incarnate Logos, all of which were implicit in Jesus' own teaching; and the Virgin Birth and the Resurrection, with the Descent into Hell, happened as truly as the Crucifixion itself. Traditional Christian faith has no important problem. Conceiving the origin of Christianity in this way, Catholic theologians have denied any essential development or evolution in Christian doctrine. That early Christians changed the form of presenting their message, Catholic theologians admit, but they hold this change to represent a divine unfolding of ideas already implicit in the teaching of Jesus himself, who of course taught all that is ascribed to him in the Fourth Gospel. Hellenistic religiosity never brought into Christianity anything essentially foreign to the thought of Jesus and his disciples. Catholics admit that Christians learned to speak and write in Greek, and came to express themselves in words which have an ancient history in paganism. But into these words, it is believed, the early Christians, Jesus himself, put a new content. The old words *charis* (grace), *pistis* (faith), *agape* (love), *soteria* (salvation), took on new meanings under divine revelation, meanings which we learn from Christian sources, not from the previous usages of these words in Plato or the Stoics or the papyri.

This is the position of traditional faith, but faith alone can hold it. Liberal Christian scholars on the other hand have been so busy minimizing the importance of theology and the sacraments in order to throw into relief the Jesus of Matthew, Mark, and Luke (well expurgated), that they have essentially ignored the historical problem of how what they admit to be the hellenized version of Christianity can have begun. They have called the change "hellenization" without facing the problem such a word implies. Theology and sacrament seemed to them in one way or another false growths on a tree whose inner core of being was the ethics of Jesus. But Jews hated paganism, especially pagan worship and mythology, and Christians learned this lesson well from Judaism. The wall of prejudice against paganism could not have been suddenly broken down, or scaled, so that Christianity could be hellenized while it continued, as it did in all its writings, to show only deep hatred for paganism. Indeed a sudden collapse of resistance to paganism would have meant a complete fusion with it in the suction of contemporary syncretism. For Judaism and Christianity to keep their integrity, any appropriations from paganism had to be very gradual. In three centuries Christianity might have made its eclectic borrowings, but not in three decades, or less. It has taken Christianity centuries even partially to accept the modern world of empirical knowledge, yet liberal historians of Christianity would have us believe that Christianity had begun in a quarter of a century to adopt the pagan thoughtways it professed

to hate, and that by the time another fifty years had passed, the Church was united in a largely pagan point of view and cultus.

It is this problem of the speed with which the transition was made, without any one thinker actually "founding" a new hellenistic Christianity, which has seemed to me for many years not adequately to have been faced. No master mind set the character of hellenized Christianity as Plato set the character of the thinking of his disciples. From the letters of Paul, the Fourth Gospel, and the Letter to the Hebrews we have three approaches to the problem which, for all they have in common, seem independent expressions of a similar tendency toward hellenized thinking rather than developments of any two of them from the third. Liberals like Frank Porter[1] tried to solve the problem by minimizing the differences in point of view between Paul and Jesus, making the "mind of Christ," as presented in the first three Gospels, the "mind of Paul." With Paul thus in the "Palestinian" tradition, the Fourth Gospel and Hebrews could be dated as much later as one pleased, and so time would be gained, at least a little time, for the transition. But Porter seems to me to have obscured the essential interest of Paul, which was to experience what in Greek tradition we should call the Orphic escape from the body or flesh to the soul or spirit, a dream of escape which is nowhere in the synoptic tradition ascribed to Jesus. Only time, and much time, could have made possible such a change in the value of Jesus to his disciples as the bringing in of this pagan notion represents. A single individual like Paul could have done it, but if he had done it all alone, subsequent writings would have been "Pauline" as the letters to Timothy are Pauline, and the Fourth Gospel is not.

We must then, with the Catholics, give up any reality in the word "hellenization," explain Christianity as a divinely inspired flowering of ideas with a verbal, but no essential debt to the pagan world, or else see where there might have been time for a leisurely fusion of thinking. If that leisurely fusion with paganism did not take place in Christianity, then it must have been antecedently prepared for the early Christians in a Judaism (not *all* Judaism) which had in a gradual way come to be hellenized. The fusion of Jewish and pagan attitudes in Christianity, already beginning to be adapted to Christianity in Paul and "John" and Hebrews, could not have occurred *de novo* in those early Christian decades, and so must have been made antecedently ready for that adaptation within Judaism itself, or some type of Judaism. So if we had no evidence for a hellenized Judaism at all we should have had to invent it, I early concluded, to make the origin of Christianity historically conceivable. Or else we should have to admit with the Catholics that for all that the beginning of Christianity occurred in a period of history as an actual phenomenon of the past, it was never in its character subject to the criteria or developments of his-

1. *The Mind of Christ in Paul,* New York, 1932.

torical movements, was never itself an historical movement at all, but something which came revealed as a totality from God. The dilemma has not been properly faced because liberal Christians, to whom the mass of students of Christian origin and history for the last century have belonged, have wanted to make Christianity *almost* an historical movement, but to discover, as its *Wesen*, a core which is essentially superhuman and beyond the vicissitudes of human origin and development. So they would talk of the "development" of theology and its hellenization, but speak of the ethical teachings of Jesus as though these were transcendent ultimates. These scholars were so dedicated to the task of demonstrating the dominance, especially through the New Testament literature, of the divine *Wesen*, the ethics of Jesus, that they ignored the difficulties which their recognition of Christian theology as a hellenization implied.

This is the problem, accordingly, which has been before me all my life. I was spared the difficulty of "inventing" hellenistic Judaism by early discovering it as an actuality, and as a vital influence in early Christianity. My doctor's dissertation, *The Theology of Justin Martyr*, gained point by having as its thesis the obvious fact that Justin's Old Testament allegory was in large part a patent adaptation for Christian purposes of allegories known to have been Jewish because they appear in Philo. That Justin, in the way dear to philological fancy, was writing with the text of Philo in mind did not at all appear: but that he was writing with a very similar tradition in mind was indisputable, and was much more important than his having the text of Philo before him, for it indicated a widespread Judaism similar to that of Philo on which Justin could draw, a tradition which turned the Old Testament stories into revelations of the nature of the Logos, and made the pattern of religion the pagan one of appropriation of and union with this Logos rather than the typical Jewish one of obedience. So I suggested at the end of the dissertation that the hellenization of Christianity had been made possible because Jews in the pagan world had opened doors through which pagan notions had come into their Judaism; that when such Jews became Christians these notions were already at home in their minds as a part of their Judaism itself, and so at once became a part of their Christianity.

To investigate the possibilities of this hypothesis has been the concern of all my subsequent investigations. Actually, direct evidence for a hellenized Judaism does exist and can be studied. Philo, of course, is the chief source, and in studying his writings the important thing seemed to me to study and reconstruct the sort of thinking he revealed. How had his Judaism modified what he took from paganism, and how did paganism affect his Judaism? Still more important was it to come to appreciate the fusion of the two into a unit, the unit that all Philo's writings passionately try to present. To pull the two apart and keep them apart, to insist that Philo was essentially a normative or Pharisaic

Jew, expressing Pharisaism in a Greek terminology which never really changed the Pharisaism, is to miss Philo himself altogether.[2] I am sure it is to miss hellenized Judaism just as completely. That all Jews in Alexandria (or Rome or Ephesus) were as mystical as Philo, Philo himself assures us over and again was not the case. The question of the relevance of Philo for understanding the background of early Christian hellenization hangs squarely upon this: How typical was Philo? It is easy to demonstrate the hellenization of Philo—even G. F. Moore admitted this; but he insisted that Philo was a unique phenomenon, and concerned with Greek points of view in a way that other Jews even in Alexandria could not have been; thus Philo, except as one could find that his writings were actually used by a later writer, could not be considered important to explain anything else, either in early Christianity or Judaism.

On this I think Moore was demonstrably wrong from the evidence of Philo himself. Philo was not unique in his thinking. He speaks to and of a group of mystic Jews, and contrasts their point of view frequently with that of the ordinary Jew, who could not "cross the Jordan," as he called it, that is, get beyond (while still observing) the legal requirements, to come into the metaphysical reality that Philo found implicit in the Torah. But direct evidence outside Philo's writings for such a group is almost negligible. There are, to name only the most important works, the Wisdom of Solomon, the Letter of Aristeas, the Jewish Sibylline Books, the three last books of Maccabees, especially Fourth Maccabees, the strange fragments quoted by Eusebius, the pseudo-Justinian *Oratio ad Graecos*, the Mystic Liturgy, and the little Jewish apology in the Clementine Homilies.[3] None of this, or all of it added together, justified my a priori, namely that there must have been a general movement of hellenized Judaism, not just a few stray hellenized Jews, since the hellenization of Christianity seemed to me to imply a general tradition on which Paul and the authors of the Fourth Gospel and of Hebrews could have drawn for their ideas, and which could have produced an audience capable of understanding them. The Letter to the Hebrews, for example, very probably is actually that, a letter to Jews. It would, so far as we know, have been utter nonsense to Hillel: Philo would have understood it very well, though he probably would have rejected its Christian novelties. But who were the Jews who could read it with understanding and sympathy? Still we have no evidence for a hellenized Judaism as a general and popular movement such as it seems to me much of the New Testament presupposes.

To assume a general and widespread hellenized Judaism from the evidence of Philo and the rest of the surviving miscellany is so much the harder

2. See my essay "Wolfson's *Philo*," *JBL*, LXVII (1948), 87–109. Now reprinted in E. S. Frerichs and J. Neusner, eds., *Goodenough on History of Religion and on Judaism* (Atlanta, 1986), 77–94.

3. These have frequently been reviewed. See my *By Light, Light*, 265–358, where all are discussed except the last.

because all literary records of such a hellenized Judaism disappear shortly after the beginning of Christianity. If there was a widespread and deeply established hellenized Judaism, why is it that we have no body of documents from such a Judaism after Philo? This point has often been raised. Used against the existence of such a Judaism in the Roman world, it is an argument from silence, but at first a telling one. Actually from the period after Philo we have an increasingly large body of Jewish literature. There is Josephus (only slightly hellenized), and there is the growing body of rabbinical tradition gradually getting itself formed and written through the centuries. In the rabbinic writings, especially in the Midrash, are a few oddments which seem hellenistic, such as a rabbinic tradition, like that of Aristophanes in Plato's *Symposium*, that man was originally created a monster with both sexes, and then split to form male and female.[4] These traces of hellenistic influence, if such they be, occur so rarely in rabbinic writings, however, that they do not affect the total rabbinic point of view which Wolfson calls "native," and which shows in general a strong antipathy toward hellenistic civilization, and a strikingly different way of thinking.

Further, it appears that in time there may be available an increasing body of apocalyptic-mystical writing from the Judaism of the first centuries of the present era, writings on which Scholem drew largely in manuscript for his fascinating account of the development of Jewish mysticism.[5] But Scholem treats these with little reference to Philo or possible hellenistic or gnostic influence: they too are "native" as he expounds them, though he does not use that unfortunate term, and we shall have to wait for the actual publication of the texts and further study to see whether they do show traces of hellenization.[6] Solomon Grayzel published *A History of the Jews* in a single volume which I shall quote several times because it gives the best results of Jewish scholarship, the "typical" attitude toward our problems, in such brief and excellent expression. As an example in point here, he has proposed several explanations of why the rabbis allowed the apocryphal books to perish from Jewish memory and, we

4. The passages are collected in G. F. Moore, *Judaism*, I, 453. This idea is not expressed in any extant passage in Philo, but, found primarily in the *MR, Gen.*, VIII, 1 (ET, I, 54), it is a sample of the sort of thing which made even Moore (*Judaism*, I, 165) say: "It is highly probable that some of the contributors [to this midrash] were acquainted with Philo."

5. Scholem, *Jewish Mysticism*. See especially the early chapters.

6. In view of the quotation from Moore in n. 4, a study of the opening sections of the *Genesis Rabbah* might well be extremely rewarding for this problem. It can be done only by a competently trained rabbinical scholar, and by one, may I add, who would not see every resemblance to Philo as *prima facie* evidence that Philo's thought was rabbinic, but whose mind would actually be open to the possibility of hellenistic influence in the mystical thinking prohibited, but practised, by certain rabbis. Even the reconstruction of such thinking, however, would not detract from its general contrast to the usual rabbinic thought forms.

understand, many other books with them. "Some of them were written in Greek and therefore could not become popular among the masses of the Jews, especially in Palestine," he says, forgetting that in the early Christian centuries in the Roman world the "masses of Jews" who could read at all were reading Greek and Latin, not Hebrew and Aramaic,[7] while even in Palestine Greek inscriptions are more common than Semitic on Jewish graves. He goes on to point out the shifting of population, the fact that these books were "not well written" (it seems to me Sirach, written in Hebrew, and the Wisdom of Solomon, in Greek, are superior in literary form as well as thought to the canonical Canticles, Esther, or Ecclesiastes), and the fact that "many of these books advocated religious laws which differed from the legislation favored by the Pharisees and the rabbis." It was for this last reason, I believe, that the books were rejected, as appears in the discussion of Sirach in the Talmud.[8] "Finally," Grayzel concludes, "these books were hard to distinguish from Christian works which soon appeared, written in the same languages and propagating the same ideas. To avoid confusion it was considered best to discourage the reading of the entire literature." So "the entire literature," including everything that was presumably produced in the diaspora, is lost (for since it was not read it was not copied) except as Christians preserved bits from pre-Christian Jewish writings. It is only through Christians that Philo, Josephus, and the Jewish Apocrypha have survived, all of them earlier than Christianity or contemporary with its beginnings. The silence, therefore, is complete: we have no convincing literary evidence of a hellenized Judaism after Philo and Josephus. A possible exception is the tradition of a dialogue between Antoninus and Rabbi Judah I, from which a few questions and answers have been preserved in various treatises of the Talmud. Wallach[9] has recently argued that these go back

7. *A History of the Jews*, 1947, 203. Not a single case of the transliteration of Aramaic into Latin characters appears in a recognizably Jewish inscription, of the sort described by W. R. Newbold, "Five Transliterated Aramaic Inscriptions," *AJA*, Ser. II, Vol. XXX, 288–329. As this volume went to press I first saw Louis Finkelstein's *The Jews*, 1949, where the essay of Judah Goldin, "The Period of the Talmud," I, 115–215, is especially important for this section. It seemed much in line with other traditional histories of the subject. How entirely dependent he is upon literary (rabbinic) sources appears from his representing the Jews of Palestine in the third, fourth, and fifth centuries as being terribly oppressed and impoverished, when it is precisely in those centuries that they seem to

have done their most expensive (and extensive) building.

8. *BT, Sanhedrin*, 90a, 100b (ET, II, 602, 680–682). See esp. the note by Freedman in ET, II, 602, n. 2. In the Gemara here a tanna is quoted as saying that Akiba was referring to the "books of the Sadducees." This seems direct evidence of books which are otherwise unknown because the rabbis suppressed them. Abaye goes on to a quotation, apparently ascribed to Sirach, but very likely from the "Sadducean" books. Freedman's suggestion (p. 680, n. 9) that this is a reference to the New Testament has no justification whatever.

9. "The Colloquy of Marcus Aurelius with the Patriarch Judah I," *JQR*, XXXI (1940/1), 259–286.

to a lost apocryphon telling of such a dialogue, perhaps something like the Letter of Aristeas, and that it was thoroughly Stoic in inspiration, that is a hellenistic Jewish document. But of the document, if it ever existed, we have only these traces, so that the silence is really not broken.

If the silence is complete, however, argument from it is still extremely dangerous. For our evidence of post-Christian Judaism comes almost entirely through rabbinic channels. If we had only the traditions of the Jews themselves as they have survived through the ages, we should hardly have suspected the existence of the whole body of apocryphal and pseudepigraphical literature,[10] for these, I repeat, have survived thanks only to Christian copyists. Some passage in rabbinic literature may refer to Josephus, but I have never seen an allusion to such a reference. Finkelstein's[11] attempt to demonstrate a rabbinic allusion to Philo only showed that no one would have suspected Philo's existence merely from rabbinic sources. If without the text of Philo and the references to him and his predecessors in Christian writings anyone had a priori said such a Judaism as Philo's had ever existed, he would have been laughed out of all scholarly company. We are then in a strange position. Only by grace of the rabbis have we literary evidence of Judaism as it developed after the beginnings of Christianity; and it is only through the Christians that we know any of the developments of Judaism (except the development of the rabbinic tradition itself) between "Old Testament times" and the beginnings of Christianity. The rabbis preserved their Bible and the traditions of their own group; but they preserved nothing else except what we get from scattered casual allusions to external events. We know of hellenized Judaism, indeed of all non-rabbinic Judaism, only from Christian sources.

The early Christians, however, and this is of the greatest importance, preserved and even alluded to hellenized Jewish literature only if it was pre-Christian, or written in the first or second century after Christ. Christian traditions of the first centuries as taken from the Christian writers refer to the contemporary writings of not a single Jew. It is conspicuous that Christian tradition made Philo into a Christian saint. His and the other writings of pre-Christian hellenized Jews seem to have been preserved as part of what Eusebius called the "preparation" for Christianity. Josephus seems the latest Jewish writer the Christians wanted. Such rabbis as Akiba and Johanan could hardly be represented, even by Christian imagination, as saints or predecessors of the new faith: and no more could other Jews, of the sort represented by Trypho in Justin's *Dialogue*. Writings produced by Jews who denounced Christianity, and continued to live the life of the Law (whatever that may have meant to them),

10. A few works, such as that of Sirach, are named by the rabbis, only to curse those who read them: *BT, Sanhedrin*, 100b (ET, II, 680).

11. Louis Finkelstein, "Is Philo Mentioned in Rabbinic Literature?" *JBL*, LIII (1934), 142–149.

to build synagogues, and put menorahs on their graves, would not have commended themselves to Christian study and copying. If Jews had no use for Philo or other hellenists, Christians had no use for Johanan ben Zakkai, or Rabbi Meir, or for loyal Jews of Rome or any other place who were opposing the Christian movement. So if hellenized Jews did exist and write books in the early Christian centuries, neither Christians nor the rabbinic Jews who ultimately dominated Judaism would have cared to preserve their writings. The Jews of the first Christian centuries who lived in the various centers of Greek and Latin civilization, if they wrote books must have written them as Philo did, in Greek (or later, in Latin), since the grave inscriptions of Rome in the period are all in Greek or Latin; and we know that the Jews had to have a succession of Greek translations of their Bible. There is no indication that Jews of the diaspora, for many centuries, could read Hebrew or Aramaic; even in Palestine and Dura, Greek is more common than Hebrew. It would indeed be a large argument from silence to assert that no Jew who spoke only Greek (there were apparently several million such Jews at any one time) ever wrote a book on his faith after Philo. There may have been very extensive writing done by Jews of the Roman world in the Christian centuries, but since if books were written in Greek by Jews neither Christians nor rabbis would have cared to preserve them, they would have perished. That we have no writings from these Jews simply indicates that if they did write, as we must presume some of them did, they wrote books of a kind unpleasing to the rabbis, and, of course, to the Christians.

The one thing most dangerous to argue from this silence is that the Jews of the Roman empire were actively and acceptably rabbinic. To write the history of Judaism as has usually been done, on the assumption that the Judaism of all Jews in the period of the Roman empire can be reconstructed from rabbinic writings, and not to stress our ignorance of what Jews of the time in general believed, is indeed to go a long way on just no evidence at all.

It seems strange to me, then, that even though scholars have known Philo and the Apocrypha now for a century or more, their conceptions of Jewish history have not basically altered from the traditional one built up on the literature of medieval Judaism, where Philo, the Apocrypha, and hellenized Judaism were never mentioned.[12] In that tradition it was assumed that all Jews thought always as medieval Jews had finally (more or less) come to unite in thinking.

The circumstances of the rise and development of rabbinism, with which we must stop for a moment, hardly justify the usual assumption that it set the

12. "The chief source for the history of the talmudic, post-talmudic, and geonic periods," says J. Z. Lauterbach, *JE*, XI, 284, is the "Historical Letter" of R. Sherira b. Ha-

nina, Gaon, of the tenth century. See the French translation by L. Landau, Thesis (Univ. of Paris), Antwerp, 1904. This is certainly true.

norm for all Jews everywhere. That assumption is expressed for example by Grayzel, who describes how Rabbi Johanan ben Zakkai got permission from Vespasian at the time of the siege of Jerusalem to retreat to Jamnia and found a Jewish academy of study. With the fall of Jerusalem this new academy soon proclaimed itself the new Sanhedrin or *Bet Din*, instituted the rabbinate, with the title "rabbi" formally conferred on a man adequately trained in rabbinic tradition, and in course of time the Romans even allowed the group some measure of power to enforce their decisions. But Grayzel goes completely beyond his evidence when he says:

> Actually, the powers of the *Bet Din* and the *Nasi* were much greater than those officially granted them, since they had not only legal authority over the Jews in Palestine but also their voluntary allegiance wherever they lived, both in the Roman empire and in Parthia. The Jews recognized their religious authority, and gladly sent contributions for their maintenance. Jewish unity was again established.[13]

Just before that[14] he says, apparently of Judaism in general: "Any man refusing to follow the decisions of the *Bet Din* as to what was or was not traditionally Jewish weakened Jewish life by loosening the ties which bound him to the group." He goes on to describe[15] the completion of the first part of the Talmud, the Mishnah, and says: "The Mishnah became a companion to the Bible. More than ever before the Jews now became the 'People of the Book.' " There is no evidence at all that Jewish life was ever generally unified in the *Bet Din* at Jamnia, or, in these centuries, by any rabbinic tradition. We can agree with Grayzel completely when he says: "The stubborn adherence of the Jewish people to their religious laws and customs overcame, in the course of years, Rome's efforts to destroy them."[16] But even the rabbis, as he recognizes, had to admit that the study of the Law was more important than its observance, and that "there are only three fundamentals of Judaism for which a man or a woman must prefer death to transgression—the worship of idols, adultery, and the shedding of innocent blood."[17] Most Jews, if we may rely upon Philo as typical, would have died rather than break not only these but many other laws, yet the question is not what points of law were necessary, but whether the rabbinic-halachic, or legalistic, point of view in Judaism was generally accepted, "normative," for Jews in the period.

The authority of the Patriarch, Ethnarch, or Nasi has seemed to Jewish scholars in general to have stabilized all Judaism under the rabbinic point of view. Studies of the authority of this official[18] appear to me greatly to exagger-

13. Op. cit., 199.

14. Ibid., 197.

15. Ibid., 209.

16. Ibid., 202.

17. Ibid., 201.

18. See especially Juster, *Juifs*, I, 391– 399; Hans Zucker, *Untersuchungen zur Organisation der Juden vom babylonischen Exil bis zum*

ate his powers, though into the details of the evidence we cannot go here. Appointed, or at least recognized, as Ethnarch or Patriarch by the Roman emperors from the second to the fifth century, the Patriarch exercised, at least sporadically, great influence. He had the right to collect for himself and the Jewish scholars of Palestine general Jewish tribute; he was recognized as the head of all the Jews, "souverain sans pouvoir territorial, chef, en quelque sorte, spirituel de *tous les Juifs de l'Empire.*"[19] The italics are Juster's but seem to me to be misplaced: they should have emphasized the vagueness of "en quelque sorte." For while the Patriarch had legally the power to appoint the rulers in the synagogues, a power which he sometimes used for his own enrichment by selling the offices, the places named where his power was exercised are all in the near-by regions, not in the Roman world in general. Legally, the Theodosian Code recognized him as having supreme jurisdiction in religious matters, but there is little or nothing to show that in practice, except in problems of the calendar, this extended to an actual supervision of Jewish thought in general. He had by this code, and probably before, the right to set up legal courts, but again the right seems to have been quite locally exercised. The decisive point is the organization of "apostles," men said to be of rank second only to the Patriarch's own, who are mentioned in several scattered passages as envoys of the Patriarch to collect the money, oversee the local organizations, and fight such heresies as Christianity.[20] All modern discussions of these passages seem to me quite unrealistic. For the Patriarch to have had enough apostles to canvass every year the entire Roman world, or even just the great centers, would have meant a large organization indeed, especially since the apostles seem usually to have traveled at least in pairs. Since until Christianity became the official religion of the Empire there were probably as many Jewish centers as there were Christian, an organization at least as elaborate as that of the Christian clergy would have been necessary to create that Jewish unanimity which is usually presented as far more complete than even the Christian. That apostles were sent out from Palestine, that the Jews in Ephesus, Rome, Carthage, and Cilicia (I am not so sure about Jews in smaller towns) often saw them, talked with them, gave them money, I do not doubt. That they effected a sense of loyal cohesion throughout world Jewry seems quite likely. But the supervision of the contents and range of Jewish thought would have required a tremendous organization indeed. A recent scholar has said that the Patriarch and his apostles caused "the permeation of world Judaism, including the Babylonian Jews,

Ende des Patriarchats, Diss., Leipzig, 1936, 142–166; Solomon Zeitlin, *Religious and Secular Leadership*, I, 1943, 7–15; Simon, *Verus Israel*, 82–86.

19. Juster, op. cit., 393.

20. Discussion of the "apostles" appears very widely. The two articles in *JE*, II, 19–21 give the best brief presentation. The article by Krauss, "Die jüdischen Apostel," *JQR*, XVII (1904/5), 370–383 seems still the best. Considerable bibliography is given in Schorer, *Jüd. Volk*, III, 1909, 119, n. 77.

with the form of life worked out in Palestine whose charter (*Dokument*) is the Mishnah and Gemará."[21] Even the elaborate organization of the Christian clergy, however, found that to keep Christian thought unified it had to have its sacred books available in the vernacular. Very early the Bible had to be translated for Christians into Latin. But so far as we know, no rabbi ever suggested translating the Mishnah to go with the Greek Bible for the Jews in the diaspora. "The Mishnah became a companion to the Bible" only for scholarly rabbis who could read Hebrew. Those who could not read Hebrew got along, as Philo's group had done, without a Mishnah. We cannot a priori fill with rabbinism the silence of the Judaism of the Roman diaspora in this period.

In contrast to Jewish practice in the Greco-Roman world, Jews of Babylonia were early organized in schools by their rabbis and taught rabbinic Judaism. The movement began in certain places in the early third century. "When Rav first returned [to Babylonia] from his studies in Palestine (around 220)," writes Grayzel,[22] "and undertook a journey through the Jewish settlements in Babylonia, he was shocked at the ignorance of the Jews about matters of Jewish observance." So he and others began a program of popular education in the principles of rabbinic Judaism which after a century or two showed great results. It is interesting that the synagogue of Dura, of which we shall have much to say, was in a provincial city destroyed in 256; the synagogue, decorated probably a decade earlier, presumably represents Judaism still untouched by this halachic reform. To assume that the traditions of the Babylonian school of rabbis must lie behind the Dura paintings is to go directly against what little evidence we have for the region.

We know that the rabbinate faded out in its influence even in Palestine after the middle of the fourth century, faded out indeed in Palestine itself to the point that the Jerusalem Talmud, which the rabbis then were composing, was never completed. Apparently the Jews within Palestine were not inclined to support a rabbinical academy, and we do not know to what extent the rabbis in Palestine actually controlled Jewish thought and practice even when they were flourishing. Occasional anecdotes of the exercise of such authority have traditionally, and to my mind unwarrantably, been generalized as typical of common practice. By the third century Greek was predominantly the language of Jews in Palestine itself, and we shall see that the invasion of Jewish art by hellenistic ornament was no less striking in Palestine than in Rome or Dura. Even in the time of Christ, Greek names are nearly as common as Hebrew and Aramaic together on Jewish tombs of Palestine, while by the third century Greek overwhelmingly predominates. This Schwabe admits, but concludes: "Although epigraphic evidence results in a somewhat different picture from that based on talmudic literature, both express the same fundamental Jewish

21. Zucker, op. cit., 166. 22. Op. cit., 229.

attitude and tradition."[23] Actually Schwabe's own epigraphical and icono-
graphic evidence from Palestine affords no basis for supposing that most Jews
even in Palestine were living "normative" lives under the guidance of those
who were forming talmudic tradition in Hebrew.

As we have said, we know that from the third to the sixth centuries a great
popular movement toward rabbinic Judaism flourished in Babylonia, and that
it supported the Babylonian scholars after those in Palestine had ceased to
exist, supported them so that the greatest monuments of rabbinism came from
Babylonia, or were based upon the work of the Babylonian rabbis. It is inter-
esting that to reconstruct the system of education which most scholars put back
into the time of Jesus, but which G. F. Moore himself claimed to apply only to
the later "Age of the Tannaim," Moore[24] had to draw chiefly on passages from
the Babylonian Talmud, whose applicability to Palestine and the diaspora in
general, to say nothing of the problem of its applicability to the time of Jesus,
is not demonstrated at all. I do not doubt that there were attempts by the rabbis
to found such schools in Palestine also, but that they were so successful that the
rabbis throughout Palestine actually guided and dominated all men's thinking,
and all the synagogues, even in the rabbis' prime, is by no means certified by
the evidence.

For the rest of the diaspora, that is for the Jews in the Roman empire,
there is no trace of any movement, comparable to the popular reform in Bab-
ylonia, to bring them rabbinism. Samuel Krauss[25] has recently said: "The Ju-
daism of the diaspora, we know, was regulated by the Babylonian Talmud,"
but Jews of the Roman empire could not read the Mishnah, and, as has been
said, no one tried, so far as we know, to teach them Hebrew or to translate the
Mishnah into a language they understood.[26] No one presents this linguistic di-
chotomy more sharply than G. F. Moore himself.[27] He first tries by implication
to suggest that the schools of Alexandria in Philo's day were dominated by the

23. *JJPES*, IV (1945), p. xxv. We should
have expected from talmudic literature, *BT,
Gittin*, 11b (ET, 39), that Jews in the diaspora
would have had "heathen" names, but that
no Jew even there would have been named
Lucus (Lucius) or Lus (Gaius): "Most Jews in
foreign parts bear heathen names." See Ber-
liner, *Juden in Rom*, I, 54. But both Lucius and
Gaius were common names for Jews in
Rome: Frey, *CIJ*, 621, 623.

24. *Judaism*, I, 77–82.

25. In *REJ*, XCVII (1934), 2.

26. After reading the above my friend
Morton Smith suggested the following emen-
dation: "The effort to make the teaching of
the Palestinian rabbis available to Greek-

speaking Jews seems to have been greater at
the time of Akiba, if we may trust the tradi-
tional dating of Aquila's translation, which
unquestionably was intended to produce a
Greek text preserving those Hebraic peculi-
arities on which so much contemporary Pal-
estinian exegesis was based. The production
of such a translation argues the existence of
preachers who followed Palestinian methods
in their exegesis and therefore found them-
selves embarrassed by the absence, from pre-
vious Greek versions, of the details on which
those methods relied." To which I add only
that the implications cannot safely be pushed
further.

27. Op. cit., I, 321 f.

rabbis, and were teaching rabbinism, but then goes on to show that there is no trace of any real knowledge or use of Hebrew among hellenistic Jews. He concludes: "It is likely . . . that in Philo's time knowledge of Greek was more common among the upper classes in Jerusalem than of Hebrew in Alexandria." Had Rab visited the Jews in Rome, Malta, or Dura, as we have seen he did the Jews in the East, he would probably have been just as "shocked at the ignorance of the Jews about matters of Jewish observance" as he was when he traveled in Babylonia; that is, he would have found them doing and thinking the wrong things. The story is told in the Talmud[28] of how indignant an Eastern rabbi became in the period of Hadrian. He had heard that a Jew in Rome with the conspicuously Greek name of Theodosius (or Theudas) had allowed the Jews to roast a whole lamb for the Passover in Rome itself, that is without going to Palestine to do so. The rabbi, Joseph, wrote him a protest and said that if he were not Theodosius he would be excommunicated for allowing such a thing. Theodosius may, indeed, have known that he was introducing a novelty contrary to rabbinic teachings, but there is no indication that he or his fellows changed back to rabbinic practices because of Joseph's protest. If Joseph had thought they would change, he would not have made this despairing allusion to excommunication. Yet this incident has been quoted[29] as the only one from the diaspora to justify the statement, "Throughout Palestine, and indeed even in the diaspora, in Babylonia, as well as in Egypt and in Rome, the words of the Pharisaic scholars were accepted as authoritative interpretations of the Laws of Moses." Rabbi Joseph in fact did not excommunicate Theodosius, and he and his followers presumably continued to adjust the Jewish Festivals and the laws to life in the diaspora in the same way as best they could, without reference to rabbinic feeling.[30]

How scanty the evidence is for rabbinic influence in ancient Rome appears from those who have tried most to magnify it. It is told that under Domitian, Gamaliel II went to Rome with Eleazar b. Azariah, Joshua b. Hananiah, and

28. *BT, Berakoth*, 19 a (ET, 115); cf. *BT, Betzah*, 23a (ET, 118 f.), where the story is told in the Gemara to comment on a ruling in the Mishnah (ibid., 22b, ET, 116) ascribed to Gamaliel permitting the same license. See further references in H. Vogelstein and P. Rieger, *Geschichte der Juden in Rom*, 1896, I, 30, n. 4, and 108–110; H. Vogelstein, *Rome*, 1941, 81–87.

29. Louis Finkelstein, *The Pharisees*, 1938, II, 621.

30. Finkelstein continues in the passage to refer to an incident where Palestinian rabbis "suppressed without difficulty" a similar move for independence on the part of a Bab-

ylonian rabbi. Actually the source (*BT, Berakoth*, 63a, ET, 398 f.) tells only of the independent act of the Babylonian, and the protest and argument that followed. But the Babylonian in the record also did not yield an inch, and the compiler of the Gemara goes on (63b) to comment that one group was giving a stricter, the other a laxer view, the former protesting "so that the people might not be led by" the Babylonian rabbi. It is perfectly clear that the Babylonians continued to be led by their own rabbis. The Babylonian rabbis, or their power of decision, were not "suppressed" for a moment.

Akiba, "and it is related," says Moore,[31] "that they discoursed in the synagogues and schoolhouses, and discussed religious subjects with heathen and Christians." This is to rely on a small body of tradition, most of which is openly fantastic, as that the Emperor wanted a rabbi to step on his (the Emperor's) back when the rabbi got into bed, and the like.[32]

According to a statement of unknown date in the Gemara of the Babylonian Talmud,[33] a number of scholars went out to found "academies" or "courts" in various places. The rabbis listed are all quite early, and there is no reason to dispute the statement that one of them, R. Mathia b. Heresh, went to found an "academy" or "court" at Rome. Tradition mentions this rabbi several times, and tells that he was a contemporary of pupils of R. Ishmael, therefore probably born in the first quarter of the second century, and perhaps himself also a pupil of Ishmael. Several of his opinions are recorded, one on medical treatment on the Sabbath,[34] one on marital relations,[35] and others.[36] But of an active rabbinic school or "court" at Rome there is no trace. When R. Simeon b. Yohai and R. Eleazar b. Azariah went to Rome, R. Mathia asked them questions on various points.[37] We may then conclude that he stayed at Rome for some time. But that the "academy" at Rome was a "regular rabbinical school," whose relation with the schools in Palestine "tended to bring the Jews in the diaspora into line with those of the home land"[38] there is not a particle of evidence to

31. *Judaism*, I, 106. It is noteworthy that Gressmann, "Jewish Life," 170–191, makes no allusion at all to this talmudic tradition.

32. *BT, Abodah Zarah*, 10a–11a (ET, 49–56); cf. *MR, Gen.*, XX, 4 (ET, I, 161); *Exod.*, XXX, 9 (ET, 355); *Deut.*, II, 24 (ET, 51 f.); *Derek Eretz Rabbah*, see the edition of M. Higger, 1935, 65. The classic study of this material is that of H. Graetz, "Die Reise der vier Tannaiten nach Rom," *MGWJ*, I (1852) 192–202. See also W. Bacher, *Die Agada der Tannaiten*, I, 1903, 79 f.; H. L. Strack, *Introduction to the Talmud and Midrash*, 1931, 111.

33. *BT, Sanhedrin*, 32b (ET, I, 204).

34. *BT, Yoma*, 83a (ET, 407) in the Mishnah, disputed below in the Gemara; so in *JT, Yoma*, VIII, 5 (FT, 252).

35. *BT, Yebamoth*, 61b (ET, I, 409).

36. These are collected by Vogelstein and Rieger, op. cit., I, 111 f., and Bacher, op. cit., 380–384.

37. The chief passages are *BT, Megillah*, 17a (GT, XII, 277) and *BT, Yoma*, 53b (ET, 253) for Simeon b. Yohai; and *BT, Yoma*, 86a (ET, 426) for R. Eleazar ben Azariah. In *JT,*

Yoma, VIII, 8 (FT, 256) Mathia asks the same question in the "academy," but there is no mention of Rome. It is generally supposed that it is the academy at Rome referred to in all these cases, which, if the incident is genuine at all, may quite well be true. Judah Goldin speaks of the academy in Rome similarly in his "The Period of the Talmud," in Louis Finkelstein, *The Jews*, I, 145.

38. Moore, *Judaism*, I, 107. On the issue La Piana seems to blow cold and hot. He appears to exaggerate even Moore's position when he says: "In the communities of hellenized Jews, or at least in the larger ones, advanced schools existed in which scholarly traditions and rabbinical learning were perpetuated." But on the same page he goes on to say: "Rome never became a centre of Jewish learning, never created a Roman Jewish school which played any part in the great work of Jewish legal exegesis, in the codification and explanation of the unwritten tradition, or in the development of Jewish scholarship": "Foreign Groups in Rome," *HTR*, XX (1927), 371. The presumption is that La

substantiate. A few lines below this Moore says: "About the relations of the Palestinian schools to the Greek-speaking part of the Jewish world comparatively little is known," and with this, if we might change the "comparatively little" to "nothing important whatever," we could heartily agree. Moore goes on to point out that there is no way to ascertain the relation of earlier Alexandrian halacha to contemporary Palestinian teaching, and concludes that "on the whole . . . it seems probable that Alexandrian scholars of his [Philo's] day did not feel themselves bound by the authority of their Palestinian colleagues." He should have admitted that the combined effort of many scholars has unearthed no evidence that the situation was different in Rome or Ephesus, or that Greek-speaking Jews were "bound" by rabbinic traditions for centuries to come.

That is, we must consider the rabbis as a group of Jewish scholars who aspired to much power in regulating the lives of Jews, and eventually got it, but who for centuries even in Palestine fought a hard battle for popular prestige and support. We know that the rabbis in Palestine were held in high esteem by Jews to the east in Babylonia, where the seat of rabbinic Judaism soon had to move, and where, when this was done, popular education under rabbinic direction at last can be seen definitely to have created "normative" Judaism, i.e., a way of life generally regarded by the Jews (in Babylonia) as standard. But nothing indicates that Jews in the Roman world, while they knew of the rabbis, occasionally contributed to their support, and respected them, ever came under their influence to any appreciable extent. I do not say that this in itself implies that the Jews in Rome or Ephesus were therefore all Philonic Jews. There is no evidence to show that the Jews of the imperial diaspora were led by rabbinic thinkers, or were "normative" or "halachic" Jews.[39]

The one attempt to control Greek Jews which I know to have come out of the rabbinic schools was Aquila's translation of the Old Testament to replace the Septuagint. The Septuagint had often opened the way for hellenistic interpretations of the Bible, and in many passages used words which had proved most useful to Christian interpretation. To counterbalance this, the rabbis had Aquila make a more literal version, one which avoided Greek words which

Piana rightly concluded that no rabbinic scholarship came out of Rome or the rabbis would probably have mentioned it, but that Roman Judaism "contributed little or nothing to speculative thought" is not at all certain. All we know is that Roman Jews contributed nothing which later rabbis or Christians wanted to preserve. When he then says (ibid., 372, n.) that the Jewish "patriarch" was appointed by Antoninus Pius to be the "spiritual head of all the Jews of the empire" I must agree with Frey (*CIJ*, pp. cii–cv) that if that was the intention, there is no evidence that the patriarch ever became so in fact. Frey is on this whole question much closer to my position: ibid., pp. xcii–xciv. In this introduction to the *CIJ* Frey restates the arguments of earlier publications which he lists on pp. xxix f.

39. It is perhaps enough simply to refer to the elaboration of the myth of rabbinic influence in ancient Rome: Cecil Roth, *The History of the Jews of Italy*, 1946, 15–18.

Christians had found useful. The translation survives only in fragments, and we have no information as to how widely Jews used it.⁴⁰ For example, in an extraordinary Jewish liturgy preserved in slightly Christianized form in the *Apostolic Constitutions*, there are a great number of Old Testament quotations, all from the Septuagint except two which are in the translation of Aquila.⁴¹ These very passages from Aquila, however, are in this liturgy made the basis of extreme hellenistic speculation, so that the implications of their being from Aquila are quite problematic. Certainly they do not remotely justify Simon⁴² in concluding from the mere presence of the quotation of Aquila, that "among the Jews of the diaspora there was an increasing docility toward the Palestinian rabbis."

It is time to stop and define "normative" Judaism, or the *Wesen* of rabbinic Judaism, as it is essentially to be contrasted with what we know of hellenized Judaism. The achievement of rabbinic Judaism was to work out a religion which was basically "halachic," to use its own term, that is, basically legal. One not a Jew who speaks of Jewish legalism is always suspect, since Christian scholars have for so many centuries thought they made their own religion more attractive by vilifying the religion of the Jews, especially of the rabbis. Any religious point of view carried to its logical conclusion reduces itself to absurdity, as the medieval scholastics, to cite only a single instance, abundantly exemplify. One problem suggests another, until the mind tends to lose touch with religion as a way of life and begins simply to play an intellectual game. But to judge scholasticism, or medieval Christianity, by the extremists in this game is, to say the least, unfair. Similarly to judge Jewish legalism by some of its more detailed expositions is just as far from reality. What I mean by halachic rabbinism in its true character has been beautifully put into a small paragraph by Grayzel⁴³ in the excellent book we have found so illuminating, where he describes what it was that the rabbis tried to teach in the new Babylonian schools:

> The ultimate aim of education was not merely to acquire information, but what was more important, to establish good habits of life. They studied the laws which regulated man's relations to God, and also those which guided man's relations to his fellow man. Philanthropy and business, wages and the rules of common politeness, morality and ethics were as much part of their religious

40. On Aquila and the translation the articles of F. C. Burkitt and Louis Ginzberg in *JE*, II, 34–38, are still the most convenient. Origen (*Ad Africanum*, 2) tells us that among Jews of his day who could not read Hebrew it was the preferred version.

41. This liturgy was first isolated and published by Bousset, "Eine jüdische Gebetssammlung im siebenten Buch der aposto-

lischen Konstitutionen," *Nachrichten von der K. Gesellschaft der Wissenschaften zu Göttingen*, Philologische-historische Klasse, 1915 (1916), 435–485. It is translated and discussed in my *By Light, Light*, 306–358.

42. *Verus Israel*, 81 f. Apparently Simon did not read my study of the liturgy.

43. Op. cit., 230.

studies as were synagogue regulations and the rules of penitence for sins committed. The attitudes towards one another were as much a subject for discussion as the observance of the Sabbath. There was no difference in their attitude
towards Law, Ethics and Morals; all were part of Religion.

And, he might have added, all were part of the Law in its broadest sense,
for this is what he means when he himself entitles the paragraph "Law and
Life." Here is a religion good and true. Believing actively in a God who made
men that they might live a certain type of life, a God who was pleased when
men did so and pained or angry when they did not, the business of the devotee
was to study the tradition in which that way of life had been revealed, and to
try as best he could to live according to it. Such Judaism was a religion of what
I have elsewhere called the horizontal path. Man walked through this life
along the road God had put before him, a road which was itself the light and
law of God, and God above rewarded him for doing so. Man was concerned
with proper observances to show respect to God, and with proper attitudes and
acts toward his fellow men, but apart from honoring God, he looked to God
only for the divine rod and staff to guide him and help him when he was weak,
while he said to himself: "What is man that thou art mindful of him?" For "all
flesh is grass." This seems to me the *Wesen* of halachic or rabbinic or talmudic
or Pharisaic Judaism (I use the adjectives quite synonymously). For the Jew the
way of God implied a kosher table, exact observances of Sabbaths and Festivals, the most abstemious recoil from any suggestion of idolatry or any tendency to "syncretize" Judaism by recognizing other religions, myths, or types of
worship as valid alternative approaches to God. Those who walked the Jewish
path were not to intermarry with outsiders, and even their social relations with
gentiles were to be as restricted as possible. The gentiles have often resented
this, and retaliated, God knows. As Christians have looked back over the wall
of exclusion which their own spiritual forefathers once scaled to run away,
they have rarely appreciated the depths of satisfaction (and what else do any
of us seek?) which Jews within the walls have found in practising their "life
under the Law"; and outsiders have as little understood the social cohesiveness
and ripeness which the common life gave to the People among themselves.

I write this deeply sincere tribute to rabbinic Judaism that I may not be
taken to disparage it when I record the simple fact that many Jews themselves
have found it inadequate. Alongside rabbinic Judaism in Palestine in the century or so before the fall of Jerusalem there sprang up a rash of other sects.
The Essenes we know by name, but we have only external and inadequate reports of their views. Then we have documents, like the strange apocalypses of
Enoch and Baruch, Noah, Adam, and the rest, whose interest seems to be in a
hero who had trod not a horizontal path but a vertical one up to the throne of
God, and had returned to tell men of another world. Grayzel again represents
the point of view of most Jewish historians when he says that the lure of early

Christianity was its offering to a discouraged world the "shining vision of life beyond the grave,"[44] but he fails to mention the mystical and apocalyptic movements within Judaism itself which offered men exactly the same thing. The vertical path of mysticism during this life the halachic rabbis have in general opposed. It has been mentioned how the early documents of apocalyptic Judaism exist today only because the Christians found them congenial to their own "shining visions." Later teachers of this tradition developed a "secret teaching" (I dare not say Mystery) explaining the chariot of Ezekiel and creation in a way which apparently gave the believer hope for an escape to a life beyond the grave, one characterized by a succession of heavens, thrones of triumph, blessed meals with the Messiah, and by a whole new array of figures (Metatron was one of the most conspicuous), who seemed to occupy these thrones, or the chief of them. These secret teachings were called *ma'asim*, and the documents in which such teaching now survives are scattered and rare manuscripts, for the most part of the eighth century or later, though they seem to be based upon a continuous tradition which goes back to the early apocalypses of the Apocrypha. While some of the rabbis were acquainted with this material, it is apparently this tradition which they denounced when they said that a man had better not have been born than to learn a *ma'aseh*.[45] From these obscure beginnings, of whose relation, if any, with the Philonic tradition we have no knowledge whatever, grew the mystic tradition of Judaism which has always challenged the rabbis in their claim to speak adequately for all Jews.

It is not for me to attempt a history of Judaism. But when one reads the wonders of this mysticism as reported in consecutive order for the first time by Scholem,[46] one seems to go from rabbinism into a new world. I have given this book to some of my Jewish students well established in rabbinic tradition, only to have them come back in utter incredulity that such a Judaism ever existed.[47] The struggle of rabbinism against the Hasidim of Poland and Russia in the eighteenth century was only a single instance of a tension which seems to have been perennial in Judaism — an opposition first to the *ma'asim*, then the Cabbala, then Hasidism. It was essentially the tension between the two basic types

44. Op. cit., 213.

45. *BT, Megillah*, Mishnah, IV, 10 (Danby, *Mishnah*, 207); *Hagigah*, 11b, 13a (ET, 59–61, 73–78). It is interesting that in the account of the four rabbis who learned these secrets as found in the *MR, Song of Songs*, I, iv, 1 (ET, 46 f.) R. Akiba alone was not destroyed by the knowledge because he came out "in peace" as he went in, and declared that his hope of heaven was in "deeds," that is in halachic correctness, and not, we infer, in what he had learned in the secret doctrine. This is of course a later elaboration of the earlier account in *BT, Hagigah*, 14b (ET, 90 f.), but shows the general rabbinic estimate of such doctrine. See, for most concise discussion, "Maaseh Bereshit; Maaseh Merkabah," and "Merkabah," in the *JE*.

46. Scholem, *Jewish Mysticism*.

47. One orthodox Jewish pupil who had read a great deal of Talmud wanted to know why he had had to come to a gentile to hear of, and be told to read, the Books of Maccabees.

of religious experience everywhere, the religion of the vertical path by which man climbs to God and even to a share in divine nature, as over against the legal religion where man walks a horizontal path through this world according to God's instructions. All great religions offer men both types of experience, and there are few individuals who could be found to exemplify one type to the complete exclusion of the other. Judaism as a great religion has offered these and other types of religious experience. But the rabbis as a group have never liked the *ma'asim* or their cabbalistic descendants. The mystics have usually been legally observant (to a point) as a matter of course. Indeed they have made legal observances themselves into mystic means, as when the white-robed Cabbalists of Safed ceremoniously each week welcomed the Sabbath as a mystic Bride, and so perpetuated in their experience the age-old values of the mystic marriage. Rabbinism in turn could come to tolerate this, and allow the poem which this rite produced, *L'chah Dodi*, with its refrain, "Go forth, my beloved, to meet the Bride; let us welcome the Sabbath," to become a part of the service of Sabbath eve. In orthodox synagogues the congregation still turns to the door as it recites the last stanza of the hymn.[48] But few if any congregations are taught by their rabbis the mystic origin and meaning of the little rite. It has become halacha for them.

Rabbinism has been able to absorb a great deal of such mystic liturgy by the simple process of failing to keep alive the mystic explanations, until only antiquarian research discovers what the rite originally meant. Unfortunately most of the rites of Judaism in which I feel mystic significance cannot now be traced with documentary proof to their origin. When, for example, Jews first began to use the wine cup in ritual as they still do in such a variety of connections, and what it originally meant to them, we can only guess. Perhaps at the beginning these rituals were as devoid of meaning as they now seem to be in the minds of most Jews whom I have asked about them. But I doubt it. The point I am making here is that rabbinism has fought against its old mystical antithesis through the ages by finally allowing popular mystic rites to come in, but by teaching the boys of each generation only the rabbinic point of view, so that the new rite seemed to have its chief value as being part of the horizontal path of conformity to the will of God. Inevitably this process in time obscured the mystic implications of the rites.

The fact is that while rabbinical Judaism can adjust itself to mystic rites in the way described, it would never have originated them. Rabbinic Judaism, with its horizontal path, finds its delight in the Law as laws, revelations of God's will each one of which is itself sacred even to its "jots and tittles."[49] In deepest contrast, while hellenistic Judaism kept the complete normative reverence for the words of the Torah as divinely given and to be obeyed in literal act, it re-

48. Grayzel, op. cit., 471. 49. Moore, *Judaism*, III, 83.

garded the verbal laws (οἱ ῥητοὶ νόμοι) as being only the body, but their inner meanings as the soul. Philo explains this and lists a number of such inner meanings: The Seventh Day represents the power of the One without beginning as over against those beings who have a beginning (τὸ ἀγένητον vs. τὸ γένητον). The Festivals are symbols of rejoicing and thanksgiving (εὐφροσύνη and εὐχαριστία, I am not sure of the translation here). Circumcision is the excision not only of pleasure but of the mind's conception of itself as in any sense "sufficient" (ἱκανός) to produce anything of merit. The "inner meaning" by no means alters the fact that all these laws must be scrupulously observed in practice. "It follows that, exactly as we have to take thought for the body, because it is the abode of the soul, so we must pay heed to the verbal laws. If we keep and observe these, we shall gain a clearer conception of those things of which these are the symbols (σύμβολα)."[50] This was said to rebuke Jews who proposed to live by the "soul" of the laws and abandon the "body." Yet Philo feels even here so strongly the immeasurable superiority of the "soul" of the laws that he goes on at once to compare the inner meaning of the laws to the laws of nature, the outer body to laws made by imposition, and to say that the heritage of the true sons of Abraham is the former, that of his bastards the latter. Jewish mystics of all ages would have read this passage with sympathy, rabbinic Jews with detestation. By this I do not mean that no rabbi properly to be classed on the whole with rabbinic Judaism would have understood this contrast, but that the whole force of rabbinic Judaism as a movement aimed not, like Philo, at discovering the soul of the laws, but at making workable and sound the literal commands, what was to Philo their body. This is rabbinic Judaism, and rabbinic Judaism has won its victory. Mystic Judaism is now largely an historical or local curiosity. "Reform Jews" went back from rabbinism to what they thought was the religion of the Prophets, that is they Judaized nineteenth-century liberalism; the Orthodox today try to keep to the laws as such, while the Conservatives tend to try to find and live by a *Wesen* of rabbinism which is popularly called "normative" Judaism.[51] But none of these has any use for the mystic Jew, or would make a place on any faculty for a Cabbalist who believes in and would teach Cabbalism literally as truth. The final victory of rabbinic Judaism over its ancient mystic rival makes it hard to convince modern Jews of the reality of Jewish mystical tradition.

We seem to have got off the point, but not far. What I am saying is that as

50. *Migr.* 89–94. Baron, *History*, I, 174, properly makes this passage central in discussing Jewish Hellenism. Simon likewise emphasizes the stabilizing power of the legal observances, in discussing IV Maccabees: *Verus Israel*, 67–70. Cf. André Dupont-Sommer, *Le Quatrième livre des Machabées*, 1939, 33–38.

51. In this G. F. Moore was in a sense only a gentile spokesman of the movement whose Jewish exponents were Schechter, Ginzberg, and many other famous scholars of a generation ago.

a young man trying to work out hellenistic Judaism I seemed to meet a stone wall in "normative" Judaism. Myself fortunately a student for a time under Moore, I had not only to face the great learning of his *Judaism*, a learning, and a set of conclusions from that learning, which my generation of Jewish scholars who could read talmudics have regarded as final, but I had also to overcome the sense of helplessness to disagree with him which any pupil of his I have ever known so deeply felt. He was indeed a scholar beyond scholars. In his own generation a few people like Frank Porter protested,[52] but for the most part it has ever since been taken for granted that rabbinic Judaism was always and universally normative for all Jews. However we may explain Philo himself, the movement which Philo represented (if indeed he was not, as Moore thought, simply a unique individual) was thought to have collapsed before Christianity. Those Jews who had been most hellenized became Christians, it was said, while the rest returned to the normative Judaism from which they had at most only superficially departed. Again Judaism was, in Grayzel's word, "united," united in the normative, the rabbinic.

Simon[53] has recently seemed to face the problem of Jewish art, and the relation of the Judaism of the diaspora with that of the rabbis. He gives a review of the art, only in the end, however, to see in it an exhibition of "rabbinic liberalism." It is clear that for him "Palestinian Judaism," by which he means the rabbis, was in unison with the Judaism of the diaspora, and the attitude of all Jews of the period toward Greco-Roman civilization was identical. That is, he seems one more scholar primarily interested in explaining the art away by minimizing its importance in the interest of the all-absorbing rabbinic Judaism.

Of all recent scholars who have reviewed Jewish history, Baron seems to me most nearly to have recognized at least the existence of the problem. He nowhere says that Jews of the diaspora were united in rabbinic Judaism, as do Moore, Finkelstein, Grayzel,[54] and indeed gives some space, as these do not, to the only remains we have of Judaism in the Roman world after the beginnings of Christianity, that is, remains of art in synagogues and graves; and he discusses the possibilities of syncretism with Sabazius as revealed in certain local inscriptions. He admits that the large population of Jews in Syria, Asia Minor, the Balkans, Italy, Carthage, and Armenia were probably more subject to gentile influences than even the Jews of Egypt. "The influence of Greek culture . . . must have been stronger in Asia Minor and Europe than on the Nile, ex-

52. F. C. Porter, "Judaism in New Testament Times," *The Journal of Religion*, VIII (1928), 30–62.

53. *Verus Israel*, 34–46. The words quoted are from p. 34.

54. Although he seems to imply this when he says (I, 189) of the Jews in the Roman diaspora that they "lived a full Jewish life among themselves without outside interference. They were governed by Palestinian law."

cept perhaps in Alexandria.[55] . . . Millions of Jews [in the diaspora] were drawn into the whirl of religious syncretism," he says.[56] He contrasts very well the prohibitions against attending Greek theaters and games which the rabbis imposed, with Philo's obvious fondness for them; and he recalls that according to an inscription in Miletus the Jews later had a section reserved for them in the municipal theater, not to segregate them but because they as a group had keen "interest . . . in the dramatic arts."[57]

Baron leaves us quite confused, however, as well he might in view of the paucity of evidence. Admitting that Jews of the diaspora must have gone into the syncretistic "whirl" in large numbers, how far did Hellenism affect the Jews who hung on to their Judaism in these countries? Is it true, as he says, that "Greek art impressed itself upon the mind of the Jew more than Greek philosophy"?[58] Although Baron gives in a note one of the best bibliographies of Jewish art for the period, he nowhere seriously examines its evidence.[59]

If we cannot here go into the problem of the attitude of the rabbis to images, let me beg the question for the moment and say that the art seems to me definitely a part of Judaism, but to have no real place in rabbinic Judaism. By that token it would fall into what is generally called hellenistic Judaism. Hellenistic Judaism, if my hypothesis is right, is altogether too important a movement for us to scamp the slightest evidence which might illuminate it. Both the later mystic movements in Judaism, and the hellenization of Christianity, seem to me to have flowed out from this largely hidden source. It may be of interest then to record how I came to regard these remains as important sources for our purposes. For the very circumstances by which I was attracted to them seem to me significant for their meaning.

In the early nineteen-twenties I was working out at Oxford the thesis of my dissertation that in his allegories Justin largely offered Christianized versions of older allegories of the sort found in Philo. One of my fellow students, whose name I have sadly forgotten, heard of my interest. He was an insatiable traveler in his vacations (which at Oxford cover more than half the year), and had got interested for some reason in the early mosaics of Santa Maria Maggiore in Rome, where scenes are depicted from the Old Testament. He told me about them and about the book by Richter and Taylor[60] in which it is suggested that these mosaics were inspired by Justin's allegories of the Old Testament. Fig. 1[61] shows a sample scene. Soon afterwards in Rome I studied the mosaics

55. Ibid., I, 206.

56. Ibid., 208.

57. Ibid., 209; the inscription is in A. Deissmann, *Light from the Ancient East*, 1927, 451 f. See *BT, Abodah Zarah*, 18b (ET, 94–96). Baron, *History*, I, 209, and Radin, *Jews*, 331 (409, n. 5), both refer to *Tosefta, Abod. Zar.*, II, 5, 6.

58. Op. cit., 209.

59. Ibid., III, 51–53, n. 15.

60. Jean Paul Richter and A. Cameron Taylor, *The Golden Age of Classic Christian Art*, 1904, see Index, s.v. "Justin Martyr."

61. From Wilpert, *Mosaiken und Malereien*, III, plate 10.

carefully, and came to the conclusion that they were indeed closely akin to Justin's allegories. But Justin, who lived in the second century, must have been little known in Rome of the fifth century, when the mosaics were presumably executed, so that I could not imagine how it could have been his writings which inspired the artist. I had been working to show that Justin's allegories themselves were based upon a hellenistic Jewish tradition, and so I asked myself whether this art had not been originally devised in hellenistic Judaism, and had not been taken over by the early Christians as part of their heritage from Judaism, along with the allegories of the Old Testament in literary form.

A very small amount of investigation showed that Christian art had not begun with representations of the Christian message directly. The mosaic designs in Santa Maria Maggiore which represented scenes from the Old Testament, for example, appeared to be older than those which represented specifically Christian scenes or figures; that is, the designs themselves were older, if not these particular representations of the designs. A slight study of the paintings in the catacombs showed similarly that representations inspired by the Old Testament antedated, and were adapted to depict, scenes from the New Testament. For example one of the scenes most used shows Jesus raising Lazarus as a parallel to Moses striking the rock (fig. 2).[62] With these go scenes of Jesus turning water to wine (fig. 3)[63] or, more often, multiplying the loaves (fig. 4).[64] Sometimes, as here, the miracle of the loaves is shown in balance with the raising of Lazarus.[65] It more often balances Moses at the rock,[66] while in two paintings all three appear together.[67] What is common in all these is the central figure in a white Greek dress[68] which has stripes on the chiton, and a mark of some kind, called a gamma, on the corner of the himation. The figure always holds a rod. It is clearly the same figure, but which of them is the original? To this, in view of the total evidence, we must answer categorically that the Moses figure was original, and that the figure of Jesus was an adaptation of it. Had the Christians first invented this figure for Christ, they would not have used it later for Moses. What seems decisive is the rod. Nothing in Christian literary tradition suggests that Jesus used a rod in performing his miracles,

62. From Wilpert, *Pitture*, II (Plates), plate 248, a painting from the catacomb of Domitilla. In this volume the two appear in definite conjunction in plates 46, 55, 58, 108, 143(*a,b*), 147, 164 (where, as in 166 and 181, they are framed together), 168, 190, 192, 198, 219, 227, 240. Moses striking the rock appears without Lazarus in plates 13, 27, 59(?), 60, 87(?), 98, 101, 119, 120, 171, 173, 186, 200, 205, 229, 234, 237, 244; the scene of Jesus raising Lazarus appears by itself in plates 62, 65, 87(?), 93, 128, 137, 159, 222,

230, 231, 232, 234, 239, 250.

63. From ibid., plate 57; cf. plate 265.

64. From ibid., plate 45(1); cf. plates 68, 74, 115, 120, 139, 144(2), 165, 186 (where Moses' rock still stands beside the scene of the Christian miracle), 226, 237, 240.

65. See also ibid., plate 228.

66. Ibid., plates 142, 158, 196, 199, 216.

67. Ibid., plates 181(2), 212.

68. It has often been called a Roman toga, but it is quite unlike the toga, which was a much more elaborate costume.

while the rod was the prime attribute of Moses. The figure of Moses striking the rock with his rod shows the rod in a natural setting. When Christians adapted the figure of Moses as the figure of Christ the rod came over by inadvertence and became a conventional attribute of Jesus himself.

A further glance through the early Christian paintings shows that Christian art began with a number of types from the Old Testament such as Noah in the ark, the sacrifice of Abraham, a figure pointing to a star whom Wilpert identifies with Balaam, Daniel in the lions' den, the three boys in the furnace, Adam and Eve, Jonah under the vine or in the mouth of the fish. In contrast, the few scenes from the New Testament either definitely derive from these, or appear only rarely — such as the paralytic carrying his bed, the coming of the Wise Men, the baptism of Jesus.

That Christian art had begun in large part by adapting conventional representations had long been taken for granted by scholars of every sort. It has been proverbial that, along with a host of other symbols, Christians borrowed from pagan art the Good Shepherd and Orpheus to represent Jesus, as well as the banquet scene at a bolster around a table on which the most important food is fish. It will seem likely as we go on that Christians took at least the last two of these from the Jews: the point is here that no one has ever thought that Christians invented these pagan figures anew, however deeply they came to express Christian ideas. It is not strange then, since we know that Christian art was so largely adaptive, that if a hellenistic Jewish art had devised types for scenes from the Old Testament, Christians should have taken these also. Did Christian art not begin with Old Testament scenes and figures precisely because they were ready at hand along with the "pagan" figures? If we may suppose that such a Jewish art existed, it would most naturally have been produced under hellenistic inspiration, since if our records in Josephus and the Gospels can be trusted at all, let alone the stories of the statue of Gaius and rabbinic references, the "native" protest against pictorial representation was steady. The character of the art itself suggested a hellenized Jewish origin, for all remains of the art that I could then find were perhaps orientalized, but belonged clearly, by their techniques and the dress of the heroes, to hellenistic tradition.[69]

In those early years I had by no means come to understand Philo's mysti-

69. Carl Maria Kaufmann, *Handbuch der christlichen Archäologie*, second edition, 1913, 260, had suggested that the predominance of Old Testament scenes in Christian art had come from "Jewish Christian influence." In the third edition, 1922, 298, he said that this phenomenon was to be "explained not merely on the ground of the Jewish basis of early Christian prayers, but it justifies also the assumption of a specifically *Jewish art*, which was already familiar with these cycles." No one I knew was familiar with this idea of Kaufmann's, or with the highly important study of it by Ludwig Blau, "Early Christian Archeology from the Jewish Point Of View," *HUCA*, III (1926), 157–214, from which, p. 192, the above translation of Kaufmann is taken.

cism as I hope I have come to do since that time, and the way in which that mysticism was integrated into Judaism through allegory of the Old Testament. But I asked myself with increasing insistence: Does not the art of the catacombs and of Santa Maria Maggiore reflect a hellenized Jewish original? The white robe of Moses came to be the uniform of the Christian saint, his almost invariable symbol. But that robe, while recognizably Greek, was very unusual in pagan art, and the usage in early Christian art is almost wholly without pagan counterpart, especially the way in which the figure with the white robe is contrasted with those in other dress. Only the chief figure in a scene would wear it, an Abraham, Moses, or a heavenly being such as the three who appeared to Abraham at Mamre. It seemed to correspond to Philo's references to the Robe of the Light-Stream, which, when put on literally in an initiation, as by the hero of Lucian in his initiation,[70] or when donned figuratively in mystical experience, indicated the culmination of sanctity. When Abraham reached the final stage of mystic achievement[71] marked by his getting a new name, he came into true Wisdom, became the traditional *Sophos*, became pure "intellect," which is a "virtue more perfect than that which is allotted to mankind." In token of this he was surrounded by light which knows no shadow. The same light, "an immaterial beam purer than ether," finally shone upon Jacob.[72] But that Philo like the followers of Osiris thought of this beam as properly typified in a white linen garment appears very clearly in his remarks about the white linen robe in which the priest entered the Holy of Holies on Yom Kippur, for this robe "is a symbol of vigor (or life), of incorruption, and of the most brilliant light." It represents the fact that the wearer "is illumined by the unshadowed and brilliant light of truth." We too, after we have been purified by the mystic teaching (ὁ ἱερὸς λόγος), are led into what is "conspicuous [ἐπιφανείς, perhaps "manifesting"] and shining."[73]

With such statements in mind it became increasingly clear to me that if hellenized Jews of the Philonic sort had taken to representing their great heroes in art they would almost certainly have represented them in white garments to symbolize their "luminous" nature in contrast to the rabble. Why they should so uniformly have selected just this robe as a symbol of sanctity I did not then stop to consider.

Another striking element in the mosaics of Santa Maria Maggiore is the great prominence of groups of three figures, usually in this dress. In the scenes of Abraham and the three men and of Moses lifting his hands at the battle of Rephidim,[74] this emphasis upon the number three might seem to imply simply a literal illustration of the text; but in the group of three in the scene of the

70. See my *By Light, Light*, 162 f.
71. *QG*, iii, 43.
72. *Praem.* 37.
73. *Som.* i, 216–218, 226. See my *By*

Light, Light, 174 f.
74. Wilpert, *Mosaiken und Malereien*, III, plate 20.

capturing of the quails,[75] in the meeting of Moses with Amalek,[76] in the stoning of Moses, Joshua, and Caleb,[77] and in the carrying of the Ark,[78] the choice of three was arbitrary, and the total number of scenes which represent a group of three seemed quite beyond coincidence.

The grouping in threes, however, seemed to me again conspicuously to harmonize with Philonic allegory. Philo brings out his conception of the transcendent "three" most importantly in connection with the visit of the three men to Abraham. The material is so important for our purpose here that I must repeat it from my *By Light, Light*.[79]

Philo quotes the verse, "He looked and behold three men stood over against him," and comments:

> Very naturally, to those who can perceive, this represents that it is possible both for one to be three and three one in so far as they are one in the Logos above them.[80] But this Logos is numbered along with the primary Powers, the Creative and Royal, and produces a three-fold apparition upon the human mind. For the human mind is denied so acute a vision that it can see as a distinct God him who transcends the Powers assisting him. So in order that mind may perceive God, the ministering Powers appear to be existing along with him, and as it were they make an apparition of three instead of one. For when the mind begins to receive a sure apprehension of Being, it understands itself as penetrating to that stage: mind is itself reduced to monadity, and itself appears as primal and supreme; as I said just above, [the mind] can perceive Being only by means of its association with those primal Powers which exist directly with him, the Creative Power which is called God, and the Royal Power, which is called Lord.[81]

Then after explaining that the eyes raised are the eyes of the soul, Philo continues:

> The eye so raised begins by seeing the Rulership, a holy and divine vision, in such a way that a single vision appears to him as a triad, and triad as unity.

For in the highest experience and clearest vision the triad disappears in the One — which makes itself appear without the assisting Powers, and

> so the intellect perceives most clearly a unity although previously it had learned to apprehend it under the similitude of a trinity.[82] . . . So speaking truly and

75. Ibid., III, plate 19, 1*b*.
76. Ibid., III, plate 19, 2*b*.
77. Ibid., III, plate 21, *b*.
78. Ibid., III, plate 22, *b*.
79. P. 33.
80. The Latin of Aucher reads "eo quod unum sunt secundum rationem supernam," which might mean "they are one by a higher

explanation," or "they are unified in the Logos who is above them." The next sentence, where the "ratio" is connected with the two to make a third, shows that the original Greek must have carried the latter sense.
81. *QG*, iv, 2.
82. Ibid., 4.

accurately, the measure of all things, intelligible as well as sensible, is one God, who in himself is unity, yet appears in the likeness of the triad on account of the weakness of those who would see him.[83]

In *By Light, Light* I have quoted at greater length,[84] but enough is here to show that Philo himself made the vision of the "three men" into a vision of the essential nature of God, the typical vision of the mystic, and that to show three figures, especially three in the dress of heavenly light, alone or in contrast to others not so clothed, would be indeed a natural convention to arise if hellenized Jews of the Philonic type took to artistic representations of their faith. To select incidents, or to interpret incidents, in such a way that they could be made to show the "vision of the three" would be quite a natural development of hellenized Jewish art. But to do this in terms of the Old Testament would be much more natural for Jews than for Christians. Christians might well have begun with the three in Jesus' transfiguration, or with the easy adaptation of a scene of Jesus' baptism, where another figure could have been put in to balance John the Baptist, or with the "two men in dazzling apparel" standing on either side of the risen Jesus, from the story of the Resurrection in Luke. But no, the Christians seem for centuries not to have come to such adaptations of their material: the early representations of the Three had to be in terms of the Old Testament.

While I by no means had all this material in mind in those early years, and indeed cannot now say how much of it I did have, still I had enough of it so that I came away from Rome convinced that I had been studying a group of pictures that Christians had borrowed, with very little necessity of change, from hellenized Jewish predecessors. When I returned to Oxford I told several of the dons my idea, and was by all of them gently told that it had no possible foundation. Jewish Scripture and tradition alike forbade the making of images, and so long as a group was loyal to Judaism at all it would have had nothing to do with art. So I abandoned the notion, did not mention it at all in my dissertation, and went on to follow the literature into a closer study of Philo to see what I could find further in hellenized Judaism which might help to explain early hellenized Christianity.

It was some seven or eight years later that I returned to the art. One incident alone had recalled it. My senior colleague, Professor Paul Baur, published[85] a study of an odd little lamp in the Yale collection, showing, over a

83. Ibid., 8: "Qui in ipsa unitate trinitati similis apparet ob videntium infirmitatem." Yet one has to be quite advanced as a mystic to get a vision even of the three. One who is still struggling along in semiobscurity (ὁ προ-κόπτων) sees only a dyad, a disconnected thing, divided in itself. The man who has completed the mystical journey (ὁ τέλειος) sees the triad, in unclouded light, its center filled out and complete in nature: *QG*, iv, 30; Harris, *Fragments*, p. 32.

84. Pp. 34–47; see also pp. 140 f., 147 f.

85. In *Yale Classical Studies*, I (1928), 41–51.

row of seven wick-holes, David stoning Goliath. This he published as "an early Christian lamp" and said (p. 45): "We may safely date it to the third century," though on the next page he said: "In fact the letters [which name the two protagonists] are very similar in shape to an inscription of the first century A.D. published by Edgar." I asked him one day why he did not then date the lamp in the first century, since that was what the lettering indicated, and he said that the lamp must be Christian since it had an Old Testament scene on it, and that he would not dare, without the most explicit evidence, to date a Christian artifact earlier than the third century. When I asked him if it might not be Jewish he answered, with the same kindness as the dons at Oxford had shown six years before, that there was no such thing as Jewish art, and such a suggestion about the lamp would be nonsense.

It was unconvincing, but I was working at other things, and again let it go. In fact I was working on Philo's doctrine of law, which led me in two years directly back to art. For in the same volume with Baur's article I had published my "Political Theory of Hellenistic Kingship," a study of the conception of "incarnate laws" to which the terminology of Philo for the Patriarchs had driven me.[86] This essay closed with a promise that I would supplement it with a further study in which Philo's treatment of the "incarnate laws" would be examined. But another aspect of Philo's law delayed me; I wrote the *Jurisprudence of the Jewish Courts in Egypt* first. It was not until the early nineteen-thirties that I began systematically to study the Patriarchs whom Philo represented as "incarnate laws," and this clarified a great deal for me. The Patriarchs advanced to the spiritual stage where they assumed the garment of light, and became the "saviors" of Judaism, the figures through whom the divine light of the Logos revealed itself, made itself available to men. I came to see that for Philo no one Patriarch was transcendently important: Philo expressed himself in superlative terms about each, though of course he had more to say about Moses than about any other. The important thing was the revelation of the saving nature

86. The material has recently had two fresh studies. Louis Delatte, *Les Traités de la royauté d'Ecphante, Diotogène et Sthénidas*, 1942 (*Bibliothèque de la Faculté de Philosophie et Lettres de l'Université de Liège*, Fasc. XCVII), has published an excellent critical edition of the texts, with translations, commentaries, and various critical studies. He concludes that the fragments are in general to be dated in the second century after Christ, and that therefore I am wrong in dating them in the hellenistic period. A date for the documents themselves I was careful throughout my study not to suggest. I was trying to show that the fragments were ringing the changes upon a hellenistic theory of kingship which survived into the Roman empire. When the fragments which we have were themselves written, I felt I could not say without such stylistic analysis as Delatte has made. This I did not attempt, so I avoided the question of date altogether, and now am quite ready to accept Delatte's date for the finished compositions. *But we cannot date the origin of ideas by the documents in which we first find them.* This is the basic fallacy of much philological study, and it seems Delatte has fallen into it.

of God, the leadership that God gave to men through certain people who by their holiness could guide men out of the darkness of sin, out of the material nature of variegated flesh, into the pure luminosity of immaterial reality. A single Old Testament figure in the robe of light, or the revelation of the sacred Three, seemed no longer to be merely interesting details in Philo's thinking, but the very core of his religious life. So I returned with fresh eyes to the mosaics and the catacombs, and to the newly discovered paintings in the catacomb of the Viale Manzoni in Rome.[87] I must be right, I felt: these were surely Christian adaptations of Jewish archetypes.[88] One day in December, 1932, I got some of this material together and took it to Professor Rostovtzeff. He knew little about Philo and his Patriarchs, but listened while I told him that I believed there must have been a Jewish art inspired by the sort of allegory to be found in Philo's text.[89] This Jewish art, I said, would have presented Old Testament scenes in allegorized form; and conspicuous in the art would have been a figure in the white robe, abstracted or leading other people not so clothed, as well as groups of three in the robe. Especially prominent would be the Patriarchs, and particularly Moses. Rostovtzeff heard me through, and then asked:

"But have you not heard about our cable from Dura?"

No, I had not. So he told me that he had had a cable two weeks before from Dura saying that the excavators had found a synagogue whose walls were covered with paintings. He had no particulars. Six weeks later the first photographs arrived, and there was my Jewish art almost exactly as I had described it. Moses dominated most of the early scenes which reached us, Moses in exactly the same robe, leading the Israelites out of Egypt. The scene of the crossing of the Red Sea differed in important details from that in Santa Maria Maggiore, but a single glance at the water, the drowning of Pharaoh, and Moses on the bank with his rod showed that there was a common ancestor of both pictures. There were quite unexpected elements in the Dura art, especially the large number of figures in Persian dress, which had apparently been added to the Greek basis as the art convention moved toward the east. But

87. See especially G. Bendinelli, "Il monumento sepolcrale degli Aureli al viale Manzoni in Roma," *Mon. Ant.*, XXVIII (1923), 289–510, with plates; G. Wilpert, "Le pitture dell' Ipogeo di Aurelio Felicissimo presso il viale Manzoni in Roma," *Atti della Pontificia Accademia Romana di Archeologia*, Ser. III, *Memorie*, I, ii (1924), 1–43; M. Rostovtzeff, *Mystic Italy*, 1927, 148–155, and further bibliography, p. 175, n. 15.

88. The figure with the staff appears with striking frequency in the new catacomb of the Viale Manzoni: see Bendinelli, op. cit., 403, fig. 48; 406, fig. 49; plates XIV, XV, XVI; Wilpert, op. cit., plates III, IV, VIII, IX, X, XXII (the central figure in the court at upper left).

89. Another parallel which much impressed me were the early Christian representations of Noah emerging from the ark as though the ark were a sarcophagus, which seemed to me very close to Philo's making the ark the body from which Noah was at last saved.

these accretions could not conceal the basic hellenistic element which Dura showed in common with early Christian representations of Old Testament scenes. This element was now indisputably Jewish.

The confirmation of my guess filled me with the "wild surmise" of Balboa. Through following up the implications of mystic Judaism, I had prophesied the existence of an art and had described its essential features, and now my prophecy had been fulfilled. But I quickly found that these pictures, while to me they so obviously expressed a mystic and hellenized Judaism, were being explained in every sort of way by others. One man said that since Dura was in Mesopotamia, interpretation of the art must hold to the tradition of the Babylonian Talmud. Others took great comfort in the fact that the discovery showed paintings, not carvings in the round, and so were convinced that, incredible as the paintings were, the Dura Jews were still good halachic Jews. Indeed most of the effort at explanation went into trying to show that there was nothing here basically against the spirit of rabbinic Judaism, rather than attempting to discover what the pictures said in themselves. The assumption that rabbinic Judaism had always and everywhere been normative Judaism still dominated all minds.

It soon became clear that if I were to convince others of the mystic character of these pictures, and of the Judaism they seemed to me to represent, I could do so only by following out a very long road. Obviously I must first publish what the literary sources seemed to me to tell of the character of hellenized Judaism. So I began at once to write *By Light, Light*, which I put forward as the first installment of a series of studies, the next of which would consider the Dura art. By 1934 *By Light, Light* had gone to press, and late that year I began seriously to study the problem of the art.

First there was the problem of finding a technique for approaching the art to ascertain what an artist had intended to say. Nothing is so dangerous as to reconstruct the purpose of an artist, especially of one with an unknown background. Usually a work of art is to be explained, at least partially, in terms of its setting: but here was an art from which I proposed to extract its language, only then to use the language to find the meaning of the art. In such a circle subjectivism seemed unavoidable, and certainly in those early years my colleagues at Yale, though they judged me with all the kindness in the world, thought my interpretations of various scenes purely subjective. Because of the way I had approached the art in the first place I was convinced that I was not merely projecting, but how was I to convey my conviction of objectivity to others?

While this problem was still unsettled the task expanded enormously when now for the first time I settled down thoroughly to investigate Jewish art. It became at once apparent that those who had assured me that Jewish art had

never existed had simply not known the facts. Actually, by a study of the art forms of early Christian manuscript illumination, Strzygowski,[90] followed by von Sybel,[91] Erich Becker,[92] Charles Morey,[93] and others, had some years before come to the conclusion that hellenized Jews had developed an elaborate art to illustrate their Bibles. It had begun at Alexandria, this school of historians of art said, and was there adopted by Christianity, especially for the great Hexateuch traditions. Inspection of this material showed again the same central features: the symbolic white robe, and the allegorical approach to the problem of illustration. These scholars were interested in the matter exclusively from the point of view of art forms, and asked no questions about why Jews should have developed the conventions they did, or what they meant, if anything, as religious symbols. But at least it became apparent that the whole range of that sort of art in both Judaism and Christianity would have to be studied, along with any traces to be found of it in paganism.

At the same time I discovered that Jewish art of another kind had flourished everywhere in the ancient world. Only two more Old Testament scenes had appeared in Jewish synagogues, but it was plain that we had a great amount of Jewish art from the period, and that this art was elaborately Dionysiac, had indeed the same vocabulary of Dionysiac borrowing as that used by the early Christians. Wine symbols were most prominent of any one kind, that is, the vine, bunches of grapes, the wine cup or the cup as a fountain, vintage scenes, birds or animals like the rabbit in the vine. But with these went a great number of other figures: lions, eagles, masks, the tree, the crown of Victory, the cock, and astronomical symbols, along with a number of figures of Greek deities, painted or carved in deep relief (sometimes in the full round) on Jewish synagogues, or on Jewish graves in the communal cemeteries of Jewish groups. This material had never been collected, and so its cumulative force had never been felt. It was a big task in itself to get this material together from the nooks and crannies where it had been published, but with that I had to begin. That I have succeeded in finding everything I cannot hope, but the material proved to be everywhere so similar that what bits are not included in the general collection below will, I suspect, be more of the same kind rather than anything radically different.

Again I had a problem of meaning. Almost universally these objects had been published by people who blandly asserted that they meant nothing, were merely decorative, or who tried to explain the objects by stray proof texts from the Bible or Talmud. This could be done quite satisfactorily by those who had only an isolated lamp or cemetery to publish. It became increasingly difficult

90. In his study with Ad. Bauer, "Eine alexandrinische Weltchronik," *Denkschriften der Wiener Akademie der Wissenschaften*, LI (1906), 183–185.

91. *Christliche Antike*, 1909, II, 109.
92. *Malta sotterranea*, 1913, 86.
93. See *inter alia* his *Early Christian Art*, 1942, 71, 76.

as the material appeared in greater abundance, until finally I was driven to feel that this art as well as the Old Testament art had been actively symbolic to the Jews who borrowed it, and indeed that the Christians at the outset used a vocabulary from pagan art so much like the Jewish borrowings precisely because the Christians had taken the pagan motifs, as they had taken the Old Testament art, directly from the Jews. Again hellenized Christianity seemed based upon a hellenized Judaism. The problem of objective demonstration, however, had only become the more complicated. What could be done with what we shall see was the chorus of assertions that these pagan motifs were "purely decorative" in Judaism, statements which seemed to me indeed to be subjective, and for which proof was never offered, but which gained conviction with repetition? Dura presented its Old Testament scenes clustered about a great vine over the Torah shrine, a vine in which Orpheus played his lyre to the animals, while numerous other pagan symbols appeared in various parts of the room. The two, the pagan symbols and the Old Testament illustrations, could not be separated. It became clear that one must try to discover a way objectively to interpret the symbols as well as the Old Testament scenes.

The theories I have evolved to meet the problems have no way of direct proof—or disproof. Conviction can be imparted only by accumulation. A certain method will be tried with symbol after symbol. That it leads to mystic Judaism in the case of a single symbol or Old Testament allegorical picture proves nothing. That the same method leads to the same conclusion in scores of cases still *proves* nothing, but does establish a probability, so that the burden of proof steadily shifts to the shoulders of those who would continue to call the art "merely decorative." All I can hope to have accomplished is to have made my hypothesis more probable than other hypotheses. Such a book, like all historical reconstruction, should properly be written in the subjunctive mood: what I say *may* be the case. It would be so written except that the subjunctive mood is rhetorically tiresome. I have tried to relapse into it often enough to keep the reader aware that I feel throughout the hypothetical character of what I am proposing. Of only one thing I am certain: that those who reject my thesis cannot do so simply by protest and assertion, but must offer a better hypothesis than mine for the mass of material here presented, one more illuminating than mine for that material as a whole. Perhaps the real service of this work will be to provoke such a hypothesis. In that case the years will have been well spent.

Method in Evaluating Symbols

STUDY OF THE rabbinic evidence has led to a negative conclusion.[1] It was not because the Greco-Roman world and its images had been accepted as valid for Judaism by the rabbis that such numbers of Greco-Roman figures were used in the Jewish tombs and synagogues of the time. The rabbis held to their aniconism [that is, non-utilization of graphic arts in general] with occasional but on the whole very insignificant modification. Accordingly, since the images were used so flagrantly, the rabbis could have had little control over the practices of the mass of Jews and I suspect that they had even less control over the ideas, pagan, gnostic, astrological, and mystical, which the Jews who made the amulets and ornaments may have been incorporating into their Jewish faith.

If the attitudes of the rabbis do not furnish an authoritative norm reflecting popular Judaism at this time, what, then, was the character of that popular Judaism? Does the hellenized art testify to a real invasion of hellenistic thought into common Jewish thinking or only to a penetration of art forms for decorative purposes — a phenomenon that witnesses no basic modification of what popular Judaism had been in Palestine under Pharisaic control before the collapse of the Jewish state?

Only one body of evidence speaks directly for popular Judaism in the Greco-Roman world, namely, the archeological data. Everything else deriving from the period, conspicuously the talmudic literature, is, in relation to popular Judaism, secondary to that evidence, because the literature comes, we have seen, from a group who could not have inspired such productions, and who destroyed this art as soon as they had power to do so. As to the Jews who built the synagogues and tombs, there is no reason whatever to doubt that they were what Galling called *thoratreu* Jews. But before the dissemination of the Talmud, being true to the Torah could scarcely, for Jews not in the rabbinic group, have meant fidelity to the Talmud. It meant in Philo's case, for example, complete devotion to the Torah as he had it in his Greek translation, along with a tradition for its interpretation. This interpretation agreed on many

1. This chapter, somewhat abbreviated and adapted, was published as "The Evaluation of Symbols Recurrent in Time, as Illustrated in Judaism," *Eranos-Jahrbuch*, XX (1952), 285–319.

points with the rulings of the Pharisees of the day. Similarly, in the period we are studying, the Jews who were "propagating" Jews, if I may call them that, were undoubtedly keeping themselves a distinct group eating kosher food as they understood the term, observing the festivals and Sabbaths, abstaining from intermarriage with gentiles, and avoiding any taint of what seemed to them idolatry or recognition of pagan gods. That Jews of the diaspora were "Torah-true" in this sense both pagans and Christians of the period attest. Jews wanted their own places of worship, which meant their own way of worship, and a close association with one another even in death, which produced special Jewish burying grounds. All of this, however, I must constantly repeat, was completely accordant in Philo's mind with interpreting the text of the Torah in terms of Greek or hellenistic religious values and aspirations, and such an attitude may have been just as natural to the mass of Jews living in gentile centers.

A. THE PROBLEM

INTO THE Torah-true lives of the great mass of Jewish devotees of the period we are studying there palpably came an amazing use of pagan art forms. Everything specifically forbidden in the halacha of the rabbis appears in the remains of their religious culture: apart from the fantastic images on the amulets and charms, even the synagogues have yielded images of pagan gods — images in the round or in relief — and such motifs as snakes, plants, hands, animals, and birds of all kinds, as well as a considerable abstract vocabulary, comprising rosettes, a great variety of wine symbols, and wreaths, fishes, bread, and the like.

The Jewish art becomes, then, in the phrase which Cumont applied to his Mithraic material, a "picture book without text." The philological approach has to be discarded. Cumont himself, in a passage recently quoted by Bonner,[2] said: "Archeology, without the help of philology, becomes a conjectural science whose conclusions achieve only that degree of verisimilitude which the ingenuity and eloquence of their authors can give them." But from his Mithraic "picture book" Cumont himself gave us much more than ingenuity and eloquence about Mithraism. When relevant literary evidence does not exist, one cannot on that account disregard the archeological remains. Obviously, in discussing such a symbol as the cup, for example, every reference to the drinking of wine which we can get from Jewish literature, including that of the rabbis, will have to be closely scrutinized; but we cannot assume from the outset (and to the end) that the rabbis tell us all that may have been in the minds of Jews who pictured the cup, or grapes, between peacocks in their synagogues, or who carved the cup on their graves. This would indeed be what

2. Bonner, *BM*, 301.

Panofsky called "indiscriminately applying our literary knowledge to the [artistic] motifs."[3] The symbols must be treated as primary evidence not simply of an art, but of the life of the Jews who made the art. To use such evidence we must learn to read the symbols as such, and here we are on ground which the historian properly regards as extremely dangerous, the quicksand of scholarship which engulfs, often maddens, those who attempt to explore it. Clearly we cannot just sit back and make guesses at meaning. Yet merely to assert absence of meanings is not conservatism, but is equally unfounded guessing. There must be some sounder approach.

We are, then, forced to ask the question: Does this art in itself indicate a large penetration into popular Judaism of religious conceptions, if not of rituals, from the Greco-Roman world, or is it most naturally to be taken as an adopting of meaningless art forms on a purely decorative level? We must assume that so long as the Jews were Torah-true, there were limits to ideological invasion. If Helios had been accepted by Jews as a substitute or equivalent for Yahweh, who could then be worshiped in images of Helios, worshiped *as* Helios, there would have been no reason to build synagogues dedicated to Yahweh: the Jew might as well have gone to the temple of Helios with his pagan neighbors. But there is always the possibility that the Jews who used these symbolic forms maintained the same distinction as that by which Christians saved their principle of monotheism and freedom from idolatry while availing themselves largely of the same pagan Jewish motifs — namely, the distinction between direct worship of an image and the use of it as a symbolic aid in worship. Hence I have suggested that, as between the motives of pure decoration and of idolatry, there is a *tertium quid* to be considered, the possibility that these figures had real meaning for Jews as symbols — symbols whose values they had thoroughly Judaized by giving them Jewish explanations.

This is the form the question now takes. Admitting that the Jews would not have remained Jews (as they obviously did) if they had used these images in pagan ways and with pagan explanations, do the remains indicate a symbolic adaptation of pagan figures to Judaism, or merely an urge to decoration? We are forced to try to find out more from the material itself than a mere morphological-historical approach would tell us. Clearly we must study the motifs which Jews actually chose, and the ways in which they used them — in what places, associations, and circumstances.

B. WHAT IS A SYMBOL?

AN OBJECTIVE approach to ancient symbolism is possible only for those who are ready to combine historical with psychological techniques. Use of the tech-

3. Erwin Panofsky, *Studies in Iconology*, 1939, 12.

niques of either one of these sciences without aid of the other has heretofore resulted in pure subjectivism. The study of religious art by the "scientific" historians of the last half century has reflected great skill and erudition in identifying the figures represented: it has "turned vases from *objets d'art* into historical documents, dated and assigned to authors."[4] What has been done in this way is of permanent importance, and has earned such scholars the right to call themselves scientific. Most of them have suddenly ceased to be scientific, however, as they have exhausted the possibilities of such study, and gone on to assert what religious values the figures did or did not have.

For example, a century ago an important school of symbolists began to use their imaginations and produced enormous works which were essentially fanciful.[5] Much good fancy was here mixed in with bad, but there was no criterion for distinguishing the one from the other. Scientific historians, thinking they were still being scientific, reacted against such symbolists, and asserted that the art had no meaning at all beyond the ornamental. On one occasion I was approached by one of the greatest classical archeologists and historians of the century and suddenly accosted with the pronouncement, "The carvings on the Roman sarcophagi are purely decorative."

"Fine," I answered, "but how do you know?"

His only answer was to repeat the assertion in identical phraseology three times.

Similarly Avi-Yonah said that if the wine cup and grapes appear on Jewish monuments, it shows that such designs had so entirely lost meaning, had become so completely decorative, that they had no meaning in Christian art either. Avi-Yonah was indeed "building a fence" about his position. It was safer to deny symbolism to all grapes than just to Jewish grapes. Such dogmatism is, like all emotional dogmatism, of great comfort to the dogmatist, in relieving him of the necessity of further question. But the questions unfortunately remain.

Up to the present there has been no serious attempt to find a method by which one could distinguish between such equally absurd extremes as, in my opinion, these symbolists and nonsymbolists present. Panofsky warned of the

4. A. D. Nock, "The Necessity of Scholarship," *Official Register of Harvard University* (Harvard Divinity School Bulletin), XLVII (1950), no. 29, p. 42.

5. Cf. esp. F. Creuzer, *Symbolik und Mythologie der alten Völker, besonders der Griechen,* 1836; J. J. Bachofen, *Versuch über die Gräbersymbolik der Alten,* 1859 (reprinted 1925); Goblet d'Alviella, *La Migration des symboles,* 1891. The practice goes back to Francis Bacon, *The Wisdom of the Ancients,* 1617, who prefaced his completely fanciful series of explanations of classical myths by remarking that he was not "entering upon a work of fancy, or amusement" or intending to "use a poetical liberty in explaining poetical fables." Many before him, he says, have "delivered fables of plausible meanings they never contained," and he properly traces such interpretation back to the Stoic allegories of Chrysippus.

danger, in iconography, of "trusting our intuition pure and simple,"[6] and assertions of absence of meaning in such devices as we are studying are as intuitional, fanciful, and worthless as the creation of pretty stories about their meaning. Only some objective method can save us from the one or the other type of intuitionalism.

The best approach to the nature of a symbol is suggested in the simple line of Ovid: *Crede mihi; plus est, quam quod videatur, imago.*[7] That is, a symbol is an image or design with a significance, to the one who uses it, quite beyond its manifest content. Or for our purpose we may say that a symbol is an object or a pattern which, whatever the reason may be, operates upon men, and causes effect in them, beyond mere recognition of what is literally presented in the given form.[8] Two lines crossing each other at right angles may be only that, as they seem to be in a small child's scribbling, or when an illiterate man uses them to make his mark. But they take on great symbolic meaning when they become the coordinates of a mathematician's graph, or when a priest merely indicates the configuration with motions of his hand toward a congregation. Similarly they take on a great variety of meanings in many savage communities. As another example, a finger ring is in itself an ornament only, but when it is given as a wedding ring it is a symbol which helps to make the marriage effective by its very presence on the hand; continued wearing of it actually helps to stabilize the couple and to make their union enduring. A flag does more to people who

6. Panofsky, op. cit., 15.

7. *Heroides,* Epist. XIII, 155. Quoted by Bachofen, op. cit., 43.

8. In this discussion I am throughout avoiding such metaphysical problems as primarily concern Tillich: see his essay, "The Religious Symbol," *Journal of Liberal Religion,* II (1940), 13–33. He finds in the religious symbol five elements: (*1*) its figurative quality, i.e., it is revered not for itself but for what it represents; (*2*) it seems to make an imperceptible reality perceptible; (*3*) in contrast to a "sign" it has innate power—originally, in the case of pictorial symbols, magical power —so that as a symbol loses this power, it loses its genuine symbolic character; (*4*) it has a socially accepted rather than a private meaning; (*5*) it points to the "unconditioned transcendent." Tillich is primarily concerned with this fifth element, and thus seems to me to be unrealistic in his treatment of symbols as they appear in the history of religion. Such abstraction as he achieves may be the desirable and logical end of religion, but has played and plays a part in the life of only an insignificant fraction of mankind. To say that "the soul is religious," in the sense that "the relation to the unconditioned transcendent is essential or constitutive for it" (op. cit., 20), rules out from religion that which has been the concern of the great majority of men of the past, whose gods or God have been definitely conditioned by and thoroughly immanent in human affairs and in nature. Of this no one is more aware than Tillich himself: he simply does not like to regard such a God or gods as objects of religion, and is courageously willing to call himself an atheist in reference to such conceptions of Deity. To him "religion" is a word for an ideal rarely attained. As an historian I use the word religion in its historical rather than its ideal sense. What religion ought to be, or what men ought to worship, it is not my business to demonstrate. For the way in which Tillich uses his conception of symbols in his formal thinking, see his *Systematic Theology,* Chicago, 1951, I, 238–247.

see it and carry it than another piece of cloth, so that "The Star-spangled Banner" is a real hymn of the group religion, and the photograph of the raising of the flag at Iwo Jima is rapidly becoming a national "holy picture" which deeply affects Americans.

Such a conception of symbol leaves out of account many other legitimate uses of the term. Any word can be called a symbol of an external object or act, or of a conception. Aside from this, a word merely as such calls to mind something quite apart from anything in its own structure, and so a symbol in this sense is often called a sign. Similarly a representational painting or carved figure, whatever its own inherent beauty of color or form, recalls some other object, and is designed, like a photograph, to call that object to mind; but since the object represented may in itself have symbolic power in the deeper sense, a painting may be more profoundly symbolic than an ordinary word can be in its literal implication. For this reason modern artists who want their designs to be regarded without such external reference have been giving up representational form for creations which, recalling nothing on sea or land, must be thought of as realities in themselves. I suspect that such artists are still speaking symbolically, however, with the difference that they have given over public symbolism for a private one. The painting still has highly symbolic, that is, operative value for the artist himself, if only because he expresses in it, as in dreams, his emotions, his sense of relatedness and fitness in form, color, and chiaroscuro. Through this his own inherent formlessness takes on form.

Indeed, in the light of latest psychological techniques it seems highly unlikely that one can make even a geometric design without producing something symbolic.[9] I have been impressed with the revelations of character obtained when an individual tells what is suggested to him by the odd-shaped blots of the Rorschach test. People appear to project their personalities into the blots and to turn meaningless accidental forms into symbols, to such a point that one skilled in evaluating such tests can make profound observations about the psychological structure of the subject. Even more interesting to me is a still newer test, called "mosaics" by the inventor,[10] in which one is given little flat pieces, geometric shapes, in a variety of colors and told to make with them, on a sheet of paper, "anything that looks nice to you." The technique of reading these mosaics is by no means well developed, but it is at least clear that with the

9. Vittorio Macchioro, "Il Simbolismo nelle figurazioni sepolcrali romane," in Reale Accademia di Archeologia, Lettere e Belle Arti di Napoli, *Memorie*, I (1911), ii, 18 f., recognizes that no art is purely decoration: "Il simbolismo esiste dunque . . . quale fatto psicologico, fuori di ogni intenzione: e appunto perchè esso è un fenomeno della psiche,

un'arte decorativa figurata in sè e per sè non esiste."

10. Dr. Margaret Lowenfeld, of London. For bibliography and discussion of this technique of testing, see F. Wertham, "The Mosaic Test," in L. E. Abt and L. Bellak, *Projective Psychology*, 1950, 230–256.

colored lozenges, triangles of various kinds, and squares, people tend to make designs expressive of their own natures.

This sort of symbolic projection, it seems to me, can especially be observed in the use of "merely conventional" rosettes, columns, lozenges, leaves, and the other formal devices ornamenting the ossuaries we have seen. Indeed, it appears likely that stonecutters sometimes left round spaces on ossuaries uncut so that the person who ordered the box might select the sort of rosette which especially "appealed to him," as we say; perhaps we should say the design which was most deeply moving, or symbolic, to him. But into such a private world modern psychology would be very bold to enter, especially when it relates to a remote period. If some psychologists would like to try it, that is for them. But the present work only secondarily deals with psychology, and I make no claims in the field. Let me assure the reader at once that I shall not attempt to analyze the patterns in Jewish art to discover the personal characters of the artists who designed them. It seems clear, however, that the ancient designers — perhaps as unconsciously as people who make the modern patterns — had a sense of meanings and values inhering in what they produced and in the vocabulary of shapes with which they were working.

1. The Psychological Approach to Symbolism

IF PSYCHOLOGISTS are right in saying that all art forms, even geometric patterns, tend to have symbolic value, it follows that in trying to establish a method for evaluating symbolism, there is no escaping the problem of psychology. Without attempting to declare my precise debt to various schools of philosophy or psychology, I may say that I have found the language of Susanne Langer very congenial, especially in her discrimination between the realms of denotative and of connotative thinking. Indeed, this distinction is being independently used not only by psychologists and philosophers,[11] but also by literary and art critics in America.[12] It is a differentiation largely between verbal and averbal thought, though this must quickly be modified, since the connotative element is very important in language also. We think, that is, on two levels, one in which language is precise, scientific, specific, and attempts to convey a single definite idea from one mind to others. This I am trying to do as I write — *préciser*, the French actually call it. It is extremely difficult to do. I can

11. Cf. C. G. Jung's chapter, "Concerning the Two Kinds of Thinking," in his *Psychology of the Unconscious*, 1916; for the logicians, cf. Susanne K. Langer, *Philosophy in a New Key*, 1942 (reprinted 1949), *passim*, esp. the chapter, "Discursive and Presentational Forms." This kind of thinking, of course, did not begin with Mrs. Langer, but it is not appropriate here to trace her intellectual ances-

try through Cassirer, Urban, and the symbolic logicians.

12. See, e.g., Cleanth Brooks, "The Language of Paradox," in *The Language of Poetry* (ed. by Allen Tate), 1942, 44: "Poetry is a language in which the connotations play as great a part as the denotations." Cf. Wallace Stevens, ibid., 101 – 104.

describe external incidents, such as a walk to the village, because we have the language for such communication. The formulas of chemistry and mathematics are more precise forms of expression than ordinary words. But behind all such precision is a thought world where thinking is by no means precise in the same way, where we are occupied rather with impressions and associations arising from words, tones of voice, forms of objects. We are aware of some of this, but of most of it we are ordinarily not conscious at all, and much of it can be brought to awareness only by hypnotism, psychoanalysis, or the like.

Our tastes, our habits, our judgments on most matters are determined by the connotations of words and objects, their associations in all sorts of metaphor, and not their literal meaning. When asked to explain them directly in literal terms we are entirely unable to do so, just as a man could never say what his parents, wife, or children "mean" to him. Philosophy is largely an attempt to justify in literal, denotative language the conclusions to which the philosopher has long been committed by the other type of thinking. The same is true in psychology. French has recently written:

> Common-sense psychology is unformulated. The "understanding" that it gives us is an unverbalized sense of what to expect and what to do. . . . "Intuitive understanding" is an art of knowing what to expect from others without knowing why, without being able to explain how we came by the practical conclusions on which we act. . . . The facts that are most obvious are those that we do not understand at all because we never really questioned them.[13]

It is a splendid definition of common-sense in general to say that it is unformulated, unverbalized knowledge. The person who can "express himself" is the person who has the rare power of translating his associational connotative ideas, his image thinking, or some of it, into specific, literal language. I am attracted by Mrs. Langer's statement: "To project feelings into outer objects is the first way of symbolizing, and thus of *conceiving*, those feelings."[14] That is, insofar as a word or form "symbolizes" an emotion, it takes us beyond pure "feeling" into an intellectualized "conception" of the feeling, one which can even be used to communicate the feeling, or the conception of the feeling, to others who have the same symbolic vocabulary. The symbolic form becomes a "word," a means of communication. All discourse is a matter of symbolic communication, whether in the literal or in this connotative sense.

I have no interest in adapting this contrast in most of our thought to such categorizing words as preconscious, subconscious, unconscious. But I have enormous interest in the fact that all our most important thinking is in this world of the suggestive, connotative meaning of words, objects, sounds, and forms, that our thinking is primarily unprecise, and that our world of precision is a tour de force, a veneer which we superimpose upon our ordinary

13. Thomas M. French, *The Integration of Behavior*, Chicago, 1952, I, 36.

14. Langer, op. cit., 100.

world of associative thought. The present generation is amazingly developing both these types of thinking.[15] At just the time when the vocabulary of science is becoming increasingly complex, in the attempt to achieve increasing precision, and when great scientific discoveries are being made possible through such increased precision, contemporary poetry, art, and music find that they can express the modern spirit only by abandoning the specific and formal and letting the unformed speak in ways quite maddening to those who still try to be verbally precise.

It is no accident that those who practise such modern art and writing revert, with a natural sense of fitness, to the word symbolism when they are forced to *préciser* their lack of precision. By definition the symbol is a word, a poem, musical sounds, forms which mean more to us, have more power to move us, than the word, or the thing represented, in itself. For example, the word apple, when used specifically to designate a certain kind of fruit, is a word of precision. It makes little difference whether we say "apple," *Apfel*, or *pomme*. The sounds are useful, not in themselves, but only as they suggest a specific sort of fruit. Similarly the picture of an apple in a dictionary, or in a treatise on fruit trees, is only another way of making precise the concept which is being conveyed from one mind to another. But when the word apple, in any language, refers to the apple awarded by Paris or to the apple eaten by Adam, the form of the apple, or even the question of whether this was an apple at all, is unimportant—for the word has become a symbol for greed, jealousy, discord, in one case, for disobedience to God, sin, in another. If I say, "The lady offered him her apple, and, as from the days of Adam, he took and ate," I am not talking about an apple at all, but about woman's sexual appeal for man. It would indeed be difficult to *préciser* all that the word apple means in that sentence. For some it would mean the acceptably desired; for some it would still imply the quintessence of sin; for most of us it would carry both ideas at the same time, with associations going far down into our unknown depths and conflicts.

If this statement about the apple had been made in a poem, or in some other form of "creative" writing, the poet would think that a professor who would try to make its meaning explicit and denotative was a pedantic fool. The professor would probably think that he was being intellectual, superior, in trying to do so. The cleft between the literary, poetic mind and the academic

15. The idea is of course not new. Maurice H. Farbridge, *Studies in Biblical and Semitic Symbolism*, 1923, 4, quotes Victor Hugo's *L'Homme qui rit:*

"Il est presqu'impossible d'exprimer dans leurs limites exactes les évolutions abstruses qui se font dans le cerveau. L'inconvénient des mots, c'est d'avoir plus de contour que les idées. Toutes les idées se mêlent par les bords; les mots, non. Un certain côté diffus de l'âme leur échappe toujours. L'expression a des frontières, la pensée n'en a pas."

Hugo correctly saw that this unexpressed, nonverbal content of our minds is idea, not merely emotion.

mind is largely the cleft between the mind which expresses itself, lives directly and deeply, in symbolic meanings, and the mind which supposes this sort of thought to be improved by annotated editions. It is the cleft between what I am calling, with reference to symbolism, "meaning," "power," or "value" on the one hand and "explanations" on the other. The symbol carries its own meaning or value, and with this its own power to move us. Indeed, even the word *préciser* is an academician's term. The poet would rightly consider the symbolic or connotative statement about the apple quite as precise as any of the lucubrations of the professor. The explanation is for some people indispensable, but it is never the reality, our poet's thought itself.

Such distinction is most helpful for understanding creative expression in painting, music, and the other arts, where the symbols of chiaroscuro, color, or form, or the symbols of successions of melodies, harmonies, and discords become the immediate vehicles of meaning, vehicles which eternally deride every attempt to make their content verbally precise. The old distinction between the emotional and the intellectual here breaks down completely, for we see that the deepest thought and meaning lie in the immediate symbolic association. Explanations are always a weak afterthought as compared to meaning itself. And significant meaning is almost always conveyed in symbols, in which I should include now drama, myth, ritual, and all connotative aspects of words, besides distinctive visual forms.

This is the real function of dreams as conceived by the depth psychologists: they are a procession of symbols—images symbolic not only in their forms but also in what happens to the forms in the action of the dream. When we become psychologically disturbed we must have help to verbalize these deeper symbols of ours, give them explanations. Jung is saying the same of his "archetypes" when he explains that the symbol itself refers neither to the literal sun, nor to the lion or king for whom the sun is a symbol, but to an "unknown third thing that finds expression in all these similes, yet—to the perpetual vexation of the intellect—remains unknown and not to be fitted into a formula."[16] Ordinarily, however, the dream is nature's own psychiatry—a sign not that we are in psychological difficulties but that we are getting dramatic purgation as the conflicts and disturbed elements within us express themselves in the medium of dream symbolism.

2. Religious Symbols

My interest in all this is to come closer to an understanding of religious symbols. It now appears that we have gone a long way toward recognizing what we mean, in "precise" terms, by the word symbol. In general, a symbol is a

16. C. G. Jung and C. Kerényi, *Essays on a Science of Mythology*, 1951, 105; cf. pp. 127, 136, and Kerényi's quotation from Schelling, p. 214.

word or form which expresses more than it indicates, and so has power beyond its literal denotation. The religious symbol is not only a direct purveyor of meaning in itself, but also a thing of power, or value, operating upon us to inspire, to release tensions, to arouse guilt, or to bring a sense of forgiveness and reconciliation. We may love the symbol, we may hate it, but so long as it is a symbol we register its message, feel its power. A most moving story was told me by a friend [Paul Tillich], a famous early refugee from Hitlerian Germany, who, when the full meaning of Nazism was presented to him at a meeting, when he grasped what was in the swastika and behind it, stood in the street after the session shaking his fist at the great swastika on the building and shouting at the top of his voice: "It's a damnable thing, a damnable symbol!"

His friends almost violently took him home and got him out of the country. He has been convinced ever since that some symbols are in their very form good, some evil. My point in recalling this man's experience is simply to emphasize that a symbol in religion (and under my definition of religion, I would include the swastika along with the cross as being both powerful religious symbols) is something which conveys meaning indeed, but which also has inherent power to operate upon us.[17] Another of my friends, who was murdered for his humanitarianism, had as a child been trained in Catholicism. He renounced the credo and theology of his religion but could not escape the power of its symbols, a fact which he revealed by saying that Christianity would always be a menace as long as it used "the damned cross."

There are many ways in which symbols may have come to have such power, but that is beyond the scope of my discussion here. In fact, our lives are largely guided and molded by symbols. There are the symbolic acts of polite society, the "code" of a gentleman, which no one could codify without becoming ridiculous. The urges and repressions of phallicism produce symbols so powerful that in our civilization we can rarely contemplate them directly at all. We recognize the symbolic force of green for the Irishman, of red for the Communist. We have the public symbols of the flag, the Shield of David, the cross. And there is the world of private symbolism manifested in our dreams and neurotic compulsions.

It would be relatively easy if on this basis we could contrive in words a specific formula of meaning for each symbol, at least for the public symbols, and suppose that the given meaning, or operative value, is always conveyed by the particular symbol whenever it appears. But this is to miss the point that sym-

17. Rabbi Silverman told me of the horror of his congregation at the Emmanuel Synagogue in Hartford when it was discovered, after Hitler came to power in Germany, that in 1927 the vestibule of the synagogue had been paved with a mosaic floor in which the swastika was frequently represented. The entire mosaic was at once ripped out. Here was a symbol which, when apparently dead, the Jews could borrow, but which, when alive, had a power indeed—one which could not be endured.

bols have a way of dying, of apparently losing their power, and becoming merely ornaments. And they also have the power of coming to life again, as fresh associations and religious awakenings take old symbols for their own. This happened when the Christians adopted the ancient and universal symbol of the cross, a symbol which in pre-Christian ornament had degenerated into merely a four-point rosette, one of many forms of the rosette. Rosettes were still actively symbolic when Christianity was born, continued to be so into late Christian Byzantine times; but the four-point rosette, within a circle or abbreviated as the swastika, had come in the pagan world to have no special significance, so far as I can see, in itself. Christianity seized upon this four-point rosette within a circle, however, then still later made it specifically Christian by using a longer upright shaft, and thus took it out of the circle, although the Coptic church and the Eastern church preferred to let it stay there. Similarly the sudden revival from the dead, or from near death, which recently occurred in the case of the swastika, a variant of the cross in a circle, was even more dramatic. Now, it would be silly to argue that Christians put nothing new into the cross, or that Hitler's swastika meant the same as the swastika on a Greco-Roman mummy, or on a Jewish tombstone from the ancient world. But it is significant that when a new movement wants a powerful symbol, it usually finds satisfaction in reviving one of the primordial symbols rather than in inventing a new one, and we presume that this happens because an old symbol has an inherent symbolic power of some kind at least dormant in itself, even when it seems to have become a purely decorative device.

Whether there is such dormant symbolic power in what may ordinarily be called dead symbols used for ornament is not for the historian to debate. He must leave this for further investigation by psychologists. Whether it is more correct to say that basic symbols die, or that they merely become quiescent, I cannot say. Yet the trouble is that one cannot leave the question without begging it. For we must continue to face the problem of the "merely decorative" as contrasted with the "symbolic" use of forms in art; and when we put the contrast in these terms, or in such terms as "live" symbols versus "dead" symbols, or "active" symbols versus "quiescent" or "dormant" symbols, we assume, in each case, a theory of the nature of the contrast. Since I must have a terminology, I shall arbitrarily, tentatively, and without prejudice, use the contrast of "live" and "dead," fully prepared to have that terminology corrected by better knowledge. For in this study I cannot wait for such problems to be solved.

3. Migration of Live Symbols

AS AN HISTORIAN I see that the transition of what I call a live symbol from one religion to another represents something quite different from the transition of a dead symbol. The difference can perhaps best be indicated by illus-

tration. If in one of the modern synagogues where ornament is increasingly being used, one should find a large cross on the Torah shrine, it would be obvious that though the worshipers still wanted to call themselves Jews (the living symbols of synagogue and Torah shrine would indicate this), they had openly taken some highly important Christian values into their Judaism. A contemporary would need no literary documents to prove this, though he might have here a "picture book without text." The live Christian symbol, the cross, would speak for itself at once. If one could get a written explanation of the phenomenon from the rabbi of the synagogue, that would be only something supplementary, and perhaps a quite sophistic rationalization. The explanation would obviously be of less importance than the immediate sense that here a *value* had been borrowed, for the cross would have direct operative power to carry Christian types of experience into the lives of the Jews of that synagogue.

From such a hypothetical, probably impossible case we may turn to actual situations. All over the world, the Catholic church (rarely the Protestant) has allowed converted natives to carry much of their old symbolism into the new Christian chapels. The phenomenon is most familiar in the Latin-American countries, where native forms, symbols, and even elaborate rites are kept up along with the Christian ones. The Catholic clergy are quite aware that this gives to the local Christianity a coloration different from that of the Catholicism of Italy or Ireland. So long as the symbols or rites thus retained are alive, actively operative, they cannot be carried over without bringing into the new religion the older values. Explanations must then be given, as when, in a story F. C. Conybeare liked to tell, a Jesuit priest got a community on one of the Pacific islands to give the name Francis of Assisi to a tribal statue which they insisted on having at least in the narthex of the chapel. The renaming did soften the paganism of the figure a bit, but did more to soothe the conscience of the priest than to put the values of the Italian saint into the savage figure. For the natives, we may be sure, the image kept its original living values in spite of the ridiculous explanation of it taught them by the priest.

The migration of symbols in the ancient world followed, I believe, the same lines. A dead symbol can be appropriated without adaptive explanation. So the egg-and-dart molding, which originally may have had symbolic value, had become a quite conventional ornament long before the beginning of the Christian era, and its appropriation by Jews and Christians probably meant nothing more than that this type of design for a molding pleased them; no explanation was necessary. The zigzag line, so much used in Romanesque architecture, is less certainly an instance of the retention of something purely formal, for it is the primordial symbol of water, and even in Romanesque ornament was used over church doorways in a manner suggesting that the flow of divine grace — which was the symbolic meaning of water in antiquity — was still felt as operative through the symbol by those who entered under it to wor-

ship in the churches. Even more clearly alive were the symbols I am studying —the eagle, the lion, the fish, the winged Victory and the wreath, the caduceus of Hermes, the figure of Orpheus with the animals. The persistence of these in Jewish and Christian art cannot be presumed to be the persistence of the merely ornamental, of dead emblems, for these were living symbols in paganism and Christianity, so that presumably, to my mind inevitably, they were living symbols to the Jews. Stripped of their old pagan explanations, as the Jesuit stripped away the name and mythology of the native idol when he called it Francis of Assisi, these motifs must have been retained by Christians, and by Jews, only because there was a value in them which they wanted to preserve for themselves. If Orpheus became for Christians a symbol of Christ taming the passions, he probably had been Moses or David, or some other Jewish figure, doing this for Jews when portrayed in a synagogue. The *value*, we see, is meaning in the connotational or associational realm. This remains constant in the migration of a symbol. The new religion will give new explanations of the symbol, precise verbalizations in the vocabulary of its own literal thinking. The historian of symbols has, then, the double task of finding the basic, unchanging values, together with the ever changing verbal explanations given by each new religion in adopting the old symbols.

Indeed, when the religious symbols borrowed by Jews in those years are put together, it becomes clear that the ensemble is not merely a "picture book without text," but reflects a lingua franca that had been taken into most of the religions of the day, for the same symbols were used in association with Dionysus, Mithra, Osiris, the Etruscan gods, Sabazius, Attis, and a host of others, as well as by Christianity later. It was a symbolic language, a direct language of values, however, not a language of denotation. Orpheus could become Christ because he had ceased to be the Orpheus of Greek legend before the Christians borrowed him, and had come to represent mastery of the passions by the spirit—a role in which he had no specific name or mythological association. Helios driving his chariot through the zodiac could be used by Jews to represent their cosmic Deity because in the thinking of the day, especially the sort of thinking associated with Neoplatonism, this figure had come to stand not for the traditional anthropomorphic god at all, but for the Supreme Principle—a concept borrowed and used by all sorts of religions at the time. Thus its presence, to our knowledge, on the floors of three synagogues in Palestine would seem to indicate that Jews had in their Judaism not Helios, the pagan god, but the value of that figure in contemporary life.

4. *The Lingua Franca of Symbolism*

To UNDERSTAND the Judaism which used these pagan symbols, then, it is necessary to reconstruct the lingua franca of the religious symbolism of the

time. To do so requires investigation of the use of each of the symbols in as many as possible of the pagan religions, even going back to the earliest occurrences of the forms in Mesopotamia and Egypt when they can be traced that far. If continuity of symbolic values can be demonstrated in all these religions, it would establish meanings for the lingua franca which, as they seem to have stability in other religions, would increasingly suggest themselves as the values of the symbols also for Jews. We seem to have familiar evidence of such continuity of meaning in the wine symbols, the cup, the vine, the grape, and the like. In Christianity, Christ is the vine; his blood, or his divine nature, is mystically given the communicant in the cup. But instantly we are reminded that for Dionysiacs and Orphics, Dionysus was the vine, and that the bacchanals received his divine nature in the cup. In both paganism and Christianity this participation meant mystic assimilation in life, and immortality after death. The symbol is really a common denominator, valid in an identical sense in both religions. For in both religions the cup and vine symbolize mystic union with the saving god, and eternal life. The bird eating the grapes of the vine is another symbol common to both religions: it is ordinarily taken in each case to stand for the devotee obtaining this divine life. So we have now the tentative suggestion that the religious experience which these particular symbols represented, the value they brought, was an experience of mystic union in which the devotee shared in the divine life of the saving god and was thereby assured of immortality, an experience which in each religion might have had a mythological explanation with or without association with the myths and cult of Dionysus himself.

In all this, however, we have constantly to bear in mind that the meaning or value of any given symbol is not a denotative, precise meaning, but a connotative one — a meaning in a language designed to speak to the mind, but having more immediate relation to the emotions than to verbal thinking. Beyond simply arousing emotions, however, these symbols carried potent ideas, even though the name or the myth linked with a given symbol changed repeatedly in the verbal formulations of the various cults. The reconstruction we are undertaking is one which will hardly please the modern philologist, who will expect me to say in precise words what Helios meant, or Orpheus, or the winged Victory or the eagle. The religious symbolist, I repeat, is in this respect like the poet, who is usually, and naturally, disturbed at the misrepresentations attendant upon any attempt to make his language literally explicit by paraphrasing it. Wallace Stevens, himself a master of connotative expression, protests against literal "truth": "We have been a little insane about the truth. . . . To fix it is to put an end to it. Let me show it to you unfixed."[18] Literary criticism must give one ability to reread a poem with a new and direct sense of its

18. "The Noble Rider and the Sound of Allen Tate), 122, 124.
Words," in *The Language of Poetry* (ed. by

"unfixed" meanings, the ability to feel the impact of its usually paradoxical metaphors until their resultant values register directly in mind and emotion alike.

Indeed, it has been objected with reason that it is quite misleading to contrast the denotative and the connotative, the verbal formulation and the symbolic meaning, as though the contrast were one between the precise and the imprecise. As a correspondent, A. B. Stridsberg, wrote me: "Nothing could be more definite, more existent, more real—even more precise—than symbolic meaning." With this I fully agree, though for convenience I keep the term "precise" for the verbally explicit. Thus the end of a study of symbolism is to have the symbol work upon us directly in its own right.

Accordingly, long as this study will become, there will be relatively little meaning in a literal or discursive sense got out of the symbols we examine. More and more we shall see that people used symbols which could pass thus from religion to religion precisely because the forms did not have any literal, denotative meaning; they spoke to a level of consciousness or mentality much less concerned with precision, but much richer and more important, than the level that responds to denotation. Christianity and Judaism alike rejected Dionysus and his rites and myths with horror, while they kept his symbols. They rejected the specific and kept what I may call the subspecific—linguistically subspecific, that is.

There is, however, a meaning, a very definite meaning, in the symbol, which is grasped by the devout quite as directly as verbal language, in the great majority of cases far more directly. That explanations of why the cross is important would so widely conflict, cannot obscure the fact that actually the cross itself carries a much more concrete and definite meaning or idea than all the verbal explanations of it put together. Theology is for the few: the cross is for all, the intellectual and the childish alike. It is this language which the historian of symbols must come to understand: he must let the lingua franca speak to him directly as the poet speaks in his metaphors, or as Bach with his masterful precision speaks in his fugues to those who know Bach's untranslatable language.

5. Modern Symbolism

JUNG feels deeply a danger that symbols may overwhelm us: they have a seduction, a dissolving power that can take us to destruction, to chaos. He sees in them autonomous forces which we study or release at our peril. The danger, however, seems to me to lie not in the symbols with their relative clarity and security, not even in the primordial symbols, but in the chaos of reality in the world and in ourselves, a chaos which first takes on meaning in the symbol. This formlessness behind the symbol which the symbol begins to make

manageable is the element that, without the help of symbols, can destroy us. At our peril we look behind the symbol, for it is the symbol which finally stands between us and the meaningless.

At the same time it is in the world of symbol that we are creative. All advance in thought, as Mrs. Langer has pointed out, consists in the making explicit, that is, the expression in definite form, of that which comes to us as metaphorical, associational perception. As the immediate expression of our connotative minds, fresh creation of forms bids fair to be the future of religion. Mrs. Langer[19] says that the conflict of religion and science is the conflict between a primitive, "a young and provisional form of thought," and discursive, literal, scientific thinking, which must succeed religion if thinking is to go on. With this I completely disagree. She herself admits, as just indicated, that new formal thought usually begins in the pregnant realm of "suggestion," of symbol, and we can look forward to a time when literal thinking will have displaced figurative thinking only as we look forward to a time when man will have ceased to be human. Ours is so tremendously vital an age because, as I have said, we are now doing both types of thinking, doing so consciously, and because, as never before, in both philosophy and psychiatry, we are trying to co-ordinate the two types by understanding a little better the connotative processes of thought. We are not only trying to make our experience of nature intelligibly denotative in science; we are trying to use connotative thinking more freely in the arts, and, by coming to understand better the relation of the two types of thought, to use both more constructively. Religion will take on fresh life as it becomes less bound to the discursive and more free to create metaphorically. Indeed, it is something very like a revival of religion which modern art, music, and poetry, as well as modern psychology, are holding before our eyes. I see nothing "young and provisional" in such thinking.

A slight contribution to this attempt to understand the nonliteral, symbolical mentality is what this study aims to make. When I speak of understanding this type of mental activity, I by no means suggest surpassing it. I certainly have myself reached no full understanding. The modern mind tries to understand increasingly in order to utilize increasingly, not to create within itself illusions of understanding. This is the difference between science now and science fifty years ago, which was so confident that it had come to understand. Now we recognize that understanding is simply an infinite limit which we approach, and which orients our entire equation, our curve, at whatever point on the curve we may be, but a limit at which it would be ridiculous to consider that we have arrived.

The symbols we are studying operate in and emerge from the deepest levels of subrational thinking. They have a history which begins far earlier

19. Op. cit., 164 f.

than history itself, and many of the earliest symbols still have potency, even in our time, when society seems to a large extent to be losing all sense of their importance. There is point in Mrs. Langer's suggestion[20] that most of the basic symbols of religion are nature symbols, that the modern intelligentsia live largely cut away from any association with nature, and that consequently a large part not only of the fading importance of religious symbols, but also of modern emotional instability, is to be attributed to the fact that our lives no longer incorporate the basic symbols of sin and salvation, of life and death. Doubts of the "meaning of life," she says, rarely occur in people who live as sailors do, that is, who, living with such symbols in nature, still find reality "meaningful" enough.

It is of equal importance in relation to our present sense of confusion that our educational system is directed almost entirely to rational, discursive treatment of literal fact. As long as purely intellectual training was supplemented by the chapel, this did little harm, but now man is trying to live by literal bread alone, and the intelligentsia are suffering from a sort of avitaminosis. We need more than calories to be healthy, and we need more than information to live balanced lives psychologically. The modern world has thrown out the old symbols, along with their explanations. The symbols speak to man, I have quoted Mrs. Langer as saying, on the "young and provisional" level, but it would be better to say on the subliterate level. For untold millions of years man was apparently only an animal: then for untold thousands of years he had a subliterate, subdiscursive intelligence. Upon these two stages most of us have now superimposed rationality in the full sense. All three of these levels are still represented in all of us. We trace the evolution from the animal stage in the development of the embryo; we just as truly relive the evolution to the subliterate (but intelligent) stage in infancy and childhood. The final rational adult strangely accepts his animal nature and treats it with respect, while he tries to believe that now he has "put away childish things." The great contribution of Freud has been to recall to us (many of the "rational" still childishly reject the idea) that this childish, subliterate element is as much a part of any individual's constitution as are his legs or liver, and that to neglect and abuse this part of oneself is as perilous as to neglect one's physique. Man has always stabilized this subliminal aspect of himself with symbols, and now we have none of real value. For a Cadillac car may symbolize a bank account, but our need of stability goes far deeper than material prosperity can reach. The pathetic avidity and abandon with which most of Germany accepted the swastika testified not to the merit of what the swastika brought with it, but to man's craving for basic symbols.

To the well-being of our physical side, analytical and discursive thinking

20. Ibid., 235.

has contributed enormously since it began, several centuries ago, on the study of physical anatomy. We have already made a bungling start on the "anatomy of melancholy," on the problem of man's subrational being, in depth psychology, in sociology, in anthropology. We have, to say the least, still a long way to go. It is my hope that the present work will contribute a little to the understanding of man as we trace some of our symbols in their transition through the ages. To the contemporary bearing of my work I shall only occasionally allude, though we shall repeatedly discover present value in many of the symbols examined, and the undertaking as a whole, like all historical studies, will finally have value only as it has contemporaneous value. For the most part, however, we shall be keeping our eyes on the immediate problem, which is the attempt to arrive at such relative understanding of the Jewish symbols that we shall be able to grasp their value for those who used them.

6. The Paradox of Symbols

AS REGARDS explanations, we must also bear in mind that in the case of a symbol of any deep importance, no single explanation of its power or scope ever suffices. One of the things that modern depth psychology has taught us is the paradoxical character of man's being. Love involves hate, death is the reverse of life, and the one seems to imply the other. Freud had to give up much of the consistency of his system when he was forced to put the "death urge" alongside the constructive "life urge" in the libido.

> The governing laws of logic have no sway in the unconscious; it might be called the Kingdom of the Illogical. Impulses with contrary aims exist side by side in the unconscious without any call being made for an adjustment between them. Either they have no effect whatever upon each other, or, if they do, no decision is made, but a compromise comes about which is senseless, since it embraces mutually exclusive elements. Similarly, contraries are not kept apart from each other but are treated as though they were identical, so that in the manifest dream any element may also stand for its contrary.[21]

Religion, it will increasingly appear, has offered man psychic therapy because it has recognized these opposites in his nature, and combined them, so that he could find life through death, save his soul by losing it, come into divine love by hating the devil and all his works. A proper religious symbol presents this paradox directly to the believer. The agony, distortion, and death of the cross bring one into divine peace, while the misbegotten religious art of the school of Hoffmann which made its way into so much of our recent stained glass, and which we still give children in the Protestant (and often in the Catholic) Sunday schools, turns out to be only emetic sentimentality, since it tries to

21. Sigmund Freud, *An Outline of Psycho-analysis*, 1949, 53.

present the sweetness, love, and kindness of God without any terror or agony. A good symbol, such as the Indian device of a cobra striking above a lingam, presents life and death together. It must always be recalled that the symbol is of value precisely as it pulls together, in nondiscursive form, propositions, desires, and attitudes which discursive formulation can only brand as impossible of combination. The language of our symbols, like the symbolic language of poetry, is what Cleanth Brooks called the "language of paradox."[22]

This is the *value* of the symbol—its power to unify a cluster of ideas or emotions or drives. The destructive chaos at the bottom of our lives, the chaos of mutually antagonistic and yet equally urgent drives, what might be called our fundamental schizophrenia, is controlled only as we get symbols in which both sides of our natures can simultaneously express themselves. I strongly suspect that what we call meaning—in the sense in which a man might say that Christianity is or is not meaningful to him, or that Communism does or does not make sense to him, or that mysticism is or is not meaningless—rests primarily on the test of whether the symbols offered by such a belief or religion, or by the symbolic acts of its practice, do or do not effect a resolution of the given individual's inner conflicts: if, when the symbol is shown, or the symbolic act is performed, it operates on the person, he is "strangely warmed," or, in Plato's term, the symbolic words light a fire within him. This fire or light brings the life of order and inner harmony, and is itself one of the primordial symbols. For the chaos behind the paradox is death and darkness: reconciliation, even in the paradox of symbols, is life and light. The experience may be one of sudden illumination as the symbol becomes "meaningful," that is, generative within the individual. Or we may be capable only of blind and often savage adherence to the symbols of our class, with chaos, darkness, and terror the apparent price of abandoning or even questioning them. Indeed, the conservative is right: he faces dissolution within himself if he must lose the old symbols without finding meaning or value in new ones, and this he is usually unable to do. The struggle between the old and the new is so rarely affected by a rational approach because rational arguments are relatively so superficial. A man "convinced in words," Plato was aware, is left of the same opinion still.

This is well illustrated by the history of the symbols we are studying, which went from paganism to Judaism and Christianity. Jews and Christians rejected the old explanations, the myths and mythological representations, while they kept their sanity by retaining the symbols themselves. One of the most notable things about the forms we are studying is that they are stripped of all their old mythological settings, because the settings implied pagan explanations. The

22. Op. cit., 44. Brooks (p. 58) quotes Coleridge's statement that poetry "reveals itself in the balance or reconcilement of opposite or discordant qualities: of sameness, with difference; of the general, with the concrete; the idea, with the image; the individual, with the representative; the sense of novelty and freshness, with old and familiar objects; a more than usual state of emotion, with more than usual order."

hypothesis on which I am working, or which I am testing, is that in taking over the symbols, while discarding the myths and explanations of the pagans, Jews and Christians admitted, indeed confirmed, a continuity of religious experience which it is most important to be able to identify. For if there was such continuity of value, as the history of art may reveal it in the continuity of symbolic forms, the history of art will have much more to teach the history of religion than we have hitherto suspected. The discontinuity of myths and explanations is of profound importance in human history, and this discontinuity is what the history of religion has hitherto been chiefly concerned to indicate: but for an understanding of man, the phenomenon of a continuity of religious experience or values would have much more significance than that of discontinuous explanations.

Another most important aspect of symbolism lies in its simultaneous multiplicity of forms and sameness of values. The symbols of Christianity, for example, are indeed many. There are the cross, the crucifix, the Holy Family, the figures of Mary and Christ, the dove, the vine, the cup, the fish, the book, the lamb, the tree, the light, the cherub, the throne, the hand, the eagle, the bull, the bleeding heart, the angel, AΩ: one could go on almost indefinitely. Yet all of these will fit into a single formula, namely, the idea that the eternal God lovingly offers to share his nature with man, to lift him into eternal participation in divine life and happiness. Each symbol presents a facet of a single jewel. Devotees or artists, by virtue of their peculiar tastes and conditioning, will each find some of these symbols moving and the others rather meaningless — for them. A religion which hopes to become the religion of a civilization must make room for individual sensitivities by having a varied symbolism. We shall come to the richness of the Christian offering through an awareness of the nature and appeal of each of its symbols, but we must understand that all of them are simply roads to the same goal, each attractive in its own way. The One cannot be fully the One unless it has within it the potency of the Many. Herein lies the difference between a "great" religion and a sect. The great religion offers many roads, the sect few, or only one. In dealing with the richness of pagan and Jewish symbols we must bear this in mind: we must feel the special values of each, but always with a view to discerning the symbol's end — which presumably will be an end common to all the symbols.

C. THE JEWISH SYMBOLS

WE ARE NOW perhaps ready to discuss more directly the problem of whether the Jewish symbols were symbols at all, or only space-filling designs. Several considerations seem to me to indicate that the designs were really religious symbols to the Jews.

The first reason has already been discussed—namely, the fact that the symbols which Jews borrowed from paganism were all living symbols, in paganism earlier and contemporaneously, and in Christianity contemporaneously and later. To be sure, we can find many ancient instances in which Victories and cupids and wreaths were primarily decorative, as the cross is often used by Christians largely for decorative interest. But these very devices were also constantly used with serious symbolic meaning, on tombstones and amulets and in graffiti, by pagans as well as by Christians later, and I do not see how any Jew could then have borrowed them, especially for use in synagogues and on graves and amulets, without a feeling that they had significance.

Secondly, the vocabulary of symbols which the Jews borrowed is on the whole extremely limited. Except on amulets, not much over a score of designs are to be found in all the hundreds of instances of such borrowing that appear in remains from southern France, Italy, Sicily, Malta, North Africa, Egypt, Palestine, Asia Minor, and Mesopotamia. If, then, decoration was the motive, why this extraordinary agreement on what could and what could not be borrowed? After I had collected two-thirds of the surviving specimens of this art, it was hard to keep going to get the rest from the more scattered sources, since everything I was finding was so similar to what I already had. For their synagogues and graves, Jews obviously favored some pagan symbols, definitely avoided others—a phenomenon explicable perhaps on the assumption that only certain devices were acceptable to them, that is, that what they did take they took not for its decorative appeal but for its symbolic value to themselves. This selective vocabulary is, however, extremely interesting, because it is exactly the vocabulary of early Christian borrowings from paganism, a fact suggesting that the Christians did not take the forms from the pagans directly, but that along with Old Testament figures, the pagan emblems came into Christian art from Jewish usage.

Thirdly, the symbols used in Judaism frequently cannot be called decorative by any stretch of the imagination. Aside from the crude amulets, we have seen many instances in which the Jews who scratched the grotesque drawings on their tombstones were scarcely activated by artistic inspiration. They wanted those symbols on the graves for something other than decorative effect, and that other can have been only the symbolic values of the forms.

Fourthly, on these graves and in the synagogues pagan and Jewish symbols are found so intimately intermixed, not only in a given cemetery but on a single grave or in one synagogue, that it is impossible, in my opinion, to say that when the menorah appears it has symbolic value, while there is no such value in the peacocks, wreaths, birds, Victories, and other motifs beside it. Far from feeling that the presence or absence of pagan symbols on a grave distinguishes the Judaism of the person buried in it, I venture that the choice between a

menorah and a bird eating grapes was a matter of indifference in this environ-
ment, so much had the two come to symbolize the same essential religious
attitude.

And lastly, I must point out that the very places where these symbols are
found indicate that their symbolic value for the religion of the group as a
whole was extremely important. In Rome and North Africa the ceilings of Jew-
ish burial places are covered with them: hence the symbols must have been ac-
ceptable to the group, not just to a few aberrant individuals. In North Africa
the mosaic pavement of a synagogue is elaborately ornamented with pagan de-
vices, and most of the synagogues in Palestine, to say nothing of Dura, show
such motifs in profusion, with Jewish and pagan forms so intermixed in the
designs that it becomes impossible to maintain that the pagan symbols were
merely decorative and the Jewish ones meaningful. But if the pagan symbols
were meaningful in the synagogues, this implies irresistibly that they were
meaningful for the Judaism of the group which constructed these buildings
and worshiped in them.

All these considerations force me to conclude that, generally speaking,
Jews throughout the Roman world borrowed these emblems with deliberate
symbolic intent. We have no literature telling us of a Judaism which could do
this, but the conclusion seems ineluctable that such a Judaism did exist for cen-
turies. And it is a likely hypothesis that on the completion and dissemination
of the Talmud, and with the beginning of Christian persecution of the Jews, a
great reaction set in which abolished this Judaism and destroyed its writings.
This possibility is heightened by our knowledge of the efficacy of Jewish cen-
sorship. If we were dependent upon Jewish tradition and Jewish preservation
of records, we should never have heard of Philo and the Jewish Hellenism of
his day. Philo and Josephus were both preserved by Christian copyists and in
Christian circles, and we should not have known even Philo's name if Chris-
tians had not adopted him. The same is true, so far as I know, of the Wisdom
of Solomon and the works of Josephus. That is, Jews have not only failed to
preserve accounts and the literature of hellenized Judaism; their records do
not even mention it. On the basis of what Jews themselves have transmitted, it
would be ridiculous to suggest that Philo and hellenized Judaism ever existed.
Furthermore, once Jews and Christians came to complete antipathy, Chris-
tians had no interest in preserving the writings of contemporary Jews. Hence
it is highly possible that there once existed a considerable literature of the
Judaism of these synagogues and graves—writings which have disappeared as
completely as rabbinic Jews would have had Philo and his Judaism disappear.
Thus, absence of literature reflecting the kind of Judaism which, we are be-
ginning to suspect, went with these symbols, proves nothing. Still, the symbols
exist as data clamoring for explanation, and they must be allowed to speak for
themselves.

We shall often, in the case of some given symbol, leave considerable doubt as to whether it had a significance recognized explicitly by the group, was a means of communication, or had become "purely conventional" in the sense that its symbolism had ceased to be consciously recognized. In all these matters the clear either-or so dear to the scholarly mind rarely applies. Indeed, in Panofsky's phrase, we must interpret iconographic material by synthesis rather than analysis.[23] An object may be used as a symbol, used in an almost compulsory way, when all explicit understanding of its value had disappeared. A splendid instance of this is the Christian use of lamps in graves through the Byzantine period. Such use of lamps long antedated Christianity, deriving apparently from the symbolism of light as life. The practice was taken over by the Christians as a matter of course, and, in the way I have suggested, the old value was Christianized by being expressed in Christian terms. In earlier Christian usage the explanation was often written on the lamp itself, in the form of a Greek motto, "Jesus Christ, the Light of the world"; that is, still equating light with immortal life, the Christians asserted that the true Light is Christ. The custom was maintained for centuries, but once the idea had come to be an axiom to later generations of Christians, the motto was more and more carelessly written, and soon it was so put on that it is almost always completely illegible.[24] The lamp itself, however, now commonly with a cross on it, or bearing the old menorah, which had become a Tree of Life, continued to be placed in Christian graves—continued, apparently, to express and encourage hope of immortality. It persisted because, in terms of our definition of symbol, it did something to the people who used it. Thus, whether the explanation is recalled or not, lamps continue to be placed in Oriental graves, and lighted candles are still important beside a Jewish or Christian corpse.

D. EVALUATING THE JEWISH SYMBOLS

THE QUESTION regarding Jewish symbolism is, then: If the designs were not put into the synagogues and tombs casually, just to look pretty, but to do something to those who made them, to those who looked at them as they worshiped, and for those who finally were buried beneath them, what was their value, what was it hoped that they would do?

Since we cannot begin by asserting what these symbols meant ideologically to the Jews who used them in the Roman world, what their basic value was, we must go a long way round. At the outset we must utilize our discovery that these are symbols which had become a religious lingua franca in the world about the Jews who borrowed them. The most important of them were origi-

23. Op. cit., 8.

24. For examples, see Macalister, *Gezer*, I, 357, 366 f.

nally Dionysiac, and though the vocabulary had been expanded to include a few symbols from Syria (the specifically solar eagle), from Egypt (the rows of wine jars and baskets, the waterfowl), and from Mesopotamia (the zodiac), it was still essentially Dionysiac. This group of symbols was accepted by the Nabateans, Syrians, and Egyptians, in the religions of Asia Minor, by the Etruscans, by the imperial Romans as they came under hellenistic influence, by the Jews, and later by the Christians. How did people of the ancient world use these motifs, and what did they mean? They were indignantly rejected by Jews of the Maccabean period, and most of the Romans of the Republic had little use for them. But they are rampant in Pompeii, and are found on most of the second-century Roman graves. Is it possible to reconstruct the lingua franca of these symbols in their varied uses so that the values thus discovered may be applied to a Jewish milieu from which we have no literature? It would seem that if we can decipher the lingua franca we shall have the basic value which passed with the symbol so long as it was alive.

This is indeed a long way round, but I can see no possible short cut. The phenomena of syncretism in the ancient world must be re-examined in the perspective of the symbols.

One thing becomes instantly apparent. The lingua franca as it was used in all religions was made up primarily of abstract symbols, not of mythological scenes. We have already noted this in regard to Jews and Christians, who could use the vine or the cup, for example, or birds feeding on grapes, but not bacchanalian cultic scenes, or portrayals of Dionysiac mythology. We see further that for Egypt of the Ptolemaic and later periods the same holds true, as also for Nabatean remains. In Etruscan remains this exclusion does not appear, nor at Pompeii.

In Pompeii, we suspect, people were actually celebrating specifically Dionysiac mysteries. On the other hand, in hellenized Egypt we find Osiris with grapes, but not with bacchanals so far as I know. Is this a meaningful distinction? I am beginning to think that it is. When we find cultic or mythological scenes with the Dionysiac symbols, we suspect presence of the Dionysiac cult. When we find only abstracted symbols of other cults, we suspect some sort of value identification, but not cultic assimilation. For in that case the cult or mythology of some religion other than the Dionysiac or Orphic is being interpreted by the adopted symbols in terms of Dionysiac or Orphic values. Was this always done consciously? A glance at the Christian usage shows at once that probably it was not. For the use of Dionysiac symbols in association with Osiris, say, may have been part of a definite identification of Osiris and Dionysus, an open identification very frequent in hellenistic literature and going back to Herodotus; but certainly no Christian thought that he was identifying Christ with Dionysus when he used the vine with a figure of Christ. Where the symbols are used apart from cultic and mythological associations pertaining to

Dionysus, they need not imply a conscious reference to pagan cults and myths. In other words, the lingua franca had, apparently, come to speak not necessarily of cult or myth at all, but of something else, and of this in its own right.

Will this conception of symbols actually work out in evaluating the data of syncretism? The first step logically would be to examine the Dionysiac remains, archeological and literary, to see if possible what Dionysus himself meant to the Greeks in terms of religious experience. This ground has been gone over many times, but heretofore with the objective of reconstructing the myth and ritual of Dionysus rather than the psychological experience or value inhering in the myth and ritual. I cannot stop to write a new history of Dionysus in Greece, but the subject must be treated historically, for there is every reason to suppose that the character of the god changed very much. Originally a phallic god of fertility, whose tokens and rites were purely agrarian, his value seems to have been primarily magical, if I may use the term — the value of imparting fertility to the fields. (By magic, I mean simply a religious rite of automatic value.) Then Dionysus became, when introduced into a society which had Demeter, particularly the god of the vine. Another great change occurred when people began to project the idea of personal immortality into the general rites relating to resurrection of plant life, and a still further change came when the magical, or immediately operative, character of the god gave way, at least in the minds of thoughtful men, to the mystical.

These changes were probably brought about largely by the "Orphic reform," but we cannot trace the steps of the development. All we can see is that a change did at some time occur. But the new type of experience was lineally connected with the old. If the old rites were softened into sacraments for the mystical, the hope was still that something would really be effected by them: the devotee would be changed into a Bacchus, a divine being. He would be raised from spiritual death, like the seeds, and — for there is good reason to assume that the hope included this also — would be born again as a result of fertilization by the divine fluid which had earlier been represented by the leather phallus of the primitive rites, or in the orgiastic drinking of wine. The new conception did not entirely replace the old. The old survived, and still survives in rural fertility festivals in certain localities. But intelligent men were seeing deeper possibilities — men of sufficient breadth of view to see the values in the religious ideas of other peoples, and so to be inclined to syncretism. The process could be carried to the heights reached in Plato's *Symposium*, where Eros leads the soul to the Form of Beauty. All this needs careful documentation, and in this chapter is stated only as a hypothetical suggestion.

As the history of each symbol is analyzed, the phenomenon of the persisting values of symbols will, I believe, seem as much an historical fact, and thus a concern of the historian, as are literary and archeological data. The phenomenon needs as distinct a method of historical study, however, as is called for in

dealing with literary or with archeological remains. Hence I have suggested
above that one can study symbolism only by combining historical and psycho-
logical methods. For the ordinary criteria of historical judgment break down
completely before the symbol, so that the historian trained only in philological
and archeological techniques falls back into an emotional negativism. At the
same time, various schools of psychology have been able to demonstrate, each
to its own satisfaction, the omnipresence of phenomena which it could label
with its particular formulations, like the "Oedipus complex," or the manifes-
tations of the "collective unconscious," by means of arbitrary collections of
myths, symbols, and rites — collections which, however, violate the elementary
laws of all historical investigation. Clearly the two approaches must be used to-
gether, each deepening and correcting the other, if we are to make any prog-
ress in religious history. Modern anthropologists are in this respect far ahead
of the historian, and are getting important results from introducing the psy-
chological factor into their considerations. As I said, I have no contribution to
make to psychology as such. But I am quite sure that an obvious place to begin
applying the new psychology to history is in relation to the history of symbols.
Perhaps, by using historical and psychological criteria together, we may at least
eliminate some of the fancifulness in which either method of investigation is
likely to end without the counterbalance of the other.

It became clear to me, then, that if I was to do more than other recent stu-
dents in the field, I must not be content with publishing all the remains of Jew-
ish art, with the parallels, or a sufficient number of them, from pagan and
Christian art. Rather, I must use the best methods at hand for archeological
identification of the evidence, and all available literary testimony, but couple
with these some appreciation of their psychological implications. The psychol-
ogist may be scornful of the archeological niceties; the classicist may grow
wroth at my mingling of psychological conceptions with archeological data.
And both will have ample cause to point out that I am far from being a trained
man in their respective fields. I have consoled myself with the fact that in open-
ing any new approach, a man is *ipso facto* an amateur in it. Thus, at the risk of
incurring the indignation of the departmentally righteous, I have persisted. I
cannot hope, working in strange fields, to be free of mistakes, though I am
exercising meticulous care as far as I can. But I still hope that the main impli-
cations of my work are sound. These implications, however, are largely in the
field of the history and psychology of religion, and it is historians of religion
and psychologists, not classicists or church historians or talmudists, who must
ultimately pass on their value.

E. PSYCHOLOGY OF RELIGION

THE PSYCHOLOGY of religion which is emerging here is as a whole my own.
Much as I have drawn upon the various schools of depth psychology, Freudi-

ans will be the first to say that I am not one of them, at least in any orthodox sense. For that all guilt feeling means fear of castration, and that the Oedipus complex is found in everyone in the sense that there is in every man a jealous desire to abolish or kill the father, seem to me not at all justified assumptions. Nor am I a Jungian, seeing our individual minds rooted in a collective unconscious, or the psyche as comprising the animus and anima, the shadow, and all the rest. I do not feel that it is my task to construct or to commit myself to a system of psychology as such, and shall make no attempt to do so. But in the perspective of the depths opened up by such approaches to psychology, the data I am trying to explain take on a meaning which they have in no other frame of reference. The systems of these schools have grown out of interpretation of the phenomena that analysts have observed in their disturbed patients. The symbols of the ancient world are a totally different body of data, and suggest somewhat different formulations. But it is not surprising that they should suggest much that is similar to what analysts have found, since the phenomena in both instances come from the depths of the human spirit. Fifteen years ago, E. S. Robinson, one of Yale's most promising psychologists of the stimulus-response school, whose work was cut short by early death, remarked that while he was not at all a Freudian, he felt obliged to say that Freud bears the same relation to modern psychology as Newton bears to modern physics. It is in this spirit that I shall make free to draw upon Freudianism, or Jungianism, for anything that seems helpful in interpreting the symbols, without committing myself to other aspects of these systems. I must sharply warn the reader not to assume that what follows is an adequate psychological account of all aspects of religious experience. To present my ideas on that subject as a whole is quite beyond our immediate need. In this section I bring out only those aspects of it relevant to the types of religious experience that seem to me indicated by the symbols we are trying to evaluate.

The psychology in terms of which I am thinking begins from man's basic drive for life.[25] This is by no means a novel idea: the "instinct of self-preservation" is as familiar in the old psychologies as is the "life urge" in the newer. Everything indicates that this was a very unreflective urge in primitive man, as it is in animals. Savage man and animals alike will fight to the death for their food, just as they will periodically fight to the death for a desired female. But the desire for the female certainly plays little part in the motivation of most

25. Just what I mean by "life" I cannot say exactly. It includes "activity free from anxiety," as defined by Robert P. Casey, "Oedipus Motivation in Religious Thought and Fantasy," *Psychiatry*, V (1942), 228, but comprises much more than that restricted phrase suggests. Hope of immortality, freedom from frustrations, ability to live creatively in whatever sense the individual defines creativity, these are certainly also in life as we desire it. I should add that an excellent introduction to what follows, as regards ideas and bibliography, is Casey's "The Psychoanalytic Study of Religion," *Journal of Abnormal and Social Psychology*, XXXIII (1938), 437–452, in which he reviews with admirable clarity the contributions made on the subject to the date of his writing.

animals (except when they are inflamed by her odor), while they spend the majority of their waking hours in the search for food. Yet the life urge seems most intimately to include the sex urge, increasingly so as man becomes more civilized, since the sexual drive not only plays a part in the relatively sophisticated desire for progeny, but also becomes a means of achieving personal expression and an enlarged experience of life.

Accordingly, I must take the sex urge as but one aspect of the much more profound urge to life, to the realization, expansion, and perpetuation of life. In this, as far as I understand them, I agree with both Freud and Jung, each of whom insists that his conception of the libido includes much more than the sex urge as ordinarily conceived. The view of sex as the door to something greater must not be confused with the sublimations and perversions of the sex impulse which for one reason or another may take the place of direct expression of the instinct through the sexual act. Indeed, I am not sure that it is correct to say that artistic creation represents a sublimation of sexual activity, any more than one can say that because water flows better through one tap if a second tap on the same main is shut off, the greater flow of the first tap represents a "sublimation" of the flow of the second. The one tap is simply getting more water from the flow behind both. Sexual activity occurs only when the life urge expresses itself through the sexual mechanism (which comprises much more than the sexual organs). When the life stream is shut off from sexual expression, it may find other outlets, but this is only very doubtfully in any sense to be called sexual activity. Hence I prefer to speak of the life urge rather than of the libido, since the specifically sexual connotations of the latter word have caused so much confusion.[26]

The most immediate satisfactions of the life urge are found in eating and sexual expression (and of course in breathing and bodily movement, which we take for granted); with these go the primitive outlets of warfare and the hunt, gratifications of the urge to kill, unfortunately familiar still. The urge to kill seeks direct expression now only episodically, but it has been necessary to

26. I feel that in this I am very close to Dr. T. M. French's "concept of the craving of all healthy organs for stimulation and functional activity." In view of this conception French adds: "Instead of postulating a basic erotic drive, we content ourselves with recognizing cravings for stimulation and functional activity for their own sake": op. cit., 147 f. He regards my "life urge" as too philosophical a conception. He may well get on without such an over-all notion in his clinical work, just as he seems to be rejecting Freud's libido as a single force manifest in various usages. But in trying to understand the data of religion we need an over-all conception, since here man seems to be functioning as a unit, in his desires to achieve immortality, or to come into a larger mystical life. A man as a whole is a "healthy organ craving for stimulation and functional activity," and this cannot be understood in terms of his individual organs and their drives. The life urge seems to me to be for the organism as a whole what French, op. cit., 44, himself more philosophically calls the "basic functional pattern."

create a substitute outlet in sport[27] and socio-economic competition. The great symbols of the life urge are by nature of three basic kinds: they are the symbols of hunting or fighting, the symbols of food and eating (or of the sources of food — the winds, rain, the sun, etc.), and the symbols of sex. In these three themes we have the meanings of the vast majority of religious symbols used by all but the most advanced and intellectualized peoples. And while any given symbol we may be discussing will represent primarily one of these three themes, it will usually also refer to one or both of the others.

Another source of religious symbolism is in the child's relation with the parents during infancy. The sex life of the great majority of men has through the ages rarely been limited to the experience of one mate, while his infancy has been concentrated into an experience of one mother. To be sure, the infant in a luxurious home may be confused by nurses, and even in the simplest home a grandmother may be a more frequent attendant than the mother. Yet any plurality of such persons makes much less impression at that stage than later: for the infant, there is simply the great beneficent personality, in which only a quite developed child can distinguish different persons. There is far greater similarity between the experience of a baby of fifty thousand years ago and our own experience at the same age, than between any of his subsequent experiences and ours at the corresponding stage. And it is the unchangeable nature of this earliest experience, along with the unchanged neurological structure of man, which furnishes the most important common ground of understanding between us and remote civilizations.

The baby has always had, if he survived at all, a passionate life urge, and very little else. To be sure, healthy infants express this life urge during the greater part of the time in sleep, a way to life through death. Their waking moments are taken up with a sense of great discomfort from hunger, thirst, and the needs of elimination, and with the ecstasy of the gratification of their desires. All babies awaken in that terrifying confusion which is sometimes upon us adults when we awaken. Their world is only a few feet, at first only a few inches, in circumference; their misery, helplessness, and terrors are their only conscious experience. They cry — and out of the void there suddenly appear a loving face and deft hands which cut the terrible aloneness and promise the satisfaction of all needs. Soon the infant is comfortable, and then comes the heavenly breast, where love and food and life are one. Insecurity, fear, and uncertainty are lost in perfect peace and trust. In heavenly security the infant sucks in the life of the great goddess, and perhaps gurgles in brief joy before

27. The cannibalistic natives of Truk are now so civilized that they stage excellent games of baseball between tribes which formerly waged war with one another and ate their captives. But during the games the women stand on the side lines mumbling charms to bring a plague of dysentery upon the opposing team. My colleague Murdock, recently returned from Truk, is my informant in regard to this.

he again takes the sleepy path of death to still greater life. No later type of experience ever equals the complete satisfaction of this one. In maturity an ideal love affair may reproduce some measure of it, but only in societies in which romantic love patterns prevail could such perfection last for more than fleeting moments. In no adult relation is the experience at all complete.

The pangs of later infancy come from the invasion of this ideal world by social realities and compulsions which spoil, one after another, the perfection of gratification earlier enjoyed. Defecation, from being a delight, becomes to the child a meaningless struggle; as bodily movements develop, the loving face of the goddess often grows stern as she imposes incomprehensible restrictions and prohibitions. And then the breast itself is lost. Indeed, even the initial monotheism becomes a confusing polytheism as the goddess, still supreme, becomes one among other great figures which appear and disappear like theophanies. A world has passed away, a world where a loving goddess from her own person gave full gratification to the life urge. Specific memories of these months mercifully fade away and do not haunt us, but the basic memory does remain as a symbol of the one time when life completely conquered death in love. The nostalgia of later years, even when articulated in terms of more mature concepts, is still a longing for those arms, everlasting arms in which we may find again the mother's warmth and life, keep it now at last forever; it is possibly even the wish for the complete nirvana of the womb.

Each aspect of this experience, and of the deprivation of it, has appeared clinically as a major cause of later psychological difficulty. But I think that in discussions of religion the experience as a whole, first of gratification, then of deprivation, has not been sufficiently stressed: it is the basis of at least one of the most important of the patterns of religion. This pattern produces little "social gospel": it is as narcissistic as the life of the infant. It arises from the craving of the individual for self-realization through absorption of and in the true Being, the craving for life after death, for atonement and reconciliation, for rebirth and the abiding presence of the Comforter. The "mystic marriage" in the form of union with the temple prostitute or with the Church, the bride of Christ, is really a union with the Great Mother, a return to her intimate care. We love the picture of the Christian version of this theme, Mary the Mother with her Child, for each of us is the child. We project ourselves into the picture, but never as Mary: we—at least we males—are each the Baby in her arms.[28]

28. The development has been sketched here from the masculine point of view, and with reference to a patriarchal society. I do not know feminine psychology nor the history of matriarchy. It is obvious that the basic experience of the tiny infant with the mother is the same for boy and girl. It is also evident that the girl in her own way is as anxious to achieve unity with the father as the boy can be. But somewhere in the development of most girls, there is a stage of transference, so that the girl's ideal is to become, by possessing the father, herself a mother, the Mother —just as the boy's aspiration is to become the

And the power which that Baby manifests is the power we want also to manifest, a fullness of life such as we feel we should have in the security of that embrace. *Ave Maria!* We pray for that loving protection, whether before a figure of the Mother, or in primitive sexual rites, or in the scarcely veiled eroticism of Protestant hymnody.

As the child enters upon the next stage of his development, the love and protection of the great beings of the adult world are still of deep importance. But the life of law and taboo is now the much more immediate concern of the child's consciousness. He still desperately needs for his self-realization the life and protection, the flow of loving approval he formerly had, but he finds that these are now to be bought at a price: they no longer come to him as a free gift. The mother goddess has by now become a male-female duality, or monad in two persons, father and mother, and the child soon learns (in the normal family as it has functioned through the millennia of our civilization) that the ultimate authority is not the mother but the father. "I'll tell your father," is the final threat in the child's life. The law he must obey is to him really a codification of the whims and fancies of his father. The sanction consists in the father-mother displeasure, or even those tortures of whipping which have inspired the notion of hell. From this sanction the child can never feel safe except in the atmosphere of approval and love which only obedience seems to produce. The "superego" is rapidly forming at this time: God and my father are one, and *Ave Maria, ora pro me* — "Intercede for me with the Father" — expresses the inevitable attitude toward the mother. In many persons, religion is found at this level. To the original pure nostalgia for complete gratification has been added a sense that the price of gratification is obedience to laws, social and ritualistic, while the concept of the mediator has made its highly important appearance.

The fully "compulsory" stage postulated by Freud is a step beyond this, but not away from it. Law becomes more elaborate, mediation less significant: and from such conditions there can emerge a religion like talmudic Judaism, in which the mother element has become quite unrecognizably obscured in the dominant pattern of the relation between a boy and his father. Here the individual is given the rewards of this life and the next strictly on the basis of obedience. To be sure, the quality of mercy does not fail, and provision is made

Father by possessing the Mother. I do not think that this difference need bother us. The symbols of religion in the civilizations from which ours is descended seem to be largely the product of men rather than of women, though perhaps the appearance of the satyr with Dionysus, and the absence of such a figure from among Astarte's followers, are results of the greater influence of women in Bacchism than among the Semites. I suspect that before a Madonna and Child a woman identifies herself as much with the Mother as a man identifies himself with the Child. But I am certain that we can go a long way without having to stop at each step to discuss the feminine counterparts in experience. At least, I shall not attempt to do so.

for repentance and reinstatement of the transgressor. But these provisions were never so important in Judaism that they produced a distinct divine personality to symbolize and execute them. Traditional Judaism is a civilization, a complete way of life, but only secondarily a personal source of ecstasy. It is intensely social in feeling, as the family is a social unit: the child as one member knows that the father is equally concerned with his brothers and sisters. Little of social importance came out of the cult of the Great Mother, or of Isis, or of the Virgin. The social aspects of religion first became important as the father became central, and the tendency reached its logical end when it produced a sense of the Father-God's universal rightness, and of universal Right.

Such a religion gets its hold upon its followers through the conditioning power of behavior. The family celebrations of festivals come to play a tremendous part in the child's life: and just as Christians cling to Christmas, a Jew, however far he may stray from orthodox Jewish belief, rarely ceases to feel the appeal of the festivals if he has been brought up under such influences. This gripping hold of Jewish observances is magnificently presented in Feuchtwanger's *Jud Süss* (*Power*). Years of participation can of course in some people instill a devotion to the festivals which involves a much more ecstatic and personal religious pattern than is usually associated with them. But a religious milieu such as that of rabbinic Judaism enforces the form, binds the believer to a compulsory pattern of life with the Father.

Religious experiences, while they take on many forms, can thus be distinguished as they show primarily the narcissistic mother pattern or the compulsory pattern of legalism. To be sure, the great religions have for the most part contained both of these elements. Certainly Christianity, with its Old Testament heritage and the ethical teachings of Jesus, has not been, at any time, engrossed simply in the problem of personal salvation. Even Judaism, commentators are now agreed, drew as heavily for its spirit upon the fertility religions of the Canaanites as upon the distinctive "religion of Moses." Most of Jewish ritual and the festivals go back to fertility rites. Still, there can be no doubt that the Jewish contribution to Christianity through the Old Testament and the Synoptic Gospels predicated a relation between a Father and his children, while the Greek contribution of Paul, of the Fourth Gospel, and of the early Greek Christians was in the direction of a personal religion of salvation which in emotional pattern resembled much more the ancient fertility cults than the teachings of the rabbis.

Regarded in the light of such a contrast of types in religion, that is, the contrast between the mystical and the legalistic type, the Jewish archeological material became increasingly anomalous as I studied its associations elsewhere. The symbols borrowed from pagan art by the Jews were precisely those symbols which stood for the type of religious experience and longing most completely at variance with the tendencies of rabbinic Judaism at the time. That is,

the rabbis were developing Judaism increasingly to reinforce its legalism, its compulsory or Father pattern. The victory of Yahwism over the Canaanites was at last becoming complete. Fertility rites, the cycle of Adonis dead and risen, the birth of the sacred child at springtime and at the winter solstice, the holy trinity of Father, Mother, Son, in which the Son was identical with the Father, all these were being finally expelled from Judaism, even in its Hosean form. God was a loving Father, but intensely masculine, and the task of his children was to study and obey his Law.

Nothing in this led or could have led anyone to suspect that in the very centuries when the rabbis, in their scholastic groups in Jamnia and Babylon, were patiently working out the Talmud, with its almost exclusively legal interest, the mass of the Jews were breaking down the traditional restrictions and filling their synagogues and tombs with symbols partly Jewish and partly appropriated from those aspects of paganism which we shall see were especially hateful to the rabbis. In Christianity these same symbols were being used in turn to represent just those aspects of the new faith most repugnant to the rabbinic schools. Nothing whatever warrants either saying that the symbols had no meaning in Judaism, or insisting that if they had meaning, that meaning must somehow be found in rabbinic thinking. The symbols themselves point to meaning, and to a meaning which the rabbis deeply repudiated.

We have suggested that the lingua franca of symbolism, the medium of continuity of values in symbolism, is the key to understanding the symbols borrowed by Jews, and that this lingua franca can be read, and the values of the symbols recovered, only as we consider the figured symbolism in the light of the newer psychology. And we have suggested that with such psychological understanding we must follow each symbol relentlessly through, in all of its typical appearances in those countries and ages whose influence carried on, directly or indirectly, into the Greco-Roman world. The elements of the psychology of religion just suggested were the product of this search, not its guide.

This psychology of religion, I have said, centers upon the phenomenon of a great life urge, a drive to self-fulfillment which may express itself in a desire for mystic union with the Mother-Father, or for security through obedience to the Father. But the symbols, as I studied them, amazed me by seeming at first to reduce themselves in almost every case to a basic erotic value. As I took up each symbol I hoped that I should at last get something different. But when even the dove, the duck, and the quail were by specific ancient testimony given erotic explanations, I felt myself overcome by the evidence itself. To the investigator this experience is much more moving than it can ever be to the reader. Only by taking this book apart and looking up these symbols for oneself, could the experience of the author be duplicated. For as I analyzed symbol after symbol, I found myself driven with relentless regularity to identical explanations,

and to ascribing identical values to all the symbols—driven not by my predilections but by the evidence itself.

The basic value, I have said, appeared definitely an erotic one. This was the major element all the symbols had in common. How could this have happened, when religious eroticism had been so driven out of Judaism? It was partly in view of this that I looked afresh at the place of the erotic in religion in general. Was it eroticism in the sense in which we use the term—namely, something akin to *ars amatoria*, expressing or enhancing the pleasure of intercourse? It suddenly occurred to me that in order to evaluate a leather phallus as a phenomenon in Greek society it was necessary to think of it in the context of Greek society, instead of projecting our still half-Victorian conceptions back upon it, or of thinking how inappropriate it would be in a synagogue or church. Whether you and I think the phallus a proper symbol for deity has nothing whatever to do with the patent fact that many Greeks, Syrians, Phoenicians, and Egyptians—with hosts of others—thought it the most appropriate symbol of all. Whatever you and I think about sexual intercourse and its place in society, many ancient peoples regarded it for millennia as one of the best forms of temple worship. Whether or not you and I are accustomed to be amused by sexual humor, the peoples of the ancient world loved it and used it as a feature of their religious festivals. I rigorously refused to interpret pillars, upright stones, altars, etc., as phallic, after the manner of many historians of phallicism (though I am far from denying the possibility of their ultimate phallic symbolism); yet I was driven by the associations in which the symbols that I was investigating were used by Greeks, Egyptians, and many others, to recognize in most of them a basic phallic meaning.

What, then, was that phallic meaning? In our day of repressed sex, phallic symbolism in dreams and gestures is usually taken to come from repressed desire for a sexual experience. But to carry this over to sexual symbols appearing in an age that knew little such repression, and to suppose that a phallus was used by ancient worshipers similarly to symbolize literal sexual desire not otherwise to be released, is utterly unjustified—equally so on the part of those who make such interpretation directly, and on the part of those who implicitly register the same judgment when they refuse to consider this type of material at all. In the earliest periods of our cultural development, when the symbol was most frankly used, as it was in Greece and Egypt, there was apparently not much sexual repression in society, in our sense. Even the almost universal taboo against incest seems to have been little known in Egypt. Nor is there any indication that religion was using phallic symbols as they were used in Pompeiian brothels, for sexual titillation. Quite the reverse: everything indicates that the early devotee wanted by means of his phallic rites to be gratified with food, and with the perpetuation of his life. He used the symbols of gratification nearest and most naturally at hand in order to get what he wanted. That is, he

used phallic symbols to represent his desire for food and life, because he had sex but did not always have enough food. Similarly in our society, analysts tell me, food—which we have—is often in our dreams a symbol for the sexual experiences that we think society is keeping from us. We use what we have as symbols of gratification of desires for what we do not have. It is in fertility rites to assure crops and flocks that the phallic symbol or rite seems most character- istically to appear, because crops and flocks represented food. The personal application of such symbols and rites, even their use to secure personal im- mortality, seems secondary to and is probably historically later than their use to get crops and flocks. It was the most obvious kind of sympathetic magic to try to make a field fertile by setting up a phallus in it, or by simulating or ac- tually performing intercourse on it or for it. The utter frankness of the symbol in its early occurrences shows that it had an origin and function completely un- related to anything like modern "nastiness." Men wanted crops and flocks, and used the phallus as a magico-religious symbol for its power to produce them. Not that they eliminated the element of pleasure suggested in the symbol. Why should they? A bull is not less serviceable as a general symbol of food because one likes beef. That sexual humor might be sinful apparently never occurred to them.

I recognized that, as Fromm has recently said, one of the most important of the contributions of Freud and Jung has been their rediscovery of the uni- versal language of symbolism, a language current in every age and civilization, but in our own held down almost exclusively within the unconscious mind, and in dreams. Once I came to recognize the complete naturalness of phallic symbolism as used in early times, and its freedom from the moldiness of repressions, the symbol language became clearer to me as I followed the history of the symbols. For as developing civilization began to distinguish between the spiritual and the fleshly, the good and the bad, the pure and the impure, the symbols lost their directness. The hideous silenus-satyr no longer raped maenads on the vases, nor, in ithyphallic representation, plucked and trampled the sacred grapes; rather, satyrs became graceful young men giving no hint of lechery, and with only pointed ears and the merest suggestion of a tail to show their ancestry. As competitors to them there appeared innocuous babies, the cupids or Erotes, still love symbols by their very name, and still per- forming the religious functions in the vine and elsewhere which the lascivious satyrs had earlier carried out. Then the cupids supplanted the satyrs alto- gether, and the satyrs survived in iconography only as devils, symbols now of the forbidden. The devil of Christianity is still a Pan or satyr, primarily inviting us to sexuality. He is the devil because frank invitation to sexuality speaks of sin to us, and taboo.

Suddenly it occurred to me that I had, in my hands, the historical antetype of such material as is found in a typical psychoanalysis. Where analyses had

over and again revealed that modern religions, especially those of the more ardent types, had at their roots a sexual motivation, I was seeing an original body of sexual symbols in religion disappear into indirection as society demanded their repression. The satyr had become a cupid, I repeat. But in their new and almost unrecognizable form, these symbols kept their old central place in the new religions which more "civilized" cultures were developing. Or, to put it in another way, a social analysis of the symbols of modern religion seemed to push back in history to the same sort of early association as is still to be found in the individual.

How did this come about? The religion of mysticism I have described in terms chiefly of the parallel of the infant longing to find complete gratification of its life urge in the person, the life substance, of the goddess, or the Mother-Father. It is therefore very perplexing that the symbols of mystical experience are almost universally the symbols of sex. How is this possible, especially in view of the fact that I have distinguished sex as a phenomenon of maturity, and as being only one outlet of the life urge?

This seems quite the most difficult problem of all in my nascent psychology of religion, and one that is extremely dangerous to try to answer for any period but our own. Here anthropology might help, by reconstructing what puberty means for the lad or girl in a society without restrictions, or at least without our restrictions, since I doubt that any contemporary society is without very definite sexual taboos. Yet the fusion of the two motifs, sex and the mother, however it comes about, seems to me most natural. The boy's whole nature at puberty is stirred by new longings, an awakening of the old drive to complete himself in someone else, but now he has a new means of accomplishing it. That this should recall the gratification of his babyhood seems again inevitable, as well as that the experience with a woman should, if only temporarily, identify itself with his earliest experiences with the mother. In adolescent years a boy is usually most moved by a woman older than himself, and even when at a later stage his craving is for the young girl, the virgin whom he can protect, and to whom he can play the ruling father, the girl nevertheless must often play the mother to him if he is to be happy with her. The mother of his religious image, the Great Mother, of whom he still dreams, becomes the Virgin Mother, I am sure, because when he is an adult the mate he desires is a virgin, and because the Mother of religion is the immediate projection of the mother as sought afresh by the mature man in a young virgin. In the highly complex picture of maturity, the young man gets his normal self-realization as he takes his father's role with the new little mother. Union is now naturally expressed in the symbols of sexual union.[29] For to the mature person the

29. It is likely that the desire for the virgin goddess, who is the Virgin Mother, reflects also the repressions of incest taboo affecting the boy in the relation with his

sexual act itself usually seems most important because it gives a sense of realization of life.

Hence in this mature quest for the mother, or for life in the mother, a quest which has produced formal religions and mystical symbolism, the magico-religious symbols of the fertility cults were the ones most naturally at hand to be developed and perpetuated. Religion evolves not by invention of new symbols but by putting new meanings into old forms. There seem to have been historically three major steps in this development. At first the sex symbol was the instrument of literal fertility magic to bring crops, as when a figure of Priapus was placed in a garden. Later, the significance of man's sex experience as a door to greater personal life came increasingly to be felt, and sex symbols or acts were used as open means of achieving union with the deity, male or female. Finally, all conscious reference to the sexual act was eliminated, and the overtly sexual pictures and rites were abandoned, so that religion could achieve the "higher" gratification. Indeed, in "higher" religions, like those described in Plato's *Symposium* and the *Bacchae* of Euripides, the sexual act is deplored or despised. This change has created the amazing anomaly that the greatest single tension in most "higher" religions is precisely the tension between spirit and body—sex as means to union and life as over against religion, which seems to achieve its goal in the individual in proportion to his renunciation of the sexual act. Marriage of course gets a religious sanction, but sex is tolerated only within the frame of this sanction; as a value in itself, sex is repudiated. The Catholic church is only quite logical when it curses anyone who will not admit that the state of virginity is superior to that of matrimony. To Philo sex is always sin—as it has been to millions of Christians down to the present day—except as it serves the single purpose of begetting children.

Yet within "higher" religion, many of the less crudely sexual symbols, such as the dove and the erotic metaphors of mysticism, have lived on. Even in ancient Egypt, the more thoughtful minds developed the idea that the supreme God is hermaphroditic, reproducing himself by having within him organs both male and female—being Father and Mother, while the Child is only an alter ego of the Father. The three, Father, Mother, and Child, are one. This conception was very common in the late Roman empire: it emerged openly in the Orphic hymns, and seems to lie behind not only the hermaphroditic figures of late antiquity, but also the effeminate representations of Dionysus and Apollo which fill the museums. The same three, with the great emphasis upon the miraculous begetting of the Child, are still the supreme objects of worship in Christianity.

It is with the divine Child that modern man, still the baby, can identify

mother, who, to him, is simultaneously Virgin and Mother. But the man wants a virginal wife largely to signify that he has broken that incest taboo and fulfilled the desire of his life.

himself more easily than with the Father's majestic greatness, and in asserting the identity of the Son with the Father in the divine realm — the Son being man himself — he finally resolves the Oedipus situation, if I may use that useful but dubious term, by becoming himself one with the Father in cosmic completeness.

Symbolic representation of this experience, or projection, or idea, may depict only the Child with its Mother: in this the Father is mysteriously implied. Sometimes we represent the three, the "holy family." On the other hand, though in halachic Judaism the Father has the kindness and brooding wings of the Mother ascribed to him, the image of Wisdom as the distinct Mother breaks through so rarely as to suggest that the occurrence marks an invasion of foreign symbolism, the use of a conception which halachic Judaism never really naturalized for itself.[30] In such Judaism the devotee is still the son, and the Psalms are full of the language of childhood. But in rabbinic tradition the mystical element of identification has been repressed: the way to the Father, I have said, is through obedience—a pattern which, while it alleviates the sense of guilt, still accentuates the duality of Father and devotee. It is in religions centering not in obedience, but in the birth and death and resurrection of the god or his son, that mystical assimilation of the devotee with the Father, or Father-Mother, is the objective. For in identifying ourselves with the Baby, and identifying the Baby with the Father, we make ourselves one with the Father. Thus our cycle becomes complete. The reality and life as well as the protection of Baby, Mother, and Father are at last fully our own: the "Oedipus conflict" and the vagaries of the "id," if one likes these terms, have been so wholly resolved, and the life urge has come into so full a satisfaction, that we see no terror even in death for this new-found masterly existence. The death of the Child and his resurrection, motifs so apt to appear in the symbolism of the divine family, are elaborations of this experience that enable even the death urge to take us away from our guilt and inadequacy into a more serene spiritual life.

This is, apparently, what lay behind the movement which we generally call Orphism. Of course the new pattern appealed deeply to only a minority, as religion of deep emotional content appeals to only a minority in any generation. The majority are always easily content to delegate the responsibilities to others and merely to perform the rituals, such as wearing an amulet or attending

30. The figure of Wisdom is a perennial subject of debate. See, for most recent discussion, Helmar Ringgren, *Word and Wisdom: Studies in the Hypostatization of Divine Qualities and Functions in the Near East*, Lund, 1947; Ralph Marcus, "On Biblical Hypostases of Wisdom," *HUCA*, XXIII, i (1950/1), 157–171. In mystical Judaism the Mother per-force returns to her great importance. It is necessary here only to recall Philo's allegorizations of the wives of the Patriarchs each as Virtue or Sophia, and the part played in the *Zohar* by the "supernal Mother," the Shekinah, as well as the tension between male and female in the *sephiroth* as described throughout that work.

stated functions and festivals. Yet it must be repeated that it is always the devout, the fanatics, who disclose the real meaning of the symbols of all religions, meaning which is felt by others in proportion to the emotional depth of their religious experiences. The new, restrained symbols (rarely altogether new) of the refined Bacchism varied, as will appear; but most commonly in one way or another they represented the power of the life fluid still. And though the life fluid no longer overtly flowed from the divine phallus, it still caused the devotee to be born anew as the divine person, insofar as it gave immortality.

From this point of view the meaning of the symbolic lingua franca seems to become much clearer. The symbols which Jews, and secondarily Christians, borrowed from paganism, relentlessly trace back to a common body of symbolic roots. They turn out to have been used in other religions always (so far as their values can be determined at all) as emblems of a certain type of religious experience. Dionysiac symbolism had little appeal for Romans so long as they held to the old flavor of their own religion, though the symbols immediately appealed to the Etruscans. In Israel, Yahwistic leaders had for centuries fought the conceptions and practices of the fertility cults of their neighbors: much had crept into the great Temple from these cults, as well as into the lives of Jews in general, but Yahwism finally triumphed, and with it the drive to abolish everything that was still recognizably akin to Baal and Astarte. That is, the formal state religions, the religions which expressed themselves in fixed laws and observances, such as the official religions of Athens, Rome, and Jerusalem, had a basis quite other than that always implied in the symbols we are studying, and correspondingly had little use for them.[31]

The evidence appears to show that these symbols were of use only in religions that engendered deep emotion, ecstasy — religions directly and consciously centered in the renewing of life and the granting of immortality, in the giving to the devotee of a portion of the divine spirit or life substance. Though they were symbols not to be seen in the forum at Rome, they were everywhere in mystical Pompeii and ecstatic Phrygia and North Africa. Largely absent from official Athens, they were common in the popular Athens of the vases. Never found in the life and teachings of the Pharisees, they became central in Christianity as tokens of its hope of divine life here and hereafter.

These are the symbols that were used in the synagogues and on the graves of Jews throughout the Roman empire. It must be recalled again that we are studying the symbols so intensively just because they have come from the Jews

31. Casey in the essays cited above (n. 25), seems to imply that all religions have been concerned with the Oedipus motivation and castration fear. I cannot follow him in this, for it seems to me that there is a profound difference between religions which have had use for the symbols under discussion and those which have not. I might mention here L. R. Wolberg, "Phallic Elements in Primitive, Ancient, and Modern Thinking," *Psychiatric Quarterly*, XVIII (1944), 278–297.

of Rome, North Africa, Palestine, and Dura—Jews from whom we have no literary survivals, and whose Judaism it is yet our desire if possible to begin to understand.

These symbols appear to indicate a type of Judaism in which, as in Philonic Judaism, the basic elements of "mystery" were superimposed upon Jewish legalism. The Judaism of the rabbis has always offered essentially a path through this present life, the Father's code of instructions as to how we may please him while we are alive. To this, the symbols seem to say, was now added from the mystery religions, or from Gnosticism, the burning desire to leave this life altogether, to renounce the flesh and go up into the richness of divine existence, to appropriate God's life to oneself.

The experience apparently implied at times an initial destruction of the self, life achieved through death, and this was expressed in pagan hunting scenes, in the god Dionysus as the hunted hunter, in the rabbit, deer, or bull torn by other animals, in the mask of the all-devouring lion; it was the basis for all mystic interpretation (of whatever antiquity) of the sacrificial systems of pagans and Jews. In Christianity the idea persisted in the Lamb who was slain and in whose death we also die, that we may rise in his resurrection. Though it is not suggested that in Judaism the animal torn had such specific reference as the lamb had to Jesus in Christianity, the religious patterns seem basically identical in emotional values.

Or the experience could be represented in the opposite terms—in terms of victory in the mystic ἀγών or conflict, in the spiritualization of the wars and religious games of Greece, even of her cock fights. For the afflatus of victory in these corresponds amazingly with the afflatus of religious achievement. When religion has brought a man into such richness of life and love that even death is defeated, his tombstone may well show in triumphant symbols that victory and its crown belong to the entombed. This crown of victory was for Philo the final Vision. For all, it meant immortality. Hence the various symbols of victory in the Jewish synagogues and on the graves would seem to indicate that the Jews who used them also looked for this victory, this crown.

Or the experience could also be symbolized quite differently, in figures of birth, of craving for the divine fluid, and of getting it. Thus, with the original phallic meaning entirely obscured to Christians and Jews, and largely repressed even by pagans, all of them alike, pagans, Jews, and Christians, still sought the cup with its medicine of immortality, the life juice of God himself, which in early times was released by the lustful satyr, but now in all three religions was made available by the endearing little Erotes, whose symbolism of love was not obscured even when they had lost their wings. And for the devout of all three religions the vine was depicted holding within its folds a multitude of symbols of life, symbols of God's mercies to man, and of man's safety in God's love of him, and in his love of God.

Or the experience could be depicted in terms of the zodiac, the planets, the cosmos, with which man unites himself as he becomes the macrocosm, or as he is borne by the solar eagle to the top of the universe — indeed outside it altogether, to that Sun and Ideal World of which the material sun and universe are only imperfect copies.

Or the old identification of one's being with the life of the fields could survive in the Seasons, depicted in synagogue and tomb with their fruits, to represent the great cycle of death and resurrection in nature, the cycle in which men first, perhaps, saw definite promise of their own immortality.

These ideas have as little place in normative, rabbinic Judaism as do the pictures and symbols and gods that Jews borrowed to suggest them. That such ideas were borrowed by Jews was no surprise to me after years of studying Philo, for in him I had long known intimately a man who thought these conceptions to hold the deepest meaning of the Torah itself. Neither will the presence of such ideas in Judaism astound students of Cabbala. What is perplexing is the problem of how Jews fitted such conceptions into, or harmonized them with, the teachings of the Bible.

No religion could have borrowed the group of mystical ideas which I suggest are implied in the symbols without harmonizing them in some way with its own myths or biblical stories, or conforming its own myths with the mystical ideas. Otherwise the borrowing would have meant actually abandoning the old religion and taking on a new one. Jewish explanations must have been given to the old pagan symbols and their values if the devotees remained Jews, as they patently did. We have a vivid example of the process when Plutarch interprets the myths of Isis to make them into expressions of the mystical Platonism of his day. He demonstrates also how Dionysiac myths had previously been retold to adapt them to the same mystical philosophy. Philo shows the same process of adaptation for earlier hellenistic Judaism. In the complete absence of writings from Jews who used the symbols, the great importance of the Dura synagogue is that it presents, in the setting of the symbols, a pageant of Old Testament scenes completely allegorized: the paintings are in no case simple illustrations of Old Testament episodes or passages. Through them we can catch actual glimpses of the integration of Old Testament story with the theme of mystic hope in this later and otherwise unknown stage of hellenistic Judaism.

It seems the most natural thing in the world that in the centuries after the fall of Jerusalem, when Jews were without a national center or, because of their loss of Aramaic, a single unifying language, and when there was no Talmud to control their interpretations of the Old Testament, or of the Law, many of them should thus have accepted the mystic ideas of Hellenism, and fused these with their Jewish traditions. That the Jews survived as a group at all is the great miracle; survival remained possible, even as miracle, only as they kept their

sense of distinction constantly vivid by observing the injunctions of the Law, especially by marrying for the most part within the group, and by holding their Torah as utterly unique. But there was nothing in their Judaism to keep them from being in other respects hellenized or gnosticized, and attracted by the philosophy of the late Roman world. How far Jews went at that time in adopting the gentile idea that religion, and par excellence their own religion, is a mystic source of life for this and the next world, we have no way of knowing. Probably, as in Philo's day, there was no unanimity: some Jews were almost complete Gnostics and laid the foundations of later Cabbalism, while others were of what Philo called the "literalist" type. The most difficult point of all to believe is the point about which there can be no dispute whatever, namely, that these Jews were so hellenized that they could borrow for their amulets, charms, graves, and synagogues the mystic symbols of paganism, even the forms of some of the pagan gods. For no error of induction or fancy in my own thinking can obscure the fact that Jews did borrow this art not sporadically, but systematically and for their most sacred and official associations. This is a fact I have not invented, and now no historian of the field may ignore or slight it.

PART II

THE ANSWER

The Shofar

THE SHOFAR, or trumpet of ram's horn, has often been mentioned among the symbols appearing in the Jewish remains we are studying.[1] In Jewish ritual the straight horn of the wild goat was at one time used interchangeably with the curved horn of the ram, but by Greco-Roman times the goat's horn was generally superseded by the ram's horn, which is the shofar of the monuments. In the Temple the shofar and a pair of trumpets were used together, and it is this pair of trumpets, apparently, that is represented on coins of the Second Revolt,[2] though it appears nowhere else. Outside the Temple probably only the shofar of ram's horn was used, as it is today. Eisenstein[3]

1. The best accounts of the shofar which I have seen are found in J. D. Eisenstein and F. L. Cohen in *JE*, XI, 301–306; Cyrus Adler, "The Shofar, Its Use and Origin," *Proceedings of the U. S. National Museum*, XVI (1893), 287–301, with plates XLVI–XLIX; Berthold Kohlbach, "Das Widderhorn (Shôfar)," *Zeitschrift des Vereins für Volkskunde*, XXVI (1916), 113–128. The material in Kohlbach is carefully reproduced and considerably amplified in the first part of the famous study of Theodor Reik, "The Shofar (the Ram's Horn)," in his *Ritual: Psycho-analytic Studies*, London, 1931 (New York, 1946), 221–361. Reik's study, like so much Freudian investigation of the history of religion, presents a great deal of acute observation, in spite of what seems to me its general neurotic compulsion to account for everything in man, past and present, in terms of the few categories of human motivation the Freudian system allows. He makes the shofar represent the craving of the son to kill the father and take his place, the guilt which follows this desire, and the castration fear attending the guilt, all within the frame of the universal to-

temism which seemed to Freud the basis of all religion. For this I cannot see that Reik presents any evidence at all, yet he ecstatically exclaims (p. 291) over his results: "Ethnology has proposed the hypothesis of 'elementary thought' (Bastian), but it was reserved for psycho-analysis to find the fundamental affective basis of this concept and to endow it with living content. Only psycho-analysis could show that everywhere in primitive society similar institutions result from the play of mental forces which are eternally the same. Only psycho-analysis has been able to hear amidst the manifold and confusing richness of sounds the hidden dynamic melody which solemnly and eternally rises from the deep and dominates chaos." That I do not share what seems to me the auditory hallucination of Reik's last sentence by no means keeps me from recognizing that much valuable interpretation is in his study.

2. See Reifenberg, *Coins*, plate XIII, nos. 174, 182. For this use of trumpets, see Eisenstein in *JE*, XI, 301.

3. Op. cit., 304.

lists a number of occasions on which the shofar was blown: "every day during
the month of Elul except on the day preceding Rosh ha-Shanah . . . a later
innovation," or only on the New Moon of Elul; to arouse the people to re-
pentance on fast days; to proclaim an excommunication; to announce a new
rabbinic decision; at funerals; to announce a New Moon; and to call to rest for
the Sabbath.

It is thus perhaps a mistake to discuss the shofar simply as a cult instru-
ment associated with the New Year, for it seems generally to have been used to
mark a distinctive occasion.[4] But in the popular mind all other uses of it have
always been quite secondary to that connected with the New Year and the Day
of Atonement. The blowing of the shofar to proclaim a New Moon or Sabbath,
or to herald a new halachic decision, must have had little importance except
immediately in rabbinical circles, and its use at funerals seems to have been
quite sporadic and rare,[5] though it is most appropriate to be recalled in view of
the representations of the shofar found on tombstones. Before discussing the
meaning of the shofar, it will be well to review the occurrences of the motif in
the art.

A. THE SHOFAR ON THE MONUMENTS

IN PALESTINE, in contrast to what is commonly found in the diaspora, I
have seen only one tombstone bearing a shofar; on this stone it stands with a
lulab, flanking a menorah. Tombstones in the usual sense are rare in Palestine,
however, and funerary symbolism is more apt to appear on the walls or on the
small objects in the tombs. Thus on one lamp the shofar is likewise with a men-
orah and a lulab; on four very similar lamps (figs. 5–8), a menorah and incense
shovel are with the shofar, while on another a group of the chief cult symbols,
the shovel, the lulab, the ethrog, and the shofar, is on one side of a menorah,
and an amphora with a vine growing from it is on the other. On one glass a
shofar is with a menorah and lulab; on two glasses a menorah is flanked by ob-
jects that I have guessed to be a shofar and an ethrog. A fine little piece of
carved bone has a menorah flanked by a shovel on one side and by a shofar and
an ethrog on the other.

In synagogues the same kind of grouping occurs. What is perhaps the ear-
liest appearance of the shofar is on a capital at Capernaum, where, balanced
by a shovel, it flanks a menorah. It is to be found thereafter in nineteen syn-
agogues so similarly presented that individual description is unnecessary. In
one case, the shofar is alone beside a menorah. In eight instances, a shofar and

4. Kohlbach, op. cit., 115–118, lists a
large number of occasions for noncultic use
of the shofar.

5. Kohlbach, op. cit., 128, recalls that on

the death of a rabbi in Sassin in 1814, the
body was brought into the synagogue, a
procession of the Torah was held around it,
and the shofar was blown.

lulab flank a menorah, and in two others a shovel is added to these. A shofar and shovel balance an ethrog and what is probably a lulab in one synagogue mosaic, and these presumably are also the objects represented in a second. The same group appears in one synagogue relief, and perhaps it is a shofar balancing a lulab and ethrog which is depicted in another. In two others some unidentified object balances a shofar. The effect of all of these together is to lead us to suppose that what is presented here is the vocabulary of cult objects which appears in full at Beth Alpha (fig. 9), though at Beth Alpha the Torah shrine is central, and the menorah and all the other objects are presented in pairs, one symbol on each side of the shrine. We shall conclude that, as in the elaborate symbolism of a Christian rose window, the symbols all together had a combined impact which was important in itself. But just as in the case of the rose window we should be in danger if we assessed the totality without analysis of the parts, so in the Jewish symbolism we must continue to study each symbol by itself.

In similar groupings — groupings which as such seem to me to have no significance — the shofar appears on ten tombstones in the Catacomb Monteverde in Rome, and on two tombstones and a sarcophagus in the Catacomb Vigna Randanini. One tombstone there[6] bears simply the words "Salpingius, infant," with a shofar on each side and two leaves (perhaps intended for ethrogs) below. There is here certainly a connection between the name and the shofar, but whether the name became a Jewish name[7] because of the importance of the shofar, or the object was put beside the epitaph because of the name, it is impossible to say with confidence, though I suspect strongly that Jews gave their children this name because of the feeling of sanctity and the Jewish association which the shofar in itself conveyed. The shofar appears three times with other cult objects in the murals of the Catacomb Torlonia, and on ten tombstones from various parts of Italy.[8] It is similarly on an inscribed gravestone from Alexandria, on one from Nicomedia in Asia Minor, and on two from Gammarth. It is displayed with the menorah, and an object that is perhaps an ethrog, in the mosaic of the synagogue of Hammam Lif. On lamps it is not so common in the diaspora as in Palestine, but it appears on one lamp from Ephesus, on one from Syria, and on one from Malta. It is with a menorah, lulab, and ethrog on a unique glass bottle from Ephesus, and occurs with other Jewish objects on nine gold glasses. Finally, it is found on a number of rings and amulets.

Several facts seem to me to come out of these appearances of the shofar. Its use on amulets would indicate that it was thought to have active symbolic power. Its constant recurrence on graves, or on objects to be buried with a

6. Frey, *CIJ*, no. 162.

7. For other instances of the use of the name among Jews, see Frey's note ad loc.

8. See also Frey, *CIJ*, 484, and nos. 523, 600, 652.

corpse, suggests that it had some sort of eschatological significance, so that it could supposedly help the deceased in the next world; its association with the ethrog, lulab, or shovel in such a great majority of the designs in which it appears suggests that the shofar as used in the festivals had this significance also. It is not a shofar as such, but the shofar of the High Holydays which we are encountering, as well as, perhaps, the shofar of funerals.

In shape the shofar resembles the Dionysiac drinking horn, but among the Jewish representations collected, I have seen only one form that suggests a drinking horn,[9] and since the horn in Dionysiac representations is always a drinking horn[10] (though sometimes hard to distinguish from a cornucopia), I see no reason to think that Jews felt any parallelism between the Dionysiac drinking horn and their shofar.[11] The horn is universally one of the commonest primitive musical instruments: thus it is surprising that its introduction into Jewish ritual seems to have occurred relatively late,[12] and I have been able to find no Canaanitic or Syrian counterpart to the shofar.

A Dionysiac parallel comes at once out of the liturgy, however, for in the ceremonies in honor of Dionysus apparently one of the earliest elements was the blowing of "trumpets" to mark or herald the vernal resurrection of the god. Dionysus was supposed to die and go into the depths of the lower world in the winter; then, in a rite of spring which we may suppose was not practised exclusively at the one place we know of, Lake Alkyonia near Lerna, a lamb was thrown into the lake and a horn sounded over it. The lamb was intended to placate the warder of the gates of Hades, and the blast of the trumpet was to awaken Dionysus and call him forth.[13] Plutarch tells of this custom,[14] and it is

9. Cf. the three little objects in the third opening from the bottom of the vine, at the left, in fig. 10.

10. The drinking horn was pictured by Greeks more commonly in the earlier period than later: see Roscher, *Lex. Myth.*, I, 1095, line 25; 1099, line 41. It would amount to a large study in itself to collect the representations of drinking horns in Greek and Roman art. A few examples that I happened to note, probably because in these cases the horn especially recalled the shofar in form, may be listed as follows: the horns in an Attic relief of Dionysus, *JDAI*, XI (1896), 104; those pictured on later Greek vases, on a table before banqueters, ibid., II (1887), 125; the forms reproduced in *Mon. Ant.*, XXII, ii (1914), plate xciii; drinking horns painted as hanging on a wall in Pompeii, *NSA*, 1934, plate xii.

11. On the superficial level of symbolism to which I am keeping myself, this statement stands. But the object was the same in both religions, and it may be that when the devotee of Dionysus drank his immortalizing wine from the horn of a ram (or bull), the association of the wine with the sacrificial animal, which in Christianity still survives in the image of the "blood of the Lamb," was definitely felt. That which, as we shall see, constituted the saving power of the ram's horn in Judaism comes very close, then, to the value of the Dionysiac horn. If the horn in Judaism had phallic association, as we may suppose it had in Dionysiac usage, that association was probably completely unconscious.

12. Adler, op. cit., 293–297; F. Brown, S. R. Driver, and C. A. Briggs, *Hebrew and English Lexicon*, s.v. *shafar*; Cohen in *JE*, XI, 301.

13. Farnell, *Cults*, V, 183–185; see p. 305, n. 89, for the classical references.

14. *On Isis*, 35 (364 F).

to this same rite that he compares the Jews' use of the shofar: "They [the Jews] use little trumpets as the Argives do at the Dionysiac festivals to call upon God."[15] That is, the Jewish horns much resembled the Dionysiac trumpets,[16] and it may be supposed that basically the two practices were indeed similar, and that the Jewish ritual usage in the same way went back to a blast to awaken God to assure the growth of the crops. Or, since the blowing of the shofar was prescribed in observance of the New Moons in general (Num. x, 10; Ps. LXXXI, 3 f.), it may originally have summoned or awakened the moon-god. At least it is interesting that while it was to be blown over the sacrifices on all the solemn feast days,[17] the shofar was from early times uniquely associated with Rosh Hashanah, the New Moon par excellence, the New Moon of the New Year. There may be some importance in the fact that the new moon is shaped like a horn, and that the use of the horn as a symbol of the new moon in cult (e.g., the horns of altars, and of Minoan-Mycenaean art) is probably much older than the discovery that an animal horn would make a sound if blown. Such speculation cannot be pursued farther, however, for it has already taken us quite beyond all evidence.[18]

If such meanings were originally associated with the horn, it is clear that by the beginning of the Christian era, if not long before, they had been forgotten in Jewish liturgy, even in the liturgy of the Temple, because Jews were now actively setting forth other explanations of the shofar.

B. THE SHOFAR IN THE TRACTATE ROSH HASHANAH

F OR THE EXPLANATIONS current at the time when the art of our study arose, one turns naturally first to the relevant tractate in the Babylonian Talmud, the *Rosh Hashanah;* but we are disappointed to find that this document, except for a few passages, is concerned largely with problems of how the days of the festivals were to be determined each year, and how Jews in the diaspora could be informed about the proper dates, especially that of the New Year. With this goes a considerable discussion about the making and blowing of the shofar.[19] But in one passage it is said: "From the beginning of the year sentence

15. *Quaestiones convivales* IV, vi, 2 (671 E).

16. The juxtaposition of the shofar and the name Salpingius in a Jewish epitaph have already been noted above.

17. Num. x, 10.

18. My colleague Harald Ingholt recalls in a note to me that "the Hebrew *halal,* 'to shout with joy,' comes from the noun of the same root, or with the same radicals, meaning 'new moon,' Arabic *hilâl.* . . . As far as I can see the Hebrew verb originally denoted

the joyous shouting at the sight of the new moon." Mention should be made of a recent study of the origin of Yom Kippur, though it contains no discussion of the shofar: Julian Morgenstern, "Two Prophecies of the Fourth Century B.C. and the Evolution of Yom Kippur," *HUCA,* XXIV (1952/3), 1–74.

19. Maurice Simon has an excellent brief outline of the tractate in the introduction to his translation of it (publ. 1938).

is passed as to what shall be up to the end of it."[20] This conception is elaborated
in another passage,[21] where the Mishnah explains that there are four seasons
of judgment each year: at Passover the "produce," probably the crop of winter
grain, is judged; at Pentecost, fruit; at Tabernacles, rain; and at the New Year
"all creatures pass before God like children of Maron," i.e., one by one, or, as
it is restated in the Gemara, "man is judged on New Year, and his doom is
sealed on the Day of Atonement." That is, the special significance of the New
Year and Yom Kippur is personal—a significance still vividly felt in Jewish rit-
ual. And so two statements are reported in this connection, bearing most im-
portantly on the meaning of the New Year rites. To the question, "Why do we
blow on a ram's horn?" one rabbi answers that it is to remind God of the "bind-
ing" of Isaac, and make him ascribe the merit of that deed to the worshipers as
though they all had done it. Another explains that because God has com-
manded it, we blow the horn with the elaborations traditional for the day in
order to confuse Satan, for if at the beginning of the New Year Satan be not
confused, it is clear that he will put catastrophe into what is being ordained for
that year.[22]

The ordaining for the year is shortly explained: three books are opened
on the New Year, one for the thoroughly wicked, one for the thoroughly right-
eous, and one for the intermediate category of men. The fate of the first two
is determined at once, but that of the intermediate group (into which most
worshipers would put themselves) is suspended till the Day of Atonement,
when it is finally decided whether to write them in the book of the bad or the
book of the good. This statement suggests that each writing is final, but since
the whole process is repeated every year, it is not surprising to learn that there
will be still the same three groups on the Day of Judgment, when the inter-
mediate ones will go to Gehenna, "squeal" for a time, and then be taken up,
apparently to join the righteous in everlasting life.[23] This sounds extremely
grim, and is meant to sound so, but all can be mitigated by repentance, since
"great is the power of repentance that it rescinds a man's final sentence."[24]
It can also be mitigated by certain rituals, for "whenever Israel sin, let them
carry out this service before me, and I will forgive them."[25] This last refers to
the reading of the passage of the Torah which sets forth the thirteen attri-

20. *BT, Rosh Hashanah,* 8a (ET, 30).

21. Ibid., 16a,b (ET, 57–64).

22. Ibid., ET, 60 f. Simon quotes Rashi
as saying that the devotion of the Jews to the
Law is what confuses Satan, but Eisenstein (in
JE, XI, 304) has a more elaborate explana-
tion, namely, that at the first great series of
blasts Satan thinks the Jews are just comply-
ing with the Law; at the second, that the Mes-
siah is coming; at the third, that the resurrec-

tion is at hand, when his power will end.
Where Eisenstein got this I do not know. The
difficulty encountered by God himself in
adapting the decrees of New Year to later
circumstances is discussed in *BT, Rosh Ha-
shanah,* 17b (ET, 69).

23. Ibid., 16b–17a (ET, 64).

24. Ibid., 17b (ET, 68).

25. Ibid.

butes of God, but "this service" must often have been thought to refer to the ritual of the New Year and the Day of Atonement as a whole, since reconciliation with God was precisely the purpose of that ritual. For it is especially "in the ten days between New Year and the Day of Atonement that the individual can find God."[26]

For all the frequent mention of the shofar in the talmudic *Rosh Hashanah*, then, little space is given to its significance. Important interpretations are, to be sure, suggested: the shofar is blown to recall the sacrifice of Isaac, to confuse Satan, and because God commanded it. But these interpretations are almost lost sight of in the far greater concern of the rabbis with the laws for correct observance of Rosh Hashanah.

C. THE AKEDAH

To one of these three interpretations we must pay considerable attention — that which connects the blowing of the shofar with the sacrifice or "binding" of Isaac, the Akedah.[27] This tradition is discussed at considerable length in the midrashic writings of the rabbinic period, but references to it in the Talmud show that it was completely accepted by the early legalists.

1. In the Talmud

The longest talmudic section of this tradition is in the Palestinian Talmud.[28] The passage begins with a statement that the salvation of Isaac is equivalent to that of Israel itself. This is explained by showing how Abraham did not protest against the command to sacrifice Isaac, though it seemed to annul God's previous promise that Isaac was to have a mighty posterity. Thus Abraham is said to have prayed that if the children of Israel should get into trouble, and have no advocate, God would himself be their advocate as he recalled Isaac bound on the faggots for the sacrifice. Such deliverance will come when God himself blows the shofar.[29] Indeed, R. Hanina adds, as Abraham saw the ram getting free from one bush only to be caught in another, so the children of Israel will be subjected to the rule of Babylonia, Media, Greece, and Rome, but will in the end be delivered through this blast of God himself on the

26. Ibid., 18a (ET, 72).

27. The term Akedah literally means "binding," but refers to all the incidents of the story of the call of Abraham to sacrifice his son, and of the events on Mount Moriah.

28. *JT, Taanith*, II, 4, 65d (FT, VI, 157); partly transl. into German in Strack-Bill., III, 242. See also *BT, Sanhedrin*, 89b (ET, II, 595

f.), to be discussed shortly. The relation of the shofar to the Akedah is discussed by Shalom Spiegel, "The Legend of Isaac's Slaying and Resurrection," in *Alexander Marx Jubilee Volume*, II, 1950 (in Hebrew), 471–547, esp. 504 f., 514, 515.

29. Zech. IX, 14.

shofar. With this conception the sounding of the shofar becomes clearly the original of the Christian "last trump," at least as heralding the Messianic Age.[30] But in the Jewish tradition the trumpet is no other, still, than the shofar of the Akedah.

These are the important allusions to the shofar and the Akedah in the Talmud. On the second day of the celebration of the New Year the story of the sacrifice of Isaac is still read from Genesis, and then by orthodox tradition there is recited a prayer ascribed to Rab, the great rabbi of the third century:

> Remember in our favor, O Lord our God, the oath which thou hast sworn to our father Abraham on Mount Moriah; consider the binding of his son Isaac upon the altar when he suppressed his love [of his son] in order to do thy will with a whole heart! Thus may thy love suppress thy wrath against us, and through thy great goodness may the heat of thine anger be turned away from thy people, thy city, and thy heritage! . . . Remember today in mercy in favor of his seed the binding of Isaac.[31]

The prayer remains in the liturgy, though it is often omitted, since the halachic rabbis do not like its implications. It is a part of their general antipathy to the principle of the "merit of the Fathers," the doctrine that later Israelites would be forgiven their sins because God had been so pleased with the virtues of the Old Testament heroes. The rabbinic antipathy to the idea of the atoning force of this vicarious merit is well expressed in the saying put into God's mouth as at the time of Elisha: "Hitherto did you have the merit of the Fathers; but from now on will each man depend upon his own works."[32] Landsberg represented such a point of view when he wrote:

> This turn given to the attempted sacrifice of Isaac is certainly in conflict with the prophetic spirit [i.e., the rabbinic spirit]. The occurrence is never again mentioned in the Bible; and even in the Talmud voices are raised in condemnation of its conception as a claim to atonement.

But if we are to understand the shofar in the graphic presentations we are discussing, we must quickly come to see that Landsberg has definitely (certainly not in ignorance) misrepresented a powerful tradition in rabbinic writings. To him the very idea of atonement is distasteful; yet Yom Kippur is the Day of Atonement, and the desire for atonement was and still is the very heart of the religious feeling of the day. Landsberg is strictly correct: references to the elements of atonement, specifically to the Akedah, are rare in the Talmud, though the rabbis quoted express the doctrine unmistakably. But the Midrash

30. Matt. xxiv, 31. In I Cor. xv, 52 the trumpet is introduced as signal for the resurrection; we shall see that this idea is also involved in the meaning of the Akedah.

31. As quoted by Max Landsberg in *JE*, I, 303*a*.

32. A. Jellinek, *Bet ha-Midrash*, IV (1857), 16; quoted by Gustaf H. Dalman, *Jesaja 53*, 1914, 42.

elaborately attests that there was much more to rabbinic Judaism than the halachic emphasis of the Talmud, and it is to the former that we return for the story of Isaac, and the meaning of the Akedah.[33]

2. In the Midrash

FIRST AS to the shofar itself. In the Midrash the shofar is connected with the New Year and the Day of Atonement on the ground that they are days of determining, repentance, and judgment. For here it is first explained that the New Year is the anniversary of the creation of the world, and so on that day "sentence is pronounced upon countries, which of them is destined to the sword and which to peace, which to famine and which to plenty."[34] The passage goes on to show how on that day God created, judged, and then pardoned Adam, and this happens to Adam's descendants each year on the same day. The story is then told of how Jacob watched the angels, that is the princes, of Babylon, Media, and Greece in turn ascend the ladder toward heaven, but all had to turn back. Edom (Rome) then tried it and was, at the time of writing, still going up; but God had promised to send him down, however high he might climb. God then invited Jacob to climb, but Jacob was afraid. He learned after it was too late that God had planned to keep him aloft forever, had he tried it, and the penalty of his timidity was that his descendants had to serve those four princes. But the end is to be a happy one: after all the others have been humiliated,[35] Israel, we gather, will some day make the ascent never to come down again.

All of this, it seems, is a sample of the deterministic judgment that marks the New Year. What has it to do with the shofar? The passage goes on to explain that God sits on the throne of judgment on this day, presumably to set the fate of nations and individuals; but when he hears that trumpeting he rises from the throne of judgment and sits upon the throne of mercy.[36] The blowing of the shofar is not enough in itself, it is stated: it must be accompanied by a

33. The most important study of the Akedah is found in Spiegel, op. cit. Still of value are: Israel Lévi, "Le Sacrifice d'Isaac et la mort de Jésus," *REJ*, LXIV (1912), 161–184; Dalman, op. cit., 37–41; Ginzberg, *Legends*, I, 271–285, with notes in Vol. V; H. J. Schoeps, "The Sacrifice of Isaac in Paul's Theology," *JBL*, LXV (1946), 385–392; Riesenfeld, *Jésus transfiguré*, 86–96; David Lerch, *Isaaks Opferung christlich gedeutet*, 1950 (Beiträge zur historischen Theologie, ed. by G. Eberling, XII). Moore, *Judaism*, I, 535–552, discusses the problem of atonement and expiatory suffering—like Landsberg, to belittle it, though he admits (p. 541) that in the later liturgy as well as in the Palestinian Targum, and in the younger midrashim, the Akedah has a much larger place.

34. *MR, Leviticus*, XXIX, 1 (ET, 369). This, J. J. Slotki remarks ad loc. in his translation, is the old "shofar benediction," now called *Zikronoth*, or "Remembrance" in the Additional Service for Rosh Hashanah.

35. Ibid., §2 (ET, 370 f.).

36. Ibid., §§3 f., 6, 9 f. (ET, 372 f., 376 f.).

genuine change of conduct, and we recall from the *Rosh Hashanah*[37] that the one who blows as well as the one who hears must "put his mind to it," or the religious duty is not performed. In this statement, then, the blowing of the shofar has become a summons to man to repent and to God to be merciful. Then follow the ten days of penitence, closing with the Day of Atonement, the exercises of which culminate in a single long blast on the shofar, which means to the worshipers that the rites are accomplished, and that thereby atonement is consummated.

Such associations might well have been recalled by putting the shofar on a tombstone: but the very fact that the horn so often was thus employed in the Roman period, and never, or practically never, appears in such use today, strikingly suggests that at that time all this symbolism had a fresh vividness which even the solemn rites now practised hardly convey. For this deeper meaning we turn to the midrashic tradition on the Akedah.

The *Midrash Rabbah* on Genesis contains the most elaborate discussion of the sacrifice of Isaac.[38] The test which God put upon Abraham, the account begins, was designed to show forth Abraham's righteousness "like a ship's ensign . . . in order that the equity of God's justice may be verified in the world,"[39] for God knew very well that Abraham could stand such a test.[40] In Jub. xvii, 16–xviii, 12, God is challenged by the devil—here called "Prince Mastema" —to put Abraham to this trial, and the tradition reappears in the Talmud.[41] It is probably with reference to this episode that, as we have seen, the devil is discomfited by the shofar. The talmudic passage has Satan accusing Abraham of failing to make sacrificial offerings on the occasion of the banquet celebrating Isaac's birth. In the midrash we are discussing, the incident arises from the fact that Abraham has not been offering rams and bullocks; according to one tradition Abraham reproaches himself, according to another the heavenly court criticizes him for the omission.[42] We stop to recall that this was the situation of Jews living away from the Temple before its destruction, and of all Jews afterwards. If the atoning sacrifices of the Temple were really necessary for removal of guilt, there was little hope for anyone who could not come to the Temple. As we continue it will appear that this interpretation of the Akedah, which makes it a substitute for Temple sacrifice, antedates the destruction of the Temple, and this circumstance is the first among many which will suggest to us that the idea of the Akedah as a permanent atonement probably had its origin in the diaspora, and, never popular with the halachic rabbis, was accepted by rabbinic Judaism afterwards when, like Abraham, no Jews could offer sacrifice in the Temple.

37. *BT, Rosh Hashanah*, 28b–29a (ET, 130–133).

38. *MR, Genesis*, LV (ET, 482–503).

39. Ibid., LV, 1 (ET, 482) and 6 (ET, 485).

40. Ibid., §2 (ET, 482 f.).

41. *BT, Sanhedrin*, 89b (ET, II, 595 f.). Cf. Strack-Bill., I, 141; Lerch, op. cit., 9–12.

42. *MR, Genesis*, LV, 4 (ET, 484).

God, the same midrash explains, knew better than Abraham or the heavenly court: he knew that if it were asked of him, Abraham would sacrifice even his own son,[43] from which we understand that the sacrifice was made to exhibit Abraham's (and Isaac's) righteousness to others, not to convince God of Abraham's complete fidelity. At once Jews in the diaspora might take comfort, for it was not any sacrifice in itself, whether of bulls or of a son, that God needed. The attitude of Isaac was similarly assured in advance. For an argument between Isaac and Ishmael, of which two accounts are given, ends in the one version in God's recognition that Isaac is willing to sacrifice himself, in the other with Isaac's declaration of his willingness. And when Isaac had thus spoken, "said the Holy One, blessed be he, 'This is the moment!' "[44] We are reminded of the Greek sacrifice, which could use only willing victims, and of Christ, who "gave himself." The conception of vicarious sacrifice, the innocent willingly giving himself for the guilty, is already beginning to appear in one of its most important aspects. Of course Isaac's willingness to be sacrificed was also a model and inspiration for Jewish martyrs,[45] as Christ's sacrificing of himself has inspired Christian martyrs.[46]

The next section, more cryptic, seems to say that by thus offering himself Isaac "came before the Lord."[47] Abraham, however, was the one especially "lifted like an ensign,"[48] for when God called him, and he answered "Here am I," it meant that God was exalting him to priesthood and kingship.[49] Priesthood is obviously appropriate for one who is about to make a sacrifice, but it is conspicuous that, as is said of Christ in the Letter to the Hebrews, it was to the "priesthood of Melchizedek" that God exalted Abraham—a priesthood, the passage reveals, whose unique characteristic, in the famous language of Ps. cx, 4, is that of being a "priesthood for ever." Abraham's sacrifice and priestly mediation, in having the value of "for ever," is made available for the faithful of every generation. Here is a sacrifice again like Christ's in that it need not be repeated, for it is timeless and eternal.

The passage adds, as we have seen, that Abraham was also made a king by this sacrifice, but in what sense he became a king is not explained, except that his kingship is compared to that of Moses. The writer in the *Midrash Rabbah* understands, and takes it for granted that his reader does: he need not explain

43. Ibid.

44. Ibid.

45. This interpretation is very old: see IV Mac. VII, 14; cf. XIII, 12, XVI, 20, XVIII, 11. It persists in modern times: see Morris Silverman, *High Holiday Prayer Book*, 1951, 108; Spiegel, op. cit., 473, 517.

46. We need recall only the line in the beloved song of the American Civil War, "As He died to make men holy, let us die to make men free."

47. The sacrifice of Isaac was acceptable, whereas the sacrifice of a son by Mesha, King of Moab, was not: *MR Genesis*, LV, 5 (ET, 485).

48. Ginzberg, *Legends*, V, 249, n. 229, has an interesting comment on the dispute in the tradition as to whether Isaac or Abraham was more glorified in the Akedah.

49. *MR, Genesis*, LV, 6 (ET, 486).

what kingship really implies, and I can only suppose that he assumes the reader to comprehend the generally current meaning of the term, which Philo also reads so richly into his explanations of the function and power of the Patriarchs. In this idea of kingship, the king's essential function, besides that of exercising the priestly office, was to be a mediator between man and God, a guide to lead man into the true right, which the king was uniquely empowered to see in the nature of God; indeed, true right was a part of the king's own nature, insofar as he was a true king. To express this theory of royal power, the king was called *lex animata*, the Law of Nature or of God become incarnate and vocal for men. Even more, the true king was the savior of his people: "in the case of ordinary men, if they sin, their most holy purification is to make themselves like the rulers, whether it be law or king who orders affairs where they are."[50] A king "will put in order those who look upon him. . . . For to look upon the good king ought to affect the souls of those who see him no less than a flute or harmony"[51] — the flute or harmony which was a means of purification in mystic rites. This sort of thinking Philo especially applied to Moses, in expositions that consistently made him the savior of his people as well as the priest par excellence. Indeed, each of the great Patriarchs was for him the *lex animata*.[52] In the *Midrash Rabbah* the parallel with Moses is at once felt, but typically, in a passage praising Abraham, Moses is represented as having been less fully king and priest. We recall that Christ is also the King in Christian explanations of his office.

Thus Abraham was commanded to take his beloved son (the element of love is beautifully stressed) and go with him to the land of Moriah.[53] The place, Moriah, is then given a number of allegorical meanings. Moriah was traditionally "the spot where in later times the Chamber of Hewn Stones in the Temple stood and the Great Sanhedrin sat and sent forth religious teaching to all Israel."[54] In the Midrash it is accordingly the place whence instruction went forth to the world, or the source of religious reverence. It is compared to the holy Ark of the Covenant, from which go forth light and religious reverence, and to the inner sanctuary of the Temple, whence issue speech (*dibbur*) and retribution. So Moriah is also the place of final judgment from which God will hurl the nations into Gehenna, the place corresponding to the heavenly Temple, the "place that God will show thee," the seat of world domination, "the place where incense would be offered."[55] All of these associations seem to me important. Moriah is clearly identical with the site of the Temple, Mount

50. Ecphantus, as quoted in my study, "The Political Philosophy of Hellenistic Kingship," *Yale Classical Studies*, I (1928), 77.

51. Diotogenes, as quoted ibid., 72.

52. See my *By Light, Light*, 181–198.

53. *MR, Genesis*, LV, 7 (ET, 487).

54. Freedman (in a note ad loc., ibid., ET, 487), states this not as a tradition but as a fact.

55. *MR, Genesis*, LV, 7 (ET, 488).

Zion—an identification that is soon considerably expanded.[56] Even more importantly, the identification continues the process of generalizing the action of Abraham and Isaac, making it into an act of universal validity, and incidentally bringing into the episode more and more of the meaning of the New Year and its judgment.

Abraham saddled his ass in the early morning, the allegory continues,[57] but this too is generalized. Abraham's act was one of love, and as such it counteracts the deeds of hate of others. Abraham was like Joseph in this: Abraham's deed of love counteracted Baalam's saddling of his ass in hate, just as Joseph's preparing of his chariot in love counteracted Pharaoh's hateful preparation of a chariot. Hence from this point of view too the act of Abraham was one of vicarious rectification of evil.

Abraham went forth, and on the "third day" he saw the place to which he was being led.[58] The Midrash then interprets the "third day" in a way that again recalls Christian speculation; the parallel immediately quoted is: "After two days he will revive us, on the third day he will raise us up, that we may live in his presence,"[59] and soon the parallel is with Jonah's three days in the fish's belly. The third day is a day of resurrection and revelation—all of which seems written with the judgment of the New Year in mind.

The place to which Abraham and Isaac were led was a mountain which they saw covered by a cloud (the Shekinah),[60] but the servants could not see it, and so they had to stop with the asses.[61] The mountain (which is still Jerusalem in the allegory) will some day be alienated from God, the rabbis interject, but will be restored by the Messiah, who will come riding upon an ass—a statement which seems cryptically to make the Messiah a second Isaac. The Midrash is so much later than the Gospels that it is extremely dangerous even to suggest that possibly this conception is older than the Gospels, and prompted the story of the Triumphal Entry. But one must admit the possibility.[62]

56. Ibid., LVI, 10 (ET, 500 f.). Riesenfeld, op. cit., 90 f., points out that this identification is as old as II Chron. III, 1, i.e., goes back to c. 400 B.C., and is recalled in Jub. XVIII, 13 and Josephus, *Antt.*, 1, 226 (XIII, 2). Some idea that the sacrifice of Isaac was the prototype of the sacrifice in the Temple seems indicated by the passage in Chronicles, but the fact that there the site of the Temple is called Moriah by no means justifies putting back into so early a period the whole tradition of the Akedah as it is developing before us. See also Schoeps, op. cit., 388, n. 12.

57. *MR, Genesis,* LV, 8 (ET, 488).

58. Ibid., LVI, 1 (ET, 491).

59. Hos. VI, 2.

60. G. Friedlander, in *Pirke Eliezer*, 225, n. 9, says that this detail is Philonic. It is so in a general way, but not specifically, for there is no exact parallel to be adduced.

61. *MR, Genesis,* LVI, 2; cf. *MR, Ecclesiastes*, XI, 7, 1 (ET, 231 f.).

62. In *Pirke Eliezer*, XXXI, it is said that the same ass was ridden by Moses when he came to Egypt, and that it will again be ridden by the Messiah (with quotation of the classic prophecy in Zech. IX, 9).

Abraham promised the servants that he and Isaac would return when they had worshiped, and this suggests to the writer of the passage a list of rewards for worship, a list which we need not reproduce. So Abraham and Isaac set off together.

First Abraham "laid the wood on Isaac his son"; on this verse it is most surprisingly commented that he was "like one who carries his cross on his shoulder."[63] This detail so strikingly brings to mind the crucifixion of Jesus that it seems impossible that there was no relationship. To conclude finally that the detail in the Midrash must have come from the Christian story, however, seems rash, even though the Christian story is so much earlier than the composition of the Midrash. The detail of Jesus carrying his cross may have come from some tradition about Isaac, but this seems also unlikely. Yet the resemblance remains, and one begins to see why the halachic rabbis did not like the theme of the Akedah. As expanded, it made a striking Jewish parallel to the idea of the atonement of Christ's death.[64] The parallel actually appears in Christian literature earlier than we can find it in Jewish writings. Important in Origen, who probably considerably antedates the Midrash,[65] it was mentioned by Melito nearly a century before Origen. In one fragment Melito says of Christ:

> He bore the wood upon his shoulders as he was led up for sacrifice like
> Isaac by his father. However, Christ suffered, but Isaac did not suffer, for he
> was a type of the Christ who was to suffer in the future.[66]

The parallel is much elaborated in this and other fragments,[67] and is mentioned in another newly found sermon of Melito.[68] It seems to me quite possible that the Christian comparison of the death of Christ with the sacrifice of Isaac had behind it some sort of Jewish tradition in which the wood that Isaac carried was likened to the cross carried by a criminal, rather than that later Jews took the idea from Christians.[69]

63. *MR, Genesis*, LVI, 3 (ET, 493): in ET, the word is softened to "stake," but A. Wünsche, GT (1885), reads *Kreuz*, and Levy, *Wörterbuch*, s.v. *tzaluv*, makes the meaning unequivocal, and adds that the same thing is said in *Pesiqta Rabbathi*, §31, 57b. See also Strack-Bill., I, 587, and III, 324; Schoeps, op. cit., 387; Spiegel, op. cit., 509.

64. Lerch, op. cit., 19 f., is likewise perplexed by the passage, but does not think that the idea was taken by the rabbis from Christian tradition, nor that it is the Jewish source of Christian interpretation of Isaac.

65. Lerch, op. cit., 52, in a digest of Origen, *Homilies*, VIII, vi, 6–8.

66. J. von Otto, *Corpus apologetarum Christianorum saeculi secundi*, 1872, IX, 416 f., fr. IX.

67. See also ibid., frr. X–XII, and the discussion in Lerch, op. cit., 27–38.

68. Campbell Bonner, *The Homily on the Passion by Melito*, 1940, §§59, 69 (Studies and Documents, ed. by Kirsopp and Silva Lake, XII).

69. Lerch, op. cit., 277, n. 2, opposes Schoep's thesis that a Jewish tradition of Isaac lies behind Christian allegories. Proof is impossible, but that the Jewish tradition is the older still seems to me the more likely of the two possibilities.

As the two walked this last part of their journey, Abraham went through his supreme trial. Samael, the wicked one, offered many arguments to induce Abraham to stop, and tried also to disturb Isaac.[70] But, as told in one of the most moving passages in the Midrash, both resisted; they went on, father and son together, to slaughter and be slaughtered.[71]

When they reached the mount, Abraham prepared the altar, while Isaac hid himself lest Samael strike him with a stone, maim him, and so make him unfit for sacrifice.[72] Then Abraham bound him, bound him indeed at his own request, lest he tremble and so invalidate the sacrifice.[73] Abraham put his son on the altar, and reached for the knife, but as he did so his tears fell into the eyes of his son,[74] and the angels likewise wept,[75] so that their tears fell upon the knife and dissolved it.[76] Thereupon Abraham proposed to strangle Isaac, and it was at this point that God declared that he knew that Abraham loved him; indeed God is represented as saying to Abraham: "I ascribe merit to thee as though I had bidden thee sacrifice thyself and thou hadst not refused."[77] God ordered Abraham to spare Isaac, and Abraham discovered the ram caught by its horn in the bush, took the ram, and prayed: "Sovereign of the Universe! Look upon the blood of this ram as though it were the blood of my son Isaac, its *emurim* (sacrificial parts) as though they were my son's *emurim*."[78] According to another rabbi the prayer was: "Sovereign of the Universe! Regard it as though I had sacrificed my son Isaac first and then this ram instead of him." This prayer, the passage assures us, was answered. It was the ram that was killed, but the substitution was so complete that the effect was as though Isaac himself had been the victim.[79] The meaning of the whole incident then appears, when Abraham says:

> I suppressed my feelings of compassion in order to do thy will. Even so may it be thy will, O Lord our God, that when Isaac's children are in trouble, thou wilt remember that binding (*akedah*) in their favor and be filled with compassion for them.[80]

70. Later legends greatly elaborated this: see B. Beer, *Leben Abrahams*, 1859, 61–63.

71. *MR, Genesis*, LVI, 4 (ET, 493).

72. Ibid., §5 (ET, 494).

73. Ibid., §8 (ET, 497).

74. Ibid. This was taken as the cause of Isaac's later blindness, but the blindness was also explained as the result of Isaac's having looked at the Shekinah as he lay bound on the altar: *MR, Deuteronomy*, XI, 3 (ET, 174).

75. *MR, Genesis*, LVI, 5 (ET, 495).

76. Ibid., §7 (ET, 497).

77. Ibid.

78. Ibid., §9 (ET, 499).

79. This identification is elaborated in *MR, Numbers*, XVII, 2 (ET, 700 f.), where Abraham is made to say: "Sovereign of the worlds! Regard the act as though the blood of Isaac were being sprinkled before thee! . . . O consider the act as though I had flayed the skin of Isaac before thee." And God answers: "By your life! I regard it as though your son had been offered first! This ram represents him!"

80. *MR, Genesis*, LVI, 10 (ET, 500).

The conception of substitution is indeed elaborate here. The ram is substituted for Isaac, and Abraham's compassion will become God's compassion. The symbol of all this for later generations, and in liturgy, is to be the shofar, the passage assures us. For Israel, in spite of all that has been done for them, will still sin: "Yet they will be ultimately redeemed by the ram's horn, as it says, 'And the Lord God will blow the horn.' "[81] This is specifically the shofar of the New Year, as R. Hanina, son of R. Isaac, said:

> Throughout the year Israel are in sin's clutches and led astray by their troubles, but on New Year they take the shofar and blow on it, and eventually they will be redeemed by the ram's horn, as it says, "And the Lord God will blow the horn."[82]

This passage is approximately repeated in Leviticus *Rabbah*,[83] immediately after the following statement:

> When the children of Isaac give way to transgressions and evil deeds, do thou recollect for them the binding of their father Isaac and rise from the Throne of Judgment and betake thee to the Throne of Mercy, and being filled with compassion for them have mercy upon them and change for them the Attribute of Justice into the Attribute of Mercy![84]

The shofar is also given a messianic or eschatological significance. Israel will continue to sin, and will become subject to the four great empires: yet each time they will be saved by the ram's horn.[85] The brief talmudic statement paraphrased above has taken on a wide significance:

> Why do we blow the ram's horn? The Holy One, blessed be he, said: Sound before me a ram's horn so that I may remember on your behalf the binding of Isaac the son of Abraham, and account it to you as if you had bound yourselves before me.[86]

The remarkable explanation of the value of the Akedah given in Genesis *Rabbah*, and the allusions to it in Leviticus *Rabbah* and in the passages of the Talmud we have quoted, are by no means unique in the rabbinic writings. Actually the use of the Akedah, the appeal to the merit of Isaac, is only a special development of a larger conception — that the individual is saved not only by his own virtue but also by applying to himself, or by God's applying to him, the merit of the Patriarchs. Rabbi Levi, in the name of R. Hama, son of R. Hanina, tells a parable:

> A king's son was to be tried before his father. His father said to him: "If you wish to be acquitted by me in judgment this day, appoint such-and-such a

81. Ibid., §9 (ET, 498); Zech. ix, 14.
82. *MR, Genesis*, lvi, §9 (ET, 499).
83. *MR, Leviticus*, xxix, 10 (ET, 377).

84. Ibid., §9 (ET, 376).
85. Ibid., §10 (ET, 377).
86. *BT, Rosh Hashanah*, 16a (ET, 60 f.).

man as advocate and you will be acquitted by me in the judgment." So the Holy One, blessed be he, said to Israel: "My children! If you wish to be acquitted by me in judgment on this day, you should recall the merit of the Patriarchs and you will be acquitted by me in judgment."[87]

The passage goes on to name the Patriarchs as Abraham, Isaac (identified with the blast of horns), and Jacob, and the judgment is said to be that of the seventh month, that is, of Rosh Hashanah. Hama, son of Hanina, was a Palestinian rabbi of the third century. It may be that in him we are nearer than we usually are in rabbinic tradition to the Judaism of the decorated synagogues, for he came of wealthy ancestors who built many synagogues. "On one occasion," writes S. Mendelsohn, "while with his colleague Hoshaiah II he was visiting the synagogues at Lydda, he proudly exclaimed, 'What vast treasures have my ancestors sunk in these walls!' "[88] Hoshaiah, who admired the synagogues less and had apparently a more halachic mind, answered that it was not so much treasure as lives which had been sunk into the walls, lives which could have been devoted to the study of the Law if the money had been given for the support of scholars. Apparently Hama's ancestors valued the highly expensive (probably also elaborately carved) walls of the synagogues more than they did legalistic study. His father, Hanina, had the same interests.[89]

The parable just quoted reproduces with amazing identity the idea, "If any man sin he hath an Advocate with God the Father." So Isaac "goes and sits at the entrance of Gehinnom to deliver his descendants from the punishment of Gehinnom."[90] Not only does he save from punishment, but individual resurrection is promised through his merit: "Through the merits of Isaac, who offered himself on the altar, the Holy One, praised be his name, will eventually raise the dead."[91] Indeed, the Jewish tradition of imputed merit presents the same peculiar combination as that found in Christianity, where the Savior is one who saves by self-sacrifice, by personal advocacy, and also through a more abstract treasury of merit stored up by his deeds of supererogation and those of the saints, which can be imputed to others to compensate for their sins.[92] The idea of a treasury of merit is presented most succinctly and vividly in a parable told by R. Aha. He is commenting upon the incident in which Moses

87. *MR, Leviticus*, xxix, 7 (ET, 374).

88. *JE*, VI, 187; W. Bacher, *Die Agada der palästinensischen Amoräer*, 1892, I, 447. Neither of these scholars gives a reference for the story.

89. For the tradition of Hanina, see Bacher, op. cit., I, 1–34; for that of Hama, ibid., 447–449.

90. *MR, Song of Songs*, viii, ix, 3 (ET, 317).

91. *Pesiqta de Rab Kahana*, xxxii, 200a, as quoted by Schoeps, 390. See GT of A. Wünsche, 299.

92. In *MR, Lamentations*, Proem (ET, 46), Abraham, Isaac, Jacob, and Moses present themselves as advocates before God, each pleading his special act of merit: Abraham's merit is that he offered his son, Isaac's that he willingly assented to being sacrificed.

reminded God of Abraham, Isaac, and Jacob, to persuade him to soften his wrath against the Israelites for having worshiped the golden calf:

> A king's friend deposited with him ten precious pearls. After a time, this friend died, leaving one only daughter behind, whom the king subsequently married and made the chief lady of the land, also giving her a necklace of ten pearls which she placed round her neck. In course of time, she lost that necklace and the king sought to divorce her, saying: "I will drive her out of my house, I will banish her from my presence." Her best friend then appeared before the king and tried to appease him, but the king would not hearken to him, repeating: "I will banish her from me." The friend then said: "Why, your majesty?" "Because I gave her ten pearls and she lost them," he replied. "Well, in spite of this," he urged, "by thy life thou must become reconciled to her and forgive her." But the king still would not hearken to him. When the friend saw the king's intention and that he refused to be appeased, but vehemently declared, "I will drive her out," he then said to him: "Thou dost seek to drive her out because of the ten pearls she lost? Dost thou not know that I am aware that her father had deposited ten pearls with thee? Well, let these ten pearls [she lost] be in exchange for those [her father had deposited with thee]." So, when Israel perpetrated that act, God was angry with them and said: "Now therefore let me alone, that my wrath may wax hot against them, and that I may consume them" (Exod. xxxii, 10); but Moses pleaded: "Lord of the Universe! Why art thou angry with Israel?" "Because they have broken the Decalogue," [God] replied. "Well, they possess a source from which they can make repayment," urged he. "What is that source?" [God] asked. Moses replied: "Remember that thou didst prove Abraham with ten trials, and so let those ten [trials serve as a compensation] for these ten [broken commandments]." This is why he said: "Remember Abraham, Isaac, and Israel."[93]

Thus R. Hama represents God as saying to Abraham:

> From thee I will raise up protectors and righteous men. . . . If thy children fall into transgression and evil deeds, I will see what great man there is among them who can say to the Attribute of Justice, "Enough!" And I will take him as a pledge for them.[94]

The treasury of merit, we are told, was enriched by the succession of righteous ones, including all the heroes of the Old Testament — "New and old have I laid up for thee, O beloved"[95] — right down to Hillel, R. Johanan b. Zakkai, and R. Meir.

93. *MR, Exodus,* xliv, 4 (ET, 509 f.). There were a great many rabbis named Aha. Any of the three called Aha I, Aha II, and Aha III in *JE,* I, 276, could have been the source of this parable, since to all of them somewhat kindred sayings are ascribed.

94. *MR, Song of Songs,* i, 14, 3 (ET, 84);

cf. the remark of Bacher, op. cit., I, 470, n. 2.

95. *MR, Leviticus,* ii, 11 (ET, 31); Song of Songs vii, 14. Indeed, in *BT, Sotah,* 14a (ET, 73 f.), the substitutionary implication of Is. liii, 12, is ascribed to Moses, in a way so strongly suggestive of Christianity that the passage has been thought to be an answer to

Was Isaac sacrificed? Clearly the story in Genesis, and the discussions of it in the *Midrash Rabbah*, say that in his person he was not; the passages hitherto adduced show that the ram stood for Isaac by substitution only. But there is a tradition — probably quite old, since it appears in the *Sifra*[96] — that alludes to Isaac's ashes. The Jerusalem Talmud and the Babylonian Talmud both make the same allusion in commenting on the mishnaic command to sprinkle ashes upon the Torah shrine and upon the worshipers when they celebrate the special rites for rain. The Babylonian Talmud says only that these ashes are to recall the "ashes of Isaac,"[97] a statement ascribed to R. Hanina, father of that R. Hama whose ancestors sank so much money into the walls of the synagogues at Lydda; both father and son seem to have been especially interested in the Akedah. The Jerusalem Talmud adds the detail that Isaac's ashes "are as a pile on top of the altar."[98] Again we must supplement cryptic remarks in the Talmud with statements in the midrashim. In one midrashic passage "our Rabbis" are quoted as saying that God did not need to be reminded of Isaac, "because he saw Isaac's ashes, as it were, heaped up upon the altar."[99] Three passages in the *Midrash Rabbah* on the Song of Songs say that Isaac was "brought as an offering like a handful of frankincense on the altar,"[100] was actually "offered on the altar like a handful of frankincense,"[101] and "was bound on the altar like a cluster of henna because he atones for the iniquities of Israel."[102] Here Isaac seems definitely to offer his merit in the form of incense.

Even the blood of Isaac is brought in. Most accounts insist that Isaac came out of the ordeal completely unscathed, but to the great R. Joshua b. Hanania, who flourished in the second century, is attributed the saying that Isaac shed on the altar a quarter of a log of blood.[103] So important was this conception that

Christianity. Cf. Moore, *Judaism*, III, 166, n. 254. In *MR*, *Genesis*, xLVII, 6 and LXXXII, 6 (ET, I, 403; II, 757), Simeon b. Lakish is quoted as saying: "The Patriarchs are [God's] chariot, for it says, 'And God went up from Abraham.' " Scholem, *Jewish Mysticism*, 77 f., takes this to mean that the Patriarchs are the basis of God's throne or *merkabah*, or that man's soul is the throne of glory. S. Fisch, *Ezekiel*, 1950, p. xii (Soncino Books of the Bible) prefers to interpret it as meaning that "the patriarchs were the Divine Chariot on earth, in that they brought the Glory of God down to the mundane sphere." But in *MR*, *Genesis*, LXVIII, 12 (ET, II, 625), the same rabbi is quoted as saying, "[God] showed [Jacob] a throne of three legs," to which R. Levi is quoted as adding, "[God said to him]: 'Thou [Jacob] art the third leg,' " a passage to which Solomon alludes, but which

Fisch did not consider. It seems to confirm Scholem's interpretation of these passages. Merkabah mysticism seems to have gone far in glorifying the Patriarchs, for Abraham and Isaac must have been the other two legs.

96. *Bechukkotai*, vIII (GT, 660).

97. *BT*, *Taanith*, 16a (ET, 74).

98. *JT*, *Taanith*, II, 1, as translated for me by Nemoy (in FT, 152, the passage seems to have been misunderstood).

99. *MR*, *Leviticus*, xxxvI, 5 (ET, 462). Schoeps, op. cit., 389 f., has a considerable collection of midrashic passages containing this idea.

100. *MR*, *Song of Songs*, IV, 6, 2 (ET, 202).

101. Ibid., III, 6, 2 (ET, 152).

102. Ibid., I, 14, 1 (ET, 81).

103. *Mekilta of R. Simeon b. Yohai*, on Exod. xvI, 2; Schoeps, op. cit., 389.

in the approximately contemporary *Mekilta* it is said: "When I [God] see the blood [of the Passover on the houses of Jews in Egypt] I see the blood of the sacrifice of Isaac."[104] Later midrashim[105] make it appear that Isaac's soul actually departed from his body just as Abraham was about to strike with the knife, and did not return until the heavenly voice told Abraham to substitute the ram; thus when Abraham unbound him from the altar, Isaac said: "Blessed art thou, O Lord, who quickenest the dead!"[106] Later legends also recount that the ram was the bellwether of Abraham's flock; as a pet it had been named Isaac, and after it was sacrificed and burned to ashes it came to life again.[107] We feel that the identification of Isaac and the ram has become almost dreamlike substitution. What the "dream" is saying is that in sacrificing the ram Abraham sacrificed Isaac — that Isaac truly died on the altar, and came to life again, as did the ram. In this is the hope of atonement for Israel: it is the eternally valid sacrifice made by the "priest for ever,"[108] and it is this merit par excellence which the shofar invokes on the New Year and the Day of Atonement.

How old the conception is that Isaac died in the sacrifice, and then returned to life, cannot be said. It seems to lie behind Heb. xi, 17 – 19, where it is said that Abraham was ready to sacrifice Isaac, in spite of his hope of having descendants through his son, because he believed that God could "raise up even from the dead; from whence he did in a figure receive him back." We cannot know whether at the time when the Letter to the Hebrews was written the idea had developed only so far as to be a figurative presentation, or whether the author of Hebrews has blunted the story in order to reserve the value of resurrection for the Christian Savior.[109]

We are unable to trace this conception of substitutionary sacrifice and atonement to its source. The Akedah is not the only element in the observance of the New Year and Yom Kippur in which the conception emerges, in view of the apparently very old rite of the scapegoat which, laden with the sins of Israel, was thrown from a cliff on the Day of Atonement. Similarly, the idea of substitutionary atonement was probably never completely absent from the sacrifices offered on the altar in the Temple. Reik may be correct in thinking that the shofar blowing was originally a bringing of God, who was the ram, into the power of man; that the shofar was the divine phallus, and that it was also en-

104. *Mekilta of R. Ishmael, Pischa,* vii (ed. Lauterbach, I, 57; see editor's note ad loc.).

105. Ginzberg, *Legends,* I, 281 f.; V, 251, n. 242 f.

106. The sentence is from a Jewish prayer of blessing, the Amidah.

107. Ginzberg, *Legends,* V, 252, nn. 245 f. Ginzberg, esp. in his notes, greatly enriches the Akedah interpretation from later mid-

rashim, but I have pointed out that the basic ideas appear in the older sources. See also Spiegel, op. cit., 473.

108. Abraham is the "priest for ever after the order of Melchizedek" in *BT, Nedarim,* 32b (ET, 99); *MR, Genesis,* lv, 6, 7 (ET, 486, 488).

109. Lerch, op. cit., 39 – 46.

dowed with power to utter the voice of the Ram-God. God spoke from Sinai, Reik properly recalls, and Israel was commanded in Exodus to approach the mount "when the ram soundeth long."[110] This sound was apparently identical with "the voice of the Lord our God" which, it is said in Deuteronomy, the people could not long endure,[111] and with the voice in which "the Lord will roar from Zion" according to Amos.[112] So at the moment of greatest tension toward the end of the traditional liturgy of the Day of Atonement, the experience of atonement would appear to culminate in the feeling that when the shofar is blown it becomes the direct voice of God, which seems to say to the penitents, *Vos absolvo.*

3. In the Cabbala

FOR UNDERSTANDING the meaning of the Akedah and the shofar as symbolic equivalents, and of both as carrying the idea of a substitutionary atonement in which the merit of Abraham and Isaac turns God from justice to mercy, it is important to see that while the story of the Akedah fell into steady neglect in halachic tradition, it continued to be highly important in the mystic Judaism of cabbalistic tradition. In a late midrashic teaching Moses asks God, "Will not the time come when Israel shall have neither Tabernacles nor Temple? What will happen with them then?" To which God answers, "I will then take one of their righteous men and retain him as a pledge on their behalf, in order that I may pardon all their sins."[113] This is part of the medieval development of the general doctrine of vicarious merit.[114]

In the *Zohar*[115] the story of the Akedah is told much as in the *Midrash Rabbah*, though it is not connected with the Day of Atonement. But the sacrifice of Isaac is the sacrifice of incense: Mount Moriah means "the mountain of myrrh,"[116] and

> Isaac purified himself and in intention offered himself up to God, was at that
> moment etherealised, and, as it were, he ascended to the throne of God like the

110. Exod. xix, 13. Reik's translation here seems to me correct.

111. Deut. v, 25; cf. iv, 12.

112. Amos i, 2.

113. *MR, Exodus*, xxxv, 4 (ET, 432). The teaching is attributed to a rabbi named Hoshaiah, but it is quite uncertain whether this is the R. Hoshaiah of the fourth century (*JE*, VI, 475; Bacher, op. cit., III, 565). This midrash is dated by Strack (*Intro.*, 215) in the eleventh or twelfth century.

114. A rich collection of passages on this doctrine from all periods of Judaism is presented in Dalman, *Jesaja 53*, 19–35, where (p. 23) the quotation will be found. One of the strangest details is the statement, *Zohar, Emor*, 101a (ET, V, 128), that while a sinner is himself lost if his sins outweigh his good deeds, these good deeds are not lost, but are accounted to the credit of some righteous man who needs additional merit to complete his garment of good works.

115. *Zohar, Vayera*, 119a–120b (ET, I, 371–376).

116. Ibid., 120a (ET, I, 373).

odour of the incense of spices which the priests offered before him twice a day; and so the sacrifice was complete.[117]

That is, the sacrifice of Isaac himself was indeed complete. A little before this it is explained that the perfect priesthood of Melchizedek effected the union of the letter hē, the earth, with the letter waw, the heavens, "and so [the letter] hē ascended and was joined in a perfect bond."[118] This, the passage assures us, is what happens on the Day of Atonement.

On the other hand, in discussing the blowing of the shofar on that day, the *Zohar*, while it keeps all the values of the Akedah, nowhere directly alludes to it. Isaac is, however, the hero in that discussion. First the Patriarchs are given a position as high as in Philo's allegory:

> Great kindness did God show Israel in choosing the patriarchs and making them a supernal holy chariot for his glory and bringing them forth from the supernal precious holy River, the lamp of all lamps, that he might be crowned with them.[119]

In the exposition which follows it appears that the great judge of the Day of Atonement is Isaac himself, and the business of the Day of Atonement is to soften the wrath of Isaac, and to turn him from justice to mercy. This is done by blowing the shofar. There seems to be allusion to a supernal shofar, which is the "illumination of all"; in the passage just quoted it is the "lamp of all lamps." This lamp ceases to shine (in mercy) when Isaac prepares himself for judgment, "takes hold of his sons." The supernal shofar then shines out, makes men repent; they blow the shofar below, which "awakens another supernal *Shofar*, and so mercy is awakened and judgment is removed." The various sounds of the shofar that men blow correspond to the voices in the supernal shofar. A first series of three blasts is directed, one blast each, to the three Patriarchs. The first blast sets Abraham on his throne; the second, "of broken notes," breaks down the wrath of Isaac; the third summons Jacob, who takes a position on the other side of Isaac, and he and Abraham restrain Isaac from violence. Two other series of blasts (we need not repeat all the details) have a similar effect, which is summarized as follows:

> This is the purpose which these blasts should serve, being accompanied by repentance before God. Thus when Israel produce the blasts of the *shofar* with

117. Ibid., 120b (ET, I, 375). On Isaac's offering himself as incense, see below, n. 127.

118. *Zohar, Lech Lecha,* 87a (ET, I, 290). The hē which ascends to join with the waw is obviously the lower hē. See note, ibid., ET, 383.

119. *Zohar, Emor,* 99a (ET, V, 124). My exposition from here on is based upon §§99a–101a (ET, V, 127). For the blowing of the shofar on the New Year, when Isaac becomes the head of the Patriarchs, see *Zohar, Vayikra,* 18a,b (ET, IV, 357 f.). A "perpetual Fire, the Fire of Isaac," is mentioned in *Zohar, Zav,* 30b (ET, IV, 381).

proper devotion, the supernal *Shofar* returns and crowns Jacob so that all is properly arranged. . . . Joy is universally diffused.

In all of this there is a lacuna in the development, but it is clear that Isaac has come to take on another of the prerogatives ascribed to Christ in Christian theology: by virtue of his being the victim sacrificed for man, Isaac has become the great heavenly judge. And just as the cross is the primary symbol of the mercy of the heavenly Judge of the Christians, the shofar has become the symbol of the hope of mercy before Isaac. That it is the symbol of mercy to be obtained before Isaac as the final judge in the next world is an interpretation I have not seen in any early documents of Jewish mysticism, and the idea, I strongly suspect, is an appropriation of a Christian value—the value that the individual sacrificed for man by the Father has become the final judge of man, a judge incredibly severe, but one whose severity can be mitigated by appeal to symbols which recall his sacrifice of himself.

A later Cabbalist, Isaac Luria, prepared a "Meditation on Blowing the Shofar on New Year's Day" which reads as follows:

> May it be thy will, O God of heaven and earth, God of Abraham, Isaac, and Jacob, great and awe-inspiring God, that thou mayest send all the pure angels, the faithful messengers, who are eager to favor Israel: *Patzpatzya* who is charged to bring to light the merits of Israel when they blow the shofar, *Toshbash* whose duty it is to confuse Satan, and the great angels *Hadarniel* and *Tusniel* whose task it is to bring the shofar-blasts before thy throne of glory. Let thy mercy over thy people prevail, and look down upon the ashes of our father Isaac which are accumulated upon the altar.[120]

The sacrifice of Isaac was, for Luria, still really being performed, and his ashes were upon the altar for God to regard when the shofar of the New Year was blown. The tradition of the vicarious value of the Akedah persisted long indeed in Judaism and has never entirely died out. A reflection of this prayer, or one of similar content, seems to appear in Morris Silverman's recent modern formulation of the liturgy:

> O may the remembrance of his [Isaac's] virtue be before thee now as the ashes of offering in thy Temple court. Remember the binding of Isaac and be gracious unto his posterity.[121]

But I do not find anywhere in modern ritual the direct idea that it is the shofar which has the power to revive the merit of Isaac's virtue in God's mind.

It is worth passing note that the Falasha Jews still celebrate a festival, corresponding to the festival of the New Year, called "Light Has Appeared," or the "Commemoration of Abraham," in which the Akedah is the theme of cen-

120. Quoted by A. Z. Idelsohn, *Jewish Liturgy* [1932], 50.

121. Silverman, *High Holiday Prayer Book*, 426.

tral interest, though the older custom of blowing the shofar on the day is now given up.[122] It is the horn of the ram of the Akedah, however, which Elijah will blow on Mount Zion on the Last Day.[123]

It may seem that in this interpretation of the redemption sought at the New Year (which essentially includes Yom Kippur, when the horn is also blown), I have presented Judaism too much as a religion of redemption. Far as medieval and modern rabbinic Judaism have gone in obscuring this element, it has never ceased to occupy a prominent place in the Jewish attitude toward the great festivals of the New Year. T. H. Gaster,[124] an authoritative spokesman for modern as well as traditional Judaism, published an epitome of the meaning of these festivals. He describes them as having several aspects. First, "individuals purge their sins by the threefold process of introspection, confession, and *regeneration*." Secondly, the house of Israel restores itself "to that state of holiness" required to fulfill its work for God among men. Thirdly, this "process of purgation" is effected by a combination of human supplication and divine forgiveness, worked out under the covenant, in which, as Israel is obligated to holiness, God is obligated to mercy: "the Blessing of God can therefore be *compelled* by righteousness as well as entreated by prayer; and one purpose of Yom Kippur is so to *compel* it." Fourthly, it is not only the righteousness of the living generation that may be applied to this end; the merit of Israel's ancestors — from the biblical Patriarchs down — has, so to speak, accumulated a substantial credit with God upon which it is possible and permissible for their descendants to draw. The italics in the quoted statements are mine: in describing Judaism I should not myself have dared use so "Christian" a term as regeneration, or so magical a word as "compel." Gaster does not mention the shofar here, but it is clear that at least in ancient times, the shofar was regarded as a direct means of transferring merit, and of "compelling" God. Certainly Israel has never lost its belief in the vicarious merit of the Fathers.

D. SYMBOLISM OF THE SHOFAR

How the Akedah came to be a part of the symbolism of the shofar of the New Year, if not the most important part, cannot, I repeat, be traced. But two things have come from the material we have been examining — the place of the Akedah as an element in Jewish tradition,[125] and the rich significance of the shofar. One question remains, however: How much of all this meaning of

122. Wolf Leslau, *Falasha Anthology*, 1951, p. XXXII (Yale Judaica Series, VI).

123. Ibid., 28.

124. In *Commentary*, XVI (1953), 258.

125. I do not profess to have done more than open the subject. E.g., Scholem, *Jewish Mysticism*, 151, quotes an anonymous Cabbalist as saying that the second stage of mystic ascent, that of being purified of earthly or bodily ties, is represented in the test put upon Abraham, when he had to give up his "only beloved son."

atonement and final judgment are we to associate with the shofar as it appears on the Jewish monuments we are studying? To suppose that all of this significance, or much of it, was consciously behind each representation of a shofar on a tombstone is as absurd as to suppose that the full scope of the mystical meaning of the cross is in the mind of every Catholic who buries his father under a cross. But the cross on the grave refers to that range of symbolic values to some extent in every case. The elaborate explanations of the more deeply pious are not extraneous ideas superimposed upon the simple, direct sense of the protection inhering in the symbol itself: rather, the person who uses the symbol is at a greater or lesser remove from understanding of its full range of meaning as developed in the minds of the mystics.

Since the shofar was so persistently and elaborately connected with the Akedah in Jewish tradition, it is hard to believe that the Jews who used these symbols did not have the Akedah in mind when they represented the shofar on their tombs. Proof of this is of course not forthcoming, since we have no documents deriving from the Jews who made the monuments. But there is at least some evidence of such an association.

It was when I had learned of the meaning of the Akedah to Jews that I first began to see point in the little design over the niche for the Torah scrolls in the Dura synagogue (fig. 11). Here is a very early painting, done by quite other hands than those which decorated the synagogue so profusely later. On the left is a menorah, and beside it an ethrog and a lulab; in the center is the façade of a sanctuary, and then, fitted in as best the space permitted, a representation of the Akedah. What long perplexed me was why this scene should have been thus crowded into that space, which might have been given to other cult objects, such as a shofar, a wine jar, a drinking cup—the emblems commonly found with those used at the opposite side. It now appears that the Akedah is here for the simple reason that it too had great importance in Jewish cult, and simply takes the place of the shofar.

That this Akedah scene refers to the New Year, usually symbolized by the shofar, seems more likely in the light of two details of the design. In general the elements of the painting are a quite necessary part of the scene—the ram caught in the bush, Abraham with raised knife, and Isaac bound on the altar, while God's hand appears above, in the critical moment of interference. But in the upper corner there is a figure standing at the door of a tent, and this recalls to us that Sarah played a definite part in the story as told in connection with the New Year: for when Abraham and Isaac returned to her in the tent, and she heard how nearly Isaac had been killed, she cried out six times—"corresponding to the six blasts" of the shofar—and died.[126] The figure before the tent seems to me then most probably that of Sarah,[127] and her presence as one

126. *MR, Leviticus,* xx, 2 (ET, 253 f.). 127. That this figure is Sarah seems as-

of the elements of the scene appears to me to emphasize the fact that the Akedah accompanies the other cult implements in lieu of the shofar. That is, the associations of the designs at Dura in themselves suggest that it is the Akedah as associated with the New Year which is represented, and that Akedah and shofar were interchangeable symbols. In any case, the representation of the Akedah here and in the Beth Alpha floor appears to underline an importance in the incident which the interpretations we have found make it most easy to understand.

We cannot leave the subject without returning to the problem suggested by the fact that conceptions of vicarious atonement are associated with the Akedah. We have seen the Akedah take on many interpretations which may have been borrowed from Christians, such as the idea that Isaac in carrying the wood carried his cross, that he died and came to life again, that he shed his blood for the People, and that he is to be the judge in the Last Judgment (anticipated in the yearly judgment of the Day of Atonement). We must again ask: At what point did the borrowing begin, and what part of the story may have lain behind, and itself created, the similar Christian thinking about Jesus?[128] It is obvious that the blowing of the shofar was a very old element in the celebration of the New Year, as the primitive instrument itself would clearly indicate; and the identification of Mount Moriah with Mount Zion was also old. Yet it is highly probable that such elaborate explanations of the shofar and of the Akedah as we have found in the Jewish literature came into Jewish thinking at a much later time than did the blowing of the shofar, or even the transfer of the scene of the sacrifice to Mount Zion. Abraham's act in freely offering his willing son came to be given such stress that it was made a synonym for the eternal priesthood functioning through all later generations, for the never failing atonement. The original story suggests a legend artificially formed to rebuke and put an end to the practice of sacrificing the first-born

sured by the parallel found in a scene of the Akedah painted in a Coptic chapel in Egypt. See A. Fakhry, *The Necropolis of el-Bagawāt in Kharga Oasis*, 1951, 73 (Service des Antiquités de l'Egypte: The Egyptian Deserts). Here Sarah (her name inscribed above her head), stands beside the altar with a box in one hand and a small object in the fingers of the other. She is apparently putting incense on the sacrifice, an act very important in view of the passages in *MR, Song of Songs* (quoted above) saying that Isaac offered his merit in the form of incense. Incidentally, the Coptic painting shows two knives in the air between Abraham's back and the hand of God (Abra-

ham holds a third knife in his hand). Fakhry and everyone he has consulted are quite at a loss to explain the two extra knives.

128. In Strack-Bill., II, 110 f., the horn of the Akedah and the shofar are treated as underlying the allusion to the "horn of salvation" and to "the oath which he swore unto Abraham our father" in the Benedictus, Luke 1, 69, 73. The authors present their usual collection of uncritically assembled quotations to illustrate this, but nothing shows by any means decisively that either verse implies an intention to identify the little Jesus with the Isaac of the Akedah.

son. But in the material we have reviewed, sacrifice is made once for all, with universal validity—a basic idea so powerful that it became the dominant explanation of the death of Jesus. Whence came this idea and when was it adopted into Judaism?

Unfortunately neither Josephus nor Philo gives us here the help we should expect. When Josephus tells the story of the Akedah he adds no significant details to the biblical narrative.[129] Philo's treatment of the life of Isaac has so largely vanished that I long ago suspected it to have been for some purpose suppressed by Christians for the reason that it said so much about the sacrifice and atoning value of Isaac which Christians wanted to say of Christ alone. Not only have we lost Philo's *On Isaac*, which he wrote to follow his *On Abraham*, but those sections of *Questions and Answers on Genesis* which treat of the birth of Isaac and the Akedah are also missing. The Akedah is mentioned in *On Abraham*, but there it is made only a part of the allegory of the two Patriarchs, especially of the interpretation of Abraham. In Philo's total allegory Isaac was really a higher type than Abraham, a being equaled only by Moses. Isaac and Moses were "self-taught"—"perfect from the beginning," men who did not, like Abraham and Jacob, reach the heights by labor and climbing, but were from boyhood the full representation of God's power to men. As such, the special attribute of Isaac was that of his Hebrew name, "Laughter," and this Philo makes to mean the supreme happiness of God, which man shares in mystic rapture. The sacrifice of Isaac represents, then, Abraham's willingness to subordinate his desire for personal happiness in his desire for God himself; it taught Abraham, and teaches us after him, that the goal of striving is the supreme desirability and virtue of God himself, not the happiness which union with God brings. The only way in which we can keep the joy of God is to be constantly ready to give it back to God who gives it. We must fix our attention upon God, not upon his gifts, if we wish to keep the gifts.[130] That is, in the few Philonic references to Isaac that we have, he is one who leads the Jew into the consummation of mystic achievement in the hellenistic sense.

As to the Akedah, Philo calls it a "thank offering"—here *charisterion* instead of his usual *eucharisterion*.[131] The difference seems to me of no importance. We have seen that the Jewish festivals all become "eucharists" to Philo, in that they become, through the giving of thanks, mystic rites of passage from the material to the immaterial. The two words occur so often in this sense in Philo's writings that when he applies *charisterion* to the Akedah it is clear that the Akedah too has this mystic meaning for him. Indeed, Philo goes on at once to explain that the transition from changing matter to the changeless Existent

129. *Antt.*, I, 222–236 (XIII, 1–4); Lerch, op. cit., 5–27.

130. *Abr.* 201–205; *LA* III, 209. Other interesting allegories (here irrelevant) on de-

tails of the narrative are to be found in *Som.* I, 64 f., 193–195; *Post.* 17–20; *Migr.* 140; *Fug.* 132–136.

131. *Immut.* 4.

One is symbolized by the binding of Isaac, by which Isaac lost his power of movement or change.

Philo also comments on the shofar of Rosh Hashanah, but does not connect this horn with the horn of the ram in the Akedah; it is the horn of war turned into what another hellenistic Jewish document calls the "trumpet of peace."[132] The explanation recalls the eighth of the Homeric Hymns, in which Ares is transformed into a god who gives man peace by making him victorious in the conflict within his own soul. The shofar is also to Philo the shofar of Sinai, whose voice was the true Law — the unwritten Logos in contrast to the written law — which was sent out by the blowing to all men. That is, Philo has a profoundly mystical and spiritual interpretation of both the Akedah and the shofar, but in his passing allusions to the one or the other he nowhere relates the two, and where the connection arose cannot be said: but one cannot help speculating on the problem.

The central point about the Akedah story as later interpreted is that it teaches not only that the Jews are heirs of the promise made to Abraham and of the Law given to Moses, but also that these heroes in their very persons are intercessors for and saviors of their descendants. The idea of the value accrued through the merit of the Fathers appears frequently in Jewish writings, especially in the haggadic midrashim, but was never quite congenial to the halachic spirit. In contrast, the conception is enormously expanded in Philo's treatment of the Patriarchs: in his thinking they are, as incarnate representations of the unwritten law of God and nature, much more important than the Code in any halachic sense. His view of them is that they actually were the Wise Men, the *Sophoi*, of pagan dreams, and that "the Wise Man [in this case he is speaking of Abraham] is the savior of the race, the intercessor before God, the one who seeks pardon for the sins of those akin to him." That is, the Wise Man is a "savior" in the sense of the mystery religions, though the term *Sophos* has come from Stoic philosophy. What I have described as Philo's "mystery religion" is the old Jewish cultus shot through with new meaning, such meaning as that in the sentence just quoted — the meaning that as we appropriate to ourselves the mystic achievements of the Fathers, we can become sharers in their virtues, in the sense of being initiates. Philo said that he himself was "initiated into Moses." In short, the concept of the Patriarchs as saviors has an inherent compatibility with Philonic thinking which it has never had with halachic thinking, since the whole idea of a savior whose merits we assume to ourselves is the idea which most differentiates Hellenism (and Christianity) from "normative" Jewish thought.

At the moment there is the deepest disagreement on the question as to

132. The so-called pseudo-Justinian *Oratio ad Graecos:* see *By Light, Light*, 303. Cf. Philo, *Spec.* II, 190–192.

whether Philo's ideas are an expansion of such "native" or rabbinic thinking as the concept of the Akedah presented, or whether the teachings about the Akedah and the merit of the Fathers conveyed in the haggada are reflections of the Philonic, or, better, hellenized Jewish adaptation of Old Testament texts and rites to Greek mystery. The interpretation of the Akedah, even in rabbinic tradition, has revealed to us the old hellenistic idea of the dying and rising redeemer. But as a whole it offers a conception I do not know in Greek thinking. For it expresses not only the familiar hellenistic idea that the savior who died broke the iron curtain of death so that we can hope to live like him after death as we identify ourselves with his death and resurrection; it goes on to indicate that his blood was shed willingly for our redemption, and he has become not only the mystic figure with whom we may be identified, but also, though at times our final judge, more often our intercessor and advocate with the Father. The whole seems a peculiar blending of the spirit of Isaiah and Deutero-Isaiah with hellenistic conceptions, and is precisely the blending which we know as the basic interpretation of Jesus in Christian theology. If in later versions of the Akedah we have suspected the presence of Christian innovations, the theme impresses me for the most part as a pre-Christian formulation which, I believe, was formative in Christian thinking. It appears to me, however, even in its rabbinical form, strongly hellenized. For the fact that atonement is centered in the Patriarchs, and associated with the Law and the Messiah, is as deeply Jewish as the figure of a dying and rising personal savior whose ashes are before God seems to me hellenistic.

In Philo we see the idea in its more fully hellenistic setting, but not in an essentially different form. The great difference between the rabbinic Jewish and the hellenistic conception, as the two appear to me here, consists in the transition from the explanation of the Akedah as a story of Isaac spared from the sacrifice by divine intervention, to an interpretation which represents Isaac as actually the eternal sacrifice atoning by his merit for all men who blow the shofar. The either-or of Judaism versus Hellenism as the source of the conception disappears when we see that the later idea would have been as impossible without both contributions as would be the idea of green without both blue and yellow. To argue whether Philo, later Christianity, and the doctrines of the merit of the Fathers and of the saving power of the Akedah are basically Greek, or "Jewish with a hellenistic veneer," is as pointless as to argue whether green is blue with a yellow veneer or vice versa. It is another instance of senseless debate of the sort that William James compared to an argument as to whether the left leg or the right leg is more important in walking, or whether a child is more closely related to its father or to its mother. The conception into which we have come seems to me to be so completely a composite that while in rabbinic writings the color is more blue, and in Philo's writings more yellow, the conception in both cases is green; the Isaac of the Akedah and the Christ

of theology are brothers, sons of the same two parents, Hellenism and Judaism, though one may resemble the father more, the other the mother. Or, may I say explicitly, in the doctrines of vicarious merit and of the Akedah, even as propounded by the rabbis, I see influence of hellenistic thinking, influence which I suspect was felt in the first instance not in the circle of the rabbis themselves, but in such centers and among such people as "Philo the Jew" represents.

With this we have come, I believe, to the meaning of the shofar on the tombstones. Probably in the minds of those who used the symbol, there was no uniform shade of green. We may assume that the shofar meant for all Jews of the time hope of a life to come, or it would not have been put on tombstones. Insofar as this is true, the thinking was green, if I may keep the figure. But where for some the symbol may have had all the implications of the Greek conception of the *Sophos* and the *lex animata*, for others it must have carried, much more simply, what the rabbis came to tolerate, however grudgingly, as the tradition of the merit of the Fathers. Even where hellenistic admixture was greatest, however, the Jewish feeling must still have been very strong, as it was with Philo. The people buried with the shofar on their graves were Jews who had blown the shofar and hoped for life in the other world through the shofar: "Eventually they will be redeemed by the ram's horn."

Nevertheless, much as has been found in the Akedah story to illumine the symbolism of the shofar, the shofar cannot be taken ever to have represented only the personal quest for mercy. Like every good religious symbol, it gathered into itself, in one way or another, all the aspirations and promises of the religion which used it. Thus we may well close our exploration with the often quoted ten reasons for blowing the shofar given by Saadya b. Joseph, called Saadya Gaon, in the tenth century. As abbreviated by Idelsohn, they are:

1) To proclaim the sovereignty of God on the anniversary of creation.

2) To stir the people to repentance.

3) To remind the people of the revelation on Mount Sinai.

4) To remind us of the messages of the Prophets.

5) To remind us of the destruction of the Temple.

6) To remind us of Isaac's sacrifice.

7) To cause the human heart to tremble.

8) To remind us of the Day of Judgment.

9) To remind us of the blasts of the Shofar of redemption which Messiah will sound.

10) To remind us of the resurrection [when again the trumpet will sound].

Such a symbol, a sign of repentance bringing hope of mercy and restoration for the nation and the individual alike, might well be carved upon the

graves of Jews. Jewish ritual still associates the Akedah and the shofar.[133] But the custom of putting the shofar on graves seems to have disappeared as the vivid symbolism of all the cult objects has faded, or as Jews have largely come to ignore those meanings which, in the period we are trying to reconstruct, had such deep importance for their ancestors. Yet Jews are still Jews because, among other things they do, they blow the shofar.

E. CONCLUSIONS

THE CULT OBJECTS which the Jews of the Greco-Roman period depicted on their synagogues and tombs have gone far to confirm the surmise that they were Jewish substitutes for pagan symbols similarly used.

The pagan tombs and sarcophagi of the hellenistic and Roman centuries display a great number of devices which indicate hope for a life after death, and which probably were thought, by their very presence on the tomb, to be of some direct help in achieving immortality for the deceased. Jews used a great number of these pagan emblems along with their own symbols. But for Jews the simplest way of securing for themselves the values implied in hellenistic burial practice was to adapt pagan usage by putting Jewish symbols on their graves, symbols which, from the way in which they were used, presumably would assure immortality to the Jew just as the pagan ones promised future life to the pagan, but would assure it in Jewish terms.

Such an adaptation would necessarily imply that the Jewish cult symbols had taken on an eschatological reference by no means implicit in the original purpose of the object represented, and quite beyond their connotations in that Judaism of later centuries which was oriented by the legalism of the rabbis. For the followers of legalistic Judaism have not put these symbols on their graves and have read little of eschatological hope into either their forms or their uses. Yet our examination of the place of the cult objects themselves in the rituals, and of the comments of Jewish mystical writers upon their meaning, has made it seem likely that such a wider, if not deeper, feeling about the values they carried was general in the period we are studying. To reach this conclusion, we have had to take only one unsupported step — the step which brought us to the assumption that the eschatological and mystical association was much more common among Jews in the Greco-Roman period than it has ever been in Ju-

133. Silverman, op. cit., 165–170. But Silverman, 107 f., uses the interpretation of modern critics earlier referred to, according to which one of the chief motives of the narrative was to put an end to human sacrifice. He undoubtedly is correct as regards the original meaning of the biblical story, but his explanations omit the idea that Isaac was actually sacrificed, as it appears in the thinking of the rabbis. M. Friedmann, "The New Year and Its Liturgy," *JQR*, I (1888/9), 62–75, does not mention the Akedah at all.

daism at any time since, and that those who made the monuments of that time found in this association the true meaning of Jewish cult and of its symbols.

The tombs have kept their silence, and the ornament of the synagogues is unexplained in any contemporaneous literary documents. What their builders were thinking must always be ultimately a matter of inference. Those who hold to the theory that the graphic designs were meaningless decoration, or to the notion that they must be explained, if at all, from halachic and rabbinic postulates, are taking an inferential step quite as undocumented as the one which I have suggested. The final inference as to the ideas that lay behind the Jewish monuments can be made, I believe, only after we have studied the complete picture—the symbolic forms themselves, their history, their cultic associations, the explanations given them in various Jewish traditions, and finally the places and circumstances in which they are represented. I simply want to stress that I am as aware as anyone can be that the final step—namely, my conclusion that the symbols have mystical and eschatological reference—is unsupported by direct evidence, and is offered only as presenting the greater probability. I do not see how any conclusions other than those I have reached can seem more probably correct to one who takes into view all the considerations I have discussed. That I have brought out everything that may be relevant I cannot hope, and anyone who can add evidence that I have overlooked will do me a great service. But any additional evidence will still be additional, and will have to be discussed as such.

The Jewish cult symbols on the monuments have at least all proved to have been given mystic and eschatological interpretation in Jewish literary documents—with the exception of the façade, which is not mentioned in such writings. But the way in which the façade was used indicates, more clearly than does the use of any of the other forms, that it had, and still has, at least subconsciously, definite association with immortality. Here is the clearest example we have yet seen of the stubborn persistence of a value along with a form, even though little explanation of the form seems to have been offered in any of the various religions that utilized it. As Jews built it into a tomb portal or the front of a synagogue, as it became the mizrach, or pre-eminently as it came to represent the Torah shrine, the façade indicated that God had come to man, and that through its doorways man could go to God in mystical union, or into immortal life.

The other Jewish cult emblems have no such connections with pagan forms as the façade has, with the exception of the incense shovel; here identification is less certain, and the probability that its meaning has been correctly explained is by no means so high as in the case of the other objects. But the menorah, the lulab and ethrog, and the shofar are idiomatically Jewish, and all appear as emblems on graves in such a way that their eschatological implication seems to me inescapable. At the same time, the references to them in Jew-

ish writings, and their use and associations in Jewish cult, appear to justify the conclusion not only that they were at the time symbols of mystical achievement and immortality, but also that Jews put them on the tombs with such meanings consciously in mind. Specifically, the menorah seems to have become a symbol of God, of his streaming Light and Law; it was the Tree of Life, the astral path to God, and the mediating female principle, the Mother. The lulab and ethrog carried on the association with Tabernacles as a festival of rain and light, but took on mystical overtones, to become a eucharist of escape from evil and of the passing into justice as the immaterial Light comes to men. They came even to signify the mystic marriage. But all of these mystical interpretations looked to immortality. The shofar was the great symbol of God's mercy and forgiveness, of imputed merit available to every man from the treasury of merit stored up through the virtuous acts of the Fathers, especially of Isaac, so that it too became an eschatological symbol.

The manner in which Jews used these symbols in ornamenting their synagogues recalls what has long been recognized about the Jewish borrowings from pagan symbolism, namely, that the symbolic vocabulary taken from the pagans and adapted in synagogue decoration is almost if not entirely a funerary vocabulary. The implication seems obvious that synagogue worship, at the time when these borrowings occurred, was oriented in mysticism and the hope of life after death. To the impression made by these borrowed symbols we can now add the impressions gained from our studies of the uses made of Jewish cult objects. These were, indeed, represented in the synagogue decorations in ways in which halachic Jews have never thought of representing them, but their primary symbolic use seems to have been in connection with graves. The cluster of such symbols found in the synagogue of Beth Alpha corresponds closely to the cluster that appears in the Catacomb Torlonia in Rome, but has a relevance in the catacomb which it does not immediately manifest in the synagogue — the relevance of its essentially eschatological implications. Transferred from the tombs to the synagogues, the symbols must indicate that synagogue worship was concerned with life after death in a sense far beyond anything that appears in synagogue worship under rabbinic guidance.

We have already come a long way, I believe, in our search for light on the question which is the central interest of our entire study, namely, the question as to what sort of Judaism produced all this art. The feeling is that it was an intensely loyal Judaism, loyal in its belief that the Jewish faith offered man the true knowledge of the nature and will of God, and that the institutions of Judaism defined the duty of man in this life and were his promise of security after death. But the Jews who lived under hellenistic and Roman influence had come to ask questions of their Jewish tradition, as they looked to it for consolations — questions which had much more importance for them than for the rabbinic scholars, who, especially in Babylonia, were more segregated

from pagan impact than the mass of Jews in the Greco-Roman world. Many of
these questions had crept into the thinking of the rabbis, and are sporadically
reflected in their writings; but the questions did not have the same immediacy
for the rabbis that they had for the Jews who built and worshiped in the syn-
agogues, and who were interred in the graves most commonly found.

The new questions were, first, the one with which Philo was most con-
cerned: How could Judaism take men from the material to the immaterial?
The second was a question which Philo's mysticism made largely irrelevant for
him, but which was crucial for the mass of pagans and Christians, as well as for
Jews: How could religion take man into a blissful immortality? Philo's answer,
and apparently that of many of his associates in Alexandria, was to turn Ju-
daism into the true Mystery, by which he had in mind the sort of conception in
which educated and thoughtful pagans saw the true meaning of the mystery
cults — salvation from bondage to the flesh and its desires, and release to share
in the freedom of immaterial reality. At the same time the great majority of
pagans were seeing in their mysteries a means of escaping from material bond-
age to a redemption which would help them to face the great judgment after
death, and make them ready for acceptance in the future life. Such a pagan
hope is expressed in the Sabazian paintings of a tomb in Rome. Correspond-
ingly, the great majority of Jews in the period appear to have been regarding
their Judaism as the true Mystery in this more popular sense. As in paganism,
there was no feeling of a discrepancy between the two levels, the eschatological
and the mystical; hence Jews probably as a matter of course conceived Judaism
as a Mystery in both senses. And as ordinary pagans put the symbols of their
mysteries on their sarcophagi, ordinary Jews put the cult symbols of their Mys-
tery in the same places and, presumably, with the same basic intent. Christians
have ever since used Christian symbols in the same way.

That modern Jews find in their religious traditions the answers to modern
social problems makes them no less Jews. Similarly, the fact that the Jews of the
Greco-Roman world were finding in their religion the answers to the problems
which concerned all men in their day detracted by no means, I believe, from
their loyalty to Judaism, and does not compromise their right to a place in Jew-
ish history, even though all that the Talmud can say of many of their practices
is that one or another rabbi did not stop them.

Such is the impression that we derive from the Jewish cult symbols as we
find them in the synagogues and on the graves of the period. We are ready to
see not only that it was possible for the Jews of the period to interpret and use
the symbols of their own cult in this way, but also that they were so close to the
thinking of their neighbors (just as modern Jewish idealists are close to the ide-
alism of gentiles) that they could take a host of pagan symbols which appeared
to them to have in paganism the values they wanted from their Judaism, and
blend them with Jewish symbols as freely as Philo blended the language of

Greek metaphysics with the language of the Bible. We must constantly assume that to their minds the borrowed symbols only enriched their Judaism, just as for Philo the terminology of Greek metaphysics seemed only to express more accurately what he felt to be the real meaning of Scripture, and as modern Jews avail themselves of the terminology of current social and philosophical thought only to bring out more clearly the intent of their Jewish forefathers.

CHAPTER FOUR

Pagan Symbols in Judaism:
Astronomical Symbols

L ATE ANTIQUITY was deeply committed to an astral approach to
religion. The religions of earlier Greeks and Romans largely revolved
round seasonal festivals, but neither people seem to have understood clearly
that the seasons themselves are controlled by the astral bodies and relations.
Similarly Apollo had been a sun god, but not at all as distinctively so as the later
Helios or Sol Invictus who largely came to take his place. As the astral concep-
tion came in from the East, most of the older myths and divine personalities,
and a large part of ancient ritual, were interpreted or altered to express the
sense of fatalism and determinism that astral control of the universe and of
man's fate indicated. With so much else from pagan religious thinking coming
into Judaism, to find the Jews using astral symbolism, and presumably astral
values, in their own worship and thinking is quite what we should now expect.
We must begin, as before, to justify a consideration of the subject by reviewing
the astral symbols preserved in Jewish remains.

A. ASTRAL SYMBOLS IN JEWISH REMAINS

O NE OF THE BEST attested designs from Jewish religious art of the late
Roman Empire and the "Byzantine" centuries is the circle of the zodiac with its
twelve signs, in the center of which Helios drives his quadriga. The Jews
squared this circle in the usual way of the period by putting a Season in each
of the four quarters outside it. The magnificent mosaic at Beth Alpha shows
this design almost intact. Here Helios is presented in full-rayed glory with the
sickle of the moon beside him and twenty-four stars.[1] The Seasons in the cor-

1. See Goodenough, *Jewish Symbols*, I,
248–251. Studies of the Beth Alpha mosaic,
in addition to those cited there, are: R. Wis-
chnitzer, "The Meaning of the Beth Alpha
Mosaic," *Yediot: Bulletin of the Jewish Palestine
Exploration Society*, XVIII (1954), 190–197.

In "The Beth Alpha Mosaic, a New Interpre-
tation," *Jewish Social Studies*, XVII (1955),
133–144, also by Mrs. Wischnitzer, she fol-
lows the earlier article in making the mosaic
as a whole a presentation of the Feast of Tab-
ernacles. She did not succeed in convincing

ners, however, are put opposite the wrong signs. Spring, for example, is beside the signs of Summer, and the others are correspondingly misplaced. This seems to me to indicate that the members of the congregation had not even basic astronomical or astrological information or concern. And if they were without even elementary information about the zodiac, they must have had little interest in celestial observation or reckoning. For to know which months of the year correspond to which signs is the very beginning of such study. The zodiac, that is, does not testify to the congregation's interest in, or use of, astrology.[2]

The other zodiacs in synagogue mosaic floors are not so well preserved. Of the zodiac of Yafa we have only Taurus and a little of Aries. Each of them is set in a circular disk, and between these at the outer edge swim dolphins. The corners could not have had Seasons, since of the one corner enough is kept to show that there was no room for a Season. Instead we have vines and a leaping tiger, and, nearby, an eagle perched on a female mask head much like the ones at Dura. The association of the zodiac, accordingly, seems to be Dionysiac. Not a tessera seems left from the center, where we should expect Helios.

Of the zodiac in the synagogue at Naaran a little more is preserved, though Pisces is the only sign not deliberately mutilated, while the face of Helios and his horses seem likewise purposely destroyed, as well as the faces of the Seasons. Here even greater disregard appears for the signs as astral symbols, for the Seasons rotate counterclockwise, the signs clockwise. From the synagogue in Isfiya only one Season is left, and enough fragments to show that a similar zodiac was there, but Avi-Yonah thought the whole as inaccurate here as at Naaran. Helios has totally disappeared from the center—if, as may be presumed, he was originally there. We have, then, four assured cases of the zodiac in mosaic on synagogue floors, and though Helios is left inside only two of them, he probably once stood in all four. The Seasons surround only three of the zodiacs. Considering the few synagogue floors whose mosaic design is still preserved at all, the high proportion with the zodiac, Helios, and Seasons makes it inevitable to presume that such decoration must have been very common indeed.

The zodiacs in mosaic are now supplemented by a bronze hanging bracket

me. S. Renov, in the same issue of *Yediot*, pp. 198–201, published "The Relation of Helios and the Quadriga to the Rest of the Beth Alpha Mosaic." The whole is messianic, he believes, the astral panel means God's glory, the moon sickles on the four horses refer to the moon as symbol of the Davidic dynasty, and "the four horses stand for the four hundred years of Davidic rule in the messianic era." All three of these articles are excellent examples of attempts to impose ideas from medieval Judaism upon the old symbols.

2. Hanfmann, *Seasons*, I, 194, suggests that such designs were "calendars," by which I suppose he means that one could recall from them which signs were in each season. That the Seasons are displaced beside the Jewish zodiacs shows this to be impossible for them.

for lamps, fig. 12.[3] It was found in the excavations in Galilee, five kilometers east of Acre, at el-Mekr. An Aramaic-Hebrew inscription is cut on the bottom of the ring,[4] interrupted in two places by a familiar group of symbols, the seven-branch menorah flanked by a lulab and shofar. The inscription is extremely difficult. Frey and U. Cassuto read it: *Ce cercle* [l'ont offert un tel et un tel] *au lieu sacré* [= à la synagogue] *de Kefar-Hananyah. Béni soit leur souvenir. Amen. Sélah. Paix.* My colleagues Obermann and Pope kindly examined it, but pointed out that to translate this as "circle" is only to paraphrase a word literally meaning "crown." Following some unintelligible letters, they read "at the holy place of the village of . . . May they be remembered for good (or, the good of God) . . . Sélah. Peace." The object was probably not made after the fifth or sixth century, since the symbols of menorah, flanked by lulab and shofar, are extremely rare after that period, and it may well be considerably older. But the place name is by no means sure. The ring is perforated by twelve holes, and a central lamp is thought to have hung from the hook below the bracket. The form, then, is that of a central light surrounded by a circle of twelve lights, and I have no doubt that it represented the zodiac. For our word zodiac is from the adjective in the Greek expression "zodiacal circle," or "circle of *zōdia*," small animals. Each sign is in Greek a *zōdion;* the whole is the "circle."[5] The "crown" would here really mean the circle of the zodiac. The central light seems to be the sun itself. The "sacred place" to which the zodiac was given was almost certainly a synagogue, since the word "place" has turned up so often as a word for the synagogue building. We cannot conclude from this inscription that the zodiac had cultic implications or was a sacred object, because the same sort of language was used for the donor of any part of the synagogue. But we look with increased interest at the zodiacs now that we know the Jews used them alive, if I may call it that, alive with burning lights as well as in the static mosaics.

Interest in the zodiac is witnessed by other pieces from ancient Jewish art. A stone frieze, or piece from a screen, was found among the remains of the synagogue of Kefr Birim, carved with a running fret. In the interstices are a shell, a bull, a woman's bust, a goat, and, along with leafy rosettes, a centaur shooting an arrow. The stone is clearly a fragment, and may be nearly complete, but the centaur shooting can only be Sagittarius, so that the others are presumably Taurus, Virgo, and Capricorn. Sukenik's restoration of the rest of the signs is possible, though all the signs need not have been originally repre-

3. Courtesy of G. Faider-Feytmans and the Mariemont Museum in Belgium. See also the photograph of the object, upside down to show the inscription on the bottom, in *Les Antiquités égyptiennes, grecques, romaines et gallo-romaines du Musée de Mariemont*, Brussels, 1952, 191 (no. S. 15), plate 65.

4. See *CIJ*, II, 164 f., no. 980, where the inscription is published in a circle after the reading of U. Cassuto.

5. LS, s.vv., give full documentation for this statement. Cf. Hanfmann, *Seasons*, I, 227.

sented in this frieze, since odd signs appear elsewhere. Neugebauer kindly wrote me that he doubted if this was ever a complete zodiac.[6] For example, Pisces is unmistakable on a carved stone from the synagogue at er-Rafid. On a lintel from Nawa the menorah is made into a solar symbol by its central light elevated as a round object, while a fret runs on either side with several openings. Clearly something objectionable has been chipped away from the openings, and as in the openings of the fret at Kefr Birim, they may well have been signs of the zodiac.[7] Reports have been made that fragments of a carved decoration were found in the synagogue of Sheikh Ibreiq (Beth Shearim) which seem to have formed part of a zodiac design. I have seen nothing to confirm the idea that a full mosaic was in the synagogue. Jewish acceptance of the zodiac appears from its identification with Moses and the twelve tribes at the springs of Elim in one of the paintings at the Dura synagogue.[8]

The potency of the zodiac in this milieu is, however, directly attested by a strange amulet that was kindly loaned to me from the de Clercq collection.[9] The two main faces were reprinted from de Ridder in my study of the Jewish amulets, with remarks that I now see were not entirely accurate. On one of these faces Adam and Eve stand beside the tree, not in Christian shame but in Gnostic triumph as the snake gives them the true knowledge. On the other a zodiac appears as a circular band with a boss in each division to represent its sign, while the sun and moon are on either side, and the seven planets (little bosses) below the sun. In the center of the zodiac circle a mound wrapped about with a snake takes the place of Helios, a fact which puzzled me earlier but which I now see represents the typical omphalos with snake, the symbol of Apollo. It seems entirely safe to see in this a product of some Jewish form of Naasene Gnosticism, in which the sacrament was to eat loaves about which a snake had coiled, for the Hebrew letters on every face, and the single long, if inscrutable, Hebrew inscription, must have come from Jews. The form of the letters dates the amulet in the second or third century after Christ. That it was typical of hellenized Judaism in general can hardly be suggested, but that this sort of thing was going on among some Jews can now hardly be denied. Our interest here is in its offering another example of astronomical symbolism in Jewish dress.

Use of the zodiac in synagogues is still customary among some groups of

6. The female bust seemed to him more likely "either sun or moon or one of the planets, e.g. Venus." But he does recognize Aries and Taurus as well as Sagittarius.

7. Morton Smith kindly reminded me that less than twelve openings are left, so that all the signs could not have been on this lintel. It was pointed out that they probably were not all present at Kefr Birim. Galling thought he saw reminiscences of the zodiac on a lamp.

8. See fig. 47 and Goodenough, *Jewish Symbols*, XII, 170–171, and *By Light, Light*, 209 f.

9. It is to be published in the first number of *Greek and Byzantine Studies*.

East European Jews, especially those from Poland. A fine example is painted round the ceiling of a synagogue in New Haven, fig. 13.[10] Like so much in Jewish custom, this seems a survival whose origin and original meaning are now totally forgotten by members of the synagogue. No consecutive history of this device in Jewish art can be traced, so far as I know, from antiquity to the present, and its modern introduction in Poland, or wherever, may have been a fresh invasion of the symbol. But it is so surprising a "decoration" for a synagogue, surprising not least to Jews from all other parts of the world, that its adoption seems impossible as a "mere decoration" at any time. I should guess that its "explanation" was in terms of the rabbinic identification of the twelve signs with the twelve tribes, each of which had a sign on its "banner."[11]

Symbols of the sun and moon are likewise to be considered as marking an astral orientation of religion. We encountered these symbols chiefly on amulets. That Helios has the moon sickle beside him at Beth Alpha cannot be pressed as meaning more than that the moon, and the stars with it, show his heavenly setting. One amulet with no Christian detail shows Daniel kneeling in prayer between the lions within the den, while he is brought an ideograph of sun and moon by a figure carrying also the crook that is usually associated with such quasi-divine personalities as satyrs. The figure here stands on a mountain, and the starry heavens are indicated by a number of stars above him.[12] The whole seems a reference to astral piety, in which the symbol of divinity brought to the hero is not a wreath or a palm branch, but the sun and moon. The design would be as strange in Christianity as in Judaism, and I suspect, but can say no more, that the amulet was Jewish. In other amulets this ideograph is directly labeled *Iaō*. But astral symbols appear commonly on amulets, and are there Judaized. Not only are the anguipede and Chnoubis definitely solar, and definitely labeled *Iaō*, but the haloed cavalier is God, and these, with Harpocrates and many other figures, are identified with Helios, who is also *Iaō*. One of the alternatives, meaning the same thing, is the solar lion, but Helios in his quadriga, along with Selene driving her pair, together are labeled Iao, Sabaoth, Abrasax, the Existing One (ὁ ὤν). Helios and Selene are represented as busts on another amulet. The fascination of later pagan antiquity with solar and astral religion is clearly reflected in popular Judaism. This led to the adoption of solar symbols of all kinds on Jewish amulets, and to such explicit solar symbols as Helios driving the quadriga through the zodiac in the synagogues.

The charms give even more specific, because verbal, testimony to the same thing. One Jewess prayed:

10. The Temple Keser Israel. Photograph courtesy of Rabbi Andrew Klein. It seems unnecessary to show more than Libra over the Torah shrine. The other signs are equally vivid.

11. For the signs on the banners see

D. Feuchtwang in *MGWJ*, LIX (1915), 244.

12. I know this amulet only through the old drawing of Garrucci, and whether he has counted the stars correctly I cannot say. I count 24 of them.

Hail Helios, hail Helios, hail thou God in the heavens. Thy name is omnipotent . . . Make me . . . beautiful as Iao, rich as Sabaoth, blessed like Liliam, great as Barbaras, honored as Michael, distinguished as Gabriel, and I will give thanks.

Two brief charms hail "Helios on the Cherubim." Another Jewish prayer says: "Hail Helios, hail Helios, Hail Gabriel, hail Raphael, hail Michael, hail all of you. Give me the authority and power of Sabaoth, the strength of Iao."[13] I see no reason to be surprised at this, for we have all along known that the Essenes addressed prayers to the sun. The figure, then, must be understood as being if not a representation of God for Jews at least a manifestation of Deity, a sign of Deity, and, because of the potency to which the amulets attest, a symbol of Deity. The other symbols which have turned out to have solar references — the bull, the lion, rosettes and wheels, the gorgoneum, the eagle — all seem to have attested in their own ways to the heavenly direction of man's piety, and that the Head of this heavenly existence was best typified in the sun.

A clearly astral symbol appeared in the Jewish adaptation of the semeion, a symbol made up of tiers of "round objects" which was definitely used with astral deities. This sign was so far from being a conventional form of decoration that its being taken over by Jews in so many places seems to indicate the astral orientation of at least much of their piety.

We have also seen the Seasons oriented with Helios and the zodiac in a way to relate them with the same sort of piety. The Seasons are the chief form of alluding to astralism in the West. The most famous Jewish example is the sarcophagus fragment at Rome, where two Victories hold up a medallion in which is the menorah, with two Seasons at the right. Originally the other two must have been at the left of this central motif. The putti trampling grapes under the menorah, and riding one a hare and one a dog at the Seasons' feet, seem to orient the whole with Dionysiac thinking,[14] but this in no sense detracts from the value of the Seasons as astral or cosmic symbols. The Seasons also appear as cupids upon a sarcophagus lid from the Jewish Catacomb Monteverde at Rome, and, as Cumont recognized,[15] this makes the fragment more rather

13. See Morton Smith, "Palestinian Judaism in the First Century," in Moshe Davis, *Israel: Its Role in Civilization*, 1956, 69.

14. Hanfmann, *Seasons*, I, 195, argues against any Dionysiac reference in the putti on this sarcophagus. "The vintage scene under the medallion may be interpreted as a seasonal scene rather than as a symbol of Dionysiac happiness." This is a possible interpretation of the scene in isolation, but it is quite unlikely in view of the history of vintage scenes as we have seen them in ancient funerary art. On the sarcophagus at Dumbarton Oaks with which he is primarily concerned, the little figures under the Seasons seem to me symbolic of fertility. A man milks a ewe (spring) in the way we have seen to be highly symbolic; a man carries a sheaf of grain (summer); and in the center is a vintage scene (autumn). All these seem to me to represent the fertility and life produced by the four Seasons above, with the fourth Season, winter, conspicuously unrepresented below. On the sarcophagus all together would naturally refer to the hopes of the deceased.

15. *Symbolisme*, 496.

than less likely to be Jewish. The same is true of two fragments, both apparently from a single sarcophagus, found in the Jewish Catacomb Torlonia at Rome.[16] On one of these fragments a reclining figure holds a cornucopia, while the bent-up knee of another has a basket on it, both of them as on the fragment from Monteverde. These fragments from Monteverde and Torlonia have been categorically pronounced chance fragments from pagan sarcophagi brought in for reuse, but there is no indication of such reuse on any of them. The judgment was pronounced because such designs of Seasons are common on pagan sarcophagi and seemed scandalous on Jewish ones. Like many such judgments, this one has gained weight by repetition. But the presence of these pieces in Jewish catacombs puts the burden of proof, not of assertion, on those who think them unfitting for Jewish original use. Since we have now seen that Seasons are so well attested in Judaism, we must assume as the greater probability that the pieces were parts of sarcophagi used for Jewish burials.[17]

In the corners of a painted ceiling in the Catacomb Vigna Randanini are four cupids, which Frey properly identified as the Seasons.[18] That these are Seasons is made likely by the very form of the ceiling design. For in this room, as well as in two others of the catacomb, the design was basically that of what Lehmann has taught us to call the "dome of heaven."[19] It consists of a central circle supported by designs at the sides and corners, usually also distinguished by being set in frames, which pull the whole into the square or rectangle of the room. The design is most basically seen in Painted Room IV of this catacomb, where the ceiling is divided into such spaces. There the spaces themselves are empty, except that lulabs are in the ones in the corners. This room presents a problem to which several answers suggest themselves, but none is satisfactory. It was obviously cut out, a most expensive operation, by a man of considerable means, and he, or his father, was almost certainly buried in the arcosolium opposite the door with the menorah above it. With this goes well the clearly expensive sarcophagus, part of which still stands in the arcosolium. Why was such an expensive operation finished off by the crudely drawn empty frames on the ceiling? There was money to have them properly painted. Was it aniconic prejudice that kept them empty? The broken corners of the sarcophagus seem to speak clearly of offensive carvings at the corners which, by deliberate effort, were hewn out and destroyed. I know of no way to account for such a

16. Cf. M. Gütschow in Beyer and Lietzmann, *Torlonia*, 44, where pagan and Christian parallels are listed.

17. I cannot agree with Hanfmann, loc. cit., that these need not be considered Jewish because not definitely attested as such. In these matters we must rely upon probability, not proof. That so high a proportion of the "intrusive pieces" show designs of Seasons in itself makes it highly probable that they reflect Jewish love and use of Season symbolism.

18. *Biblica*, XV (1934), 284.

19. Karl Lehmann, "The Dome of Heaven," *Art Bulletin*, XXVII (1945), 1–27.

crude ceiling in so expensive a setting. Of only one thing can we be sure: the system of frames in the ceiling themselves had a meaning, whether they contained anything or not, and the meaning would seem to be that of the dome of heaven. This conclusion seems confirmed by the little painted catacomb in the Via Appia Pignatelli, of which only a verbal description is known. "The ceiling is simply decorated with lines, only that in the middle there is a circle which seems to have contained some representation. Within this circle are traces of a crown of laurel."

In the circle at the center of such ceiling designs, as Lehmann has demonstrated, was usually painted the chief hope of heaven, the deity to whom one desired to come, or the savior, or saving symbol, to take man there. The crown still to be seen in the ceiling last described would agree with this. So in Painted Rooms I and II of the Catacomb Vigna Randanini are pagan symbols of salvation, divine figures, which, contrary to antecedent ideas, it must be imagined the Jews had somehow reconciled with their Judaism. The young man getting the crown has already got to heaven. It is no more shocking that Jews should have made use of these figures than that they used Victory, or Helios himself.

Further adaptation of the design appears in the Catacomb Torlonia, where the divisions of the ceiling are identical but where a flaming menorah occupies the circle at the center. Four dolphins with tridents are in the spaces at the four sides, but the corners are dedicated to three lulabs and a shofar. Adaptations of this design are put in the arches of the arcosolia, both with lighted menorahs at the center, in one case balanced by pomegranate and shofar, in the other by pomegranate and scroll. In another arcosolium the vault was covered with a design made up of a series of geometrical units each containing a star or sun, while at the bottom of the vault on either side a peacock seems to pick at a bunch of grapes. The combination suggests astralism as a symbol of immortality. In the vault of a fourth arcosolium were painted larger and more ornate geometrical units, with rosettes rather than the cruder star or sun symbols within them. Both can be taken to be designs of the starry heaven, and to be astral in reference. We see again that since the dome of heaven is interchangeable with the starry ceiling, both probably refer to an astral conception of religion.

Although no zodiac or Helios is preserved from Jews of the West, therefore, the Seasons and the ceiling decorations make it highly likely that they also thought of their religion in astral terms.[20] Cumont[21] noted that specific astral signs in the pagan West also were very rare, but he did not notice that the place of these was taken by the ceilings, which were so common in the West as to be-

20. A strange temple, striped in seven colors, stands among the paintings of the Dura synagogue. These seven colors have seemed to reflect the seven planets.

21. *Symbolisme*, 240, 252.

come a most important part of Christian tradition, while the more definitely astral signs, such as the zodiacs and the sun and moon ("star and crescent") had little importance in Christian symbolism. It is clearly noteworthy that the same distinction is found in Jewish art.

The specific astral signs do appear at the back of two of the Torlonia arcosolia. In one the design is largely destroyed, but the top of a gabled shrine or temple is still preserved, and a crescent moon stands beside it on either side, waxing and red at the left, waning and green at the right. This little shrine I take to be a temple, since unlike the other designs of Torah shrines, it shows one side as well as the front. But in the other arcosolium an indisputable Torah shrine stands with its doors open, cult implements clearly about it much as at Beth Alpha. This shrine is definitely in the heavens also, however, because at its left, as Lietzmann describes it, "the sun (green) breaks through clouds which are striped in black, green, and red, while on the right the moon stands likewise in striped clouds, and a dark star is directly above the shrine itself."[22] His photographs do not show this, but the fact is highly important. The impression is that the synagogue implements are elevated to the heavens, that the Torah shrine is in some way equivalent to the little temple of the first arcosolium, and that the Jews buried here could hope for nothing better upon reaching heaven than to have their own forms of worship continue. Indeed the worship prescribed for Jews on earth anticipates the life in heaven, and prepares them to go there. One feels also that the same group of symbols above the Helios and zodiac at Beth Alpha have the same reference to the heavenly nature and preparation of Jewish worship.

Cumont's long insistence upon the astral significance of the seven lamps of the menorah goes very well with this interpretation, where the flaming menorah is three times in the center of the heavenly ceiling.[23] There is much more here than Beyer and Lietzmann's "hallmark of Judaism."[24] In contrast, they take the star over the shrine to be *unzweifelhaft* the symbol of the Messiah.[25] They identify it with the star that appears over a shrine on the coins of Bar Kokba, where they suppose it means: "The Messiah will restore the Temple and its cult." Cumont's astral interpretation of the menorah by no means exhausts its symbolism, but it has the virtue of considerable literary evidence. The interpretation goes perfectly with the position of the candlestick in the design, as it well may for the candlestick between the Seasons on the sarcophagus fragment. Identification of the star with the Messiah, however, is one of those specific interpretations which I consider so dangerous that I rarely in-

22. Beyer and Lietzmann, *Torlonia*, 13.

23. *Symbolisme*, 495 f. In his earlier publications of this study in *RA*, Ser. V, Vol. IV (1916), 11–13, Cumont seemed more nearly right, though he was not then so well in-

formed on the Jewish menorah of the period in general. He by no means abandoned his old position in his later revision.

24. *Torlonia*, 20.
25. Ibid., 24.

dulge in them.[26] Largely because they were looking for such definite explanations, I feel, Beyer and Lietzmann thought that the fragments of the Seasons sarcophagus could not be Jewish, but must be pagan intrusions into the catacomb. Increasingly these fragments now seem in harmony with the astralism that appears on the walls.

One turns with fresh interest to a sarcophagus fragment found in the same catacomb which shows part of the hunting scene at which Adonis was killed. No weight can be put upon a single motif as evidence for the general beliefs of Jews at the time, but when one recalls that Adonis was an eastern symbol for the hope of immortality through the changing astral configurations that produced seasons, the irrelevancy of this piece is not so obvious as the first investigators supposed. Adonis came to be a favorite symbol in these terms throughout the West, and how far late antiquity went in lifting it above the literal level of the story appears in Macrobius' allegory of it:

> One cannot doubt that Adonis was likewise the sun when one regards the religion of the Assyrians, among whom the worship of Venus Architis and Adonis especially throve at one time, a worship now continued by the Phoenicians. For the "physicists" worshiped the upper hemisphere of the earth, the part on which we live, giving it the name of Venus, and they called the lower hemisphere of the earth Proserpina. Accordingly among the Assyrians or Phoenicians the goddess is represented as sorrowing because the sun, as it proceeds in its annual journey through the order of the twelve signs, goes down also with the part of the lower hemisphere, since of the twelve signs of the zodiac six are thought to be higher and six lower.[27] Now when it is in the lower, and accordingly makes the days shorter, the goddess is thought to grieve because the sun is as it were here lost in the grip of temporary death, and is being held by Proserpina, whom we have called the deity of the lower circle of the earth and the antipodes. They are pleased in turn to believe that Adonis has returned to Venus when, after the six signs of the lower order have been conquered, the sun begins to illuminate the hemisphere of our circle with increasing light and length of days. They teach that the killing of Adonis by the boar is a figure of winter, seeing it in this animal because the boar which is rough and tough likes wet muddy places, places covered with snow, and properly feeds on acorns, a fruit of winter. So the winter is like a wound upon the sun which diminishes both its light and heat to us, because both occur to animated things in death. A statue of this goddess has been set up on the mount Lebanon with her head veiled and with a sad expression. She holds her face with her left hand covered by her garments and they believe that tears trickle down at the sight of the onlookers. This image, besides representing as we said the sorrowing goddess is likewise a figure of earth during the winter, at which time when the sun is veiled

26. In reading explanations of symbols I have found that "doubtless" is almost always a prelude to a very dubious suggestion.

27. This conception of the zodiac is discussed from the astronomical point of view by Franz Boll, *Sphaera*, 1903, 247.

with clouds she is widowed and benumbed, and the fountains, as though they were the eyes of the earth, flow more copiously, and the very fields which for the time are left untilled show a sorrowful face. But when the sun emerges from the lower parts of the earth and passes over the line of the vernal equinox while the days lengthen, then is Venus gay, and the fields become beautifully green with rising grain, the meadows with grass, the trees with leaves. Wherefore our ancestors dedicated the month of April to Venus.[28]

We are getting ahead of our story, but it is at once clear that if the Jews had use for the Seasons as symbols of their hope, they could as well have used the figure of Adonis, whose death represented the death of the sun, of vegetation, and the hope of nature, and of us as part of nature and its resurrection. If a Roman Jew who thought of the future life in astral terms wanted a sarcophagus which expressed that hope, since the Roman world had no convention for direct designing of astral signs upon sarcophagi, it is hard to think how better, or, to those who knew, how less invidiously, he could plan his sarcophagus than to have Seasons, or the death of Adonis, upon it.

Steadily we are pushed back to the possibility that these astronomical symbols, and Helios himself, meant something in the Judaism of these Jews, something which could be as central in their thinking as the zodiac panels are physically central in the synagogue floors. In synagogues we cannot take them to be the pagan Helios, or personally divine Seasons or zodiac signs. Had these Jews regarded Helios or the Seasons or Adonis as valid and acceptable personal gods, their Judaism would have become meaningless: they might better have worshiped with the pagans in their temples and spared themselves the trouble of building distinct houses for Jewish worship and the distress of Jewish particularism in Roman society. We have seen, however, that Jews were indeed practising syncretism in another sense, for the other types of symbols we have discussed have shown a strong probability that Jews brought the symbols into Judaism in order to appropriate the values inherent in the symbols, and that though by giving them Jewish explanations the origin of the symbols in paganism was obscured, at least to the Jews who borrowed them the basic values were by no means lost.

The astral and cosmic symbols in themselves have superficially suggested that Jews had done much the same with them as with the others, that they had Judaized them with explanations in Jewish terms while they had used the original values of the symbols to enrich Jewish religious life and hope. If such a hypothesis seems suggested by the astral symbols as they appear in Jewish archeological remains, we must test it by trying to isolate the essential religious

28. Macrobius, *Saturnalia*, 1, 21 (ed. Eyssenhardt, 117 f.). He may have had this from Porphyry: PW, XIV, i, 195; Cumont, *Symbolisme*, 42.

values of astral symbols in paganism, and then by looking to see if Jewish literature justifies our thinking that those values did go over into Judaism.

B. ASTRAL SYMBOLS IN PAGANISM

THE PAGANS from whom Jews borrowed astral symbols could have used them with symbolic reference, or as mere ornament, so far, at least, as the designs themselves are concerned. We must accordingly recall the place of astralism in ancient thought before we can judge whether the representations had more than decorative value, and, if so, what that value was.

1. In Religious and Philosophic Thought of the Greco-Roman Period

INFORMATION on the place of astralism in Greco-Roman thinking is scattered through a great number of ancient sources. Some of them are as familiar as the writings of Plato, even as his *Apology* itself, where Socrates takes it for granted that the sun and the moon are the one type of gods in which everyone (except the incredulous Anaxagoras) believes. Other sources are highly difficult astrological treatises of which the most commonly known are the *Astronomicus* of Manilius and the *Tetrabiblus* of Ptolemy, while new ones occasionally turn up in manuscripts.[29] Throughout the literature of antiquity more or less elaborate allusions are made to the stars, their nature and relation to men, allusions which for our purposes have even more importance than the formal treatises. The monuments of antiquity furnish many references to the stars in inscriptions and carved representations. And the documents of later philosophers and Gnostics, such as the passage just quoted from Macrobius, as well as the literature and archeological data of early Christianity, offer perhaps most pertinent evidence.

To all this the beginner has still no adequate introduction, though the best approach is through the repetitious but highly imaginative (in the best sense of the term) writings of Cumont.[30] He is to be supplemented by technical his-

29. The most recently published, to my knowledge, is a Hermetic astrological tractate; see Wilhelm Gundel, *Neue astrologische Texte des Hermes Trismegistus*, 1936 (Abhandlungen der Bayerischen Akademie der Wissenschaften, Philosophische-historische Abteilung, N.S., XII).

30. Aside from Cumont's many smaller studies in periodicals, the results of which

were usually incorporated in later studies, the most important for the religious value of astral symbolism are: "Le Mysticisme astral dans l'antiquité," *Bulletins de l'Académie Royale de Belgique*, Classe des Lettres, 1909, 256–286; "La Théologie solaire du paganisme romain," *Mém.*, AIB, XII, ii (1913), 447–479; *Les Religions orientales dans le Paganisme romain*, 3d ed., 1929, esp. chaps. VII, VIII; *As-*

tories of astronomy, the works of W. Gundel,[31] Hanfmann,[32] Nilsson,[33] and others.[34]

We have seen that nothing in the Jewish monuments seems to refer to astronomy as a science or to astrology as a technique of divination, so that we may leave those highly controversial subjects to the experts. Briefly it may be remarked that the experts still seem basically to disagree: champions of Egypt oppose protagonists of Mesopotamia as the original site of astronomy, the source whence it flowed to others. And there is just as little agreement on the contribution of Greece. One thing however is obvious: by the hellenistic period interest in the stars was spreading rapidly all over the western world. Philosophies like Stoicism early became drenched with astralism, as the pantheistic cyclical determinism of Zeno was seen to have its counterpart in the cyclical determinism of the stars themselves. According to Cicero,[35] "Zeno attributed a divine power to the stars, but also to the years, the months, and the seasons." Other schools were no less eager to adopt the stars as gods in order to get a deity, or deities, who, following the strictures of Plato and all thoughtful men of Greece, would take the place of the Olympians. Even in Aristotle the stars are what we should call personalities, and the efficient causes in the universe.[36] In this, as Cumont points out, Greeks were but paralleling (or following) a sim-

trology and Religion among the Greeks and Romans, 1912; Etudes syriennes, 1917; After Life, 1922; "Zodiacus" in DS, V, 1046–1062; L'Egypte des astrologues, 1937; Symbolisme, 1943; Lux perpetua, 1949, esp. pp. 303–342.

31. Besides the work just cited see his Sternglaube, Sternreligion und Sternorakel, 1933; Dekane und Dekansternbilder, 1936; and, with Boll, "Sternbilder, Sternglaube und Sternsymbolik bei Griechen und Römern," in Roscher's Lex. Myth., VI, 1937, 867–1071.

32. Hanfmann, Seasons, is so centered on the Seasons that other aspects of astralism are considered only incidentally. But the book is very rich, and critically developed.

33. See esp. his Griech. Rel., II, 256–267, 465–498. He here gives elaborate references to the sources and to his and others' earlier works. See also his "Die astrale Unsterblichkeit und die kosmische Mystik," Numen, I (1954), 106–119.

34. Much of interest is in Lynn Thorndike, A History of Magic and Experimental Science, 2d ed., 1929, I; Ernst Herzfeld, "Der Typus des Sonnenund Mondwagens in der

sasanidischen Kunst," Jahrbuch der preussischen Kunstsammlungen, XLI (1920), 105–140; Franz Boll, Sphaera: Neue Griechische Texte und Untersuchungen zur Geschichte der Sternbilder, 1903; P. Boyancé, "La Religion astrale de Platon à Ciceron," REG, LXV (1952), 312–350; one should never omit Robert Eisler, whose various works, especially Weltenmantel und Himmelszelt, 1910, are highly valuable as phantasmagorias of uncritically used material.

35. Natura deorum, I, 36. Cf. Cumont, Astrology and Religion among the Greeks and Romans, 108.

36. See W. D. Ross on the "Intelligences": Aristotle, 1937, 98, 181. Aristotle, perhaps, is thinking of the "spheres" as thus animate rather than the stars themselves, as E. Zeller insists (Aristotle, 1897, I, 495, n. 4), but Zeller admits that Aristotle says of the stars that we are to think of them not as mere inanimate bodies, but as partaking of initiative and life: On the Heavens, II, xii, 292a18–21 (ed. W. K. G. Guthrie, Loeb ed., p. 206).

ilar tendency of religious thinkers in the East, which put the old gods of my-
thology, gods which were originally local fertility or nature deities, into the
stars.[37] When Ishtar or Venus became a planet with a predictable course, and
even the vagaries of Mercury or Mars had been stabilized, man himself took
on a new and civilized dignity as he strove to live an ordered life in an orderly
universe. From the point of view of science, astronomical and astrological (our
sharp sense of distinction between these is very recent), the goal was to chart
accurately the paths and influences of those cosmic rulers — that is, to achieve
complete comprehension of what was now becoming comprehensible. Blind
fortune, chance, disappeared from such a universe, and fate or providence,
two terms for the same thing, took their place.

Iamblichus has already been quoted at length for his final summary of this
development. Powers, says he, radiate from the sun to every part of the
heaven, to each sign of the zodiac and heavenly motion. These recipients par-
tially absorb the radiation. So the zodiac represents God who, hourly changed,
is yet changeless. Plural in manifestation, God is single in himself and in his
power.

Man's position in the universe was clear: the soul of man, whether in Pla-
tonic-"Orphic" dualism of matter and spirit or in Stoic distinction between
finer and less fine matter, was a prisoner on this earth. This soul came, prob-
ably, from one of the stars and was destined at death to return, either imme-
diately or after contingencies variously defined by different religions, to its
source. The cycle implied with some the extinction of a star (a falling meteor)
and then its later rebuilding as the soul returned to the primum mobile; or it
implied the reverse, and the falling star was a death. With some the body, too,
could ascend.[38] Great people, especially kings, could seem to be great stars,
even the sun itself, on earth.[39] By no means excluding other beliefs, there came
into wide acceptance the conception that the sun was the source of all souls and
was their constant nourisher, just as the moon nourished men's bodies. At
death the sun took the soul back to itself, was its "anagogue" to draw up the
soul of men from cloying matter.[40] Cumont has brought this out, as so much
else, and refers to the "mass of literary evidence and a number of figured mon-
uments" which show the power of the sun god as god of the dead. The astral
immortality was combined with the solar in many devious ways, such as in the
theory that souls in ascent had to stop at each of the planets for certain purifi-

37. L.-H. Vincent discusses an interest-
ing instance of this in his "Le Culte d'Hélène
à Samarie," *RB*, XLV (1936), 221–232.

38. W. Gundel in Roscher, *Lex. Myth.*,
VI, 1062 f.

39. On the Emperor as beyond the effect
of astral determinism because of his inherent
divinity see Firmicus Maternus, *Mathesis*, II,
xxx, 4–7 (ed. W. Kroll and F. Skutsch, 1897,
I, 86 f.).

40. *After Life in Roman Paganism*, 101–
109, 156–164; *Symbolisme*, 202–252.

cations; or the astral and solar theories were just left side by side unrec-
onciled.[41] Still another conception, of great importance in the centuries when
the Jewish monuments were being made, is lunar immortality, the notion that
the abode of the happy dead was the moon. Cumont[42] has richly expounded
with abundant documentation the manifold forms in which this doctrine was
expressed. He shows that the sun and moon, in some circles especially the
moon, came to be regarded as the actual site of the mythological Isles of the
Blessed, where the fortunate had their immortality, and that this idea was ex-
pounded especially by later philosophers and popular oriental cults, but from
all his material what emerges most clearly is that there was no standardized
version of this conception. Sometimes the moon was this abode by itself, some-
times the sun; sometimes the souls of the blessed went into the sphere of the
fixed stars, using the sun and moon as gates; sometimes they ascended
through the seven spheres of the planets. Certainly there was no such unanim-
ity of interpretation that we can recognize in the funerary symbols any definite
system of reference to the heavenly bodies. Indeed, like the Dioscuri, the Sea-
sons, and the zodiac, the sun and moon seem often to represent the great
cycles of the universe, day and night, winter and summer, so that Eternity is
often represented on coins as a veiled goddess holding in either hand the sun
and moon. As such she could represent, as she seems to do on coins, the eternal
power of the state; similarly the sun and moon on tombstones could represent
eternity as the hope of the individual.[43]

To complicate this picture philosophers of the Platonic and Pythagorean
tradition could neither escape the attraction of the astronomic scheme nor ac-
cept it literally. So by some all of this was transferred to that basic Platonic con-
ception of the Good as the Sun which Plato originally set forth in the *Republic*.
Here the visible sun, the material sun, is the highest existence in the material
world, and is a copy of the ultimate self-subsisting entity of the world of Forms.
Astronomy is studied by Plato's guardians in order that the conception of
material units and order may lead to the higher conception of true order in the
immaterial world. So for the later immaterialists and Neoplatonists astronomy
and number had tremendous importance, but only as introductory to philos-
ophy itself, which went completely beyond them into the One. The philoso-
phers, of course, were also human beings, so that even Origen kept much

41. Christianity similarly has a double
conception of the after life: by one concep-
tion the dead sleep in the grave until the day
of the Resurrection, and by another they go
at once, "this day," to Paradise or Purgatory
as the case may be. Both conceptions are rep-
resented in burial services, and if they are
reconciled by professional theologians the
reconciliation is no part of popular under-

standing. A devotee, from a memorial mass
for his father in Purgatory, goes to decorate
the grave without the slightest sense of incon-
sistency. Consistency in beliefs is a necessity
for very few people of any age.

42. *Symbolisme*, 177–252. Cf. Nilsson,
Griech. Rel., II, 471–475.

43. Cumont, *Symbolisme*, 78 f. (esp. 79, n.
5); 94, n. 2.

literal astralism along with his Platonic immaterialism, as indeed did most of the Neoplatonists, such as Julian, Porphyry, Iamblichus, and Proclus.[44]

Popular theosophy made still other modifications. As represented by the Hermetic tradition, for example, the true God was one, quite beyond the universe; but the actual rulers of the material world are the visible gods, the stars, of whom the sun is the greatest. These give out the decrees of fate, and only rare people have so spiritual a nature that they can by gnosis ascend beyond fatalism through the spheres to the spiritual world.[45] This gnosis is the special and secret possession of the Egyptian priests, for to them the gods, and especially Hermes-Thoth, have revealed all human knowledge and useful inventions. Especially has Thoth invented writing and indited sacred books which cannot be entrusted to the profane.[46] Astrology and philosophy are conspicuous parts of this sacred and secret lore, for "philosophy" as Hermeticists use the term was the erudition wherein the old oriental mysticism has learned to use the terminology of the Greek philosophic schools.[47] During the most scientific period of the hellenistic age the connection of the stars with human immortality faded out. Men were content to study the stars and learn to submit to their implacability, or to try to ascend to them, or to the spiritual world they represented, in mystic ascent during this life.[48] It is to Ptolemy himself that these verses are attributed:

> I know that I am mortal and ephemeral, but when I trace the dense multitude of stars in their circular courses my feet no longer touch the earth, but I am, along with Zeus himself, filled with the ambrosia on which gods are nourished.[49]

Centuries later, when the values of astralism for immortality had become central, its value for mysticism and ethics was still proclaimed. So Firmicus Maternus says:

> Gaze upon the heavens with open eyes and let thy spirit never cease to regard that most beautiful fabric of divine creation. For then our mind is regulated by

44. Cumont, *After Life in Roman Paganism*, 107 f.; cf. ibid., index, s.v. Neoplatonists. See also Thorndike, *History of Magic and Experimental Science*, I, 298–321.

45. Thorndike, 290.

46. Cumont, *L'Egypte des astrologues*, 152. This remarkable book was inspired by the discovery of the latest and greatest of the hermetic tracts on astrology, that published by Gundel (see above, n. 29), but Cumont made his reconstruction on the basis of all the available material. The chapters on religion and morality (pp. 113–206) are especially impor-

tant for the religious value of pagan astrology.

47. Ibid., 122, 152 f.

48. Ibid., 203–206.

49. *Anthologia Palatina*, IX, 577. Frequently quoted by Cumont, as in *L'Egypte des astrologues*, 206. He quotes this also in his "Le Mysticisme astral dans l'antiquité," *Bulletins de l'Académie Royale de Belgique*, Classe des Lettres, 1909, 277. This entire essay, especially the collection of material on pp. 279–286, still has great value.

the memory of its own majesty, and so is freed from the vicious seductions of the flesh; stripped of the restraints of mortality, it presses forward with rapid steps toward its Author, and through every hour of the day with wise and ever eager curiosity it investigates nothing but divine matters. By doing this we get a notion, however inadequate, of divine knowledge, and even come through to the secrets of our origin. For as we keep ourselves constantly busy with divine discussions, apply our souls to the celestial powers, and initiate them with divine rites, we are removed from all desires of the wicked lusts.[50]

Philo so well reflects the spirit of his day that he, too, has amazingly little to say about personal immortality and seems to find complete satisfaction in mystical absorption of an almost Hindu type, although, with his predictable inconsistency, in a few passages he speaks of the next life in terms of more personal survival.[51] Perhaps here Philo's very inconsistency reflects the change which was coming upon men, a fresh desire for personal immortality in the Imperial centuries.

For after the great scientific advances of the hellenistic period there came a breakdown of interest in pure science and such a popularization that astrology or astronomy again seemed to have its chief point in nourishing a hope for immortality, which Plato had shown but which had largely disappeared in the age of science. These sciences, as Cumont said, no longer presented themselves as a learned theory taught by mathematicians but became sacred doctrines revealed to the adepts of exotic cults, which have all assumed the form of mysteries.[52] Now, while the philosophers could continue to use scientific conceptions, each school in its own way, the common man could increasingly put Seasons and other recollections of the starry hope on their graves, while the Emperor himself could, at last completely, base his claims to authority upon Sol Invictus.[53] Still the debate continued as to whether the cosmos was itself the ultimate, and the stars were the determining forces if they were not actually personalities, or whether the stars did not merely reveal the purposes and ineluctability of an immaterial causation. Neoplatonism, of course, took the second choice, but to Plotinus the stars had great power, or were manifest signs, in shaping the future. He did not like the astrologers or their works but seemed unable to get away from their influence. Only the soul, he felt, was free of magic and determinism: in the life of reason, and in it alone, could man rise above the tyranny of the stars.[54]

50. *Mathesis* (ed. Kroll, Skutsch, and Ziegler), VIII, 6, 7 (II, 282).

51. See my "Philo on Immortality," *HTR*, XXXIX (1946), 85–108.

52. *Astrology and Religion*, 91. See the excellent presentation of the astral mysticism of Vettius Valens by Festugière in his *L'Idéal religieux des Grecs et l'Evangile*, 1932, 120–125.

53. *Astrology and Religion*, 94–99. One recalls the portrait of the Emperor Constantius Gallus in a toga covered with pictures, many of which recall signs of the zodiac, and which Eisler thinks shows the ancestry of the medieval starry mantel of royalty: R. Eisler, *Weltenmantel und Himmelszelt*, 1910, I, 38.

54. Thorndike's chapter "Neo-Platon-

It becomes clear, then, that in adapting their various mythologies and types of worship to the new astronomy, the ancients of all sorts and places felt that they were squaring their faith with the new and true science. The old rites were kept, to be sure, though they had to be allegorized. For example, Porphyry asked why the ancients used the old phallic pictures and rituals if the gods are in reality these unruffled and unresponsive stellar beings? The answer which Iamblichus and all later antiquity gave to this was that the old rites were symbolic, valuable not for drawing the gods down to us but for elevating man to the impassive gods. So in a world of scientific causation religion kept not only its value but its ancient forms. "The [words] of the ancient prayers, like holy sanctuaries, must be preserved identical and unchanged, with nothing either taken away from them nor added from other sources," said Iamblichus.[55] One could not live, and still cannot live, in a scientific world and keep one's faith in a traditional religion, formed centuries before the science itself, in any other way. Presented with the dilemma, some will be "fundamental" to the point of rejecting the world of science: others in the interest of science will reject the traditional values (conceived now as injurious falsehoods) in favor of a "purely scientific" point of view. For religion itself the path is precisely such a compromise as the later Platonists devised, as well as Philo and the Christians after them. The major premise of all such compromising has been that if the traditional religion is literally false according to science but pragmatically true in its elevating effects upon human life, the religious act must be true in some symbolic sense which we may or may not be able to describe.[56] We may or may not, for example, identify our beloved Venus with a star and say that the old forms of address to her had always, though unwittingly, been directed to sidereal rulership. But if the science of the day asserts that causation in the universe is sidereal, we cannot continue to be wholehearted scientists unless our beloved Venus either is rejected or suffers from such transformation. Certainly we cannot continue to be religious and scientific at once without such allegory. The possibilities of these allegorical transformations are manifold. Our God may become immaterial and, rising to heights quite beyond this sidereal system, become the force behind it. The god ceases to be the old Venus or Dagon or Yahweh in this process and, beyond even physical determinism, becomes the immaterial Unmoved Mover. Religion saves its face, moves over into the age of the new science, as it learns to call the new force by the old

ism," *History of Magic and Experimental Science,* I, 298–321, contains much pertinent material not to be found elsewhere.

55. *De mysteriis,* VII, 5. Quoted by Thorndike, 311 f. See his pages 308–312. Iamblichus wanted prayers said in their original languages, since "words do not keep quite the

same meaning when they are translated" (ibid.).

56. See the argument to this effect by Sallust, *De diis et mundo,* XV, XVI, and the translation and commentary by A. D. Nock, *Sallustius Concerning the Gods and the Universe,* 1926, pp. LXXXIII–LXXXVI, 29–31.

name. The essence of religious continuity lies in the persistence of the rite—
the name, the symbol, the emotional attitude—and when this continuity is
preserved, the rest may change and welcome. The value thus survives into a
new world of explanations.

Men of the declining Empire, like many of our own contemporaries, were
more concerned to make this religious appropriation of science than to de-
velop science itself. For the appropriation, as has been mentioned, brought a
renewed source of inspiration and strength to this life, and a hope of life after
death, as it devised a fresh expression of that hope in astronomical symbols.
Cumont has shown how inscriptions indicate, even in the first century B.C., the
widespread conception that the soul goes to the stars at death, as the body re-
turns to the dust.[57] This was a popularization of the apotheosis of kings and
other great ones, just as the general hope of immortality seems to have devel-
oped in Egypt from a popularization of the divine nature of the king. Most
men, then as always, who had such hopes of ascent as that through the stars to
the pure fire or ether, or to the immaterial nature behind all matter, based
their hopes largely upon the effectiveness of ritualistic ceremonies, what is
generally called "magic."

Plato had hoped for restoration to the Forms beyond the stars through the
purification of his nature by philosophy, by mathematical discipline, by high
ethics, and by strict asceticism, and the later Platonists fully agreed with him,[58]
as did the Pythagoreans from whom Plato may largely have had the notion.
Such a conception could easily be combined with that of a saving god, a
Hermes or Helios, who, each in his own way, took the soul to the blessed re-
gions. We have already found in the eagle, Pegasus, the griffin, the ladder, and
the boat suggestions taken into Judaism of this saving activity of God. Now the
sun god in his chariot is added as another symbol whose chief religious value
lay precisely in the hope that the soul might rise to the stars, and beyond, in
such a fiery chariot.[59]

2. In Pagan Art

SUCH WAS the meaning of the astral symbols to pagans. And these symbols
went into all aspects of their religions. Not only does the zodiac normally ap-

57. *Astrology and Religion*, 174–179.

58. See my "Literal Mystery in Hellenis-
tic Judaism," *Quantulacumque, Studies Pre-
sented to Kirsopp Lake*, 1937, 227–241, and
P. Boyancé, *Le Culte des Muses chez les philo-
sophes grecs*, 1936.

59. On this see the last chapter in Cu-
mont's *Astrology and Religion*; his "Mysticisme
astral dans l'antiquité," *Bulletins de l' Académie*

Royale de Belgique, Classe des lettres, 1909,
256–286, and his "La Théologie solaire du
paganisme romain," *Mém., AIB*, XII, ii
(1913), 447–479. See also Seyrig, "La Triade
héliopolitaine et les temples de Baalbek,"
Syria, X (1929), 314–356, where is discussed
the promotion of Hadad and other Near-
Eastern sun gods to being the transcendent
Deity; at the same time a minor deity, in

pear upon Mithraic shrines:[60] it surrounds a peculiar figure which seems a syn-
cretistic softening of the leonine Chronos of Mithraic symbolism, whereby that
ferocious figure is identified with some milder (perhaps "Orphic") personal-
ity.[61] Similarly the zodiac in the form of the twelve months surrounds a strange
figure, enthroned and with a cornucopia, at whose feet lies another figure on
a couch, with hand raised toward his companion, fig. 14.[62] The identity, and
even the sex, of these figures is uncertain. Again the Seasons[63] are in the cor-
ners, and the border of animals, for all its striking differences, suggests the
basic scheme of Beth Alpha. Cagnat recalls: "In this place in analogous mosaics
we find Apollo surrounded by the signs of the zodiac, very often Bacchus or
even Mercury with Abundance, or even Annus holding the sun and moon in
his hands." The "Apollo" or Helios is now a familiar motif. The mosaic with
Hermes and Abundance[64] to which he refers has only the Seasons, not the zo-
diac, with it, and at once suggests the figure on the ceiling of the Jewish Cata-
comb Vigna Randanini. Pellegrini thinks that this Hermes and Abundance, on
the mosaic floor of what seems to be a private house, indicated that the house
belonged to a rich merchant who was hoping for prosperity from the patron
deities of commerce. He may be right, but the Seasons certainly had little to do
with this, and I suspect that the "merchant," if such he was, used a symbolism
which implied for him rewards in the next life as well as in this life. The Annus
in the zodiac to which Cagnat refers[65] is a medieval adaptation of an ancient

Greek usually the equivalent of Hermes, was
made the revelation of this supreme God in
the material realm (the physical sun was one
manifestation), and the psychopomp to take
men to him. Hermes in this sense was also
Dionysus, and his symbol was the grape.

60. See Cumont, *Textes et monuments fi-
gurés . . . de Mithra*, 1896, II, plates v, vi, vii,
and figs. 304, 315, 419. The Dura Mithreum
also has a zodiac.

61. See F. Cumont, "Notices sur deux
bas-reliefs mithraïques," *RA*, Ser. III, Vol. XL
(1902), 1–13, plate I. R. Eisler, *Weltenmantel
und Himmelszelt*, 400, suggested that this was
an Orphic piece, as had C. Cavedoni much
earlier (see Cumont, 5). Cumont in *Les My-
stères de Mithra*, 3d ed., 1913, 107, n. 3 opined
that Eisler had gone too far but argued that
this relief might have resulted from Orphic
influence upon Mithra. See also L. Ziegler, in
Neue Jahrbücher für Philologie, XXXI (1913),
562; idem in Rocher, *Lex. Myth.*, V, 1536;
F. M. Cornford, *Greek Religious Thought from
Homer to Alexander*, 1923, 56, n. 1. The best
recent collection of zodiacs of this sort, and

discussion of them, is by Alda Levi, *La Patera
d'argento di Parabiago*, 1935, 8–10 (R. Istituto
di Archeologia e Storia dell'Arte, Opere
d'Arte, V). Miss Levi agrees with Cumont.
She discusses also two other Mithraic com-
binations, in which Mithra is born from the
rock within a zodiac circle: see p. 9, and
plate v, 2 f.

62. From R. Cagnat, "Une mosaïque de
Carthage," *Mémoires de la Société des Anti-
quaires de France*, LVII (1896), 251–270,
plate IV. Cagnat (p. 256) suggests the possi-
bility that the seated figure may be *Annus*;
Eisler *Orph.-dion.* 28, asserts positively that it
is *Aeternitas*.

63. On the Seasons in Mithraism see Cu-
mont, *Textes et monuments relatifs au culte de
Mithra*, I, 92 f.; Hanfmann, *Seasons*, I, 182.

64. *BICA*, 1870, 167.

65. Ernst A. Weerth, *Der Mosaikboden in
St. Gerreon zu Köln*, 1873, plate IX. Several
other interesting medieval zodiacs are pub-
lished in this volume: see plates I, VIII, and p.
22.

design, and while this and the medieval zodiacs in general are very interesting, it is dangerous to bring them into a discussion of earlier symbolism beyond noting that they persisted in spite of the official Christian prejudice against use of the zodiac.[66] Miss Levi[67] is probably right in identifying the central figure here with Dionysus, but the recumbent figure is probably Tellus, from analogy with the other zodiac scenes. The motif of a deity with zodiac or Seasons frequently appears. In the mosaic of Sentinum at Munich, Helios stands within the zodiac, with the Earth, or Tellus, and her four children, the Seasons, at his feet.[68] Helios in his quadriga rides at the center of a zodiac in the Münster mosaic. In this a pair of fish confronting an urn take the place of each of the Seasons in the corners.[69] In the cameo shown in fig. 15[70] the sun god rides through the zodiac, with the goddess Earth, or Tellus, cornucopia in arms, beneath him. We are beginning to feel that the god or goddess with the cornucopia symbolically declares that the old hope of immortality which man got through identifying himself with the fertility cults was the same as that one got through astral identification. For the cycle of the year itself is on earth as it is in heaven: that it brings fertility and life can be symbolized by Helios or another in the zodiac along with the Seasons, or by some abridgment of this.[71] Earthly and heavenly symbols together show that the early fertility-mystic hope of future life has identified itself with the new astronomical hope. The phenomenon is too familiar to need detailed exposition. The idea itself is as old as Egypt, where from very early times, we have seen, the Osiris of the Nile, the fertilizer of the earth, was identified with Ra of the sun, or took his place. It is again reflected in Plutarch's *On Isis.* From later times we need perhaps only a single

66. Cumont in *RA,* Ser. V, Vol. III (1916), 6, quotes the tenth canon of the Council of Braga (A.D. 563): *Si qui duodecim signa, quae mathematici observare solent, per singula animae vel corporis membra disposita credunt et nominibus patriarcharum adscripta dicunt, anathema sit.* Cf. Augustine, *De haeresibus,* LXX (Migne, *PL,* XLII, 44); *Ad Orosium,* II (*PL,* XLII, 677). To this we shall return below.

67. Page 9.

68. Frequently published: see R. Engelmann in *AZ,* XXXV (1877), 9–12, and plate 3.

69. Reinach, *Peintures,* 25, no. 1. That this is not a chance motif appears from a mosaic from Vienne in which the head of Poseidon is in a circle at the center of a square design and surrounded by cantharoi and dolphins: ibid., 37, no. 5; but Poseidon can ride his marine quadriga in a circle with the Seasons in the corners quite like Helios: ibid.,

36, no. 2.

70. From J. B. Wicar and M. Mongez, *Tableaux, Statues . . . du Palais Pitti,* 1804, III. The plates are not numbered: this is the 39th from the beginning, the 10th from the back. The conception of Helios or Sol riding the chariot above, and Tellus or Earth as a prone woman holding the cornucopia is also found, Reinach recalls, on coins of Antoninus Pius and Marcus Aurelius: Reinach, *Pierres,* 67, and plate 69, fig. 87.

71. We do not know what was in the center of the North African mosaic floor, in which a central medallion was surrounded by the twelve months, with the four Seasons in the corners. The religious importance of each seems to be indicated by the attributes: R. P. Hinks, *Catalogue of the Greek, Etruscan and Roman Paintings and Mosaics in the British Museum,* 1933, 89–96, plate XXIX.

illustration, a statement from the fourth century of what the old nature myth of the Mother of the Gods and Attis had come to mean, a statement important to the ancients because it appears almost identically in the writings of Sallust and of the Emperor Julian. I quote Nock's translation:[72]

> If I must relate another myth, it is said that the Mother of the Gods saw Attis lying by the river Gallos and became enamoured of him, and took and set on his head the starry cap, and kept him thereafter with her, and he, becoming enamoured of a nymph, left the Mother of the Gods and consorted with the nymph. Wherefore the Mother of the Gods caused Attis to go mad and to cut off his genitals and leave them with the nymph and to return and dwell with her again. Well, the Mother of the Gods is a life-giving goddess, and therefore she is called Mother, while Attis is creator of things that come into being and perish, and therefore he is said to have been found by the river Gallos: for Gallos suggests the Galaxias Kyklos or Milky Way, which is the upper boundary of matter liable to change. So, as the first gods perfect the second, the Mother loves Attis and gives him heavenly powers (signified by the cap). Attis, however, loves the nymph, and the nymphs preside over coming into being, since whatever comes into being is in flux. But since it was necessary that the process of coming into being should stop and that what was worse should not sink to the worst, the creator who was making these things cast away generative powers into the world of becoming and was again united with the gods. All this did not happen at any one time but always is so: the mind sees the whole process at once, words tell of part first, part second. Since the myth is so intimately related to the universe we imitate the latter in its order (for in what way could we better order ourselves?) and keep a festival therefore. First, as having like Attis fallen from heaven and consorting with the nymph, we are dejected and abstain from bread and all other rich and coarse food (for both are unsuited to the soul). Then come the cutting of the tree and the fast, as though we also were cutting off the further progress of generation; after this we are fed on milk as though being reborn; that is followed by rejoicings and garlands and as it were a new ascent to the gods. This interpretation is supported also by the season at which the ceremonies are performed, for it is about the time of spring and the equinox, when things coming into being cease so to do, and day becomes longer than night, which suits souls rising to life. Certainly the rape of Kore is said in the myth to have happened near the other equinox, and this signifies the descent of souls. To us who have spoken thus concerning myths may the gods themselves and the spirits of those who wrote the myths be kind.

Such a combination of fertility and astral symbolism seems to have disappeared when in the North African mosaic of Bir Chana the days of the week

72. From Nock, *Sallustius Concerning the Gods and the Universe*, 7–11. See the notes on pages L–LV. It is generally supposed, as Nock indicates here following Cumont, that Sallust has used, with discretion, Julian's Oration on the Mother of the Gods (*Orationes*, V, 161C–162A).

are surrounded by animals, and these by the zodiac, all worked into a six-point star.[73] For here the symbols are all temporal or astronomical, and fruits or a cornucopia are left out.[74] Yet precisely that combination appears very frequently, as in the gem in fig. 17,[75] where a young god in a zodiac (only ten of the signs) has the crown of Helios, the wings of Eros, and the cornucopia of Abundance. It is presumably Dionysus in the place of Helios in fig. 16[76] who holds the zodiac in one hand, the cornucopia in the other, along with a grape-vine and the flowers of the Elysian Fields. The Seasons surrounded this. So when it is a Pan and goat beside an altar within the zodiac, fig. 18,[77] the Dionysiac nature-hope seems suggested, though this gem, with the star at Pisces, may well have been the lucky birth-piece of the owner. To be sure other gods appear within the zodiac frame: Zeus,[78] Serapis,[79] Heracles,[80] even Selene.[81] The portraits of the deceased can be put inside the same frame upon their sarcophagus, fig. 19,[82] and Cumont is certainly right in seeing in this their apotheosis in astronomical terms. He seems also right in associating such a conception with the Jewish Seasons sarcophagi. The same combination of astronomical and fertility hopes is symbolized in both. For on the pagan sarcophagus the Seasons stand beside the zodiac frame of the portraits, and

73. Frequently published. See Reinach, *Peintures*, 226, no. 4.

74. As was quite commonly the case when Helios rides without any such earthly concomitant: see, for example, the instances in Reinach, *Pierres*, plate 69.

75. From ibid., plate 125, fig. 49.

76. From Levi, *La Patera d'argento di Parabiago*, plate IV, 2; cf. p. 9.

77. From Reinach, *Pierres*, plate 69, fig. 88[3].

78. C. W. King, *Antique Gems*, 1860, plate III, 7; two are shown in *Monumenti antichi inediti*, Rome, July, 1786, plate III, one on a medallion of Antoninus Pius, the other on a peculiar memorial to the dead, where Atlas holds the circle of the zodiac, in which Jupiter or Zeus sits enthroned with an eagle at his side, while another eagle, whose pose suggests the solar eagle of the east, sits above the whole. In Reinach, *Pierres*, plate 82, fig. 1, Zeus with a zodiac circle similarly sits enthroned; Ares and Hermes are at either side as throne guards, with Poseidon at his feet.

79. G. B. Passeri and A. F. Gori, *Thesaurus gemmarum antiquarum astriferarum*, 1750, plate XVII.

80. The funerary monument of the Secundinii at Igel has in relief a scene of the apotheosis of Heracles surrounded by signs of the zodiac, with the four Winds in the corners. The twelve labors and the twelve signs of the zodiac, if this association was not original, came together inevitably in the hellenistic syncretism: C. Picard, *La Sculpture antique de Phidias à l'ere byzantine*, 1926, 457, fig. 181. Cf. Cumont, *Symbolisme*, 174 f., with bibliography at 174, n. 3.

81. A. H. Smith, *A Catalogue of Sculptures in the British Museum*, 1904, III, 231. I am not at all sure that this is not a portrait, in which the person portrayed has the attributes of Selene. Aesculapius with other unidentified figures appears within the circle: *Monumenti antichi inediti*, Rome, July, 1787, plate II; and the group is quite perplexing in the same setting in Reinach, *Pierres*, plate 129, fig. 34.

82. Courtesy of the Dumbarton Oaks Collection, Washington, D. C. See Hanfmann, *Seasons*, II, 2–16; cf. I, 3–15. See also the similar sarcophagus at the Campo Santo, Pisa, with the comments by Cumont, *Symbolisme*, 487 f.

Dionysiac scenes of vintage and of milking a ewe are below. In comparison, the menorah on the Jewish sarcophagus may well represent the seven planets, and be an astronomical reference in Jewish terms, along with the Seasons and Dionysiac fertility representations, for such was the meaning of the menorah as Philo and Josephus described it. To this we shall return.

One interesting syncretistic variant was to make the twelve Olympians into the twelve signs of the zodiac (on a Dionysiac altar),[83] and here it is clear that the person who made such an identification wanted to keep the values of the old Greek gods as he went over into the new religion of the cosmos. The Jews seem to have transposed values in much the same way, we shall see, when they identified with the zodiacal signs the twelve stones of the ephod as well as the twelve tribes. The Christians did similarly with the twelve apostles.

Another syncretistic use of the zodiac is shown in fig. 20.[84] Here Helios and Selene ride their chariots above, led by the stars of dawn and sunset respectively. Below, in a quadriga drawn by lions, ride a male and a female figure, whom Miss Levi calls, with great probability, Cybele or the Great Mother with Attis. They are accompanied by three warriors in the dancing poses of corybantes. Before them is a group made up of Atlas supporting the zodiac again, and a young god within, who, Miss Levi says, is "evidentemente solare," but whose only attribute is the Dionysiac thyrsus. Miss Levi is aware of the strong assimilation to Dionysus of this figure, the position of whose fingers indicates the Taurus of the zodiac. Below these lies Tellus with the cornucopia, balanced on the other side by two nymphs of running water, but whose connection with fertility is stressed by the blade of wheat and of some other plant they hold. In the center of the lower group are the four Seasons as four wingless putti; Poseidon and a female companion are in the deep sea at the bottom. The central motif obviously represents the marriage of Attis and Cybele, at the season indicated on the zodiac, the spring; but the whole is given a cosmic setting by the zodiac, Helios, and Selene, and the fertility gods below. From the depths which Poseidon represents, to the heights of the sun and zodiac, the sacred marriage of these gods is alike celebrated. We have seen that the similar myth of Cybele and Attis had been given an astral interpretation in literary sources, and this interpretation now appears in the art of later paganism. The bowl has also assembled in brief the symbols for sky and earth with the saving gods of the particular faith between, in which man may hope for immortality. So it is not strange that the patera was found in a grave; it covered a vase containing the ashes of some man, to whom this design, it may probably be assumed, indicated hope of a future life.

The material suggests that when the zodiac was used in this way, and when

83. Reinach, *Statuaire*, I, 64. 84. From Levi, *La Patera d'argento di Parabiago*, plate 1.

in it Helios and earthly fertility were combined, the whole had definite religious value. The art designs seem to tell us of much the same hope which we summarized above from literary sources.

Another combination of symbols likewise speaks of the union of various deities in the one hypercosmic immaterial deity of late antiquity, the deity which Jews found so congenial. The monument is now broken and scattered in various museums of Europe.[85] It would seem to have had four faces of the same size, with the center of each depicting an empty throne covered by a veil. Fig. 21[86] shows the face where the god was Neptune, the god of the marine thiasos, with a dolphin under the throne, and cupids bearing his symbols on either side, a trident and a great "wreathed horn." The fourth little figure seems to be missing from the right. Fig. 22[87] shows only a bit of the throne and its veil, but the cupid beside it holds a quiver, so that the throne was presumably that of Venus or Diana. Fig. 23[88] shows only a cupid carrying a great thunderbolt, and we may assume he was approaching a veiled throne also, this throne conceived in terms of Jupiter. Fig. 24[89] shows the only side still largely complete. Here we have the cupids at the right holding between them what was presumably a scepter, while cupids at the left carry a heavy pruning hook, the symbol of Saturn. Beneath the veiled throne of this frieze is the starry globe of the cosmos, wrapped with the band of the zodiac. One can safely assume that these four faces were originally part of the same object. To me it is equally obvious that the person who made it, or ordered it made, had in mind not four gods but a single god, one that from its abstract nature could not be represented at all. The four faces would represent, in accordance with late Roman ideas, four aspects of the single Deity. This god could be approached through the symbols of the marine thiasos, those of the power of Jupiter, those of Venus or Diana, or those of the cosmic Saturn, quite interchangeably. At the top of any of these symbolic ascents was the same mysterious throne, whose occupant could not be represented because he (or it) was immaterial.

Many Neoplatonists were thinking in this way at the period when the plaques were probably carved, and some such connection of ideas seems inevitable. It is striking, parenthetically, that while not a detail suggests that these plaques had any connection with Jews or Judaism, yet a curtained throne is an

85. See C. Ricci, *Ausonia*, IV (1910), 249–259. Some pieces of it appear to survive in close duplication, though both were apparently made at the same time. I would not attempt to judge which was copied from the other. We may leave that problem to art historians.

86. Photo Umberto Trapani; cf. Ricci, fig. 1. This piece is at the Church of San Vitale, Ravenna.

87. From ibid., fig. 9: at the Archeological Museum, Milan.

88. Compliments of Dr. Mario Bizzari and the Soprintendenza alle Antichità, Florence. It is at the Uffizi Gallery, Florence.

89. Courtesy of the Louvre Museum, Paris. Cf. Ricci, fig. 5.

important part of Merkabah mysticism in Judaism, in which the "throne" is generally central. Before this throne was the cosmic veil or curtain. Metatron describes it vividly to Rabbi Ishmael in a late Midrash, but the idea is found in the second century, and appears in the Pistis Sophia, as well as in III Enoch,[90] and "he who sees it penetrates at the same time into the secret of messianic redemption."[91] The throne of Solomon seems often to have been allegorized as the same throne, veiled and approached by six steps (the throne itself the seventh). References to these are collected by Wünsche.[92] The animals on the six steps were made into the zodiac, so that the veiled throne above the zodiac of one of the plaques would be only a variant representation of this idea. Wünsche's pan-Babylonian methodology is not now convincing, but the striking similarity of this veiled throne to that of the plaques remains.

Like the speculations of Julian or Proclus, the design of each of these plaques retains from popular cult the cupids beside the awful and empty throne. Nothing suggests identifying these four cupids with the Seasons, but notably there are four of them, and the number four seems to have had importance of its own in this connection. For whether the attendant spirits were the four Seasons or the four Winds or any other four made little difference, apparently.[93] I have not stressed number symbolism, for while I am convinced that Jung is right in emphasizing it (who that has glanced at Philo or Cabbala could deny its importance for Jews of the period as well as Greeks?), it is an extremely elusive subject, and the possibility is always strong that in any *single* object of art the number of cupids or whatever may have no meaning, be determined purely by artistic considerations. Still the four cupids here are suggestive. Which takes us back for a moment to the Seasons.

Cumont, as noted above, thought that the Seasons, even when they appeared on sarcophagi without the zodiac or other celestial symbols, reflected that cosmos which the East was teaching westerners to introduce into their religious hopes. This has been more elaborately documented by Hanfmann,[94]

90. See esp. *3 Enoch* x, 1 (ed. H. Odeberg, 1928, 27 f.): "Metatron . . . said to me: All these things the Holy One, blessed be he, made for me: he made me a Throne similar to the Throne of Glory. And he spread over me a curtain of splendor and brilliant appearance, of beauty, grace, and mercy, similar to the curtain of the Throne of Glory; and on it were fixed all kinds of lights in the universe." The curtain seems to be clearly the heaven with its stars. But in ibid. xlv this curtain has all the events of the world's history written upon it, presumably to indicate the heavenly determination of earthly events.

91. Scholem, *Jewish Mysticism*, 71; cf. 43, 67–72, and 362, nn. 112–114.

92. A. Wünsche, *Salomons Thron und Hippodrom, Abbilder des babylonischen Himmelsbildes*, 1906 (Ex Oriente Lux, II, iii).

93. Proclus uses the seasons in praising the number four; see his *In Timaeum*, 298c (ed. E. Diehl, 1906, III, 193). He gives, as other examples of the four, the four elements and the four cardinal points (of the ecliptic), so that "in general the number four has great power in creation." Various groups of four in such a context are listed by Hanfmann, *Seasons*, I, 155 f.

94. *Seasons*, esp. pp. 142–159.

who, with even more emphasis than Cumont, regards the Seasons as primarily marking the regularity and order of the universe, and of the God of the universe. But he, too, recognizes[95] that during the Empire interest steadily shifted from science and philosophy to religion, from concern for the structure and nature of reality to anxiety about the relation of the individual to the cosmos and about his fate after death. In this atmosphere Hanfmann sees the Seasons as the bearers of annual and seasonal sacrifices, and as symbols of the passing of time, of the recurrent succession of life and death, even in successive incarnations. The Seasons became the four horses of the solar quadriga which took the emperors to immortality, but this had little general application. Still, the Seasons so often symbolized immortality that the early Christian fathers took them to represent the Resurrection.[96] Like all symbols, the Seasons in the late Empire came predominantly to refer to the world beyond rather than to the world of time and matter.

I am much impressed by a phenomenon noted by Hanfmann that the Seasons take on Dionysiac and erotic associations and values.[97] The Seasons so often appear as cupids that we instantly suspect that groups of four of them, as on the peculiar monument just discussed, represent the Seasons even though they have no symbols of the seasons. If the Seasons are not themselves represented as cupids,[98] they are put beside a scene where cupids are prominent,[99] or Cupid is brought in with them in any way possible.[100] On a sarcophagus the Seasons may flank Dionysus riding on a lion or panther,[101] and in decorative wall painting they often so closely represent maenads that it is impossible to say whether Seasons or maenads are intended (in which case it seems clear that the identification of Season with maenad is indicated as, other-

95. See his summary, pp. 191 f.

96. Hanfmann cites Augustine, *Sermo*, 361, 10: PL, XXXIX, 1604.

97. For a quick review of ancient representations of the Seasons, see not only the plates in Hanfmann, *Seasons*, but the indices, s.v. *Saisons*, in the three collections of Reinach: *Peintures*, *Reliefs*, and *Statuaire*. The frequency with which the motif is put with Dionysiac symbols becomes increasingly striking as one goes through this material.

98. As, for example, in Reinach, *Reliefs*, III, 253, no. 1; 296, no. 1; 410, no. 2; 475, no. 3; Robert, *Sarkophag-Reliefs*, III, iii, 504 f. (where Eros is both Season and a miniature Helios in the chariot); and *AAL, N*, 1911, 92, fig. 14 (where the pose is as on the Jewish sarcophagus). See also ibid., 1916, 140 f., fig. 1.

99. As when they surround a bath scene

of Aphrodite in which two Erotes assist her: Reinach, *Peintures*, 62, fig. 5.

100. See the gravestone from Boretto: *AA, JDAI*, XLVIII (1933), 574 f.; also the sarcophagus lid in Robert, *Sarkophag-Reliefs*, III, iii, plate CXXXVI, fig. 432.

101. Reinach, *Reliefs*, II, 57, fig. 9; cf. idem, *Peintures*, 110, fig. 1. For other representations of Dionysus at the center between the four Seasons on sarcophagi see Charles de Clarac, *Musée de sculpture antique et moderne*, 1828–30, II, plates 124, 146; Amelung, *Sculp. Vatican.*, II, plate 24, fig. 102v, and compare the evaluation in the Text, II, 318. See E. Michon in *RB*, N.S., Vol. X (1913), 111–118. The Seasons were a part of the Dionysiac procession of Ptolemy Philadelphus described by Athenaeus, V, 198B, C.

wise, of Season with cupid).[102] The Seasons as dancing maenads show the whole cosmos as a Dionysiac riot.[103] Similarly, the Seasons, along with the animals, listen to the music of Orpheus.[104] It seems to me violent, as it does to Hanfmann, to try to make all of these indicate an astral hope of salvation, though since the two outer Seasons can become the Dioscuri on a sarcophagus the possibility of astral significance can never be excluded from them.[105] Widely used symbols like these, which are identified with a great number of older conceptions, fused with various older mythological figures, could hardly be expected to keep any sharp ideological or theological consistency. That they often appear as graceful figures floating in the corner of a ceiling does not indicate that they had become *mere* space fillers. As they were always bright symbols of hope apparently, for that very reason they were also good decoration. And when Cupid, or Victory, or a maenad, became a Season, the hope implied was intensified. Like the zodiac, like all these symbols, as we are coming to see, the real meaning of the Season itself was the hope inspired by the regularity of the seasons, the fertility and new life which always followed decay and death, hope that man, too, was safe in the regularity and reviving power of God or nature. So Proclus sees in the Seasons, along with the other celestial phenomena and divisions of time, a reflection of the unmoved and timeless Nature; they are properly worshiped for their power thus to reveal the Ultimate. The Greek worship of Month and the hymns to Month in the Sabazian mysteries of Phrygia seem to Proclus to be justified on that account.[106] He quotes Panaetius and "other Platonists" that the proper mixtures of the Seasons was what produced intelligence and, the passage implies, made souls immortal.[107] So he, too, is willing to pray to them.[108] The zodiac, Proclus thought, was figured in the Nile, and he saw in both zodiac and Nile a source whence life is poured forth.[109]

Similarly the Orphic hymns generalize the cult value of the Seasons in the prayer:

Seasons! daughters of Themis (Law) and Lord Zeus, Eunomia (Regularity), Dike (Justice) and Irene (Peace) lavish in blessing: ye of the Spring, of mead-

102. *Peintures*, 131–138.

103. Hanfmann, *Seasons*, 148.

104. Ibid., 200.

105. B. Ashmole, *Catalogue of the Ancient Marbles at Ince Blundell Hall*, 1929, plate 47, fig. 233. The author on p. 90 suggests that the symbolism not improbably "implies a belief in some form of resurrection." See Helios in a zodiac with the Seasons painted on a tomb: G. Calza, *La Necropoli del Porto di Roma nell'Isola Sacra*, 1940, 184, fig. 92.

106. *Commentaria in Platonis Timaeum*, 249C–251C.

107. Ibid., 50B–F.

108. Ibid., 66A, cf. 101D, 248D.

109. Ibid., 30A; cf. 171D. That Deity was both solar and the Nile is abundantly attested from Egypt, especially in the later period, when, in a single song ("The Song of Isis and Nephthys," transl. R. O. Faulkner, *JEA*, XXII, 1936, 121–140) the same god is the Nile (9.26) and yet has "all the circuit of the sun" (16.9).

ows, blooming Seasons who recur in cycles, sweet of face, clothed in fresh robes
of the many flowers that grow, playmates of holy Persephone when the Fates
and Graces, to the delight of Zeus and her beauteous mother, lead her with cir-
cling dances to the light: come to the pious new initiates at our auspicious mys-
teries, and bring without reproach the fertilizing products of the Seasons.[110]

The zodiac and the Seasons were not, of course, the only symbols by which
paganism expressed its hope of astral mysticism and immortality, if I may use
the term "astral" to cover the whole variety of formulations of this hope. The
cosmic cycles were now not limited to the seasons of the year, but could also be
thought of as day and night, the yearly journey of the sun to the southern hem-
isphere, the phases of the moon,[111] the Cosmic Year of the fixed stars, the
cycles of the planets and their influence upon terrestrial events, or the spheres
of the planets as methods of ascent, or as seven heavens. Sometimes the details
of a given design indicate in which form of astralism the thought of the devo-
tee or artist (or both) was moving. But frequently the reference seems to be to
astralism in general, or the symbols are so abbreviated that they can be inter-
preted in several of these ways even though they may have meant some specific
one of the forms of hope to the devotee.

One could well stop at this point to reproduce entire the fascinating
material presented by Cumont on the lunar symbolism of the funerary monu-
ments of antiquity.[112] His material shows for the most part a general astralism
rather than specifically lunar hope. For if the moon appears prominently upon
the monuments he reproduces, it rarely stands alone.[113] It is interesting to see
a gravestone from Numidia, fig. 26,[114] where above a pair of portrait busts, as
above the shrine at the Catacomb Torlonia, the sun and moon stand at either
side of a central star. Here a cupid flies with a torch beside the star. I am
intrigued with the possible parallelism presented between this row of symbols

110. *Orphic Hymns*, XLIII. The descrip-
tion of the flowery, sweet-faced Seasons re-
calls the heads at Dura. One can at least rec-
ognize in this similarity a possibility.

111. This, which I have not discussed,
may be sufficiently illuminated by a state-
ment that Cumont, *Symbolisme*, 212 n. (cf.
218), quotes from Augustine, *Sermo*, 361 (PL,
XXXIX, 1604): "Quod in luna per menses,
hoc in resurrectione semel in toto tempore."
I quite agree with Cumont (219, n. 3) in feel-
ing that the phases of the moon have a real
symbolism as, for example, they appear to
have on a tombstone from Geneva (ibid.,
plate XVII, 1), and in rejecting Déonna's at-
tempt to reduce them to a mere artistic de-

vice for symmetry.

112. *Symbolisme*, 203–252.

113. It seems to be alone, above a por-
trait bust, on a tombstone from Pannonia
which Cumont publishes, p. 206, fig. 36. But
below it are two pine cones, and the pine cone
can take the place of the solar disk or star: see
Cumont's plate XVII, 4 (cf. 3). So one cannot
be sure that the hope of this man buried in
Pannonia was purely lunar.

114. From R. M. du Coudray la Blan-
chère and P. Gauckler, *Catalogue du Musée
Alaoui*, 1897, plate XXIII, no. 871 (Description
de l'Afrique du Nord). Cf. J. Toutain in *REA*,
XIII (1911), 167, fig. 7; Cumont, *Symbolisme*,
212, fig. 40.

and the row at the top of the stone, for there, between two rosettes, and with a gable front, a cupid pours from a pitcher. If the rosettes on this stone are, as often, symbols of light or stars or the sun, they may here correspond in more astral form to the sun and moon below, while ths star at the center of the lower row, with its light-bearing cupid, may be represented above by the triangular gable within which the cupid pours from the pitcher. To the triangular gable we shall come in a moment. Returning to the lower row, it is dangerous to suggest what the central star between a sun and moon could be. Cumont plausibly says that the star is Venus, since the cupid "bearing light" beside it marks the star as "Phosphorus," an alternative name for Venus as the morning star. But he has no suggestion as to why Venus should have been selected and so carefully specified, and he does not discuss at all a possible meaning for the cupid above with his pitcher. I feel strongly that the two cupids go together. The star may indeed be Venus immediately, but it is Venus as Phosphorus, the Light Bringer, in some special sense which goes with the cupid bringing fluid above. One of the cupids, literally, gives the heavenly light, the other the heavenly fluid. Now we have seen abundant evidence of the complete identification of the light of life and the water of life, an identification which through the Fourth Gospel has become deeply symbolic for Christianity. Both, separately and together, symbolize the Logos as the flow of life and power from God, a flow which is the great love of God, creating the world and ruling it, and bringing God to man. Once begun on such fancies, it is easy to go farther, but symbolic interpretation must at this stage hold rigorously back. All we can say as a fact is that the sun and moon with a star between them is a proper decoration to put on portrait busts on a gravestone, and it is still to be presumed that in some way, which now only uncontrolled fancy can fill out, this astral design was connected with hope of immortality in the astral terms omnipresent in the literature of late antiquity. For our immediate purposes this is sufficient.

It has been suggested that the triangle in which the upper cupid poured out his pitcher was itself symbolic. Cumont[115] has an interesting discussion of such triangles, in which he recalls that for the Pythagoreans the equilateral triangle represented the decade, and hence "the principle of celestial and divine life." He goes on to say that the Pythagorean triangle "explains why they carved the triangle on the funerary monuments, and why they preferred to put the crescent [and the other heavenly bodies] in the triangular gable" so common on the top of ancient tombstones. "The triangle expressed discretely the belief in a celestial immortality." Cumont shows several triangles in funerary ornament, some of which are actual gables above the inscription, and some little triangles[116] as isolated forms. But he also shows several tombstones, such

115. *Symbolisme*, 224, where the documentation is interesting.

116. Ibid., 223.

as fig. 27,[117] where instead of a gable the upper part of the stones are equally distinctive sections above the inscriptions, and filled with astral symbols, but finished with a rounded arch. I am accordingly inclined to agree with Cumont that the gables represent the divine sphere to which the deceased has gone, but I should guess that it is so not through the symbolism of the equilateral triangle (which a gable rarely is) but through that of a temple, the abode of a god, which might have a peaked roof, or a vaulted one. That the temple contains the heavenly bodies is clear in the last figure shown, while the value of the upper section of the stones as the site of deification seems to me clearly indicated by fig. 25,[118] where the deceased, with the sun and moon on either side, has come up into the gable, and so been deified. The temple is of course not an earthly temple but its heavenly counterpart.

One of the reasons I am most reluctant to allow my fancy to carry on in explanations of these astral symbols is that no system I have been able to devise (and I have thought of a good many) for explaining the arrangement of astral signs on ancient funerary art actually seems to apply to more than a very small percentage of the stones that survive. Fig. 27, for example, shows three of the little six-point rosettes which appeared so important on Jewish ossuaries, the "banal" rosettes, and which seemed ordinarily to be solar. But in the middle is the "star and crescent," a design that I take normally to be the moon and sun, and two peculiar objects like carpenter's squares, facing either way.[119] None of these identifications is at all secure (except the lunar crescent in the middle), and I can make no sense at all out of the arrangement. Apparently here, and in most of the other such groups of astral symbols that Cumont shows, the aim was to suggest the celestial regions whither the deceased had gone, with no attempt at detailed elaboration or specific symbolism.

This, finally, is exactly the impression which we get from fig. 28,[120] the central figure on a beautiful relief from South Italy. It shows the funeral procession in which the funerary bed or litter was carried to the grave. The deceased is represented as being in heaven simply by the drape covered with moon and stars behind her. It would be useless to try to reconstruct a specific type of astralism expressed in this curtain. So far as I can see, the lady simply

117. From ibid., 237, fig. 54, a gravestone from Pamplona, Spain; cf. 235, n. 2.

118. Courtesy of the Museum of Langres, France; cf. Cumont, ibid., 225, fig. 46; E. Espérandieu, *Recueil général des bas-reliefs . . . de la Gaule romaine*, IV, 1911, 273, fig. 3228.

119. Cumont shows three other instances of such objects: see *Symbolisme*, figs. 51, 53, 57. In Cumont's fig. 57 they have notched ends which strikingly recall the gams

on the costumes of the chief figures on the Dura synagogue. Cumont calls them squares, which they certainly resemble, and he quotes (p. 233) various suggestions, as that they can be locks or hinges on the doors of heaven. In such a case it seems better not to guess at all.

120. From Cumont, *Symbolisme*, plate xix at p. 238. Cumont says that it dates from the end of the Republic or the Augustan period.

has gone to heaven, a conception as vague and varied then as now. This very vagueness of detail made the symbolism so generally acceptable to Christianity later, and, presumably, to Judaism. Christianity used astral symbols when it put upon Mary a mantle covered with stars to indicate that she is the "Queen of Heaven" — not that she actually was in, or one of, the stars but that she, as a cosmic figure above the stars, wore the starry heavens as her garment.[121] The astral symbolism appeared again in the tradition of turning the vaulted ceiling of the medieval cathedral into the starry heavens, and in representing apotheosis as "ascent to heaven" in forms that used the heavenly bodies.[122] But astral representations appeared nowhere in a religious setting, so far as I know, without having a definite value at least in turning the thoughts of the worshiper to a divine realm that might be astral or superastral. I am convinced that astral symbols in paganism and Christianity may always be taken, when put with other religious symbols or with persons, to indicate the heavenly nature of the symbols and persons.

C. ASTRALISM IN JEWISH LITERATURE

THAT THE RELIGION of early Israel was filled with solar and astral elements is now a commonplace, however much experts may disagree about details. F. J. Hollis[123] seems to me right in pointing out that this was rejected at or about the time of the Exile and of Ezekiel, when the plan of the new Temple was deliberately altered to destroy any orientation with the sun. Certainly the Old Testament as finally edited preserves only fragmentary relics of the earlier concern with the sun and seasons. The sudden re-emergence of sun, seasons, and zodiac in the synagogues and graves of our monuments is definitely a fresh invasion of astral representations. Clearly, then, the first hypothesis to be tested is that this invasion meant a fresh adaptation of Judaism to astralism, a fresh modification of Jewish thought by the current pagan ideas connected with astralism. Did Jews begin to show a sense of mystical identification with the macrocosm or with the cosmic spheres, or with the seasons and their promise? And does this identification, when it appears on a grave, mean that the Jews, too, hoped for immortality and thought of it, like the pagans, in cosmic or hypercosmic terms, or in terms of the seed which dies in the earth to revive

121. The phenomenon is too familiar to illustrate: see, for example, Eisler, *Weltenmantel und Himmelszelt*, I, 85, fig. 27, and indeed that entire volume for a great mass of material for the heavenly garment worn by royalty in ancient and medieval times, as well as by a great number of gods in ancient religions and on into Christianity.

122. Volume II of the same work of Eisler presents a similar body of material from sources of all sorts on the vault of heaven as a religious symbol.

123. In his article "The Sun-Cult and the Temple at Jerusalem," in S. H. Hooke, *Myth and Ritual*, 1933, esp. pp. 106 ff.

at the proper season in a new life? Since the symbols appear not alone on individual sarcophagi, as Cumont supposed, but everywhere in the Catacomb Torlonia in Rome, in the plan of two ceilings of the Catacomb Vigna Randanini, and, in Palestine, in synagogue after synagogue, our hypothesis would go on to suggest that this sort of thinking had great importance to the Jews of the time as a group, or groups, not merely to individual Jews. Such a hypothesis must be tested from Jewish literature. Did such conceptions appear anywhere in our survivals of literature of the period, and, if so, in what sort of literature?

1. In Rabbinical Writings

OUR INTEREST is not with use by Jews of astrology as such.[124] There is abundant evidence, as has repeatedly been pointed out, that Jews, even the rabbis, were much attracted by the pretensions of astrology to predict the future. Even rabbis who wanted to keep Judaism free of such speculations by asserting that Abraham and the Jews had been lifted above the stars admitted that the gentiles were under astral domination.[125] Insofar as astrology was a field of its own, to which Jews like Christians could turn without prejudicing their religious faith, Jewish astrology does not concern us here at all: its presence would simply mean that like the majority of the human race, perhaps, in one sense or another, the Jews who at that time practised astrology had a twofold religion or philosophy, each to be used on its proper occasion, but the two not blended. A modern Christian who goes to confession and communion over the week end, and to an astrologer or other type of fortune teller in the middle of the week, rarely makes the slightest attempt at reconciling the two, and to the extent that the two are thus kept separate, astrology has no part in the Christianity of such a person. But if the individual should attempt to unite the two, explain astrology in terms of Christian theology, or theology in terms of as-

124. In discussing this question I draw heavily upon material already collected by others, and without accrediting each citation to its secondary source. Much of the material I cite (although I have added much) will be found collected in the following: Leopold Löw, "Die Astrologie bei den Juden," *Gesammelte Schriften*, 1890, II, 115–131 (first published 1863); articles "astrology" and "astronomy" at different periods in the *JE*, II, 241–251, by L. Blau, K. Kohler, P. Jensen, and J. Jacobs; Eisler, *Weltenmantel und Himmelszelt*, 265–275; idem, *Orph.-dion.*, 9, n. 8; 39, n. 5; D. Feuchtwang, "Der Tierkreis in der Tradition und im Synagogenritus," *MGWJ*, LIX (1915), 241–267; J. Trachtenberg, *Jewish Magic and Superstition*, 1939, 249–259, 311–313; Cumont, *Symbolisme*, 382–388.

125. *BT, Shabbath*, 156a, b (ET, II, 798–801) is the locus classicus. Here is expounded what it means to be born under the power of each of the planets, and R. Chanina says that Jews also are under power of the birth-star. Rabbi Johanan, Rab as expounded by Jehuda, Samuel, Akiba, and Nachman bar Isaac, each in turn, deny this, as they give instances of how God has overcome astrological prophecies. But none of it is properly a fusion of astrology with Judaism. On Israel's superiority to astral determinism see also the passages cited by W. L. Knox in H. Loewe, *Judaism and Christianity*, 1937, II, 101.

trology, astrology would become a part of his Christianity. The archeological remains, which put the astral signs within the synagogues and catacombs, or with Jewish tokens on graves, seem to witness this genuine fusion of Judaism and astralism.

For such a fusion in Judaism we seem at first to have much literary evidence in the rabbinic writings. The rabbis often said that the biblical references to the number twelve are allusions to the zodiac. When Jacob "blessed" his twelve sons (some he roundly cursed) he compared five of them to animals: Judah to the lion, Isachar to the ass, Dan to a serpent, Naphtali to a hind, and Benjamin to a wolf. The rabbis commented on the passage:

> Twelve princes will be begot. The tribes are determined by the order of the world. The day has twelve hours, the night twelve hours, the year twelve months, the zodiac twelve signs: therefore it is said, "All these are the tribes of Israel."[126]

Many scholars have thought that this identification was originally intended by the biblical writer;[127] if that is so, it is amazing that astronomical conceptions should have played so rare a part in the Old Testament, and be so little integrated into the religious thinking of Israel and early Judaism. Not until much later were all these twelves, and many other twelves, made into explicit references to the zodiac. So Feuchtwang quotes R. Phineas ben Jaïr that the twelve silver basins, the twelve silver cups, the twelve golden spoons, twelve oxen, twelve rams, lambs, goats, as well as the twelve Princes and Leaders of the Soul, and the twelve tribes all similarly refer to the zodiac. R. Eliëser ha-Mudai added the twelve springs of Elim, which were created at the beginning of the world. The brazen sea of the temple was most elaborately identified in this way, for among various identifications of details, its ten ells of diameter represented the ten Sefiroth, its roundness the heaven, its two rows of knobs the sun and moon, and the twelve oxen on which it stood the zodiac.[128]

126. Gen. XLIX, 28; the rabbis' comment is quoted by Feuchtwang, "Der Tierkreis," 243, from *Tanchuma*, Wajchi, 16 (ed. M. Buber). The following material is taken from this section of Feuchtwang's discussion.

127. H. Zimmern, "Der Jakobssegen und der Tierkreis," *Zeitschrift für Assyriologie*, VII (1892), 161–172. E. Stucken, "Ruben in Jakobssegen," in his *Beiträge zur orientalischen Mythologie*, 46–72 (Mitteilungen der Vorderasiatischen Gesellschaft, 1902, VII, iv).

128. For references see Feuchtwang, 244, and L. Ginzberg in *JE*, III, 357 f. Another study is that of E. Bischoff, *Babylonisches Astrales im Weltbilde des Thalmud und Midrasch*, 1907. Much interesting material is here collected to prove the pan-Babylonian origin of astrology in Judaism. The first section on the heavenly counterparts of earthly things, like the Throne, the Temple, Jerusalem, etc., is interesting but of no value to our study, because the link between these heavenly counterparts and the starry heavens is so very shadowy. Bischoff, pp. 48–59, has interesting material on the zodiac, but it shows no more than does the material of Feuchtwang why the zodiac and Helios should have been put in a synagogue. The same is true of his material on pp. 116–126, which shows the traces of interest in astrology manifested by various rabbis.

In none of these identifications as made in rabbinical and cabbalistic writings can I find any motive, any real objective. In the form in which they are stated the identifications express a sort of idly curious playing with names and numbers, that could not, so far as I can see, explain why Jews would ever have made the zodiac and Helios a central symbol in their synagogues. A sample of identifications on this level is presented in the curious Syriac fragment published by A. Mingana, entitled "Fragment from the philosopher Andronicus and Asaph, the Historian of the Jews."[129] Who wrote this, and when, the editor only very vaguely conjectures, but the Asaph would seem to have been, as Eisler indicates, a ninth- or tenth-century Syrian Jew, whose amazingly diverse writings draw heavily upon much earlier material. The fragment purports to be "a discourse upon the twelve *stoicheia* of the sun, written by Andronicus." The stoicheia are obviously the signs of the zodiac. He wants to expound these and their influence, for they "gravitate circuitously in the number of the twelve months of the year, and foretell events which happen to us by order of God, creator of everything." This is clearly a theistic adaptation of zodiac fatalism: it is not the stars or the astronomical signs but the Creator God behind them which determines the future, but he acts through the signs. Andronicus then goes on to tell the names of what gods the Greeks gave to these twelve signs: Dio son of Cronos is Aries; Poseidon is Pisces; etc. But Asaph, the writer and historian of the Hebrews, while he "explains and teaches the history of all these," calls them not by their Greek names but by the names of the sons of Jacob. Asaph, we are clearly told, changed in all this only the names. In the Aramaic language he put Reuben as Taurus at the head, with Simeon as Aries, Levi as Pisces, etc. in procession behind. This fragment then concludes with the following strange paragraph:

> As lovers of the truth you will see and understand that these [stoicheia] have been named according to the number of days (of lunar computation). I say this, even if it happens that the peal of thunder is heard [in them]. At each month of the year, each one of the stoicheia turns circuitously according to the *kanones* of the month and gravitates according to the number of the moons, each one of them having been brought about by the three *kanones* of the evolution of the moon. This is their exposition, their order, and all their influence of which we are aware.

This piece, whatever its date, seems to me to represent the sort of adaptation most common in rabbinical Judaism, for it makes no real identification in a religious sense at all. The author obviously liked to use astrology for predictions, and had freed himself of the notion that it was the stars themselves which de-

129. No. 3 in *Some Early Judeo-Christian Documents in the John Rylands Library*, 1917, 29–33 (reprinted from the *Bulletin of the John Rylands Library*, IV, 1917, 1). See Eisler, *Orph.-dion.*, 39, n. 5. For Asaph, Eisler refers to the very interesting article in *JE*, II, 162.

termined the fates: he saw their "influence" as the work of God. So he gives the signs of the zodiac good Jewish names, which at once clears his conscience. He can continue to cast horoscopes without feeling that in doing so he is in any way betraying his Judaism.

In another Syriac fragment published by Mingana in the same essay the zodiac appears forced into a similar artificial relationship to Judaism. Here, Shem, son of Noah, gives a series of prophecies of what is to be expected when the year begins in each of the zodiac signs. Except that it is Shem who makes the prophecies and that the Passover is three times mentioned, not a hint of Jewish thinking emerges in the document. Shem predicts the high or low flooding of the Nile for that year, the weather, the crops, and the political, sanitary, and moral conditions. That is, again a Jew would seem to have believed in both Judaism and astrology but to have been content to join the two together thus loosely rather than try really to fuse them. Conspicuously the Judaism is made to give its blessing and terminology to astrology; astrology contributes nothing to Judaism. Feuchtwang concluded from his study that although the rabbis condemned astrology ("Thou shalt be a prophet, but not an astrologer") they conquered it only in theory, for in the lives of the people it remained important to the seventh century, and even to the present time.[130]

Yet that theoretical condemnation is of great importance for us, since it would have closed the door upon the admission of the zodiac into formal Jewish symbolism insofar as it was under rabbinic control. This is not enough to explain the zodiacs in the synagogues. For while we have not the setting for the other three zodiac mosaics in Palestine, the one at Beth Alpha, occupying the center of the floor, with sacred Jewish symbols above it and Abraham's sacrifice of Isaac below, can hardly have been inspired by the fact that Jews, in spite of official disapproval, liked to cast horoscopes. Sukenik[131] in discussing the phenomenon says that there is much evidence that the zodiac and astrology played a great part in the life of the people. He quotes Philo and Josephus, to whom we shall come, and mentions the hymn-prayers of Ha-Kalir, who lived probably in the ninth century and whose two poems, one a prayer for dew, the other for rain, are oriented in the twelve signs.[132] Feuchtwang says that so far as he

130. Op. cit., 267.

131. *Ancient Synagogues*, 66; see also his *Beth Alpha*, 36.

132. These will be found conveniently translated and discussed by Feuchtwang, "Der Tierkreis," 257–266. I am not certain that Feuchtwang has not missed some of the meaning of these prayers. That they were only literal prayers for dew or rain seems to me quite dubious: I should guess that they were also mystical prayers for an experience which being wet with dew, or drenched with rain, very strikingly and commonly symbolizes. Indeed it may be a symbolic prayer for immortality, since the rain, and more especially the dew (usually so translated, but see the *EB*, s.v. dew) was something kept in the highest heaven, called the "Dew of Resurrection," by the descent of which the dead will be revived. See also *JE*, IV, 552, and V, 643, s.v. *geshem*, for references. And see I Enoch xxxix, 5: "Mercy like dew upon the earth."

knows these ninth-century compositions are the only things of the kind in synagogue ritual. Sukenik adds the hymns of the *Paytonium* discovered in the Ginza, but these, most dubious evidence for Judaism, are likewise late compositions and betray Hebrew connections only in the fact that the twelve signs are given their Hebrew names.

What still appears is that while the hymns of Ha-Kalir might possibly have been sung in a synagogue like that of Beth Alpha, they are unique in rabbinic and synagogal literature and are as little to be expected from talmudic references to the zodiac as are the mosaics themselves.

Actually the feeling of the earlier rabbis about representations of the heavenly bodies is plainly recorded.[133] The Mishnah reads:

> If one finds utensils upon which is the figure of the sun or moon or a dragon, he casts them into the salt sea. Rabban Simeon B. Gamaliel says: if it is upon precious utensils they are prohibited, but if upon common utensils they are permitted.

Upon this the Gemara comments in a very interesting way. Assuming that the Mishnah represents the attitude of the earlier rabbis (before A.D. 200, when the Mishnah was codified), they seem to have taken an uncompromising position. Figures of the sun, moon, or dragon are so abhorrent that they are to be utterly destroyed ("cast into the salt sea" is only figurative) if they are found. This was the general law, and one may suppose that the law mentions only samples, and that other types of images are implied in these. Actually such inference is extremely difficult, because sometimes a passage which originally meant what it said, such as the cooking of a kid in its mother's milk, was later expanded into the whole superstructure of Jewish milk and meat meals. On the other hand, the rabbis were just as competent to take a law couched in specific language and virtually annul it by insistence upon literalism. Here, however, it is clear that the feeling against astral images was so strong that they, with the "dragon," were taken as the illustration par excellence of what could not be touched, even if found by chance. It seems to me a fortiori intentionally implicit that if one must destroy any object found with these images on them, much more must one do so with images of gods, and still more is it forbidden to Jews themselves to make such images. So, at least the great majority of Jewish scholars through the ages have understood the passage.

In ancient society, however, it is interesting that as early as the Tannaitic

The zodiac and astral signs would be appropriate if the prayer was literally for dew and rain; it would be highly significant if these were at the same time prayers for mystical visitation or immortality. See also *Apocalypse of Abraham*, XIX, with G. H. Box's note *ad loc.*

BT, Hagigah, 12b (ET, 71; cf. pp. 61–104) puts the dew in heaven in one of the loci classici for the conception, where it is explicitly a piece of Maaseh mysticism. On this see below.

133. *BT, Abodah Zarah*, 42b–43b (ET, 211–217).

Age—that is, before the Mishnah was closed—the rabbis showed some tendency to modify this strictness. So Simeon ben Gamaliel did not fear that a Jew would worship an image of the sun or a moon-sickle on a common object like a water pot, but saw danger in a golden or silver moon-sickle which might be worn as a talisman, as he is quoted in self-explanation in the Gemara. It is clear that Simeon would not have the Jew himself put such a mark anywhere, but neither would he require a Jew to destroy some useful object just because it bore that mark.

In the next two centuries the feeling changed. The Gemara in commenting upon this mishnaic statement, presents several divergent points of view. The remarks of Rabbi Abbaye, of the fourth century, are especially interesting. He first seems to be trying to restrict the mishnaic statement to the three objects mentioned, for he says that these three objects are the only ones which pagans made for worship. They might actually be found worshiping almost anything, but as to fabricated images, all but these three were made "only for ornamental purposes." It might seem then that the Jew could do as he pleased. But this is by no means the implication, especially of making images of the sun or moon or stars, or of human faces. The argument is extremely confused, and has in general been already reviewed. As to astral symbols, however, the prohibition is definitely joined with the biblical text "Ye shall not make with me,"[134] in the sense that this means to prohibit not only the keeping when found of representations of any heavenly bodies, but the making of them as well, for they are God's attendants who serve before him in the heights, and while there was some disagreement, it was made to apply to all creation down even to worms in the ground.

As to the astral figures, the text repeatedly recalls the stubborn fact that the great Rabbi Gamaliel had a chart in his room which illustrated the different phases of the moon. This he used to show to rustics who came to report seeing the moon in its different quarters, reports on which festival dates were based. Gamaliel would say to them, "When you saw the moon, did it look like this or that?" The great rabbi was finally excused for having this chart, on the ground that presumably he did not make it but had it made by gentiles. Or perhaps, it is added, this chart was in sections, and was joined only momentarily, which would seem to imply that a small part of the chart could be shown at a time, and the whole could be put away when not in use. The advantage of this was that the danger of worshiping images was considered much greater if they were exhibited to a large number of people, especially to a formal assembly, than if kept privately. And, clearly, the cycle of the moon was more dangerous a thing to show than its single phases in isolation. So there was a synagogue, of Shaph-weyathib in Nehardea, where an image had been set up.

134. Exod. xx, 23.

Into this synagogue, it is a matter of unique record, two great rabbis actually
entered to pray, but only when the congregation was not present. "It is differ-
ent when there are many people together."[135] Needless to say, this was not an
approval of putting such an object in the synagogue in the first place, let alone
indication that the rabbis would have done so themselves.

When from this passage we turn back to the actual Jewish monuments, we
see how the monuments go against the decisions of the rabbis on point after
point. The rabbis quoted in the Talmud would never have approved Helios,
the zodiac, and the Seasons for the center of the careful Jewish symbolism of
the synagogues, or have put the Torah shrine between phases of the moon or
between sun and moon on their graves. Meaningless as representations of the
zodiac might have become in synagogues and prayer books a thousand years
later, their original invasion into popular Jewish symbolism, obviously never
approved by the talmudic rabbis, must have had a great deal of meaning
indeed.

It is here that Sukenik's remarks, while quite true, prove inadequate. He
has not distinguished between the testimony of nonrabbinic types of Judaism
and the Judaism of the rabbis. None of the evidence we have seen suggests that
Jewish astralism originated with them, for as R. Eleazar Hisma said, they con-
sidered astronomy and geometry "mere fringes to wisdom."[136]

The difficulty for an outsider is that no secondary work I have seen seems
to me sufficiently to contrast the types of Judaism, or to keep a sense of chro-
nology, in quotations from rabbinic sources. Anything which any rabbi ap-
proves is usually taken to be rabbinical in origin, and generally characteristic
of a mythically uniform rabbinic Judaism. That there were various currents
alive and productive in Judaism which often influenced the thought of individ-
ual rabbis seems to me obvious from the rabbinic writings themselves. Yet such
ways of thinking were essentially foreign to what has come to be regarded as
the usual rabbinic positions. Scholem[137] is an illuminating guide to some of
these nonrabbinical sorts of Judaism, and he repeatedly emphasizes the "con-
trast to the tendencies which already during the Talmudical period dominated
the outlook of the great teachers of the Law."[138] One type of speculation, he

135. *BT, Abodah Zarah*, 43b (ET, 216).

136. *Pirke Abot*, III, 23. It may be noted
that A. Marmorstein completely ignores the
problem ("Some Notes on Recent Works on
Palestinian Epigraphy," PEF, QS, 1930, 154–
157). He thinks it adequate explanation of
the mosaics (p. 155) that in the *Pirke Eliezer*,
VI, the sun is mentioned as riding in a chariot,
with "the only difference" being that the
chariot of R. Eliezer is drawn by four
hundred angels. Similarly he is confident (p.
156) that the poets Ha-Kalir and R. Phineas

"must have had before their eyes these newly
discovered mosaics in Ain Duk [Naaran], or
Beth Alpha, calling the attention of their
hearers to these signs." It may well be that
Ha-Kalir did have such a mosaic before his
eyes. Still we must ask: how did such a thing
get into the synagogue in the first place; and
why Helios?

137. *Jewish Mysticism* is his most valuable
single contribution (out of many) to the sub-
ject.

138. Ibid., 59; cf. 62.

thinks, must have "originated among heretical mystics who had all but broken with rabbinical Judaism."[139] The same must have been true of the "Metatron mysticism," says Scholem, since the whole Babylonian Talmud makes only three references to it.[140] Still another type which Scholem calls "gnostic" and the beginning of later cabbalism, centered its interest in creation and cosmology, and hence was akin most closely to the symbols we are here studying. It was invented by Jewish Gnostics, who "tried to stay within the religious community of rabbinical Judaism," but have left only the fewest and faintest traces in haggadic literature.[141] These were types of Judaism which came to the rabbis from the outside, and captivated a few of them (usually, it is said, to their eternal damnation), but which had no proper part in rabbinism at all, and certainly had not arisen out of the rabbinic movement as such. For these Jewish schools orthodox rabbinism has today as little use as did most of the Tannaim and Amoraim. They are a part of a "naïve popular Jewish faith" of the first centuries of the Christian Era, which was preserved finally in the Cabbala.[142] Our art symbols heighten the sense of contrast between that popular Jewish faith, to which they obviously belong, and the Judaism of the rabbis. For the rabbis would have disapproved representing the zodiac and Helios in the synagogues as much as they as a group frowned upon Metatron and the mystics of the *Shiur Komah*.[143] When these art symbols are studied in connection with the Jewish literature which the rabbis rejected, both the art and the literature take on full meaning. In that literature I must include a group of writings which Scholem unfortunately never brings into his studies, the writings of hellenistic Judaism.

2. In Merkabah and Apocalyptic

IN SEEKING a Judaism that would show such an open and conscious appropriation of astralism as to warrant the astral symbols of the Jewish art, we naturally turn with great expectations first to the literature on which Scholem reports. The earliest Jewish mysticism that he considers (he works exclusively with literary evidence) is of the sort which he groups under the term Merkabah mysticism. For this he has texts which, he thinks, go back in part to the second century of our era.[144] Astral immortality, in fact, even appears in the earliest Jewish Apocalypse, Daniel XII, 3: "Those who are wise shall shine as the brightness of the firmament, and those who turn many to righteousness as the stars for ever and ever."[145] The notion continues in II Baruch, IV Esdras, and the

139. Ibid., 64.
140. Ibid., 67.
141. Ibid., 73.
142. Ibid., 202 f.
143. Scholem (pp. 81 f.) quotes without naming him a "distinguished Jewish scholar"

who said of the writings of a later mystic "that he hoped they would never emerge from their 'well deserved oblivion.'"
144. See Scholem, 44, and 353 f., nn. 13 f.
145. Cf. Matt. XIII, 43. Wolfson, *Philo*, I,

early Enoch literature, such as the Slavonic and Ethiopic Enoch, and the Apocalypse of Abraham, with the Hebrew Enoch[146] a valuable if later source. In this literature the astralism of the pagan world has clearly made a deep impression, and we must stop to recall it.

In I Enoch (Ethiopic), for example, chapters LXXII–LXXXIII are devoted to the "luminaries in heaven." The passage begins (chapter LXXII) with a description of the twelve signs of the zodiac, six in the east, six in the west, and of the yearly course of the sun through them, with the variations of length of days that ensue. The next chapters describe the moon, how she "rides in her chariot driven by the wind,"[147] with arithmetical reckonings of the lunar year as compared with the solar, an interest in astronomical accuracy which was quite beyond the Jewish mosaics. The winds are now discussed[148] as coming through twelve portals, four groups of three each—that is, the seasons, as we judge from the benefits brought by each of four main directions of the winds. The seasons and their power to lead the stars are set forth in greater detail in chapter LXXXII. No religious interpretation is given this exposition of astronomy. True it is stated (LXXX, 2–8) that "in the days of the sinners" the regularity of the heavenly bodies will be confused;[149] but no hint of mysticism or astral immortality appears here. The very presence of such an account in this book, however, suggests that it may have had religious value, and so it is not surprising that in an earlier part of the book the fate of the soul after death

399, quotes the passage in Daniel as a parallel to Chrysippus, who says that the souls of the wise "mount to heaven and there assume the spherical shape of stars." Wolfson thinks that Jewish apocalyptic statements of astral immortality "must have been a combination of these two sources," i.e. Daniel and Chrysippus. Wolfson likes to move thus precisely from one literary document to another without considering active popular religious currents. Actually all that Eustathius, Wolfson's source of Chrysippus, says is that Chrysippus did not agree with Homer and others who, like him, made the soul resemble the body: διάφορός ἐστι δοξάζων σφαιροειδεῖς τὰς ψυχὰς μετὰ θάνατον γίνεσθαι. There is no ascent or even comparison to the "stars" in the passage. See Eustathius, *Commentarii ad Homeri Iliadem*, Leipzig, 1830, IV, 267, line 19 (1288, line 11).

146. *3 Enoch, or The Hebrew Book of Enoch*, ed. and transl. by Hugo Odeberg, 1928. Odeberg, whose notes are secondary in value only to the writings of Scholem, dates III Enoch in

the third century, but Scholem, p. 44, calls it "very late," certainly after the *Greater Hekhaloth* of the sixth century. Scholem describes this latter, as well as the *Lesser Hekhaloth*, as being much more valuable than III Enoch, but as existing only in defective Hebrew MSS never edited, much less translated.

147. I Enoch LXXIII, 2. Many of these passages are discussed by Hanfmann, *Seasons*, I, 192–196.

148. It is strange that no Jewish representation of the winds as psychopomps has appeared in Jewish remains, in view of Cumont's elucidation of their meaning (*Symbolisme*, 104–176), and of this passage and I Enoch XVIII.

149. The disturbance of heavenly order —a stated element in apocalyptic writings to describe the "last days"—is familiar in the words ascribed to Jesus in Mark XIII, 24–27. In *Sibylline Oracles*, v, 512–531, this final cataclysm is described in terms of the various creatures of the zodiac fighting each other in utter confusion; cf. IV Ezra v, 3–6.

is discussed, and it seems that the old Sheol has quite disappeared. The righteous are "at the end of the heavens," or in the heavens, where is the Elect One and his angels; and righteous souls will be "without number before him for ever," will be like "fiery lights."[150] That is, obviously, they become stars in a purely astral immortality. The book is, indeed, filled with astralism.[151] But so is most of the apocalyptic literature of Judaism. The seers go up to the heavens in their visions,[152] and there, it is taken for granted, the blessed will abide. II Baruch LI, 10, says:

> For in the heights of that world shall they dwell,
> And they shall be made like unto the angels,
> And made equal to the stars.

Different strata of "heavens" are also familiar,[153] a conception which seems to come from the planetary spheres through which one goes to the highest heaven.[154] In II Enoch (Slavonic) the planets still have their Greek names,[155] and not only are bodies but each is a "heavenly circle." A sun's journey through the zodiac is also important,[156] and the houses of the twelve signs are in the ninth heaven, just below the tenth, where Enoch

> saw the appearance of the Lord's face, like iron made to glow in fire, and brought out, emitting sparks, and it burns. . . . But the Lord's face is ineffable, marvellous, and very awful, and very, very terrible.[157]

Here clearly we have the Jewish God as Helios above the zodiac. Astral immortality is indicated by the fact that the souls of the righteous will shine seven times brighter than the sun.[158] In IV Ezra VII, 88–99, it is described how the souls of the righteous will rest in the "seven orders," which are explained as orders of joys. But since verse 97 says that the righteous in the sixth "order" will shine like the stars, their faces like the sun, Cumont[159] seems to me quite right in seeing in the passage a moral adaptation of "sidereal immortality."

Now it is familiar that in popular and rabbinic Jewish parlance "Heaven" was a name for "God," so that in the Gospels the "Kingdom of Heaven" directly means the "Kingdom of God." Similarly we go not to Sheol or Hades or the pit,

150. I Enoch XXXIX, 3–7; cf. XLVII, 3; CIV, 2, 6.

151. See esp. ibid., XVII, XVIII, XXI, XXXIII, XLIII, XLIV. In II–V the regularity of the stars and seasons is contrasted with the willful wanderings of men. In Ps. Sol. XVIII, 12–14, it is denied that this order has ever failed, except at the special command of God's servants: the author clearly has Joshua in mind.

152. See, for example, the opening chapter of II Enoch (Slavonic).

153. Testament of Levi III–V.

154. So Abraham goes to the Seventh Heaven in the *Apocalypse of Abraham* (ed. G. H. Box, 1919), XIX.

155. II Enoch XXX, 2–4.

156. Ibid., 5–7; cf. XIII and XIV.

157. Ibid., XXI, 6–XXII, 1.

158. Ibid., LXVI, 7.

159. *Symbolisme*, 383 f.

but, if worthy, to "heaven" after death, so that "to lay up treasure in heaven" could be understood by the simplest audiences. This represents an invasion of "sidereal immortality" that is probably very old in Judaism, one whose origin is not to be recovered.[160] Such vague references, however, one feels to be distinct from the apocalyptic ascents, the rehearsing of the seven heavens (or three), the turning of the blessed into stars, the religious value in recounting the stages of the zodiac. A Jew, like a Christian later, could hope to "go to heaven" with no specifically astral thought at all. But the apocalyptic schematizations, like the later Merkabah, seem much more in the spirit of the astral symbols we are trying to evaluate than a simple hope of "going to heaven." To put the sun, moon, and stars with the Jewish cult objects is to put the cult objects definitely into the heaven of astralism. In a fragment from an early apocalypse the following is said:

> In time to come, the Holy One, blessed be he, will take his seat in Eden and expound. All the righteous will sit before him: all the retinue on high will stand on their feet. The sun and the zodiac [or constellations] will be at his right hand and the moon and stars on his left; God will sit and expound a new Torah which he will, one day, give by the Messiah's hand.[161]

The definite connection of God and the righteous with the cosmos is here an important matter, and it is notable that the eschatology is messianic as well.

Astral symbols and language were thus a means of bringing out the cosmic nature of God, or his hypercosmic nature, and the universal significance of the human soul, as well as man's destiny to become himself a cosmic or hypercosmic being. In Merkabah mysticism of the earliest stages the mystic ascended through the seven heavens (that is, the seven planetary spheres) to the throne of God. This later became an ascent through the seven heavenly palaces,[162] and in all cases one needed proper knowledge of the passwords to be allowed by the dread keepers to enter each heaven or palace or gate. The state of this literature, its rudimentary form in the earliest sources, its tendency to abandon literal astralism in the later writings, may well misrepresent the tradition. It may be that when the later texts are properly edited, they will show such astralism, but if so Scholem has completely misrepresented their character, and I do not think he has done so. The mystic colors and temples, the throne atop the vine, on the walls of the Dura synagogue, the seven steps to the shrine in

160. One recalls at once the chariot of Elijah, II Kings ii, 11.

161. The passage is quoted at much greater length by Herbert Loewe in his essay "Pharisaism" in the collection edited by W. O. E. Oesterley, *Judaism and Christianity*, 1937, I, 117 f., whence this is excerpted. It is from *Yalkut* to Isaiah, Sec. 429, but seems to be early because it mentions "Antoninus," supposedly one of the Roman Emperors who bore the name.

162. Scholem, *Jewish Mysticism*, 48. A Christianized version of this Jewish pattern is preserved in the *Ascension of Isaiah*, vii–xi (transl. Charles, 1919).

Sheikh Ibreiq, tie up with these writings, as we shall see, in a way the zodiacs and Seasons do not.

3. In Jewish Gnosticism of the Maaseh Bereshith

IN CONTRAST, some Jewish writings do use astralism in quite essential form, and Scholem calls these more Gnostic than the Merkabah. They belong to the Maaseh Bereshith, a little known mystic teaching about the Creation. One of the books, the *Sefer Yetsirah* or Book of Creation, was written, Scholem thinks, probably between the third and sixth century, and so is "the earliest extant speculative text written in the Hebrew language."[163] It is primarily concerned with explaining the ten Sephiroth and the twenty-two letters of the Hebrew alphabet. In the fifth chapter the author collates the twelve simple letters with twelve activities of man, the twelve directions of the compass, the twelve signs of the zodiac, the twelve months of the year, and the twelve major organs of the human body. And at the end of the book the letters all "shine in the seven stars and lead in the twelve zodiacal signs." The Gnostic or Bereshith fragments thus give extremely important hints that popular Judaism did have a real use for the zodiac and other astral symbols.

Judaism was genuinely influenced by solar conceptions wherein God is not himself the sun, but is an immaterial source of light. The "light" of God's countenance, the fact that in heaven there need be no sun since the light of God illumines all things, these are familiar in Judaism and Christianity alike.

> The sun shall be no more thy light by day;
> neither for brightness shall the moon give light unto thee by night.
> But the Lord shall be thy everlasting light,
> and thy God will be thy glory.
> Thy sun shall no more go down,
> neither shall thy moon withdraw itself:
> for the Lord shall be thine everlasting light,
> and the days of thy mourning shall be ended.[164]

This is an early example. A later one is in the prayer ascribed to Abraham:

> Eternal, Mighty, Holy, El,
> God only — Supreme!
> Thou who art self-originated, incorruptible, spotless,
> Uncreate, immaculate, immortal,
> Self-complete, self-illuminating;

163. *Sefer Yetsirah: The Book of Formation,* by Rabbi Akiba ben Joseph, transl. Knut Stenring, 1923. See esp. pp. 29 f., 32. The seven planets also appear on pp. 27 f. On the little treatise as a whole see Scholem, *Jewish Mysticism*, 74–76; and 363, n. 127. On p. 76 he contrasts this with the Merkabah tradition.

164. Is. LX, 19 f.; cf. Rev. XXII, 22.

Without father, without mother, unbegotten,
 Exalted, fiery One!
Lover of men, benevolent, bountiful, jealous over me and very
 compassionate;

Eli, that is, My God —
Eternal, mighty, holy Sabaoth, very glorious El, El, El, El, Iaoel![165]
Thou art he whom my soul hath loved!
Eternal Protector, shining like fire,
Whose voice is like the thunder,
Whose look is like the lightning, all-seeing[166]
Who receiveth the prayers of such as honor thee!
Thou, O Light, shinest before the light of the morning upon
 thy creatures,
And in thy heavenly dwelling places there is no need of any
 other light
than (that) of the unspeakable splendor from the light of thy
 countenance.[167]

This psalm of praise, in which as in the Johannine writings God is light and love, Abraham recites as he approaches the throne of God. In many ways it resembles the Merkabah mystery, for the next vision is of the fiery throne itself, and the fiery chariot. In this connection we recall that in the Midrash Rabbah, Rabbi Samuel ben Nahman tells Rabbi Simeon ben Rabbi Jehozadak that the "light" created in Genesis 1, 3, was something with which God wrapped himself as a garment, and then irradiated the whole world.[168] But he tells the conception to the younger rabbi in a whisper, suggesting again that this was part of a mystic teaching, presumably of the Bereshith.[169] From whatever source the conception of God as light came to Second Isaiah, then, and though it was used always by rabbinic Judaism,[170] it seems to have been developed most

165. Box notes that this four-fold El, as well as Iaoel, are each substitutes for the tetragrammaton. We are clearly very near to the language and atmosphere of the charms and amulets.

166. Box compares Dan. x, 6; Ezek. i, 13 f.

167. Apocalypse of Abraham XVII, as translated from the old Slavonic by G. H. Box 1919, 58–61.

168. *MR, Genesis*, III, 4 (ET, I, 20 f.).

169. Incidentally the passage (see the beginnings of chapters XVIII and XIX) shows the similarity of the Light-Stream to water which was one of the dangers of the mystic in his ascent: see Scholem, *Jewish Mysticism*, 51 f. Box

compares this passage with *Pirke Eliezer*, III: see the transl. of G. Friedlander, p. 15.

170. Box (p. 60, n. 7) recalls II Enoch XX, 1; XXXI, 2. There is also the radiance of God, still older in the story of Sinai, and how Moses' face shone when he merely approached this Light, itself utterly unendurable to humans (*BT, Megillah*, 19b). In the benediction over light which immediately precedes the *Shema* in the Synagogue Liturgy, the light which God created is described as being "eternal light in the treasury of life; for he spake and out of darkness there was light," a statement quoted by Box, p. 61, n. 3.

by the mystics of Judaism, as represented by hellenized Jews[171] and the Maasoth, and by Christianity in the Pauline and Johannine tradition. Actually it is in hellenized Judaism that we find the full appropriation of astralism which, we have felt, was suggested by the art.

4. In Hellenized Judaism

IN A THOROUGHLY hellenized, yet thoroughly Jewish, book, IV Maccabees, immortality is presented in astronomical terms. Seven brothers accept martyrdom by torture rather than eat pork, and they are made the equivalent of the seven planets turning as a choir in harmony round "piety"; or they themselves circle round the hebdomad.[172] The text is corrupt, but the general astral meaning of the passage is confirmed by the eulogy pronounced after the mother had followed her sons to death:

> Not so majestic stands the moon in heaven amid the stars as thou. Having led
> thy seven starlike sons with light into righteousness,[173] thou standest in honor
> with God; and thou art set in heaven with them.[174]

The Wisdom of Solomon, unique among the Apocrypha in many ways, shows astralism fully taken into Jewish ideas and worship. How old the conception was in hellenized Judaism cannot now be said. That it was proverbial when Wisdom was written seems likely from its appearing as a passing allusion, almost unintelligible in itself, an allusion which seems to refer to a conception already widespread. The passage describes how the Logos intervened in several episodes of Israel's history; so it was the Logos as the avenging Angel who slew the eldest sons of Egypt.[175] But when in the desert the Israelites were threatened with death, Aaron as the Logos, or with the Logos' help, "subdued the Chastiser":

> He conquered the Wrath not by strength of body,
>> Not by the force of arms,
>> But by Logos did he subdue the Chastiser,
>> In recollection of the oaths and covenants of the Fathers.
> For when the dead were now fallen in heaps upon one another,
>> He stood between and cut off the Wrath
>> And obstructed his [the Wrath's] path to the living.
> For upon the robe that reached to his feet was the whole world,

171. See my *By Light, Light,* passim, esp. the passages listed in the index, s.v. Light.

172. IV Mac. xiv, 7 f.

173. The word *phōtagōgēsasa* is perplexing. This clause may well mean: Having drawn down supernal light upon thy starlike sons for their righteousness.

174. Ibid., xvii, 5. Cf. M. Simon, *Verus Israel,* 1948, 68.

175. Wis. xviii, 15.

And the glories of the Fathers upon the carvings of the four
 rows of stone,
And thy magnificence was upon the diadem of his head.
To these the Destroyer yielded, these were the things he feared.
 For it was sufficient merely to put the Wrath to the test
 [i.e. by presenting him with these symbols].[176]

Commentators have long recognized that this description of Aaron in robes
was to be understood in the light of Philo's and Josephus' accounts of their sig-
nificance, to which we soon will come. But I some time ago pointed out that this
was a peculiar combination of Logos with Aaron's regalia, in that to confront
Death with this group of symbols was to confront Death with the Logos.[177] And
now I should add that in the author's mind the presentation of these symbols
specifically conquered Death. Of Aaron's regalia Wisdom says only that upon
the robe was the universe—in some sort of symbol, we presume; that the
glories of the Fathers were upon the twelve stones (of the breastplate, we
understand); and that God's own magnificence (his glory or Shekinah) was
upon the diadem of the priest's head. In what sense these were true the author
assumes the reader need not be told; apparently the author took it to be
common knowledge.

It is in the writings of Josephus, Clement of Alexandria, and Philo—all of
whom, I suppose, were later than Wisdom and none of whom seems to me to
have used any of the others as a source on this subject—that the allusion in
Wisdom becomes clear. I have already discussed the matter at considerable
length,[178] and need here only summarize it. These sources together indicate a
widespread belief, though one that does not register in any but writings
obviously influenced by Greek sources,[179] that the worship of the Jews, even in
the Temple, fell into two main categories. The first was the religion of ob-
servance, the halachic Judaism of the rabbis, what Philo called "literalism."[180]
Here God's rewards—usually of a material nature but perhaps including a
resurrection—came to those who were actually observing the laws, the sacri-

176. Ibid., 22–25.

177. In *By Light, Light,* 276.

178. Ibid., 95–120, "The Mystery of Aaron."

179. W. L. Knox, in an essay in *Judaism and Christianity,* II, edited by H. Loewe (1937), p. 79, discussed this material briefly, and Loewe inserted a footnote that "symbolism of the High Priest's robe has penetrated into rabbinical theology," with references to *JT, Yoma,* VII, 33, 44b (FT, V, 244 f.); *MR, Levit.,* x, 6 (ET, IV, 129 f.). But neither of these passages has an astral interpretation of the robes. The rabbis saw in the different parts of the priestly regalia atonement for different types of sin.

180. Wolfson's denial (*Philo,* I, 49; cf. 43–55) that there was any distinction be-
tween the mystic Jews and the "literalists" seems to me to dismiss the evidence without considering it. The evidence as presented in the passages which he himself cites still seem to me decisive. See M. J. Shroyer, "Alexandrian Jewish Literalists," *JBL,* LV (1936), 261–284.

fices, the Sabbath, the Jewish diet, and the rest. Over against this was a Judaism which saw its true being not in the physical observance of those laws (careful as most Jews, like Philo, were to observe them) but in going on from this literal conception to discover a deeper meaning in the laws and to be led by them into a spiritual perception and apprehension that far surpassed the mere observance of the law in physical act or abstention.

The higher Judaism seemed to Philo (whatever it may seem to modern writers) so much like a mystery that he himself constantly used mystic terms for it without the slightest hesitation. But it divided itself in turn into two main types, which were both represented in the sanctuary of Judaism itself, the Temple, or, more properly, the Tabernacle as described in the books of Moses. The cultus in this sanctuary was on two levels, one the cultus in which the ordinary priest shared, the other the entry into the Holy of Holies allowed only on the Day of Atonement, and then only to the High Priest. The distinction between the ordinary priest and the High Priest was made to represent that the cultus of the mass of priests was a material thing, one which used visible objects. Philo regarded these "visible objects" as symbols, to be sure, and awareness of their symbolic reference seemed to him to lift Jewish worship above the "literalist's" level, for the visible symbol became a help to the Invisible. In contrast even to this, when the High Priest entered the Holy of Holies in the Tabernacle he came into the presence of a new symbol, the Ark of the Covenant with its sacred contents. Philo so allegorizes the Ark that it represents to him the ontological procession from Deity, the very inner and immaterial evolution of the nature of God itself. Actually Philo never forgets that that room was empty in his own day, and it is this, it seems to me, which suggests to him a contrast between a cultus that used material symbols and a cultus that did not but that appealed to the mind alone, and abstractly. Actually, even the High Priest should so blind himself with incense that he could not really see the Ark at all.

The symbols of the outer shrine were material also in another sense. They represented the material manifestation of God in the universe, represented indeed the universe itself, and one who properly shared in this cultus joined the great cosmic worship wherein all creation manifested and worshiped the Creator. Philo himself preferred the mysticism of the inner shrine, the mysticism represented by the High Priest, who, stripped of his robe of splendor, clothed in simple white, went alone into the Alone. Yet he gave a great deal of attention to the Cosmic Mystery of Aaron, as I have called it, and in doing so he made the chief cultus of the Jews into a truly astral worship.

To Philo the Universe was, in good Neoplatonic sense, the lowest manifestation of the effulgence from the One. Philo was not a true monist, for unformed matter itself seemed always to him to be in contrast to the immaterial nature of God. But God, in himself utterly remote and abstract, presented

himself by a descending series of divine representations, a series with several collective names, the most common of which was Logos. This creative and ruling radiation of divine nature was also to be thought of as the world of forms, and therefore it could, in a sense, further be represented as the formal aspect of the universe. Like Plato, and like most Platonists, Philo considered the universe as a whole, especially its organization of the heavenly bodies, to be the purest of these representations. In the order of the heavenly bodies, their action, the zodiac, and the sun itself, collectively, the nature of God had its supreme visible revelation. And these not only gave visible revelations: the heavenly bodies in their harmony constituted the greatest of all choirs, offered the supreme cultus—to the God manifest in them, to be sure, but in truth incomprehensibly above them. One of the highest achievements of man was to join in this cosmic cultus, since the stars and the zodiac, the four seasons and the four winds, the four elements, and the sun, moon, and planets all function as the cosmic priesthood. This sort of astralism was not like the Chaldean and Stoic astralism which Cumont has described, for there men saw in the heavenly bodies, supremely in the heaven itself ("heaven," *ouranos*, was in Greek an equivalent for "cosmos"), the object of worship as a materialistic pantheism which Philo hated above all heresies. For Philo the cosmos was itself not God and should never be worshiped; but it was the supreme priest of God, the only true priest, and the Jewish High Priest when ministering in the outer shrine clothed himself with symbols of the cosmos to guarantee the source and validity of his own priesthood. Philo has much to say of this regalia, but the following is the best single summary of his conception:

> The high-priest is adorned in this fashion when he sets out to perform the religious rites, so that, as he goes in to offer the ancestral prayers and sacrifices, the whole cosmos may go in with him by virtue of the symbols (*mimēta*) which he wears: the long robe reaching to his feet a symbol of air, the pomegranate of water, the flowered [embroidery] of earth;[181] the scarlet of fire, the ephod of heaven; he wears in type the two [celestial] hemispheres in the emeralds on his shoulders, with the six characters engraved on each; symbols of the zodiac are the twelve stones upon his chest arranged in four rows of three stones in each row, while the breastplate (*logeion*) as a whole represents that Principle [i.e., from the context, the Logos] which holds together and rules all things. For it was necessary that he who was consecrated to the Father of the world should have that Father's Son who is perfect in virtue to plead his cause that his sins might be remembered no more and good gifts be showered in abundance.[182] Yet perhaps it is also to teach in advance one who would worship God that even

181. That is, the tunic symbolizes air, water, earth—the strictly sublunar elements and parts of the universe.

182. I have in several places improved the translation I gave of this passage in *By Light, Light*, 106, by comparing it with Colson's version in the Loeb ed.

though he may be unable to make himself worthy of the Creator of the cosmos, he yet ought to try increasingly to be worthy of the cosmos. As he puts on his imitation (symbol) he ought straightway to become one who bears in his mind the original pattern, so that he is in a sense transformed from being a man into the nature of the cosmos, and becomes, if one may say so (and indeed one must say nothing false about the truth), himself a little cosmos.[183]

Here the two types of mysticism are clearly named. One type is to be "worthy of the Creator," which in the context clearly means to become worthy to be identified with, to take on the characteristics of, the Creator through mystical union and transformation. This is the supreme experience, Philo's highest ambition. Second best to that, in the cosmic mysticism one takes on in one's mind the pattern of the Son of God, the cosmos, and so has the intercession of that Son with God, to the remission of one's sins and the gaining of all other spiritual gifts. The conception of the microcosm emerges in one of its earliest expressions, but man is a microcosm not because of his material form, or because the parts of his body resemble the universe as the reflection of the zodiac or of the later Sephiroth. He resembles the cosmos in the Platonic sense, in that the worshiper's mind appropriates the Form of the world, is transformed into the cosmic pattern. This Form is the Logos itself, as the reality of the material cosmos is the Logos present in it. As the Logos thus clothed in matter, the Son of God, turns in worship toward God, similarly the worshiper can become like the universe, a microcosm, as his mind becomes one with the Logos-Form. With that Logos-Form he is fused in such a mysticism that the cosmos, his type and ultimately himself, intercedes for him as he joins in the cosmic worship now by his own right: for he is the replica of the universe, its very self. This the High Priest teaches men, and represents to them as he wears his cosmic robe in the Temple that symbolizes the cosmos. The High Priest in putting on the cosmos, and becoming in his robes the Logos in the Cosmos, typifies the ideal (by this cosmic-mystic formulation) for every worshiper. The High Priest only shows the way for us all. In another place, where Philo allegorizes the whole burnt offering, he says of the stipulation to wash the feet of the victim:

By the washing of the feet is meant that his steps should be no longer on earth but tread the upper air. For in truth the soul of one who loves God springs up from earth to heaven and with its wings flies about, longing to take its place and share the dance with the sun, the moon, and that most sacred and perfectly attuned company of the other stars, whose marshal and leader is God.[184]

Again Philo says:

For the cosmos is a temple in which the high priest is his first-born, the divine Logos . . . of which the one who offers up the ancestral prayers and sacrifices is

183. *Mos.* II, 133–135. 184. *Spec.* I, 207.

a material imitation. He is commanded to put on the aforesaid tunic as a copy
of the universal cosmos, that the universe may worship together with man, and
man with the universe.[185]

The supreme instance of this sort of mystic identification occurred at the
death of Moses. Moses throughout Philo's writings supremely reveals the
human possibilities of perfection, is indeed the chief incarnate representation
of the Logos to men. In one of his more exoteric writings Philo thus describes
his death:

> He gathered together a divine company, consisting of the elements of all exist-
> ence and the most important parts of the universe, namely earth and heaven
> — one the hearth of mortals, the other the house of immortals. In the midst of
> these he composed hymns in every type of mode and interval, in order that
> men and ministering angels might hear: men that as disciples they might learn
> from him a similarly grateful attitude; angels as attendants to watch how,
> judged by their own technique, he made not a single false note. The angels
> could hardly believe that a man imprisoned in his mortal body could have a
> power of song like the sun, the moon, and the sacred choir of the other stars,
> in that he could attune his soul to the divine musical instrument, namely the
> heaven and the whole universe. And Moses the hierophant, when he had taken
> his place in the aether, mingled, along with the choral hymns of praise to God,
> his own true feelings of good will to the Nation. He reproved them for their
> past sins, gave them warnings and corrections for the present, and advice for
> the future based upon good hopes which were bound to be fulfilled.[186]

When Moses had finished the song he began to be changed

> from mortal into immortal life, and noticed that he was gradually being disen-
> gaged from the elements with which he had been mixed. He shed his body
> which grew around him like the shell of an oyster, while his soul which was thus
> laid bare desired its migration thence.[187]

The comparison of the body to an oyster shell goes back at least to Plato's *Phae-
drus*,[188] and shows "Orphic" immortality put here into a cosmic frame. Al-
though Philo always resisted the Stoic and "Chaldean" resolution of the per-
sonality into an ultimate cosmic substance, aether or fire or what not, still this
passage closely resembles the Stoic conception. Cosmic mysticism opens the
gate to immortality, and Moses' gate, Philo feels, can still be ours. Here at last
appears a true astral or cosmic Judaism such as we have felt from the begin-
ning must have lain behind the art.[189]

185. *Som.* I, 215; see 214–219, and *Migr.*
102–105.

186. *Virt.* 73–75.

187. Ibid., 76.

188. *Phaedrus*, 250c.

189. The reader may perhaps be re-
minded that the argument is basically as fol-
lows: At a time when astralism was an almost
universal form of religious hope, Jews widely
took over the symbols of that hope. That they

Can it be inferred at once that Philo's cosmic and astral conception of Judaism did lie behind the art? Certainly not. But it does help that his remarks seem to be a full expression of the ideas briefly alluded to by Wisdom. And a third Jewish writer, Josephus, in less detail than Philo, describes and evaluates the Temple or tabernacle cultus in terms of astral mysticism in a way essentially identical with Philo's explanation, but with such minor variations of detail that Josephus could hardly have been drawing directly upon Philo's writings.[190] From these independent sources, then, we have evidence that Jews actually made their temple cultus, made Judaism itself, into an astral religion.

Philo's evidence must in the second place be taken to indicate the beliefs of the Jews of his day, because, much as he made of their allegorization of the cultus, he really did not like it, and the allegorization of Judaism which seemed to him the truest took man definitely beyond the stars into the immaterial world. This comes out very clearly in several extended passages where he analyzes the experiences of Abraham.[191] Abraham had been brought up in Chaldea, where men believed in astral determinism, and identified God with the material world itself, or with the "soul" of the universe. Now Philo, like the rabbis, believed in astrological predictions, though he lists only natural phenomena — the weather, crops, earthquakes, and the like — as thus predictable.[192] He followed Plato in asserting that man learned to be philosophical first by means of his eyes, which could observe the cosmic phenomena.[193] He believed that the stars were intelligent beings[194] but repeatedly denounced their worship as the deepest heresy. Abraham, certainly, could not remain on the Chaldean level.[195] He was told to leave Chaldea first to go to Haran, where he discovered how to distinguish his senses, and the sensory mind in his soul, from what he thought must lie beyond the material universe altogether, a great Charioteer who drives and controls according to law the parts of the universe, as the mind in man controls the senses and bodily members.[196] These passages emphasize not the value of Jewish cultus, or man's joining with the cosmos even in its great worship of the God above it, but in withdrawing alto-

did so cannot be explained by casual allusions in Jewish writings to astral concepts, but suggests that many Jews adopted astralism deeply into their Judaism. Such an adoption we are finding in some aspects of Philo's allegory.

190. I have analyzed these remarks of Josephus in *By Light, Light*, 99.

191. The following is a composite of ideas in *Abr.* 70–88; *Migr.* 178–199; *Heres* 96–99; *Som.* I, 53–60; *Virt.* 212–216.

192. *Opif.* 58. He definitely called upon men to abandon astrology (*Migr.* 194),

though he said that the planets make all things grow (*Opif.* 113).

193. *Opif.* 53 f., 77; *Spec.* III, 185–191.

194. *Gig.* 7; *Plant.* 12; *Som.* I, 135.

195. Much as Philo praised the study of the stars, he was quite aware that he had no technique for arriving at scientific knowledge of their nature and so felt that, fascinating as astronomy might be, it had its limitations: *Som.* I, 22–24; *Heres* 97–99. Yet he proposed to keep trying: *Spec.* I, 39.

196. *Migr.* 186; *Abr.* 84; *Heres* 99.

gether from the world which is seen into the world which is not seen, the true world of the immaterial Reality, God.[197]

I have elsewhere elaborated what I called this "Higher" or Immaterial Mystery as contrasted with the "Lower" or Cosmic Mystery, and this need not here be repeated. But the contrast is now in point because it shows that Philo had no personal interest in the cosmic and astral interpretation of the Jewish temple cultus. Astralism appears rather dragged into his scheme, more properly integrated with the "Higher" mystery of his own preference. From that I can conclude only that astralism was so generally popular among the Jews of his day, especially those influenced by Hellenism, that he could not omit it.[198]

D. HELIOS

WE ARE STILL LEFT with the problem of what Jews meant when they put the zodiac in their synagogues and the other astral signs on their graves. The central position of the zodiac in the synagogues made us suspect that astralism was a vital part of the Judaism of these synagogues, and we have found a Judaism in Philo, Josephus, and the Wisdom of Solomon which centered high aspirations in an astral worship of God. But we have not yet had any explanation of why the particular symbol of Helios the charioteer within the zodiac should have been chosen especially to express this Judaism. We have seen that Helios supremely symbolized God in the Syrian world, indeed in the Roman world in general from the third century onward. We have often been reminded of Helios by such symbols as the bull, the lion, the eagle. It has appeared that to pagans the zodiac with Helios meant the supremacy of the law of nature, the orderly cosmos, under the direction of Sol Invictus. To some, we have seen, Sol Invictus was literally the physical sun, to others the real Sol lay behind the material sun. The astral system promised immortality, as the soul returned to its cosmic, or hypercosmic, origin.

It seems to me that, divergent as the suggestion may be from orthodoxy, Jews could hardly have used the device in any essentially different way themselves. When they saw the Seasons and the zodiac, they were presented — if

197. On the power of man's mind to soar above the material universe see *Opif.* 31, 54 f.; *Det.* 85–90; *Heres* 88 f.; *Spec.* I, 37–40; II, 45; *Praem.* 41, 65. One reads the story of Abraham's leaving Chaldea in the Apocalypse of Abraham, I (transl. G. H. Box) with a sharp sense of contrast, as well as the passages Box has collected in the appendices, pp. 88–96. In the rabbinic tradition Abraham goes out from the folly of idolatry, and while in the Midrash Ha-gadol, as quoted

ibid., 92, Abraham does come to see that the heavenly bodies are powers inferior to God, the Apocalypse shows none of the mysticism of Philo in the interpretation, the active use of the stars in worship or in ascending to God.

198. It should be noted that Philo, like the rabbis, equated the twelve tribes with signs of the zodiac: *Praem.* 65; cf. Colson's note *ad loc.* in the Loeb ed., VIII, 454 f.

Philo and Josephus and the Wisdom of Solomon are any guide to us — with the conception of God's rule, of the beneficence of the seasons, their regularity, and the starry world of heaven which the zodiac most succinctly represented. For the continuity of the notion into later cabbalistic Judaism, the statement of the *Zohar* is most illuminating:

> We are aware that the structure of the Tabernacle corresponds to the structure of heaven and earth. The Companions have given us just a taste of this mystery, but not enough for a real mouthful.[199]

Above these was the charioteer. And here Philo comes again most forcefully to mind. For he tells us that God is the shepherd of the flock of the stars, and that the twenty-third Psalm is a cosmic hymn, the hymn of the heavenly flock to the God who leads them.

> This hallowed flock he leads in accordance with right and law, and sets over it his true Logos and first-born Son, who shall take upon him its supervision like some viceroy of a great king.[200]

This supervision of the world by God, whether directly or through his Logos, Philo usually describes in terms not of a shepherd but of a charioteer. He describes how God made the seven zones and put a planet in each, and continues:

> He has set each star in its proper zone as a driver in a chariot, and yet he has in no case trusted the reins to the driver, fearing that their rule might be one of discord, but he has made them all dependent on himself, since he held that thus would their march be orderly and harmonious.[201]

In another passage Philo shows how God foresaw astral worship directed toward the stars and Seasons themselves. He took many steps to forestall this, chiefly in that he gave the stars power, but not independence, and himself retained direct control of all things, the stars included.

> Like a charioteer grasping the reins or a pilot the tiller, God guides all things in what direction he pleases as law and right demand.[202]

Again Philo says:

> The oracles tell us that those whose views are of the Chaldean type have put their trust in heaven, while he who has migrated from this home has given his

199. *Zohar*, Terumah, II, 149a (ET, IV, 22).

200. *Agr.* 51; see 50–54.

201. *Cher.* 24. We recall a curious Roman gem with Medusa, certainly a solar symbol, on one side; on the other a seated deity (I cannot agree with Reinach that it is a man — I should guess it is Apollo with his bow) is surrounded by two concentric bands. In the outer band are the signs of the zodiac, and in the inner band are the seven planets represented as seven charioteers in their quadrigas. See Reinach, *Pierres*, plate 127, figs. 96 f.

202. *Opif.* 46.

trust to him who rides on the heaven and guides the chariot of the whole world, even God.[203]

All of this might well have been symbolized by the Seasons and zodiac, with the Charioteer, and such a design would properly come in the very center of the synagogue floor. Such a conception of the meaning of the zodiac does violence to predominant rabbinic opinion, but we cannot cling to the determination to explain the pictures from rabbinic writings. The pictures must be explained in terms of a Judaism in which they have meaning. Were astral symbols the only ones which suggest interpretation in terms of a hellenized Judaism, we should have less confidence in suspecting that Helios and the chariot symbolize the divine Charioteer of hellenized Judaism, God himself.

E. SUMMARY

THE ZODIAC in the synagogues, with Helios in the center, accordingly, seems to me to proclaim that the God worshiped in the synagogue was the God who had made the stars, and revealed himself through them in cosmic law and order and right, but who was himself the Charioteer guiding the universe and all its order and law. Nothing indicates that the Jews in these synagogues followed Philo's stricter philosophy in regarding the Charioteer as the Logos, while God was himself the remote and unaffected Monad in self-sufficient isolation. Actually the floor of Beth Alpha as a whole, the only one that shows the zodiac in its full original setting, seems to me to outline an elaborate conception of Judaism. In the center is presented the nature of God as the cosmic ruler. Above are the symbols of his specific revelation to the Jews, primarily the Torah in the Torah shrine; below in the sacrifice of Isaac is, I suspect, the atonement offered in the Akedah. All this is surrounded by familiar mystic symbols: birds, animals, and baskets within the intersticies of the vine. At the top of all inconspicuously stand the little fish and the bunch of grapes.

As I explained the three large scenes before, the first seems to me to be the Akedah as the atoning sacrifice of Abraham and Isaac, by which Abraham became the priest forever after the manner of Melchizedek. This corresponds to the first step in mysticism of the *philosophia perennis*, purgation. In the second panel, one goes up to the illumination of the heavens. In the third, one comes to the implements of the revealed cult of Judaism, the whole properly veiled but here shown with the veil drawn back to allow what was behind the veil to appear. It is no coincidence, I believe, that the Higher Mystery had its chief symbol for Philo in what lay behind the veil of the Holy of Holies. But here the most sacred symbol of all is only implied, the Torah behind the closed doors of

203. *Heres* 99. *Theos* at the end is without the article and may thus refer to the Logos. Equally definite are *Decal.* 53, 60; *Spec.* 1, 14.

the Torah shrine. Here the third stage of mysticism was possible, that of uni-fication. It is this scene which we found so prominently used for the back of arcosolia in the Catacomb Torlonia. To this closed shrine also ascend seven steps in the cemetery of Sheikh Ibreiq. We shall see other apparent references to the same idea in the paintings at Dura. The menorah in the center of the ceilings at the Catacomb Torlonia seems to me to go with this astral symbolism, since the menorah has been seen to symbolize, among other things, the seven planets.

Similarly the four Seasons that appear in the mosaics and on the sarcoph-agi would have represented to Philo an abbreviation of the cosmic order. The twelve stones in the High Priest's breastplate were arranged in four rows of three each, he says, to correspond to the fact that there are three zodiacal signs in each season.[204] The transitions of the seasons are controlled by strict math-ematical laws, and reveal the Logos who guides them.[205] Philo warns against the pagan hypostatizing of the seasons, with the assumption that they have in themselves the power of producing what grows upon the earth.[206] But once he has entered that caveat, he has no reluctance to saying, like any pagan,

> The four seasons of the year bring about achievement by bringing all things to perfection, all sowing and planting of crops, and the birth and growth of animals.[207]

He even schematizes the Jewish Festivals according to the seasons, and so makes the Festivals into a cosmic worship.[208] The Jewish calendar is, he thinks, designed to make the whole cycle of the year into a Festival.[209] Celebration of a Festival in the true sense is

> to find delight and festivity in the contemplation of the world and its contents and in following nature, and in bringing words into harmony with deeds and deeds with words.[210]

204. *Spec.* I, 87.

205. *Mos.* II, 124–130. In Greek the breastplate is called the *logeion*, we have seen, which makes it for Philo a symbol of the Lo-gos, ruling the cosmos as presented in the zo-diac. His allegory of the breastplate could largely be transferred to the design of the zo-diac, Seasons, and the Charioteer. See *Mos.* II, 133–135; *Spec.* I, 88. On the mathematical scheme of the seasons see *Heres* 148–150; *Spec.* IV, 235.

206. *Opif.* 54 f. Cf. *Congr.* 133.

207. *Opif.* 59. "The yearly seasons by which all things are brought to their consum-mation," *Spec.* III, 188. See *Spec.* IV, 99. Some of the crops of the earth are sown by farmers,

some "every springtime spontaneously brings forth," *Aet.* 63.

208. It hardly needs documentation that Philo's guess here was very credible, since most modern scholars see in the Jewish festi-val cycle a celebration of the year of nature and its seasonal goods. Taken over, possibly, from Canaanite nature and fertility cults, the seasonal nature of most of these was always transparent. See, for example, W. O. E. Oes-terley, "Early Hebrew Festival Rituals" in S. H. Hooke's *Myth and Ritual*, 1933, 111–125.

209. *Spec.* II, 48.

210. Ibid., 52.

Specifically the Feast of the New Moon celebrates beginnings, the coming of light, and the fact that the moon goes through the zodiac most rapidly of all the heavenly bodies. The new moon calls us to imitate the heavenly kings (the stars), and the moon also makes important contribution to earthly fertility.[211] Philo, as is customary, combines Passover with the Feast of Unleavened Bread, which, as the Feast par excellence of the Spring equinox, commemorates the act and product of God's first creation and the creative power of God in nature.[212] Most elaborately the Feast of the Sheaf is likewise made into a spring Festival of fertility.[213] But there is no reason to review each Festival here. The substance of the long section on Festivals is stated in another treatise, where, after showing the cosmic importance of the mystic number seven, and its repeated presence in the stars, Philo says:

> The sun, too, the great lord of day, brings about two equinoxes each year, in spring and autumn. The spring equinox in the constellation of the Ram, and the autumn equinox in that of the Scales, supply very clear evidence of the sacred dignity of the seven, for each of the equinoxes occurs in a seventh month, and during them it is enjoined by law to keep the greatest national Festivals, since at both of them all fruits of the earth ripen, in the spring the wheat and all else that is sown, and in the autumn the fruit of the vine and most of the other fruit trees.[214]

The Seasons, then, symbolize at once the regularity of the cosmos, its law, and the beneficent power which comes to earth from heaven and its God. In them we find united again astralism with fertility cult, the combination most generally in favor in the symbolism of immortality and mysticism in the Roman world. That Philo does not connect the seasons specifically with immortality is only to be expected of a man who was himself so little interested in immortality. For Judaism in general their presence on the graves and their mention in other sources is sufficient indication that like the stars they suggested the hope of man at death to change into a greater life. But Philo does show that the seasons had been elaborately accepted into Judaism by such allegory of Jewish Festivals as makes them celebrations of precisely this combination of astralism and fertility cult, and so the basis of genuine mystical experience and sacrament within Judaism itself.[215] The figures of the Seasons on the Jewish sarcophagi at Rome, then, were more in harmony with Judaism than Cumont himself indicated, in harmony with a strongly hellenized Judaism. The menorah, itself a sign of the seven planets, flanked by Seasons, meant much in terms of Jewish thought: it meant hope of immortality, astral immortality

211. Ibid., 140–142.
212. Ibid., 150–161.
213. Ibid., 162–175.
214. *Opif.* 116.

215. On the Festivals see esp. my "Literal Mystery in Hellenistic Judaism," *Quantula-cumque, Studies Presented to Kirsopp Lake*, 237–241.

granted by that beneficence which, while it came from the relentlessly regular heaven, made all the earth fertile and promised renewed life also to man. But the menorah added that all this came from the Jewish God who governed the universe. When Christians took over the same value and put Christ enthroned between the Seasons upon a sarcophagus in place of the candlestick, it may be assumed that in Christian terms the design indicated the same hope.[216]

216. *Mélanges d'archéologie et d'histoire,* XIV (1894), 445, plate IX.

PART III

THE SYNAGOGUE AT DURA-EUROPOS

Interpreting the Art of the Synagogue at Dura-Europos

FEW ARCHEOLOGISTS have had so amazing an experience as that of five young people when in November 1932 they saw the painted walls of a third-century synagogue emerge from the sands of Dura Europos. Their names should be freshly recorded: Clark Hopkins, Director; M. le Cte. du Mesnil du Buisson, Vice-Director; Miss Margaret Crosby; Frank E. Brown; and Van W. Knox. Others joined them when the magnitude of the discovery showed the need. The original group had gone out carefully coached by Franz Cumont, René Dussaud, and, above all, Michael Rostovtzeff, who, with his usual flair for the best place to dig, had spotted the great mound of sand on the desert side of the city. Here, it turned out, a whole row of buildings had been preserved, including not only the synagogue but also the earliest known Christian meeting room or baptistry, and a magnificent Mithraeum.

About A.D. 256 the citizens of Dura, with a little Roman garrison, had been cut off from all help and faced inevitable extinction at the hands of an advancing Persian host. To strengthen the most exposed wall of the city the desperate people tore the roofs from the buildings in the street behind it and constructed a great ramp by filling the whole with quantities of earth. It did no good. The Persians tunneled under, and Dura was never heard of again until, in 1921, a British captain warring against the Arabs camped on the site, and in the course of "digging some trenches in the ruins" discovered the painting of the "Palmyrene gods." J. H. Breasted, who was near by, came and took photographs; he reported the discovery to the members of the French Academy of Inscriptions, who excavated the site for two years.[1] They did not touch the ramp behind the wall, however, and there the decorations of the synagogue, freshly painted just before being buried, remained in the dry earth. They came out eventually with the colors almost as clear as when the *morituri* had buried them.

When Jews first came to Dura we do not know. The painted synagogue

[1] The best accounts of the discovery are by J. H. Breasted, *Oriental Forerunners of Byzantine Painting*, 1924, 52–61 (University of Chicago Oriental Institute Publications, I); Cumont, *Fouilles*, pp. 1–x.

was clearly built upon an earlier one, which in turn had been made by remodeling a typical dwelling of the city. Kraeling estimated that the first synagogue dated from the end of the second to the beginning of the third centuries, approximately fifty years before it was demolished to make the second synagogue in A.D. 245.[2] The earlier synagogue had had a ceiling painted to imitate coffers, with a gilded plaster rosette in each coffer, and on the walls painted panels to imitate marble. An inscription on one of the ceiling tiles of the second synagogue established its date firmly,[3] but not the date of the murals. The ceiling this time was made of real painted tiles; some decoration, as on the reveals of the doorways, and the panel over the Torah niche, was probably done at once. Then, apparently, a great vine was painted over the niche to the ceiling —a device several times repainted, and finally divided to go with the extraordinary painted panels within grapevine borders with which the walls were entirely covered. This last was done very shortly before the fall of the city in 256, for paint droppings are still to be seen on the floor. We cannot suppose much more than a five-year interval.

The building was cut back to buttress the city wall, as just mentioned. Kraeling[4] has carefully reconstructed the steps taken in this emergency. At first sand was brought in from the desert to fill Wall Street to the level of the tops of the houses; but this put such great pressure on the walls of the houses that they began to buckle and had themselves to be braced. Apparently, embankments of earth and carefully packed mud were built from the inside against the threatened wall, and this was further strengthened by sand and by rubble from walls destroyed for the purpose. The portions of the walls of the synagogue which projected above the growing ramp were knocked off, to add their weight to the buttress. Accordingly, of the north and south walls less than half remains, while of the east wall at the back we now have only the dado and part of the bottom register of paintings. The west wall, however, was preserved almost intact, and since this was the wall toward which worship was directed, it seems to have been the most important of all. Enough of the whole is left to make the paintings one of the most important discoveries of all time for the history of religion.

A. RELATION TO SURVIVING JEWISH LITERARY TRADITIONS

After the first wave of incredulity at the new discovery had passed, discussion began about what the paintings can tell us; though considering the importance of the material, they have received relatively little attention. The

2. H. Pearson in Rostovtzeff, *Dura-Euro-pos*, VI, 311; Kraeling, *Synagogue*, 4–33.

3. See C. Torrey in Kraeling, *Synagogue*, 261–266.

4. *Synagogue*, 4 f.

synagogue had quite as radical implications for our knowledge of Judaism as the Dead Sea Scrolls, if not far deeper; but whereas hundreds of people were prepared to read the Scrolls, no one alive knew how to read the language of the murals. In their remarks about the Dura Synagogue scholars have thus far united only in feeling that explanation of the paintings must begin by orienting the paintings with their own conceptions of Judaism. Few scholars, that is, began with the paintings themselves: practically all began with notions from this or that body of Jewish literature, with which they insisted the paintings agreed. One scholar, for example, has said specifically that in interpreting archeological monuments we must "proceed from those elements which fit recognizable types and have reasonably certain meanings . . . that is, from the normal and obvious." So he recommends doing what Kraeling has done: explaining the relation of the paintings first to the Old Testament, next to the "great bulk of Jewish literary material of approximately their own time and area," and then to the contemporary pagan art of Dura. Other matters can safely be left, he says, to "special studies."[5]

Just what a special study may be he does not explain. But I see little to commend the assumption that we may consider the evidence offered by the place of the paintings in the history of iconography and symbolism only after we have safely chained them to a Jewish literary tradition of the same "time and area." For by that first move we shall actually have closed the door against seriously considering the evidence of the art itself, or of other types of Judaism. The history of art, as has often been recognized — conspicuously by the great Henri Focillon — is the history of the human spirit in terms of forms. Monumental texts, he rightly says, have the same value as written texts, and often a much higher value. "There exist whole segments (*pans*) of civilization for which their forms are the only, or almost the only, sources of information to reach us."[6]

Jewish art seems to have opened such a *pan* in Jewish history. The literary remains of Judaism in the Greco-Roman period had led us to suppose that Jews at that time used no images. Although for centuries archeologists had been finding a great number of Jewish images from the period, the Dura synagogue, and the other remains of Jewish art collected in the first three volumes of the present study, came as a total surprise to those historians who had used

5. Kraeling said essentially the same thing, *Synagogue*, 340: "There is great danger of letting our eyes be blinded to, or by, the novelty of the material, and thus of losing perspective either upon the paintings themselves or upon the picture of ancient Judaism as it has been developed from the study of other types of evidence by the scholars of the

last hundred years."

6. H. Focillon, "Lettre à Josef Strzygowski," *Civilisations. Orient-Occident, génie du Nord-Latinité*, 1935, 133 f. (Institut International de Cooperation Intellectuelle. Correspondence IV). Quoted by Naményi, *L'Esprit*, I.

only literary evidence. In alluding to that collection I by no means forget the large number of predecessors I drew upon who did know some or all of this art, even before the discovery of Dura. Their labors, however, were not such that the art remains of Judaism had taken an important place in any general history of Jews in the period alongside the literary remains. Indeed very few even of those who themselves discovered and published the various monuments had considered for a moment that their discoveries were really opening up a new *pan* in that history. Jewish history, based upon Jewish writings, has been largely written on the assumption that the basic motif of all Jews of this period was total rejection of pagan religion. Even the monumental study of Tcherikover[7] is devoted to the thesis that hellenization affected only a few great families corrupted by their riches, while the mass of Jews everywhere rejected any taint, and remained what G. F. Moore called "normative" Jews. By rejecting paganism, it has been supposed, Jews strengthened themselves as a group, a group distinguished by their worship of the one true God. Along with the peculiar cycle of sabbaths and festivals, the in-group marriage, and peculiar food went, it was thought, an abhorrence of images, especially those associated with pagan worship. Some Jews added mysticism to this normative Judaism, others messianism and eschatological concern, but however much such extremists as even Philo may have borrowed from pagan religions and metaphysical attitudes, they expressed the basic detestation of pagan worship and images quite as strongly as any rabbi. Paul might have drawn from either Philo or Gamaliel when he wrote of the pagans: "Claiming to be wise they became fools, and exchanged the glory of the immortal God for images resembling mortal man or birds or animals or reptiles."[8]

Suddenly, however, the new discoveries presented us with a Judaism that had no such feeling about pagan art or images—to the point that at Dura the god Ares, for example, could supervise the Exodus from Egypt, Victories bring their crowns on the acroteria of the Temple, and the three Nymphs guard the infant Moses while Aphrodite-Anahita takes him out of the little ark. Helios riding in the zodiac had occupied the center of Palestinian synagogues. All of them directly violate what had seemed the basic attitude of Judaism. True, nothing suggests that Jews ever worshiped these figures, any more than that they worshiped the Moses or Aaron or Abraham that accompanies them. We cannot on that account dismiss the fact that nothing in the literary remains of Judaism suggests anything but the most occasional and grudging tolerance

7. V. Tcherikover, *Hellenistic Civilization and the Jews*, 1959. See my review in *Jewish Social Studies*, XXII (1960), 105–108. Tcherikover speaks very well of the present work on p. 523, n. 2, but I cannot agree that I am "anxious to emphasize the Hellenization of the Jews." I am "anxious" only to let the evidence, all of it, speak for itself.

8. Rom. 1, 22 f. See Philo, *Decal.* 66–81, and my *Introduction*, 108 f.

of such art. Why would any loyal Jew (and all these were loyal Jews) have wanted to borrow the art forms of paganism, and represent them in their places of burial and worship, at Dura represent them alongside, and even integrally within, their paintings of Old Testament scenes? If the literary evidence gives us no way of explaining such a desire for pagan art forms, we must see that the monumental evidence has taken us into a new *pan* of Judaism, for which the art remains themselves are our only direct evidence. Because here, clearly, is a widespread Judaism that did want them.

How are we to deal with such a phenomenon? It was suggested in Chapter Two that we should trace the history of the symbolic forms used by Jews to see whether out of their history we might recover some constants of meaning. Meaning we saw in a symbol's "value" rather than its "explanations." A live symbol when borrowed by a new religion is borrowed for its value and given explanations (if at all) in terms of the traditions of the new religion. We assume that Jews were borrowing the symbols of pagans not for ornament but to say something. What the symbols had said for pagans in terms of pagan religions the Jews wanted them to say in terms of Judaism. The rabbis clearly had no conceptions in their Judaism to express which they needed a figure of Helios, the eagle, Cupid, or Victory. This must not blind us to the fact that, in contrast, we are here dealing with Jews who felt that they needed precisely these figures to express values they found in, or projected into, their Judaism. On no other basis does it seem possible to explain the wide use of these symbols, the kinds of symbols selected from paganism, and the places they were used.[9]

The same method should be used in interpreting the paintings of Dura. The first premise is that we must get to verbal statements about the meaning of the art only after, and out of, a study of the monumental remains themselves, rather than begin by imposing verbal statements from some or other types of Jewish literature upon them. I have tried to evaluate the pagan symbols found in synagogues and Jewish graves. The discussion takes on a new dimension when we see at Dura basically the same borrowed symbols accompanying an assembly of paintings obviously inspired by Old Testament incidents.

All of my predecessors who have discussed the Dura synagogue have regarded it as their first duty to explain that the pagan motifs in its ceiling and dado had no importance whatever, were "purely decorative." The most elab-

9. Morton Smith, "The Image of God," *Bulletin of the John Rylands Library*, XL (1958), 473–512, has shown traces of hellenization in the rabbis themselves. He follows Saul Lieberman, and adds many scattered details. But the details remain scattered, and the rab- bis give us no such collected and extensive hellenization as the Jewish art, at Dura and elsewhere, presents. See my "The Rabbis and Jewish Art in the Greco-Roman Period," *HUCA*, XXXII (1961), 269–279 (Julian Morgenstern Festschrift).

orate of those attempts is Kraeling's;[10] he has presented a summation of all other arguments, with many additions of his own. One cannot disagree with him without reason, and as we expound the pagan motifs of the ceiling, the dado, and the reredos we shall have to take his ideas seriously. Many of the pagan motifs in the synagogue have already been discussed, and the new ones must be examined historically.

Pagan motifs in Jewish synagogues and graves have already led us to suspect that Jews used them to express faith in heaven, in the love of God, in coming victory, and, for some, in mysticism. I believe that, as we continue, the new symbols which Dura adds to the old vocabulary will seem to point to similar meaning. All these symbols—the vine, or birds in the vine, or the harnessed felines—had promised such hopes impartially in many pagan religions as they migrated from one religion to another. To early Christians the same symbols apparently expressed the same hopes, *hopes that ceased to be pagan when they lost their associations with pagan gods and myths.* They would indicate the Christian aspect of the hope explicitly as they were represented along with symbols from the Old Testament or life of Christ. The biblical scenes of Christianity in no sense detracted from the symbolic power of the borrowed pagan emblems, or changed their values. The biblical scenes only spelled out how the Christians were reinterpreting the universal symbolic language, declaring Christian explanations for the pagan values now claimed by Christianity, presented in Christianity. The natural hypothesis is that at Dura, Jews were doing the same thing in the name of Judaism: that the biblical scenes they selected to present in such a setting would declare in Jewish terms the values and hopes which pagans had set forth by these symbols before the Jews used them, and for which Christians were already beginning eagerly to borrow them. For, let me repeat, I am confident that the representations in the synagogue, pagan and Jewish alike, express the Judaism of the people who designed the whole scheme. We must treat as a unit the decorations in the synagogue, along, indeed, with the plan of the building itself.

If we regard it as our first task to associate the biblical scenes with one or another body of Jewish literature, we at once rule out the possibility of such association with pagan devices, since, as was just said, we know no Jewish literature that shows any need of pagan symbols to express itself. In point of fact, all early attempts at explanation actually looked for elements in the paintings that would suggest the sort of Judaism each of us had come to know best by previous study. Some saw eschatological and apologetic cycles represented, and looked to this type of literature for proof texts. Others felt that if Dura was Jewish, it must be explained out of the Talmud and Midrash. In *By Light, Light,* I made a preliminary announcement that the paintings were inspired by hel-

10. Kraeling, *Synagogue,* 39–54, 65–70.

lenized Judaism of the kind I had learned from Philo.[11] None of these bodies of literature can be ruled out, a priori; much illumination will prove to come from all of them. The art, however, may be presenting us with a *novum* altogether, or such a mixture of elements as to constitute a virtual *novum*. The paintings may go back to any of these three great kinds of Jewish literature. But we obviously need some objective approach in appraising them.

B. DURA AND BABYLONIAN JEWS

WHAT SEEMED at first such an objective view was suggested years ago by Kraeling in a paper read to the New Haven Oriental Club. While I do not recall that he formulated the idea directly in his monumental *Synagogue*, clearly it still operates powerfully in his thinking. He suggested in his paper that we appeal to time and geography. He said that since Dura was on the Euphrates, only about 250 miles north of Nehardea, which was at that time the seat of the great Babylonian Jewish Academy, we should take their Judaism, as expressed in Babylonian Talmud and Midrash as well as in the Targumim, to be what presumably lies behind the art of Dura. This has always sounded to me like a treacherous criterion of judgment.

Nehardea and the towns about it had become a little island of Jews where Jewish traditions seem almost entirely to have taken over. How far this was true we do not know, for in A.D. 220, when the first synagogue of Dura was in operation, the great scholar Rav returned to Babylonia from his training in the Palestinian Academy and went through the Jewish settlements of Babylonia establishing schools where his fellow Jews, whom he found painfully ignorant of the Law, could be trained. But these little Jewish communities of Babylonia had no importance as military or trading posts for either Greeks or Romans, and so were never permanently occupied or influenced from the West. Indeed when the Persians conquered all southern Mesopotamia and ruled it in place of the Parthians, the first Persian king persecuted the Jews of the region, but his successor relaxed this and allowed them to live peacefully according to their own legal traditions. In A.D. 258, two years after the destruction of Dura, the Palmyreans conquered Babylonia and destroyed a few Jewish cities, including Nehardea; but this, too, proved only temporary, and the Jews there soon continued to live their own lives with essentially no control from gentile civilizations. As a consequence, legalistic or halachic Judaism had a freer hand to develop there than at any other time or place in Jewish history, with the possible exception, much later, of similar Jewish centers in Eastern Europe. The fully developed halachic Judaism which we associate with the Babylonian Academy and life, and which produced the Babylonian Talmud, was probably still quite unformed when the Dura synagogue was decorated; so if there

11. *By Light, Light*, 209 f., 222, 242, 262.

was any significant relation between the Judaism of Nehardea and Dura, Naményi[12] seems to me right in saying that Dura would have represented Babylonian Judaism before the halachic reform.

We may question, however, that the Judaism of Dura ever resembled at all closely the Judaism of the Babylonian communities. For in contrast to Babylonian Jews, the Jews in Dura constituted a small minority within a pagan city, where they lived cheek by jowl among first Greek, then Parthian, then Roman soldiers and merchants. Their little synagogue, when they had one at all, was engulfed and dwarfed by the houses and temples of the goyim throughout the city. Their surroundings, therefore, resembled much more those of Jews in Ephesus, Corinth, or Antioch than those of Jews of Nehardea. The bilingual inscriptions show us that Greek was commonly spoken by the Dura Jews, and the art they used has itself an undoubted hellenistic base, with highly important Parthian or Persian accretions. In physical setting, then, the Jews of Dura, an outpost of Greco-Roman civilization, had much more in common with the Jews at other centers of that civilization than with the Jews in the natural ghetto of Babylonia. So far as actual distance goes, Dura lay closer to Nehardea than to Antioch or Damascus, but was closer to Palmyra than to Nehardea. The distance from Dura to the Babylonian center was really almost as great as that from Jerusalem to Alexandria. In culture and atmosphere Dura was utterly remote from Jewish Babylonia.

Obviously, then, we cannot insist that the art of Dura, or the Jews of Dura, must be confined to the terms of Babylonian Jewry, any more than we can assume that the two groups had nothing in common. Lacking any writings from the Jews of Dura, we must be equally open to the idea that the Jews of Dura thought quite like the Jews of Nehardea, or quite differently from them, much more like Jews in Ephesus or Alexandria. Or they may have thought in terms of a mixture of ideas from both sources, or in a way suggested by none of our literary sources. We have, indeed, no Jewish literature so full of Iranian elements as are the synagogue paintings. Let me repeat, we have only the monuments themselves from which to judge the opinions of the men who made them.

C. PROCEDURE

THE ART, along with the architecture and inscriptions, must be approached as nearly as possible as a problem in its own right. As we shall see, the recognizable Old Testament scenes with their labels, along with the donors' and builders' and visitors' inscriptions, make it indisputable that the building was a synagogue, and we must suppose that the Jews who built it based their think-

12. *L'Esprit*, 14.

ing on the Torah, as did both Philo and the rabbis, and, indeed, all Jews we know. Since the paintings represent scenes not only from the books of Moses but also from the books of the prophets and later history, we may at once conclude that Jewish interests here were not so concentrated upon the Pentateuch as were Philo's. But for the nuances of their Judaism we return to the archeological remains as our only source of light, the archeological remains as a whole, not as expurgated by our preconceptions.

1. Architecture

WE MUST start, indeed, with the structure of the synagogue itself, where we shall discover that although it was made by remodeling a house, and still retained some features of domestic architecture, the original building was changed to resemble as far as possible the inner shrines of the pagan temples of the city, even to focusing the main room in a niche. Scholars have hitherto minimized this resemblance, and especially stressed the fact that in all the inner shrines of the pagans which focused in a niche, the niche was used for the cult statue or relief of the deity of the group.

I see no contrast between the Jews and pagans in their use of the niche. When the Jews put their cult objects, especially the Torah scroll, into their niche, they put there the cultic means of obtaining the presence of Deity which is precisely what a pagan aimed to get from the cult image in his own niche. When the Jew opened the shrine, pulled back the curtains, and directed his "adoration" toward the scrolls, he was not of course "praying to" the scrolls. But he was, as he still is in that ritualistic act, praying to the Shekinah which the scrolls brought into the synagogue. All intelligent pagans would have denied any higher value than this to their cult figures. In brief, both pagan and Jewish shrines focused in a niche containing the symbolic means of bringing the real presence of deity into the room. The synagogue was built for Jewish worship of the Jewish Shekinah, but conducted deliberately in a frame devised by pagans. Only a preconception that Jews *could* not have been so influenced by paganism would prevent such a conclusion. Analysis of the architectural details will then be a highly important beginning, not only for symbolism but for suggestions of cult practices.

2. Pagan Symbols

THE ARCHITECTURE and pagan symbols in the synagogue suggest strongly also that the Jews of Dura thought much as did the Jews throughout the Roman world (including Palestine) who used such borrowed symbols. It is from this point of view that we must approach the biblical paintings. For the first time in our study, as I have said, we find, at Dura, Jews using pagan symbols

along with biblical scenes, and so giving a clue to how they interpreted their Bibles. We have suspected that Jews of that period, in adopting the pagan symbols, appropriated much of the religiosity of their neighbors, i.e. what seemed best to them in it. We have therefore supposed throughout that since they kept their loyalty to Judaism, they must somehow have interpreted their Judaism, or their Jewish Bibles, to include the values of the borrowed symbols. No evidence has appeared that they accepted polytheism or idolatry, or indeed any gods on a level with Yahweh or equivalent to him, or in any way worthy of worship. I see no hint of such a thing here at Dura. But new interpretations of the Bible, whether we call them allegories or midrashim, must have gone with the borrowed symbols of paganism.

It is obviously my belief that suggestions of such allegory can be found in the biblical paintings of Dura, but we cannot begin on that assumption any more than with an assumption of similarity to Babylonian Judaism from geographical propinquity. All we can say at this point is that the presence of the biblical paintings in the pagan-styled building with its pagan decorations establishes a possibility that the biblical paintings, through allegorized biblical incidents, expressed in Jewish terms ideas similar to those expressed by the pagan symbols. Yet although pagan forms stand thus alongside and within biblical scenes in the building, we must still begin with minds as free from prejudice as possible to examine the paintings themselves. We can do this only as we find a vantage point outside the problem of Jewish meanings. The only such vantage point I know is still in the history of art, in the history of the symbolic conventions used in the paintings, and in the way in which the decorations on the walls were planned to go together.

As to the over-all design, or arrangement of the paintings, this can be studied only in the west wall. The other walls are too fragmentary to disclose a general plan, if one existed. In the west wall the history and structure of a developing plan is quite apparent, however, and becomes an important guide in interpretation. No expert who has studied the paintings has the slightest idea that we have here a totally new creation by local Jews. In spite of the many differences from anything we know elsewhere, the biblical scenes at Dura show many details like those in the illuminations of early Greek manuscripts of the Old Testament, in some of the early frescoes in the catacombs, as well as in early Christian mosaics, so that we must presume a common art tradition behind them all. The Christian designs have for a number of years been thought to have originated with Alexandrian Jews perhaps a century before Christianity, and to have come over into Christianity in the Hexateuchs and other manuscripts of selections from the Septuagint,[13] or from architectural origi-

13. J. Hempel in *ZAW*, LI (1933), 284– 294; Morey, *Early Christian Art*, 76 f.; Hem- pel, "Problem," 103–131.

nals. In the illuminations of biblical and ritualistic manuscripts of medieval Jews no comparable similarity has appeared. Hence we may presume that since the early Christian illuminations of Old Testament manuscripts were essentially Greek in art form, just as the biblical texts they illuminated were in Greek, the artists who began making such illustrations not only were Jews but were in some sense hellenized Jews. We may also presume about the Jewish paintings at Dura that they derived ultimately not from Aramaic and Hebrew-speaking Babylonia but from the Greek-speaking West. Kraeling and others have used the Christian illuminations for reference in identifying Dura scenes, but that the Christian art itself may also have an ideological base in hellenized Judaism does not enter at all into their evaluation of it. Even if, however, the hellenized Jews who first began such Old Testament painting had all been hellenized exactly as was Philo (a position I should not dream of defending), and even though the paintings were all designed to illustrate ideas central to Philo's thinking (equally indefensible), it could just as little be assumed a priori that these ideas, and these only, carried through to Dura and inspired the synagogue paintings. All that this part of the art tradition tells us is that since the Jews who began it spoke Greek and used Greek art forms to illustrate their Bibles and books of ritual, the art began with Jews hellenized at least to that extent. But this at once takes us a step toward concluding that the paintings in the synagogue harmonize in some way with the hellenized architecture and symbols. We cannot on that account, I repeat, transport the hellenistic Judaism of Philo, the one we know best, in full details to Dura.

With the hellenistic features others as thoroughly Persian are elaborately combined — especially the dress of many of the figures, but also such details as the horse and figure of Mordecai; the army beside the sleeping Saul; and the pair of gods lying shattered before the Ark of the Covenant in place of Dagon. These details are so completely integrated with what I may call the hellenistic base that such integration has seemed to everyone to antedate the examples we have at Dura. But for the meaning of the mixture we can only hope that the art, since that is all we have, will at least partially answer the questions which it presents: is the eastern dress used in some symbolic way or, in other words, are the artists trying to say one thing when they represent a character in Greek dress and to mark with some other meaning those in Persian dress? We shall clearly be forced to investigate whether it seems likely that dress played a symbolic part in the original Alexandrian paintings.

It is useless to discuss a biblical painting without identifying the scene it was designed, at least basically, to represent. But suddenly we find that some of the scenes at Dura represent no biblical incidents, or combination of incidents, at all. Twice a stone temple is represented, once a temple with Aaron and the implements and animals of temple cult, and once a temple as a pure abstraction, only masonry not even set on the ground. The second of these cer-

tainly was suggested by nothing in biblical description; the first shows Aaron with a stone temple utterly unlike the portable tent the Bible describes him as using. To complicate matters, both temples are formal and utterly unrealistic presentations of Greek temples, with winged Victories at the acroteria. Except for the menorah and Ark of the Covenant beside Aaron, all details of both temples are either Greek or Persian. Even the animals wear Greek garlands as they advance for the Jewish sacrifice. The artist may be trying to present the ideals and values of ancient Jewish temple worship; he is certainly not illustrating any biblical texts or descriptions. We cannot begin, then, with forcing even biblical texts upon these temples. Some of the paintings clearly correspond to texts — as, for example, the scene of Moses at the burning bush. But if some correspond to no texts at all, we must presume that the artists, even when they show a recognizable scene, have more in mind than to put up pictures merely as illustrations. And we suspect strongly that if some of the scenes point thus to symbolic intention rather than to specific illustrations, symbolic intention may also have guided the members of the congregation, or the artist, in selecting what scenes from the Bible to represent.

Here lies my basic disagreement with Kraeling. Is the didactic element in this art quite secondary to the narrative element, or are the scenes selected throughout for their didactic value, and the narrative or illustrating elements freely altered for didactic purposes? Kraeling[14] insists upon the former alternative, but I cannot see how one can avoid the latter; and although many of my interpretations differ from those of my predecessors, almost all commentators on the paintings have in fact assumed that various ideas, eschatological, messianic, or what not, guided the artist in selecting and arranging the biblical scenes. Our antecedent ideas of what might have guided the artist's selection and arrangement must be made secondary to studying the tradition of art and the plan and arrangement of scenes as whole. Then comes the highly important matter of identifying the individual scenes, along with recognizing how each scene differs from biblical descriptions. With all this in mind we can consult other literary sources of all kinds, and the history of conventions in Old Testament illustration, to try finally to understand what the artist was saying.

3. Order of Considering the Paintings

AS TO THE ORDER in which the paintings are to be considered, we notice at once that the artists never tried to represent biblical narratives or events as such. A succession of incidents, comparable to that which Giotto used at Padua in painting the walls of the Serovegni Chapel and made conventional for later painters, does not appear here at all. While several incidents of Elijah and

14. *Synagogue*, 179, 202.

Ezekiel were represented in sequence, incidents of Moses' career were put at various parts of the west wall with no apparent reference to one another, while incidents from the career of Elijah are painted quite out of order. To begin with any one scene or register will always be arbitrary. The only straightforward course, with any hope of objectivity, seems to lie in continuing to follow the architects and designers in their work. For it is well known that the paintings were not all done at once. We must then follow the development of designs for painting the walls. Experts who have studied the walls have united in the judgment that in the second synagogue the first mural, fig. 29, was a relatively small presentation of a menorah, lulab, and ethrog, along with an architectural façade (which I take to be a shrine), and the sacrifice of Isaac, which, as I shall argue presently, seems to me to represent the shofar. Such interpretation must be justified, but in any case it is with these first paintings that we must begin.

The next painting to be put on the wall, all agree, was a large one put above that shrine, the central painting of the room, fig. 30. This painting (I shall call it the reredos) went through a series of modifications, which will all seem to point to the development of an idea in the mind of the artist, or of the people in the synagogue who repeatedly asked for these modifications. That we cannot be sure of the exact order of all these changes does not detract from the great importance of the changes we can identify. The successive changes in the reredos suggest that the artist and congregation were trying to express an idea in the painting, one which presumably would have harmonized with the ideas that seemed to motivate the architecture and the pagan designs.

We can then follow the plan of paintings on the west wall, paintings which clearly were designed to go with the reredos, and which, since so much care went into the symbolic design of the reredos, presumably expanded its meaning. These paintings have clearly an artistic balance which must have been planned. Four portraits were designed, two on each side, to flank the reredos, or be an essential part of it, figs. 31 – 34. On either side of these, in the middle row, the two temples already mentioned were painted in a balance that at once suggests a balance of meaning, but by their different details one of contrast not identity. Each of these temples is accompanied by a scene that may well emphasize the meaning of the temple it accompanies. On the bottom register are two outer scenes concerning a baby, one baby restored to life by Elijah, the other the baby Moses saved from the Nile to be the ideal king. Between these and the reredos are two scenes, each of which refers to royalty: in one the pagan king is put at the service of Jews under Esther; in the other Samuel anoints the ideal Jewish king, David. Again, that is, there is a definite balance of meaning. On the top register we cannot trace a similar balance because opposite the great narrative of Moses leading the People out from Egypt was a scene now almost entirely destroyed. In it king Solomon was enthroned with women be-

fore him—perhaps the Queen of Sheba, perhaps the two harlots with their disputed baby, perhaps something quite different. But if balance cannot be discussed in the top register, the principle of balance is well attested on the parts of the wall where pictures are preserved, so that it will be most instructive to see whether the idea derived from study of architecture, pagan designs, and the reredos seems further illuminated by this balance of scenes. The wall as it appears in the Damascus Museum adds to this what the reproductions cannot convey, that the colors of the backgrounds of the different paintings are likewise balanced. Also, the felines on one side are as distinctly female as those on the other are male. This greatly strengthens the impression that the artist was doing everything possible to bring out the parallelism and contrast of the paintings on the two sides of the reredos.

4. Methods of Interpretation

IN INTERPRETING the individual pictures we shall often find ourselves forced into circular reasoning. Some scenes, as has been said, cannot be identified as being based upon any biblical incident at all. Most of the others, even though they can be so identified, include elements quite strange to any biblical text. To explain these we shall of course turn to the interpretative embellishments of Jewish traditional midrash, including the midrashim of Philo Judaeus. But we shall also have to watch, as has been suggested, the symbolic conventions of the art itself. Here the problem is acute. Shall we interpret the individual scenes in terms of an assumed language of symbols in the art—for example, that of the robes—or shall we begin by expounding that language in itself, and then read the paintings in terms of it? In either case our reasoning must be circular. Within the limitations of the synagogue itself we can show the symbolic meaning of the pictures only in terms of the symbolic code, and show the existence of the code only out of its consistent use in the paintings. But we cannot escape this circle by declaring it unscientific or poor logic, and concluding that we must deny to the painters a symbolic vocabulary or intent altogether. In essence such a declaration means that what is difficult to recover cannot have existed, and that a simple explanation is always preferred to a more complicated one, as being presumably nearer the truth. If we have learned anything from modern psychiatric study, it is that a simple explanation of human motives is apt to be the simplicity of closed eyes and minds. Actually circular reasoning often has most profitable results. It offers the only hope of deciphering a lost language, for example, or of breaking a code. We can only study the material we have, get a suggestion that a given word or sign means this or that, and then try it out on the rest of the material. Usually the guess is wrong and will not work out. But as a few guesses do seem to lead us to meaning, we then build more guesses around these, until the language can

be restored. When at the end the scholar presents the results of such study, however, all the wasted efforts, the wrong guesses, or most of them, are ignored—he simply says: here is the code; try it for yourself on other texts. Such confidence supposes that there is a mass of other texts, as in Egyptian, where the code can be tested, and a new scholar can try it out for himself with undeciphered inscriptions. I hope sincerely that more art like that of the Dura synagogue will appear in Jewish remains, so that the results of this volume can thus be tested and, of course, corrected. In the absence of such additional data I must here argue the value of my suggestions much more closely, and stay within the circle of reasoning to which the single building confines me. One can escape circularity somewhat, however, as one moves from painting to painting in the building. Will the symbolic implications of dress and arrangement that seemed significant in one scene prove to be so in others? We should expect that many scenes were represented in the synagogue through a desire to enrich the symbolism as a whole. The central reredos should announce the central theme for all the paintings, since it originally stood in the synagogue alone, and always remained central. New facets of meaning would be presented in the elaboration and change of that painting, yes, but probably only facets of the same meaning. If this is true, we do in some measure escape circularity.

The most important of the symbolic devices in the paintings, I have said, seems to be the dress of the characters. This one symbol, unfortunately, will not always work. I do not understand it fully. Four chief types of dress appear: first, there are many figures wearing the ordinary eastern dress of caftan and trousers; secondly, the kings all wear this in a more ornate form (and yet the angels on the ladder of Jacob's dream wear the ordinary eastern dress); thirdly, many men and children wear only the simple chiton or tunic of Greek dress; fourthly, many great figures wear over this the Greek himation, cloak, or shawl, usually with distinctive marks upon its corners. This last Kraeling identified as the dress of private citizens, in contrast to that of kings and priests, but his theory seems to me not to carry through. The full Greek dress, however, can be investigated outside the circle of the Dura figures. We must accordingly look in Greco-Roman and early Christian art to see where this costume appears, who wears it, and under what conditions. If from such investigation it seems that this dress indicates a special character for the wearer, and if in the Dura paintings it appears that the dress is reserved for individuals who might have been thought in Jewish terms to have a similar character, we shall thereby have some objectivity in interpreting the value of those wearing it in the synagogue. Since even the very crudely drawn Abraham in the sacrifice of Isaac—part of the earliest painting in the building—wore this robe, we may well stop for such review before beginning upon the biblical paintings at all. Thereafter we must study the other scenes in the order indicated. I warn the

reader in advance that at places the "code" I shall suggest will not seem entirely satisfactory. I shall suggest the code nonetheless, even though it obviously needs modifying in ways I cannot see. In this connection it is fair to remind the reader that although the early suggestions for reading the languages of ancient Egypt and Mesopotamia had to be drastically modified by later scholars, it would have served the cause of learning very poorly had the earlier ones timidly refused to publish the best they knew for others to use and correct.

D. THE "PHILOSOPHER" OF THE SYNAGOGUE

THE READER must further be warned that increasingly these paintings seem to me to witness a master hand, one who need not have been a painter at all, but may have been one of the men named on the tiles, "those who stood in charge of this work: Abram the Treasurer and Samuel son of Sapharah," or the "priest Samuel son of Yedaya" himself, who was elder of the group (perhaps also archon) when the building was erected.[15] It may have been Uzzi, who "made the repository of the Torah shrine."[16] Or perhaps it was Orobazus, another Iranian-named Jew, apparently, whose name appears on five tiles.[17] It may have been any of a number of others thus named. The plan of decoration may have been the result of several of these serving together as a committee. I suspect that the decoration of an ancient building was rarely planned by the technicians themselves.[18]

The most important description of ancient workshops I know is that given in an account of the martyrdom of the Christian Claudius.[19] The document speaks of the Emperor Diocletian as coming to a great workshop in Pannonia where 622 workmen were employed as stonecutters under five "philosophers." The latter seem to have made the designs and supervised their execution. Diocletian first ordered a large figure of Helios in the chariot, with accompanying symbols, and this the best cutters — of whom Claudius, a Christian, was chief — carved without objections, though they kept stopping to cross themselves as they worked. When the image was completed, Diocletian had a temple made for it, with marble pillars cut to specified size in the same workshop. He then gave more orders. First he demanded *Conchas ex lapide porphyritico cum sigillis et herba acantu*, which probably means fountain basins with little figures of some sort, and acanthus leaves, but may mean little niche-shrines containing figures. He also ordered foliated capitals, Victories, Cupids, eagles, deer, and lions spouting water. None of these offered any problem to Claudius and his

15. See Torrey in Kraeling, *Synagogue,* Inscription 1, pp. 261–266.

16. Ibid., Inscription 2, p. 269.

17. C. B. Welles, ibid., Inscriptions 26–28, p. 279.

18. Weitzmann, *Joshua,* 87, says the same about the planning of illuminations for a manuscript.

19. Published in the *Sitzungsberichte* of the Vienna Academy, X (1853), 115–126.

friends, and their work delighted the Emperor. But when he asked for a statue of Asclepius they refused to make it, on the ground that a human image was forbidden; they quoted Psalm cxxxv, 18, from the famous passage prohibiting the making of idols. The end result was that others were put frantically to work on the order. They made the image in thirty-one days, but Diocletian had the Christian recalcitrants executed. The significance of this document from the viewpoint of prohibited images I have discussed elsewhere.[20] Here it is relevant to note that the skilled craftsmen who did the carving were directed closely by the five "philosophers," men who would probably now be called designers. They probably also controlled symbolic development and expression. We recall that Strabo tells us

> The philosophers attend upon their kings, and act as instructors in the worship
> of the gods, in the same manner as the Magi attend the Persian kings.[21]

"Philosopher" would then seem to be the name currently applied to a master of symbols and ceremonies, one who understood meanings beyond the range of the ordinary craftsmen, or even beyond the king himself until tutored. We recall that for Philo the word "philosopher" meant a man who had gone into the deeper retreats of Jewish allegory, or had himself had the vision of God.[22]

It seems obvious to me, as I hope to make it to the reader, that such a creative religious thinker designed the decorations of the Dura synagogue. The painters had to execute at least two, and probably several, designs upon the reredos before the "philosopher" was satisfied. And we shall see that the other paintings were so planned to fit the walls that they seem very likely to have been planned at Dura itself. Who the "philosophers" in the Dura synagogue were we cannot say, but we must approach the paintings with the possibility of such a thoughtful mind, or group of thoughtful minds, clearly before us.

E. THE GOUGED EYES

MUCH AS I feel the inevitability of assuming that symbolic designers were creatively at work in the synagogue, one little detail makes me doubt that we can speak of the Judaism of the Jews of Dura as though it were a unit, and to be reconstructed from the paintings. The biblical paintings, I believe confidently, pleased the priestly Elder Samuel and the other designers of the synagogue much more than they did some of the less influential Jews. The Jews who did not like the paintings seem to have been impotent to stop their being put up on the walls, but we appear to have clear evidence of their dissent. For on figure after figure of the lower registers the eyes have carefully been

20. See my "Communications," *Judaism*, VIII (1958), 178.

21. Strabo, xv, i, 68.

22. See the great number of passages in Leisegang, *Index*, s. vv. *philosophia, philosophos*.

scratched out.[23] This at once suggests an incident recorded in the Talmud: Rab Judah had a figure on a seal which others had made for him, but Rabbi Samuel demanded that he annul it by putting out the eyes of the image. The idea seems not to have been peculiar to Jews. Morton Smith has called my attention to a statement in a sermon of Macarius: "Even though an engraver in making an image of the king makes all the parts beautifully, he has wholly spoiled the work if he has left out a little of the eye, or spoiled it, or drawn it imperfectly."[24] It seems quite likely, then, that the eyeless figures in the synagogue attest secret visits by members who did not care or dare to demolish the building or ruthlessly to disfigure it, but who reached up with knives, and by taking out the eyes annulled the threat of such creations. In the gloom of the place their act may long have gone undetected, so that it would have been difficult to establish their guilt. But only such protest seems to me to account for these slight but deeply significant defacements. Perhaps those people represented a very considerable part of the congregation, or perhaps a single recalcitrant member gouged out all the eyes. But we must beware of thinking that the pictures reflect a type of Judaism common to the group. On the other hand, the scratched-out eyes tell us that these pictures could hardly have been meaningless ornament to anyone in the congregation. Even those who mutilated them felt their power. The pictures attest a type of Judaism, perhaps one of the types we know from literature, perhaps a mixture of those types, perhaps a new type altogether.

It is my task to try to decipher that Judaism, in its essential features. The suggestions of predecessors to this study present a problem in composition. To recite all the various interpretations for each scene with my reasons for agreement, disagreement, or modification would be a labor of pedantry rather than scholarship. Rostovtzeff, du Mesnil, Sonne, and Kraeling seem to me to have made by far the most important suggestions, but even with them I shall not attempt to come to grips in detail. Without such elaborate controversy my references to the interpretations of other scholars (which I make *a piacere*) must seem spotty and unsystematic. I can only assure the reader that I have carefully considered all the important studies of the paintings that I know, and make my own suggestions with those studies well in mind.

23. See Goodenough, *Jewish Symbols*, XI: the eyes of Mordecai and Haman are gone in plate XVI, of the woman presenting the baby in plate VIII, and of the first two, and probably the fourth, figures from the left in the Ezekiel panel, as well as of Ezekiel being arrested at the end, plate XXI. The eyes of Moses and of the small figure below him at the right in plate XII have also been dug out. This latter painting was in the second register. Kraeling, *Prelim.*, 309, had no evidence whatever for saying that "it was a fact" that the workmen who finally braced the wall with mud brick during the siege of the city were the ones who did this gouging.

24. *Homilies*, XIII, 4. See E. Klostermann and H. Berthold, *Neue Homilien des Makarius/Symeon*, I, *Aus Typus III*, 1961, 69, lines 15–19 (TU, LXXII). See also E. Urbach, "The Rabbinical Laws of Idolatry," *IEJ*, IX (1959), 230 f.

Cosmic Judaism: The Temple of Aaron

IT WAS SAID at the outset that the guide to interpreting the paintings must be the details of the paintings themselves, and that what literary sources should be used to interpret the paintings must be determined by the designs and their relation to one another. Examination of the scenes to this point has strongly suggested that a master "philosopher" had planned the wall in general, and specified the artistic and symbolic details by which the Old Testament scenes should be represented. After studying the reredos with the portraits of Moses, we have examined the lowest register and found in balance two scenes of kingship, each flanked by a scene of a suprahuman baby, marked as such by the artistic conventions for such babies in pagan art. Since the suprahuman baby in the ancient world normally became the king, the connection of the royalty and the baby scenes appeared by no means accidental.

The conception of royalty in each of the two scenes is different, however. On the left the widow's son, miraculously restored to life, fig. 35, adjoins a scene that shows all the Jewish chauvinism of Purim, fig. 36. Through the intervention of the heavenly "four," Haman, degraded, has to lead the now utterly royal Mordecai, in comparison to whose dignity even Ahasuerus and his court are thoroughly subordinated. On the right of the reredos, however, beside the miraculous baby Moses, Jewish royalty is presented in a totally different way. David is being anointed by the leader of a purely hieratic group of seven. While no parallel representation of initiation could be found in pagan art, the scene so much represents the abstraction of mystical initiation that we feel here a royalty not of this world, a sort of royal mystic achievement. This impression of contrast between the triumphant Judaism of the material world and an immaterial Judaism, as it will repeatedly recur, will justify our looking for explanation to the Jewish sources which expound such a double value in Judaism, do so in hellenistic language as we see it expressed in pagan art in the synagogue.

The paintings on the west wall immediately above the ones we have been considering continue to present this same contrast. Here again two scenes stand on either side of the reredos, with one of the portraits of Moses inte-

grated with each pair. Moses as a mystic philosopher expounding the law, at the right, balances Moses being taken through the heavenly bodies, or sharing their worship, on the left. Beside each Moses is a scene in which a temple unit is painted. In both cases it consists of a lower outer wall with three doors, and an inner shrine with columns, whose acroteria are winged Victories bearing the wreath. But with this basic similarity of the two temples resemblance strikingly ceases. Beside the cosmic Moses, if I may so describe the figure on the left with the heavenly bodies, the temple stands on the ground, and shows Aaron in priestly robes, with five men assisting him. Two bulls and a ram advance for sacrifice, and an altar, two incense burners, and a lighted Menorah, stand in the court. The veiled Ark can be seen within the sanctuary. Details will be discussed below; but this shrine teems with activity. In complete contrast, the temple on the right stands beside Moses as he reads from the scroll; it has no priests, animals, or ritualistic implements. It does not even touch the ground, but is indicated almost like a modern abstraction showing an inner shrine superimposed upon courses of stones that run from border to border. Symbols are painted on the doors, but the temple otherwise has not a suggestion of realism.

Each of these two temples in turn has an accompanying scene as did the two scenes of royalty below. Beside the temple of Aaron, Moses strikes the rock for the twelve tribes. At the right of the abstract temple stands an incident clearly based upon the return of the Ark of the Covenant from the temple of the Philistines.

The selection of these paintings and their details seems to me for several reasons to follow the interpretation of the register below, which we have been discussing. First the balance of the two scenes of royalty is repeated in the balance of the two temples, and is obvious at first glance, in that Aaron's comparatively realistic temple stands over the realistic royalty and the abstract temple stands over the hieratic and abstract royalty of Samuel anointing David. As I have further studied these paintings it has seemed to me that the two scenes beside the temples belong ideologically each with its own temple, just as did the two babies with the two conceptions of royalty. It will be best, then, to consider the paintings of this register as they appear paired on either side, or, really, in triple balance, as each pair is introduced by its distinctive representations of Moses.

A. THE PAINTING AND ITS DETAILS

AARON PRESIDES over the temple at the left, a large figure identified by his name painted in Greek beside his head. See fig. 37. If the artist had been guided by the description of the sanctuary over which Aaron presided as found in Exodus, he would have shown us a portable tent — the "tabernacle,"

as Kraeling still calls this temple.[1] Instead, the building is of stone, and thereby disassociates itself at once from the shrine of the wilderness. An outer crenelated wall extending only part way across the painting encloses an inner sanctuary. The courses of stones turn slightly upward at the right end, the change in direction beginning at the door on the right. Considering the representation of the two faces of the inner sanctuary above the wall, and the similar turning of the inner sanctuary of fig. 38, it would seem that we should recognize two faces of the outer wall also. The abstract temple clearly represents the same design further broken down for purposes of symbolism. The court of the Aaronic Temple is adapted to Judaism by having the cult utensils of the Jewish Temple or Tabernacle, but these clumsily intrude themselves into a design which showed two faces of an outer wall, a temenos, and two faces of a colonnaded shrine, topped by Victories. The design was almost certainly affected, or made to seem pertinent, by the great stone Temple of Herod, which Philo describes as an outer wall of great length and breadth, whose massive appearance was broken by four porticos (*stoai*).[2] Then came inner walls, and within this the inner sanctuary "with a beauty baffling description, to judge from what is exposed to view." The whole unit was of "mountainous" proportions, and "amazed visitors with its beauty and magnificence." Josephus' description makes the Temple even more phenomenal.[3]

Fortunately several examples of temples having the design of the synagogue painting have been preserved to us from paganism. Fig. 39,[4] a relief of unknown origin at the Berlin Museum, illustrates our first specimen. It shows Apollo carrying a cithara and holding a basin out to Victory who stands beside an altar and pours wine into the basin. Artemis[5] and probably Leto[6] follow him. But behind the row of figures rises a wall, which, like the outer wall of the Aaronic Temple, bends just above Apollo's head to suggest that it encloses the

1. Kraeling's title for this scene, "The Consecration of the Tabernacle and Its Priests," seems to me not entirely unjustified. For the Tabernacle and its furniture see Exod. XXV–XXVII, XXXVI–XXXVIII. Philo says that the "Tabernacle was constructed to resemble a sacred temple" (*Mos.* II, 89), but he otherwise follows the literal description of the tabernacle in the Bible. A drawing in a manuscript of *Cosmas Indicopleustes*, as published in Riedin, 290, fig. 316, shows that it was quite feasible at least to try to represent the tent of the curtains. The Dura temples show no signs of such an attempt.

2. *Spec.* I, 71–75.

3. *Antiquities*, xv, 380–425 (xi, 1–7).

4. Photo courtesy of the Staatliche Museen at Berlin. See F. Studniczka, "Die auf den Kitharodenreliefs dargestellten Heiligtümer," *JDAI*, XXI (1906), 77–89. See esp. his fig. 3, where a smaller fragment from the British Museum is illustrated, and J. Overbeck, *Griechische Kunstmythologie*, 1889, III, 259–269. The object has often been discussed. See the bibliographies in Studniczka and by P. Paris in DS, II, 139, n. 219; and O. Jahn's list of parallels in his *Griechische Bilderchroniken*, 1873, 45 f.

5. She carries her torch with the flame, as commonly, blown over. See Paris, 137, fig. 2356; 143, fig. 2373.

6. Little identifies her here, except that a second female figure with Apollo and Artemis can usually be taken as their mother.

inner court. Within the court stands a peristyle shrine, its two faces flattened
out just as at Dura, and again with exaggerated figures of Victory as the acro-
teria. A holy tree indicates the inside of the temenos at the right, and in front
of it, outside the wall, the statue of a putto, or an actual child, stands on a high
pedestal. Those who have examined the original say that a tripod once stood
upon the free-standing column at the left.[7] Overbeck lists sixteen varied ex-
amples of this design.[8]

It would seem that Jews, either originally at Dura, or at the source of all
this Jewish iconography, thought the design most suitable to illustrate their
Jewish Temple worship. Other designs could have been adopted, and we know
one striking Jewish example where the outer wall and inner temenos and
colonnaded shrine were so adopted — on the famous gold glass at Rome. Here
the whole is seen from above: the wall surrounds a temenos in which there is a
shrine in perspective, the front with four columns and four steps. Again Jew-
ish cult instruments are crowded into the court, drawn as though they stood
on the wall. But except for the central menorah, which again burns toward the
inner shrine, only the cult instruments of the synagogue appear — the lulab,
ethrog, two unidentified objects, and two cups for wine. Since the design was
in a cup, the whole centers in wine as definitely as the painting at Dura suggests
the old cultus of Israel.

In trying to reconstruct what ideas may have lain behind the Dura design,
we must understand what the Apollo relief really represents. We notice first
that the Victories on the inner shrine are as exaggeratingly emphasized on the
pagan relief as on both the Jewish paintings, and that even "Apollo" himself
is being given the wine by Victory. At one place Strabo refers to a wall at
Athens which stood between the temple of the Pythian Apollo and that of
the Olympian Zeus.[9] Studniczka accordingly supposed that the relief cele-
brates the sanctity of the *citharodia*, a contest in singing to the cithara. The
temple over the wall, he said, is that of the Olympian Zeus as actually recon-
structed by Hadrian.

Studniczka may have been right, but he was drawing heavy conclusions by
a slender thread.[10] His argument rests upon the assumption that the relief rep-
resents an actual scene, a specific temple, and does so with complete realism.
But the main motif of the foreground, in which the god Apollo, accompanied
probably by his sister and mother, has wine poured into his cup by Victory,
could not be further from realism. There is no more reason to suppose that
the temple and wall in the background represent real structures than that the

7. The tripod still remains on a fragmen-
tary example published by Studniczka, 82,
fig. 3; cf. p. 81.

8. *Griechische Kunstmythologie*, 259–262.

9. Strabo ix, 2, 11 (Loeb ed., IV, 295).

10. C. R. Morey, *Early Christian Art*,
1942, 250, in commenting on his fig. 12, says
that the temple was "possibly meant to rep-
resent Apollo's shrine at Delphi."

procession to Victory in the foreground depicts an historical incident. The composition in itself speaks of the divine power of ceremonial music to take one to a victory which seems represented below by the goddess in person, and above by the inner temple, mysteriously screened by the wall, a temple which she dominates in exaggerated emphasis. With such a victory, the artist seems to tell us, the tree, the putto, and the tripod of Dionysus find proper association. All this manifest declaration of the design itself may be ignored perhaps, that we may use the quotation from Strabo that a wall stood in Athens between the temple of Apollo and that of the Olympian Zeus. But to do so is to identify a design by a literary passage of no obvious relevance to any details of the relief except that it shows a wall before a temple.

The head in the front gable would seem to indicate that the temple was dedicated to Medusa—that is, to the supreme solar deity that Medusa had come to represent.[11] On such a temple Victory is to be found, or the temple is characterized by Victory, Victory so great that even Apollo and his music are appropriately glorified in her. We would seem to have the Apollo of the mystery which Rostovtzeff described as being very popular among the more intellectual people of the first centuries of the Roman empire.[12] In this, Apollo was still associated with Dionysus, as he was at Delphi, and as the tripod suggests here, but his was a more dignified and less ecstatic approach to salvation.

The emphasis of the design indicates this interpretation, but it would be much strengthened by external evidence, and this can be found only in the meaning and usages of Victory in the early imperial centuries. We have already seen that Victory and her crown were used primarily in contexts of the athletic games of Greek worship, in crowning a king or emperor, in crowning a victorious general, or a victor in contests of the Muses (poetry, music, etc.), or as a symbol of success in the mystic *agōn* or struggle, and hence appropriate for the "crown of life" on funerary monuments. Of these the symbol seems to have settled down to two predominant usages, the one for a victorious general or emperor, which continued the ancient association of the goddess with military victory; the other for the mystic victory which gave immortal life.[13] Both had a common denominator in the supranatural or divine character of the king or emperor, or the supranatural power which victory in war implied, which was

11. On the symbolism of Medusa see Goodenough, *Jewish Symbols*, VII, 224–229.

12. Rostovtzeff, *Mystic Italy*, 1927, 126 f.

13. Pausanias, for example, mentions two temples with Victories as acroteria, or on the pediment in his *Description of Greece*. In v, x, 4, he says she is on the pediment of the temple of Zeus at Olympia, a temple, the context shows, deeply associated with military and athletic contests. In ii, xi, 5–8, he de-

scribes a sanctuary of Asclepius at Titane, which had images of Asclepius, Hygeia, the deified Alexanor and Euamerion, as well as of Dionysus, Hecate, Aphrodite, Tyche, and a famous athlete who distinguished himself in the Olympic games. On this temple Heracles and Victories stand "on the gables at the ends," presumably as acroteria. The two types of associations, that is, seem very old.

quite analogous to that aspect of divinity, immortality, which the mysteries promised. Figs. 40[14] and 41 show the two ideas combined for Roman generals in the East, where Victory brings the crown from the supreme solar deity, represented as either a Medusa or a Helios figure.

We are concerned, however, to see on what sort of temples people of the time used Victory as an acroterion. The question seems difficult, since acroteria are among the first things on a building to perish, and restorations cannot always be trusted for such details. The coins, however, show clearly that emperors liked to use the goddess in various ways to indicate their own power,[15] and that they accordingly put her up as an acroterion on temples to themselves or to Rome.[16] If the temple of fig. 39 was a temple built by Hadrian, then he might have used Victories, but would dubiously have done so for a temple to the Olympian Zeus at Athens, at least in the sense in which he used Victories on temples to imperial divinity, as in fig. 42,[17] or as shown on his coins.

In contrast, Victory appears on mystic temples, as on the temple to Cybele or the Great Mother in fig. 43.[18] She rarely appears on the temples in Roman paintings, but when she is represented she seems usually to accompany mystic motifs. She appears many times in the decoration of an extraordinary Pompeian house, the Villa Farnesina.[19] While a few of the scenes in it are erotic, most of them, and especially those with which Victory is associated, belong to what even Rostovtzeff was forced to call "Mystic Italy."[20] In a similar Roman house, that of Livia, Victories flank a painting, itself within a painted shrine, in which Hermes, and perhaps Ares, come to a woman seated beneath a female statue on a high pedestal.[21]

The most important example, however, is a painting from Pompeii in the Casa del Citarista, of which I publish the old drawing, fig. 44.[22] Here a woman

14. From Sélim Abdul-Hak, "Rapport préliminaire sur des objets provenant de la nécropole romaine située à proximité de Nawa," *Les Annales archéologiques de Syrie*, IV/V (1954/55), plate VI.

15. See M. Bernhart, *Handbuch zur Münzkunde der römischen Kaiserzeit*, 1926, II, for example plates 4, no. 4; 8, nos. 1, 9; 47, no. 10; 93, no. 12. Cf. the Text, pp. 101 f.

16. Ibid., plates 57, no. 2; 91, nos. 6–8; 93, nos. 2, 5.

17. Photo courtesy of the Deutsches Archäologisches Institut, Rome. Studniczka, *JDAI*, XXI (1906), 86–89, and fig. 4. Mrs. Arthur Strong, *La Scultura romana da Augusto a Costantino*, 1923, I, 71, fig. 45; cf. p. 69.

18. Photo courtesy of Deutsches Archäologisches Institut, Rome. Strong, ibid.,

fig. 44. For this and the foregoing see also E. Petersen, *Ara Pacis Augustae*, 1902, plate III, 7, 13.

19. *Mon. ined.*, XII (1884–85), plates Va, XVIII, XIX, XXVIII; Supplementary Volume, plates XXXII–XXXVI. Cf. J. Lessing and A. Mau, *Wand- und Dekkenschmuck eines römischen Hauses*, 1891, plates I, V, VII, XII–XVI.

20. He discusses the house in his book of that title, 113–124.

21. Curtius, 93, fig. 65. I can find no discussion of this scene.

22. From Helbig, *Wandgemälde der vom Vesuv verschütteten Städte Campaniens*, 1868, Tafeln, plate V; cf. p. 44, no. 152. See also *Monumenti della pittura antica scoperti in Italia*, III, 1939, Pompeii, i, by O. Elia, plate IV.

and a girl, perhaps mother and daughter, are apparently engaged in some sort of rite, since another woman approaches at the left with a dish of fruit and with two wreaths ready to be tied on their heads. The woman who approaches also carries a pitcher. Helbig thought the goose or swan beside the central woman might indicate Leda, but the great eagle flying in at the left would hardly go with this interpretation. Notably the two statues at the back have one a musical instrument, the other a bird. Behind these figures stands the temple drawn in two faces, like the other temples we are especially considering, and it has Victories at two of the angles of the roof. The festoons on the temple lead us again to suppose that the occasion being depicted had special significance. The wreath at the side of the temple certifies that the value of the temple and its rites was that of the Victories. Trees appear, but this time outside the wall, which itself again has the angle of bending. The scene, that is, represents the inside of the temenos, perhaps in a "House of the Cithara Player," ideologically the same temenos. The wall has a row of little plinths with urns on them, and this may originally have been the function of the crenelations on the wall of Aaron. We recall at once the similar jars of wine on the wall of the temple scene of the Jewish gold glass.

We strongly suspect, accordingly, that this painted temple from Pompeii had some sort of mystic significance, and that its Victories and wreath, certainly here not mementos of imperial or martial divinity, referred to the mystic victory. The wall and the little temple may well have been modifications, or variations, for expressing the ideas we found suggested in the citharode scene with Apollo.

Another ancient relief, fig. 45,[23] gives us a fresh approach to our problem. Here a female figure very similar to those in the cithara reliefs again offers a basin to Victory, who pours into it with the same gesture. The female figure holds a torch, and by this seems to me identified with Artemis.[24] Victory stands beside an altar on which Apollo is carved with the cithara, accompanied by two females. Behind Artemis is a tripod on a high pedestal, and behind it, his name written beside his head, Heracles, who also holds out a libation basin. In an upper register "Heracles at rest" is shown on a great lion skin like a flying carpet, where he is surrounded by a Bacchic company. It has seemed clear that the whole design represents the apotheosis of Heracles, and clearly the means presented is the pouring by Victory into the basin. We have in this and the Apollo

23. Courtesy of the Deutsches Archäologisches Institut, Rome. See Jahn, *Griechische Bilderchroniken*, plate v; cf. pp. 39–53; L. Stephani, "Der ausruhende Herakles," *Mémoires de l'Académie imp. des Sciences de St. Pétersbourg*, Ser. VI, Vol. VIII (1855), 251–540; idem in *Compte rendu de la Commission Impériale Archéologique pour l'année 1873*, 228–242; Furtwängler in Roscher, *Lex. Myth.*, I, 2251 f.

24. I make this suggestion tentatively, in the hope that it may not bring down the wrath of a Stephani, as did the suggestions of Jahn.

relief, then, exactly the same mystic rite, with the implication here spelled out
that the rite takes one "out beyond." The *au delà* is the Bacchic heaven in the
lion skin; in the Apollo relief it is the hidden inner shrine with its Victories. Fig.
46[25] shows Apollo alone with Victory in the same act. Between them an om-
phalos takes the place of an altar.[26]

I see no reason to try to identify the original pagan temple, or the scene.
For our purpose we note that this scene of pouring by Victory, so important
that it could be represented quite by itself, shows by its setting in the two other
scenes that it carries the hope of immortality or divinization which the myster-
ies offered. The immortality could be presented as Heracles in the Dionysiac
thiasos, or as the hidden temple with Victories. The motif of a woman thus
pouring for a man, a woman who could become Victory herself, seems a very
important one, with significance much like this, in classical Greece. Victory and
Apollo stand here in an old and meaningful relation.

It becomes now highly important that the artist or "philosopher" at Dura
should have taken over from such a setting precisely this design of shrine and
wall, with the exaggerated Victories as acroteria, to use in representing the
Aaronic priesthood and its significance. I cannot believe that he selected it, and
kept the Victories, just because it was what Kraeling calls a cliché. The artist has
broken the wall with doors, he has raised the inner shrine to make room for
the Jewish cult objects, and been quite ingenious in putting them into the nar-
row space, especially in planning the relation of the menorah to the inner Ark.
And he could at once keep the design and break it down almost completely for
the other Jewish temple, fig. 38. Both the Victories and the design seem to say
that for him the Aaronic worship was a sort of mystery which led to the victory
of eternal life.[27]

Other details of the Aaronic temple strengthen such a conclusion. Of the
three doorways which break the wall, the center one is slightly larger than the
other two, the one at the right slightly larger than the third. Possibly we are to
suppose that the doorway at the right goes with the face of the wall here
turned, and that the difference in sizes represents an attempt at perspective.
Of this, of course, we cannot be sure, for in fact the doorways as painted are
not integrated with the courses of stones at all. They merely indicate three
openings in the wall, with little attempt at realism.

The doorways contain each a pair of doors, six in all, and each door has

25. Courtesy of the Louvre Museum. Cf.
Overbeck, plate XXI, no. 11.

26. On the significance of the omphalos
see, inter alia, my "A Jewish-Gnostic Amulet
of the Roman Period," *Greek and Byzantine
Studies*, I (1958), 74, and A. A. Barb, "Diva
Matrix," *Journal of the Warburg and Courtauld*

Institutes, XVI (1953), 222 f., n. 104 f.

27. The form reappears in Christian art
on many pages of the ninth-century Utrecht
Psalter. See E. T. DeWald, *The Illustrations of
the Utrecht Psalter* [1932], passim, esp. plates
XV, XCII, CIX. Cf. *Menolog. Basil II*, plate III.

two panels. The lintels over the doorways carry a shell in an arch. The shells, here drawn with exaggerated prominence, would mark the entrance to a sacred place, if they did not carry more specific suggestions of hope for immortality. The doors with their panels and shells have the favorite form used for mystic shrines and arks of the Law, and that three doors stand in the outer wall of this and the other temple will also imply a symbolism of immortality to those who have read my discussion of the shrine form in a previous volume. Actually the three entrances correspond to the biblical requirement of the "gate of the court," which was to have "four pillars and with them four bases."[28] The four pillars would have made three entrances, and it may well be that symbolism lay behind the original specifications. According to the Bible, a curtain was to be hung across this entire front, apparently, since the curtain was twenty cubits long, approximately thirty feet. But I should guess that the "philosopher" is following an allegory of the specifications for the temple rather than the biblical text, since he so rarely agrees with the text. The pink-lined blue curtain, half withdrawn from the center door, has little resemblance to the curtain before the three entrances to the tabernacle as described in the Bible. The curtain as here drawn suggests at once a mystery,[29] and, by being half withdrawn, an invitation to enter. Possibly its colors too may have had significance: blue curtains and robes have for centuries been the robe of the heavens, and the light pink, which is also the color of the veil with the Ark above, will seem often at Dura to represent light.[30] On the matter of color symbolism, however, I put no emphasis, since one cannot select some colors in a painting to be symbolic and not others, and I am by no means prepared to trace color symbolism throughout these scenes. Philo allegorizes the biblical colors,[31] but they only occasionally correspond to the colors in the painting. It will appear, however, that the scene as a whole represents a Judaism which expressed itself in cosmic mysticism, so that the possibility of color symbolism should be borne in mind.[32]

Within the temenos or court between the wall and the inner sanctuary stand at the left one of the five temple servants or priests whom we shall discuss together, as well as two burning altars of incense, a menorah with lamps lighted, an altar of sacrifice with an animal lying on it (which Kraeling felt he

28. Exod. xxvii, 16.

29. C. Schneider has collected most interesting material on curtains in the mystery religions: "Studien zum Ursprung liturgischer Einzelheiten östlicher Liturgien," *Kyrios*, I (1936), 70–73.

30. The colors of the curtain in Exod. xxvii, 16—blue, purple, and scarlet—may have been emphasized in the allegory which the "philosopher" is following.

31. *Mos.* ii, 87 f.

32. Kraeling, *Synagogue*, 130, identifies this curtain on the central door with the screen or cloth for the gate of the court of the tabernacle, Exod. xxvii, 16; xxviii, 18. But this screen, as just recalled, was to be twenty cubits long. It might be identified, as du Mesnil suggested (*Peintures*, 56), with the "screen at the gate of the court" of Exod. xl, 33; Num. iv, 26.

could identify as a ram³³), and, finally, the majestic figure of Aaron himself. The wall obscures Aaron's feet, so that we must assume that he, like the other objects, stood in the court behind it. No smoke rises from the altar, presumably because the artist had no room to show it, but the fire of the menorah and smaller altars indicate a ceremony being performed.

Behind these, the inner sanctuary of the Greco-Roman form has been adapted to show the Holy of Holies of the ancient temple. Its front and one side, drawn with no attempt at perspective, show five columns; four are on the side, and the first of these serves also, along with the fifth column, to carry the gabled pediment of the front. Brown stone courses form the wall behind the side columns. The little shrine carries only two symbols: an eight-point rosette in the gable, and the three representations of the goddess Victory with her wreath as acroteria. We recall again that the rosette was symbolically a counterpart of the gorgoneum of the pagan temple so much like this one. Beneath the gable, where we should have expected a front wall and door, the artist has given no masonry whatever. Instead, a black background fills the space. The branches of the menorah stand out against the lower part of this background, and above it the artist has put the front face of a round-topped object with paneled front. In spite of the varieties of detail with which this object frequently appears in the synagogue paintings, all scholars agree that it represents the Ark of the Covenant. A pink curtain draped behind it seems to follow the convention so common on sarcophagi of the period. For when a curtain is put behind the portraits of the dead at the center of a sarcophagus the scene must be read in reverse, and we must suppose that it shows the dead as having gone behind the curtain of death. The convention seems an obvious one to represent a curtain and what is behind it at the same time.³⁴ So I take it that we are to understand that the Ark stands behind the curtain in this scene, as it did in the biblical tradition. In the rounded top of the Ark above the paneled doors the artist put a menorah, with a rosette on either side of it.³⁵ The Ark is represented several times in the paintings, each time with different insignia. The dominating symbol of both this scene and the one at its left, fig. 47, is the menorah, and we shall see that it is entirely proper that the Ark should be marked here with that symbol.

Although the Ark and the inner sanctuary seem to have little connection with the active sacrifice, the Ark could well be taken to be the object before which the sacrifice is offered, as would be true according to both biblical and pagan traditions. The hidden "real presence" is here not a statue, but again the

33. *Synagogue*, 126, where he gives a detailed description of the altar and the other objects, with a line drawing of the altar and ram.

34. Du Mesnil, *Peintures*, 57.

35. In the final restoration these were painted out except for a meaningless arc of a circle. Gute's painting, fig. 37, and the early photographs support du Mesnil's drawing.

supreme symbol of Yahweh, the Ark itself.[36] Most obviously the lights of the menorah are oriented toward it. The Ark conspicuously has no cherubim and takes the form of a bookcase such as Moses has beside him for the scrolls in fig. 34. The form itself is attested as a chest for scrolls beside Moses, but does not appear in pagan art to represent a bookcase. But there can be no doubt that the artist or "philosopher," who could have put winged Victories as cherubim on the box had he so desired, did not wish to do so, and instead, for the box with Moses, and all the arks of the synagogue, shows a form extremely old, one chiefly associated with tombstones, or the ends of round-topped sarcophagi. When one considers the great care often taken to represent Jewish tomb doors as paneled, one suspects that, like the similar paneling on the doors of the outer wall below, paneling was in some way itself at least so much associated with sacred doors that whether used with conscious symbolic intent or not, it had almost become *de rigueur* to put panels on sacred doors. Here we are helped by the paneling of some sacred object adored by a priest, and with the sign of Ohrmazd above it, on early coins of Persia, fig. 49.[37] It is customary to call this object a temple, but it may well have been a chest which, like the Ark, brought the divine presence. The form of the Ark as a whole is also that of actual Jewish Torah shrines as represented in the period, except that they usually had a shell in the rounded top. The most important single things that God told Moses to put into the Ark of the Covenant, indeed the only ones which the Old Testament mentions,[38] were two stone tablets of the Decalogue. Hence the Ark of the Covenant, once the Old Testament description of the box with the cherubim was abandoned, inevitably took the form of the synagogal Torah shrine. But the historic origin of this object remains for later discoveries to illuminate. One of the most telling witnesses that the Dura art had an original connection with the tradition which lay behind the early Old Testament manuscript illustrations of Christianity is that the Ark takes precisely the same form in them. Fig. 48[39] shows the Ark without the cherubim, fig. 50[40] the same

36. The arrangement of the tabernacle of the wilderness, as well as of the later temples of Yahweh, had the sacrifices there before the Ark. Josh. VIII, 30–33, describes such a sacrifice at an altar erected by Joshua on Mount Ebal.

37. A coin of Autophradates, of the late second century B.C., from de Morgan, *Numismatique de la Perse antique*, Planches, plate XXVII, 19; cf. plates XXVII–XXIX passim. On later coins the paneling disappears and the god sits directly on the chest. Cf. Hill, *Arabia, Mesopotamia, and Persia*, 1922, plates XXVIII–XXX (*CBM*).

38. Deut. x, 5; XXXI, 26 (where it is put beside the Ark), I Kings VIII, 9. The statement in Heb. IX, 4, that it also contained "a golden pot holding the manna, and Aaron's rod that budded" has no counterpart in existing Jewish legend, but may well have been current among Jews at the time. See *JE*, II, 103–106.

39. Courtesy of the Vatican Library. It is from fol. 331ʳ of cod. vat. gr. 746, an illuminated Octateuch.

40. Courtesy of the Vatican Library. It is from fol. 158ᵛ of cod. vat. gr. 747, another illuminated Octateuch. The cherubim could

sort of Ark with the cherubim added. The two lines almost certainly met in pre-Christian Jewish art in Alexandria.

Before this Ark in the synagogue painting the sacrifice takes place. Again it seems to me not a matter of chance, however, that even the altar is subordinated, and that the cult object put in immediate relation with the Ark is the menorah, shown in exaggerated importance as compared with the other objects. To this we shall return.

Aaron himself stands in impressive dignity beside the altar of sacrifice. Kraeling[41] has gone to considerable trouble to find details of resemblances between his dress and the robes prescribed for Aaron in the Bible,[42] but seems to me to fail completely. I fully agree with Widengren when he says that the two robes are *diamétralement opposées*, and that "one could not imagine a costume more Iranian and less Jewish."[43] Widengren was here still using the earlier sketches of the robe that showed Victories and Erotes along with the "round objects" for jewels, but Kraeling seems quite right in discarding this sketch for the robe as drawn in fig. 51,[44] where only jewels are shown. But to this Widengren's remarks seem also appropriate. The costume consists of the caftan and trousers in rich colors and with a yellow stripe down the front of the caftan and each leg. The red cape, open at the bottom and covered with jewels, is held together across the breast by a large oval brooch of gold, and is lined with a checkerboard pattern of black (or dark) and white squares clearly visible in fig. 51.[45] These checks, so far as I can see, have intruded themselves into the painting from the Old Testament, for in Exodus XXVIII, 39, the whole coat of Aaron was to be made of checker work of fine linen. I can find no trace of such checks on Iranian robes. The cape itself, without the checks, is worn over the caftan and trousers by a man on the ladder above Jacob, fig. 52, but by no one else in the synagogue. The royal cloak, as it appears on Ahasuerus and Mordecai, fig. 36, on Pharaoh, fig. 53, and on a figure who is apparently a captain on horseback, fig. 54,[46] resembles this, but has sleeves and no checks. The sleeveless

be angels in the form of Victories: Riedin, *Cosmas Indicopleustes*, 283, fig. 304; 286, fig. 311.

41. *Synagogue*, 127 f.

42. Exod. XXXVIII.

43. "Juifs et Iraniens," 212. Kraeling, *Synagogue*, 127, n. 451, notes the similarity to Iranian royal costume, but tries to connect its parts with details of the biblical garments, for which see J. Gabriel, *Untersuchungen über das alttestamentliche Hohepriestertum mit besonderer Berücksichtigung des hohepriesterlichen Ornates*, 1933 (Theologische Studien der Österreichischen Leo-Gesellschaft, 33).

44. From Kraeling, *Synagogue*, 127, fig.

41.

45. The checks probably disappeared in the course of restoring or exposure to light. Such checks appear on the chiton, himation, clavi, and gams of Moses in fig. 47. Pfister, *Nouveaux textiles de Palmyre*, 29 f., discussed fragments of such cloth found at Palmyra, and thought them to be very fine cloth with purple dye, but whether these fragments had ceremonial use or implication with pagans I cannot say.

46. So it appears in the original photograph: the reconstructed drawing is clearly wrong.

cape does reappear, however, in the Dura Mithraeum on each of a pair of enthroned figures at either side of the sanctuary, fig. 55,[47] on holy figures of some sort on three frieze fragments from the middle Mithraeum, and, we now recall, here and generally on Mithra himself, both when he kills the bull[48] and when he is the mystic hunter.[49] It is worn by Adonis in his Dura temple, fig. 56, and, by Ohrmazd in the Tak-i-Bostan relief, on which from either side a god and goddess offer king Chosroes II a crown, fig. 57.[50] Daniel in the lion's den at Ravenna wears this cape, as does Melchizedek at Ravenna and at Santa Maria Maggiore in Rome.[51] The figure of Daniel is often clearly designed to double for Mithra himself,[52] so that the combination of Persian caftan and trousers with the cape would seem to distinguish a divinity or priest rather than a king, though of course the king might have worn such a cape when he functioned as a priest. The transition to the Christian cope clearly appears when Daniel wears it as a priest, but still without the chiton-cassock.[53]

The jewels on Aaron's cape are another token, I should guess, of divinity or priesthood. True, the king Chosroes II in fig. 57 has a caftan and trousers covered with jewels, but in this scene the king seems in the act of being apotheosized by the god and goddess.[54] A similar jeweled dress appears on two little

47. Courtesy of the Yale University Art Gallery. This is the figure at the right: see Rostovtzeff, *Dura-Europos*, VII/VIII, plates II and XVI f. Cf. du Mesnil du Buisson, "Le Nouveau Mithréum de Doura-Europos en Syrie," *Gazette des Beaux-Arts*, Ser. VI, Vol. XIII (1935), 1–14.

48. Rostovtzeff, plates XXIX f., and H. H. von der Osten, *Die Welt der Perser*, 2d ed., 1956, plate 90 (Grosse Kulturen der Frühzeit).

49. Rostovtzeff, plates XIV f.

50. From E. Herzfeld, *Am Tor von Asien*, 1920, plate XLIV, and see his plates XLII, XLIX, LV f., LVIII; cf. Pope, *Persian Art*, IV, plate 160b; Kraeling, *Synagogue*, 127, n. 451; du Mesnil, *Peintures*, 61, fig. 48. Chosroes II (A.D. 539–628) was the last great Sassanian king.

51. The three are reproduced by Alföldi, *Late Classical and Medieval Studies in Honor of A. M. Freund*, plate IX, 19; cf. 20, 22, and p. 47. And see du Mesnil, *Peintures*, 60, fig. 47.

52. Weitzmann may be right, but I cannot share his confidence that any of the figures in the "Martyrion" at Antioch represent either Old Testament or New Testament characters or scenes. The keystone of his argument (see his p. 135) seems to be the "cer-

tain identification" of Daniel, wearing the cape and buckle in the same way, and his feeling that, were the fragment complete, the lions would have appeared. Actually "Daniel" is so framed that the lions could never have stood beside him, and in their absence the figure would probably have represented "Mithra" or some other god. See his "The Iconography of the Reliefs from the Martyrion," in R. Stillwell, *Antioch-on-the-Orontes*, III, 1941, 135–149; the "Daniel" is on plate 17, fig. 368. The buckle has the form of a "round object." What Weitzmann calls the "Joseph scene" is likewise by no means certainly such. The rest of the fragments, even the "Christ Pantokrator" seem even less assured.

53. Cf. Weitzmann, *Roll and Codex*, 162, and fig. 155. It is from a manuscript of *Cosmas Indicopleustes*, cod. vat. gr. 699, fol. 75ʳ. I find it interesting that the rulers of the four universal kingdoms, described in Dan. VII as riding on monstrous beasts, wear in this drawing the Persian costume, and ride what look to be Dionysiac lions, although the second seems to have a bear's head, and the last, for no recognizable reason, a horse's or ass' head. These figures must have had a long and interesting history.

54. Cf. the jeweled royal clothing in

unpublished bronze figures, one in the Yale Babylonian Collection, fig. 58,[55] the other in a private collection in New York, fig. 59.[56] Their headdress is unique in Sassanian art so far as I know, but the horns would probably be the moon sickle associated with Mah, the moon god, and since a divinity is so much more apt to appear in little affixes than a king, I should suppose that the figures represent Mah.[57] That is, the jeweled robe is that of a deity, and may well have been a convention to suggest the "bright, white" garment, "round and manifest afar" of Ohrmazd himself, as described in Zurvanism.[58] Another source says he "is clad in the stone-hard sky,"[59] and the jewels may well refer to the stars in this sky. But Vay, Ohrmazd's militant alter ego, or assistant, wears a "red, wine-colored, and jewel-bedecked robe of warriorhood,"[60] so that while the jeweled robe suggests divinity, it by no means identifies the god.

An amateur runs great danger in using Iranian literary sources. As we have them, they are late compilations of early material, but how much earlier is not decided. Most scholars agree, however, that their main ideas go back at least to the period of the synagogue. The Denkart has a passage which may be relevant to our purpose. It is a Zurvanist account of how Ohrmazd through finite time made four agents of creation, two good and two evil. One of the two good ones is the "robe of priesthood," a priesthood which "orders good in its pure estate"; we shall return to it below. The second good one, the "robe of warriorhood," seems so pertinent to the meaning of this painting that I quote it in full. The robe

> which, since it comprises good order, ability, priesthood, the parent of wisdom, power, and the orderly dispensation of the [natural] law, influences whatever has the character of orderliness and tends to benefit creation; and this was bestowed on him [sc. Vāy] through Time from its decisive dispensation that orders aright to its ultimate advantage, and it has the same origin as Vāy, the recipient of this very weapon above and within both [creations] till the end: and

Herzfeld, plate XLIX. Chosroes wears the same cape, at least, in a miniature in the Gothas manuscript of the Saxon World Chronicle: see L'Orange, *Studies on the Iconography of Cosmic Kingship in the Ancient World*, 116, fig. 84. See also the little figure at Dumbarton Oaks, Washington, D. C., published in their *Handbook of the Collection*, 1955, 85, no. 148.

55. Courtesy of the Yale Babylonian Collection. It is 2⅞ inches high, cast in half round and hollow, presumably to be attached to a wooden surface which has disappeared. Of its provenance the only record is that it was "found in a quarry near Mosul."

56. It was formerly the property of Mr. Theodore Leavitt.

57. The crescent moon frequently appears on Sassanian crowns, as on that with Chosroes II in fig. 57. See also E. Herzfeld, *Archäologischen Mitteilungen aus Iran*, IX (1938), 102, fig. 1; 141, fig. 21; 143, fig. 23; plate VIII; Pope, *Persian Art*, IV, plates 213 f., 229, 239. But these all have the sun as a globe or star within the crescent. Mah appears with the crescent alone (not as headdress) on two silver plates: J. Orbeli, ibid., IV, plates 207B and 233A; cf. I, 735 f. The crescent is on the crown to represent Mah: Herzfeld, 110, 113, fig. 9.

58. Zaehner, *Zurvan*, 119; cf. 122.

59. Quoted by Zaehner, 120.

60. Ibid., 122.

this robe is the essence of Vāy of lofty deeds and his garment; among the gods it is associated chiefly with the Spirit Vāy whose name is the Wheel, that is the firmament, and it is also called Spahr (θwāša), and with the swift wind and the breath of man; among virtues it is with the speed which is in men, that is valor; among modes of conduct in . . . orderliness; among characters in righteous desire and action conducive to greater good order; among material "forms" in the swift and valiant body; among the castes in the warriors; among rulers in the valiant commander of an army; among garments in the red and wine-colored garment, adorned with all kinds of ornament, with silver and gold, chalcedony, and shining ruby; among deeds in the great good ordering of character, the destruction and furtherance of both the good and evil creations.[61]

We could not get a better description of the robe of Aaron than a "red and wine-colored garment, adorned with all kinds of ornament, with silver and gold, chalcedony, and shining ruby." When we see how the symbolism of the Closed Temple accords with the description of the other type of creation, it will seem highly likely that this conception (not necessarily this literary passage) has entered into the synagogue artist's conception of the priestly robe and priesthood of Aaron. In Iranian terms it presents him as a priest of "the good in its contaminated state" — that is, material creation.

Aaron wears the garment, I am sure, not to identify him with any Sassanian deity, but to announce to people who knew the local oriental symbolism that he was "priest of the Most High God," by virtue of his being priest of the God of Judaism. The only feature of Aaron's dress which seems to me to echo the biblical description is the checked lining of the cape which appeared at the bottom. This single detail cannot obscure the total dissimilarity of Aaron's cape to the biblical robe of Aaron. It seems impossible to identify the cape more closely, in view of the difficulty of Persian written sources in the period and the paucity of plastic representations. But Aaron may well be wearing a robe like that of some priest in one of the Dura temples. We shall come to feel its relevance to order in material creation.

How this cape got into the western Christian tradition of the Old Testament illustration for Aaron's robe I cannot say, but its presence in the two traditions again suggests a common ancestor. For the cape is definitely not a western garment, much as it seems to resemble the chlamys. Yet it appears for Aaron several times in Christian art, and, indeed, became the cope of ecclesiastical dress, worn, of course, even by Aaron over the Greek tunic that became the cassock, fig. 60.[62] In fig. 61[63] Aaron is robed by Moses in the center, and

61. As translated by Zaehner, 377 f.

62. From *Smyrna Octateuch*, plate 60, fig. 183 (85 ro.); cf. *Const. Octateuch*, plate xxiv, figs. 137, 139, 146.

63. Courtesy of Museo Civico, Bologna, Italy. Cf. H. Graeven, *Frühchristliche und mittelalterliche Elfenbeinwerke in photographischer Nachbildung, aus Sammlungen in Italien*, 1900, fig. 2. Cf. a medieval enamel plaque at the British Museum published in the *Burlington*

then, nimbed, stands in his priestly dress with his rod. I can only suppose that the cope or cape was borrowed by Christians for ecclesiastical dress in the East, and that Westerners kept the cope while they rejected the Persian trousers that originally went with it. In view of its complicated history in Christian art and vestments, its appearance in a synagogue for Aaron, along with its proper accompaniment of other eastern garments, is most important.

As another eastern element, Aaron wears the Parthian tiara, which here, as often, comes down over the ears and has a row of pearls round the front edge.[64] Except that Phraates III (70–57 B.C.) has an additional row of pearls over the top of his tiara, fig. 62,[65] his tiara seems identical with that of Aaron.

This headdress has no relation to that of the biblical high priest, for the latter was "wound" upon the head.[66] We ordinarily call such an object a turban, but the Septuagint translates it as *kidaris*, a headdress which Philo described as "regularly worn by eastern monarchs instead of a diadem."[67] He wears it, Philo also says, to show that "he who is consecrated to God is superior to all others when he acts as a priest, superior not only to the ordinary layman, but even to kings."[68] So while the rabbis, following the Hebrew, were describing the head-dress of the priest as a piece of cloth sixteen cubits long and wound round the head like a turban,[69] Philo saw in the Greek word a definite reference to the royal tiara of the East. This is also the tiara of Aaron in the painting. It would have looked quite appropriate to one whose Bible was in Greek, not at all so to one reading in the Hebrew.

The tiara likewise has a long history in Christian ecclesiastical costume, its most famous survival being the triple tiara of the Pope at Rome.[70] Aaron's tiara conspicuously lacks the distinctive mark of his Hebrew priesthood, the tetragram.

With his checker-lined and jeweled cape, the Persian garments beneath it, and the oriental tiara above, Aaron proclaims himself priest with all the dignity

Magazine, XXXVII (1920), plate XVI, and in color by A. W. Franks, "Vitreous Art," in J. Waring, *Art Treasures of the United Kingdom*, 1858, plate 6.

64. Du Mesnil, *Peintures*, 60. Compare the headdress of many kings on Persian and Parthian coins: J. de Morgan, *Numismatique de la Perse antique*, for example plates XXXIII f.; Pope, *Persian Art*, IV, plates 141 f.

65. Courtesy of the American Numismatic Society, New York. See Pope, ibid., IV, plate 141*q*. The thin cloth hanging down Aaron's back was made part of the tiara in the repainting for restoration, fig. 51. It can be clearly seen in the sketch by du Mesnil, *Peintures*, plate XXVIII, which reproduces the tiara as it appears in the first photographs.

66. Lev. XVI, 4 (see the Hebrew).

67. *Mos.* II, 116; cf. *QE* II, 105.

68. *Mos.* II, 131. See my *By Light, Light*, 105. There is always the possibility that this headdress was actually worn by the Hasmonean priest-kings, but I know nothing to confirm such a suggestion.

69. G. T. Purvis in *HDB*, III, 398*b*; J. Eisenstein in *JE*, VIII, 622 f.

70. Still the best treatment of the history of the tiara is that of E. Münz, "La Tiare pontificale du VIII^e au XVI^e siècle," *Mém.*, AIB, XXXVI (1898), 235–324. A late survival of Aaron's tiara is on his head in Riedin, *Cosmas Indicopleustes*, plates XXVI f.

and prerogatives of Persian divinity, royalty, and priesthood. He is still Aaron, and, with the Jewish cult instruments before him, clearly presides over the ancient Hebrew sacrifice. We can hardly explain this combination by agreeing with Kraeling that since the artist was "not an antiquarian" he was coming as close to the biblical costume "as his repertory of design . . . would allow"; that he had "done his very best to portray . . . all six of the garments of the Israelite High Priest."[71] Instead, he has done his best, and succeeded very well, in giving to Aaron the appurtenances of Persian priesthood. When even the ephod and tetragram fail to appear, we must suppose that in giving Aaron the accouterments of Persian priesthood the artist was proclaiming that the values of Persian priesthood inhered in Judaism itself, just as when Mordecai wears the diadem in the scene below Aaron, he assumes for Jews the prerogatives of Persian royalty.

In the sacrifice five attendants, much smaller than Aaron and hence of less dignity, accompany him. Four stand each with a shofar,[72] the two at the right with the shofar at their lips, apparently just about to blow them. The shofars have bands about them, and suggest that they might have come from a special kind of ram that grew ringed horns. But I have been unable to identify any such sheep. It is interesting, however, that exactly such shofars appear in early Christian illumination, as in fig. 63,[73] so that, since horns of this kind must have been rare, we have another detail that calls for an ultimate common ancestor.[74] The fifth attendant carries a sacrificial ax over his shoulder, perhaps about to strike the bovoid he holds,[75] though I should think it is here only being led in for sacrifice. We should note that sacrifice with an ax is quite foreign to Jewish tradition; while the painter may have ignored Jewish tradition at this point, he probably did not know it at all.[76] The animal seems about to be sacrificed, since

71. *Synagogue*, 127; cf. 128.

72. Those who examined the painting carefully reported that the one at the extreme left carries some object in his hand. I see no reason for associating the peculiar form reported for it with the half-shekel of Exod. xxx, 11–16, as does Kraeling, *Synagogue*, 129.

73. From the *Const. Octateuch*, plate xxxv, fig. 233 (fol. 480ᵛ). For other appearances see Weitzmann, *Joshua*, plate v; cf. pp. 14, 16, 37.

74. Such a horn has actually been used as a shofar: see no. 12 of those illustrated in *JE*, XI, 303. My colleague D. Ripley tells me this is an antelope horn. How it came to be used as a shofar I leave others to investigate.

75. Cf. the cup from Boscoreale: Strong,

La Scultura romana da Augusto a Costantino, 1923, I, fig. 56 on p. 83. Here the act of sacrifice appears clearly. The position of the man with the ax is quite different when he is in the act of striking the animal. See I. Ryberg, *Rites of the State Religion in Roman Art*, Rome, 1955 (Memoirs of the American Academy in Rome, XXII), where the matter is abundantly illustrated. See, for example, the bull led in for sacrifice, figs. 25, 36a, and passim; the bull being struck with the ax, figs. 39a, 46, and passim. The man with the ax in the Dura painting has raised it higher than usual for those leading the bull, but the hand on the animal's back shows that he is leading it in.

76. For the tradition see Nordström, "Water Miracles," 81–83.

he has a garland round his body. His genitals, if indicated at all (there seem faint traces in an early photograph), by no means are so presented here as to determine the sex, nor are they on two animals at the right, another bovoid and a sheep.[77] Absence of genitals on the animal garlanded for sacrifice, then, if they actually were absent, by no means indicates a heifer. Still Kraeling may be right, and it may be the red heifer of Numbers XIX, 2 – 9, which is indicated, for the reddish brown color contrasts with the colors of the other animals in the painting, and its being outside the temple (city) precincts makes the identification plausible.[78]

Only the three curtains, one green and two red, looped at the top of the painting, remain to be mentioned. Such curtains we found in the two scenes of the babies in the synagogue, but in no other painting there, and since the same curtains, by no means common anywhere, appeared on the sarcophagi of the baby Dionysus, we must suppose they have special significance when represented. The same conclusion suggests itself when we see a painting with draped curtains over a table in the Octateuchs, fig. 64.[79] Such curtains appear in the Octateuchs only here. The miniature, in presenting the table of the tabernacle, shows something which can be explained from Old Testament texts only by the most insistent allegory. For the table looks much like a Catholic altar, except that two ewers and two cups stand upon it. The cups rest upon plates of some kind, but the plates contain no bread. The obvious guess is that the ewers represent water and wine. If the Christian table suggests the Eucharist, incidentally, it recalls even more strongly the table of pagan mystery, fig. 65,[80] where Demeter's stalks of grain are added, but the presentation is very similar. Since so much in the Octateuchs seems to have come from Jewish art (eventually), we wonder whether the table was not originally copied from a Jewish adaptation of such a pagan table as that in fig. 65.

The table strikingly recalls the one mentioned in a famous fragment ascribed to Philo, a table that I have long insisted seemed to have much of the value of the Christian mystery. The cultic table is represented in the scene immediately at the left, and we shall return to it.[81] But the table in the miniature looks very much like a "mystic table," and all the more so because above it the curtain is draped and held up by the hand of God himself, to reveal the table.

77. The two little tokens between the two animals' hind legs at the right, and possibly of the animal at the left, could as well indicate the undeveloped udder of a female as the penis of a male. Certainly the "bullock" at the right does not have carefully drawn genitals, as Kraeling says, *Synagogue*, 129, n. 465.

78. *BT, Sotah*, 45b (ET, 235). Kraeling, *Synagogue*, 130 f.

79. From the *Const. Octateuch*, plate XXIV,

fig. 147 (fol. 262ᵛ).

80. A stucco relief in the Basilica di Porta Maggiore, Rome.

81. If the evidence does not warrant complete assertion of such meaning, even less does it support Kraeling in asserting that they are "ornamental" (*Synagogue*, 129, cf. n. 463) or are the "hangings" of Exod. XXVII, 9 – 15 (*Synagogue*, 130).

The miniature is too extraordinary to furnish a basis for firm conclusions, but it does show the curtain again in what looks like a thoroughly mystic setting. This need not surprise us. Curtains naturally associate themselves with the mysterious and hidden, and the curtains over the sacrifice of Aaron in Dura may well have come from the Mysteries, have brought with them a sense of the mysterious and concealed, and have proclaimed that that value inhered in the Jewish cultus. They do not remotely recall the curtains that made the walls of the Tabernacle. They are more like the curtain that screened the inmost sanctuary, except that here are three of them.

B. INTERPRETATION

Kraeling sees in the scene as a whole "the episode described in Exod. XL and Num. VII when the Tabernacle was finally erected, and Aaron, the priest, and the Levites were installed in office." He sees this event specifically identified by the "number and identity of the sacrificial animals portrayed."[82] The sheep on the altar (which indeed *may* be a sheep), along with the ram and bullock at the right, are, he says, the animals required for the consecration of priests by Exodus XXIX, 1. I find this very unconvincing. In Exodus XL, Moses, as instructed by God, sets up the Tabernacle with all its furnishings; he then robes and anoints Aaron and his sons. No sacrifice is mentioned at all, and in the painting Moses does not appear. In Numbers VII Moses again consecrates Aaron and his sons, but the sacrifices described in this account involved a great number of persons and animals. This scene, likewise, the painting does not represent. Kraeling does not allude to the chief account of the consecration of Aaron and his sons by Moses, Leviticus VIII–X. Here are various animals named, chiefly, of course, bulls and rams, but no list corresponds exactly with the painted animals. The great difference is that here Moses specifically is himself the one to kill all the animals sacrificed, while Moses does not appear in the painting at all. The animal at the left of the painting may indeed represent the red heifer of Numbers XIX, 1–10, as we have said. But nothing whatever in the Bible connects the heifer with the installation of Aaron in office, and actually the heifers had to be offered in general the day before the consecration of priests so that their ashes could be used for the consecration.

If the painting cannot be taken to represent any specific biblical episode or passage, we are forced to conclude that it presents an idealized generalization of the priesthood of Aaron, the "temple cultus as such."[83] For the Taber-

82. *Synagogue*, 130 f.

83. It should be noted that du Mesnil saw in the painting an abstraction of the values of Jewish cult also: *Peintures*, 63 f. This interpretation Kraeling, *Synagogue*, 130, spe-

cifically rejected for the specific identification we have just discussed: "It is unlikely that [the artist] created this scene to represent the cultus as such."

nacle is not a real tabernacle, the curtains have no relation to it, the sacrifice is purely ideal, the attendants cannot be identified, the holy objects are quite arbitrarily selected (*two* incense burners, no table, no showbread, etc.). But the Ark, incense, menorah, and altar of sacrifice stand with the animals and priests under the dominance of Aaron. He presides over these in a temple enclosure entered by three doors, the central one suggesting a mystery by the half-withdrawn curtain. The worshiper who enters will go to Aaron and his sacrifice, which itself is directed toward a little Greek shrine marked with a rosette. In this shrine, behind a veil, stands the real center of worship, the Ark of the Covenant that represents the Shekinah, or presence of God. The draped curtains at the top again mark the scene as having mystic value, while the little Victories on the inner shrine suggest the achievement at the end, the mystic victory. If we continue to follow details of the design, we notice that the inner shrine shows us five columns (in contrast to the ten in fig. 38 and six in fig. 66), and that Aaron has five attendants. The painting itself would seem to declare, then, that the priesthood of Aaron directed Jewish cultus toward the Shekinah in the Ark, and that in the cultus, sacrifice, incense, and the menorah all had great significance, as well possibly as the number five.[84] We must interpret the painting in terms of its own details.

Few of the details come from the Bible. The veiled Ark, the menorah, the four shofars of the assistants, and the name Aaron—these are the only elements which, outside the synagogue, would justify anyone's even associating such a painting with Judaism at all. The Jewish details show, however, that the Jewish cultus was meant, but the Jewish cultus as seen through oriental-hellenistic eyes. For interpreting the painting we cannot isolate the Jewish details, but must take the hellenistic-mystic and oriental symbols associated with them quite as seriously as the Jewish components.

We have already indicated roughly some of the points of contrast between the temple of Aaronic sacrifice and the purely schematic temple which balances it. Four points of contrast especially emerge: the Aaronic Temple stands firmly on the ground, the other has no relation to this world at all; the Aaronic Temple is a temple with priests and human beings, the other has no people; in the Aaronic Temple sacrifice with cult implements, and ritual, is in active progress, in the other nothing happens whatever, and no means of cult are suggested; in the Aaronic Temple the five attendants and the five columns themselves bring out the contrast that the inner shrine of the other temple has ten columns, though on its top also the Victories offer the wreaths. The scene of the Aaronic priesthood centers in the figure of Aaron, and in the menorah burning upward toward the holy Ark.

84. I cannot make out whether the three, emphasized on the doors, is again taken up by the three animals of sacrifice, because I do not know whether we should think of the animals as being three or four, including the animal on the altar.

Is there a Judaism in which these points of contrast and this focusing of interest would have meaning, one that might have resorted to pagan conventions of pictorial art to express itself? We must seek a Judaism in which these basic features are indeed basic, not look in the great forest of Jewish writing for fugitive details from here and there, which may correspond to isolated features of the design. Philo Judaeus, for all his detailed differences, did explain Judaism in a way that matches the painting in central ideas, though of course he has many differences in detail. I know no writings from the rabbinic masters which do so.

Philo conceived most elaborately of two levels of Judaism. One of these led man through law and ceremonial observances, indeed through the cosmos, to God. On this level God functioned in the cultus as a hidden referent, present as the Shekinah in the Ark of the innermost sanctuary but not directly accessible for, or a part of, the cultus itself. In contrast Philo described also a Judaism in which the soul directly communed with God as it put away all dependence upon material things, even upon the cult and cosmos itself. The Ark, he believed, revealed the inner quality of this second Judaism, since its very structure expounded the immaterial nature of God, and the immaterial approach man can make to him. The perfect number ten characterized this Judaism in contrast to the number five in which Aaron's material worship of God centered. I know no other Jewish source which contrasts so systematically a Judaism of the senses with one of the immaterial, a Judaism of the five and of the ten.

The reader at this point may wish to read my *By Light, Light*, especially chapter IV, "The Mystery of Aaron," as well as the discussion above on "Astronomical Symbols." What follows is a digest of that material.

Philo discusses three times the Judaism of the five, each time in connection with the priestly office of Aaron and the symbolic value of the specified dimensions and materials of the Tabernacle, as well as of the cult instruments and their usage.[85] He admits that the specifications call for fifty-five pillars,[86] but sees in the fifty a perfect number, and at this level distinguishes the five; since

> Five is the number of the senses and sense in mankind inclines on one side to things external, while on the other its trend is towards mind, whose handmaiden it is by the laws of nature. And therefore he assigned the position on the border to the five pillars, for what lies inside them verges on the inmost sanctuary of the tabernacle, which symbolically represents the realm of conceptuals, while what lies outside them verges on the open-air space and court which represent the perceptibles. And therefore the five differ from the rest also in their bases which are of brass. Since the mind is head and ruler of the sense-faculty in us, and the world which sense apprehends is the extremity and, as it

85. *QE* II, 73–83; *Mos.* II, 101–103, 105. 86. *Mos.* II, 77–140; *Spec.* I, 67–97; *QE* II, 69–124.

were, the base of mind, he symbolized the mind by the gold, and the sense-objects by the brass.[87]

The "five" generally represent to Philo the five senses, of course.[88] Similarly in his most elaborate discussion of the Tabernacle and its appurtenances, that in the *Questions on Exodus*, Philo first treats the Ark and the Holy of Holies. Then he turns to the other parts of the Tabernacle, and remarks that in doing so he is turning from the symbols of the incorporeals to the symbols of those things that are *in sensu*.[89] The five appears again as the fifth element out of which the heavens are made, in contrast to the four out of which the rest of the universe is made. He says that the menorah was made of pure gold to represent this fifth element, and its seven branches stood for the seven planets in the heavens.[90] With the menorah the incense burner was associated as a symbol of the earthly, and from it properly the incense smoke goes up. The smoke and the censers represent the four elements, we gather from various passages of Philo, and they both offer themselves and are offered as a *eucharistia* to God.[91]

When Philo speaks of the altar and its sacrifice, which were as remote from most of his readers as was the original altar of Aaron, he lifts it out of any

87. *Mos.* II, 81 f.; cf. *QE* II, 97. The contrast between the "conceptuals" (*ta noēta*) and the "perceptibles" (*ta aisthēta*) is basically the Platonic contrast between ideal forms to be apprehended only by the mind, and material things "under the aether" (*hupaithron*), the Greek word for "open air," apprehended by the senses. The passage is difficult because it presents two ideas at once, the relation of mind to sense perception, and of the "conceptuals" to the "perceptibles." Just what Philo took the LXX *stuloi* to mean, whether columns or tent poles, I see no way to determine.

88. So explained in *Opif.* 62; *Plant.* 133; *QG* IV, 110; *Migr.* 201. For similar statements in Greek literature see the references in K. Staehle, *Die Zahlenmystik bei Philon von Alexandreia*, 1931, 31, n. 32a. For the continuation of this meaning of the five into Christianity, see E. Testa, *Simbolismo dei Giudeo-cristiani*, Jerusalem (Jordan), 1961, 8.

89. *QE* II, 69. Cf. ibid., 94: "I have said that the simple holy parts (of the tabernacle) are classified with the sense-perceptible heaven, whereas the inner (parts) which are called the Holy of Holies (are classified) with the intelligible world. The incorporeal world is set off and separated from the visible one

by the mediating Logos as by a veil."

90. Ibid., 73. He says that the altar was five cubits long, ibid., 97 and 99, and, that the "covering" being on five columns, the pentad is the number of the sense-perceptible class; both the outer court and the altar belong to this class.

91. In *Mos.* II, 101. Philo says that it is a "symbol of the *eucharistia* of earth and water"; later, ibid., 105, he says that the censer symbolizes "earthly things, from which vapors rise." Cf. *Spec.* I, 171. But in *Heres* 226, he says that the altar and its offering represent the four elements, for which a *eucharistia* is offered, by which he suggests the identity of the object and its offering. He has already said, ibid., 199, that the incense offering symbolizes the cosmos itself, which burns morning and evening as a *eucharistia*. Philo cannot be tied down to a single meaning but that man should offer the elements of the universe in a thanksgiving for its benefits, and in doing so reproduce an inherent relation of the elements themselves to the whole, will trouble no one who understands ritual. The prayer in *Spec.* I, 210 f., is addressed from the microcosm, as *eucharistia* for the universe as macrocosm. I strongly suspect it reports a prayer used in Philo's synagogue.

literal significance and makes it into a symbol of piety for Alexandrians. We shall increasingly feel that the incidents selected for illustration from the Bible in the synagogue, and the way they are depicted, indicate the same sense of contemporeity and immediacy. The following statement of Philo about the sacrifice therefore seems to me to have general, if not specific, relevance:

> The great altar in the open court he usually calls by a name which means sacrifice-keeper, and when he thus speaks of the altar which destroys sacrifices as their keeper and guardian he alludes not to the parts and limbs of the victims, whose nature is to be consumed by fire, but to the intention of the offerer. For, if the worshiper is without kindly feeling or justice, the sacrifices are no sacrifices, the consecrated oblation is desecrated, the prayers are words of ill omen with utter destruction waiting upon them. For, when to outward appearance they are offered, it is not a remission but a reminder of past sins which they effect. But, if he is pure of heart and just, the sacrifice stands firm, though the flesh is consumed, and even more so if no victim at all is brought to the altar. For the true oblation, what else can it be but the piety of a soul which is dear to God? The thank-offering (*euchariston*) of such piety receives immortality, and is inscribed in the records of God, sharing the eternal life of the sun and moon and the whole universe.[92]

The last sentence says quite clearly that it is the *euchariston* which receives the immortality of the universe, but I have no doubt that in Philo's mind the pious soul who made the true *eucharistia* actually achieved that state. For in another treatise when he describes the sacrifice as properly offered within the soul he tells how

> by the washing of the feet is meant that his steps should be no longer on earth but tread the upper air. For in truth the soul of one who loves God springs up from earth to heaven and with its wings flies about, longing to take its place and share the dance with the sun, the moon, and that most sacred and perfectly attuned company of the other stars, whose marshal and leader is God.[93]

Philo's conception of the immortality achieved through correct sacrifice at last now clearly manifests itself as the celestial existence of Plato's *Phaedrus*,[94] in which properly the soul drives among, or follows, the company of the stars or gods in their diurnal revolution, the "ordered march" of Philo. He often recurs to this idea, that only in offering ourselves do we make a proper sacrifice or *eucharistia*, which essentially consists in "the true purity of a rational spirit in him who makes the sacrifice."[95]

Aaron in his robes represented this worship to Philo. He describes elaborately how various parts of the robe mentioned in the Bible represent the elements, the heaven, the zodiac. In this worship Aaron appealed to the cosmos as the Son of God to intercede for him and for nature.

92. *Mos.* II, 106–108.
93. *Spec.* I, 207.

94. *Phaedrus*, 246A–247E; 250B, C; 256B.
95. For example, *Spec.* I, 272–277.

For it was necessary that he who was consecrated to the Father of the world should have that Father's Son who is perfect in virtue to plead his cause that his sins might be remembered no more and good gifts be showered in abundance. Yet perhaps it is also to teach in advance one who would worship God that even though he may be unable to make himself worthy of the Creator of the cosmos, he yet ought to try increasingly to be worthy of the cosmos. As he puts on his imitation (symbol) he ought straightway to become one who bears in his mind the original pattern, so that he is in a sense transformed from being a man into the nature of the cosmos, and becomes, if one may say so (and indeed one must say nothing false about the truth), himself a little cosmos.[96]

Here again the priesthood of Aaron is made the priesthood of all who in their devotions "put on the Cosmos," and so identify themselves with the son of God.

One detail of the painting seems to me to confirm such an interpretation, the red heifer about to be slaughtered outside the precincts. For just before speaking thus about the true nature of sacrifice, Philo mentions the red heifer. He says that he has fully allegorized it elsewhere (a section of his writing now lost), but he summarizes its meaning as follows:

So we see that they who mean to resort to the temple to take part in sacrifice must needs have their bodies made clean and bright, and before their bodies their souls. For the soul is queen and mistress, superior to the body in every way because a more divine nature has been allotted to it. The mind is cleansed by wisdom and the truths of wisdom's teaching which guide its steps to the contemplation of the universe and all that is therein, and by the sacred company of the other virtues and by the practice of them shown in noble and highly praiseworthy actions. He, then, who is adorned with these may come with boldness to the sanctuary as his true home, the best of all mansions, there to present himself as victim. But anyone whose heart is the seat of lurking covetousness and wrongful cravings should remain still and hide his face in confusion and curb the shameless madness which would rashly venture where caution is profitable. For the holy place of the truly Existent is closed ground to the unholy. To such a one I would say, "Good sir, God does not rejoice in sacrifices even if one offer hecatombs, for all things are his possessions, yet though he possesses he needs none of them, but he rejoices in the will to love him and in men that practise holiness, and from these he accepts plain meal or barley, and things of least price, holding them most precious rather than those of highest cost." And indeed though the worshipers bring nothing else, in bringing themselves they offer the best of sacrifices, the full and truly perfect oblation of noble living, as they honor with hymns and thanksgivings their Benefactor and Savior, God, sometimes with the organs of speech, sometimes without tongue or lips, when within the soul alone their minds recite the tale or utter the cry of praise. These one ear only can apprehend, the ear of God, for human hearing cannot reach to the perception of such.[97]

96. *Mos.* II, 134 f. 97. *Spec.* I, 269–272; cf. 277.

If Philo shows us the way in which the values of the Tabernacle or Temple could be preserved for Jews who had no access to either, he deeply stresses the menorah and its relation to the symbol of the world of "conceptuals," the immaterial world of Platonic forms. The menorah has seven branches because it represents the seven planets, he says, the highest objects perceptible by the senses, and the "seven" itself the pure existence of the One. It is made of gold, and gives light because it symbolizes the Light Stream from God, or the Logos. But it represents not only the coming down of God's creative force to earth, but the praise to God (*eucharistia* again) of the celestial bodies.

Philo's discussion of the symbolism of the Tabernacle, its ritual, and the priestly garments goes far beyond what could be conveyed in the painting. Since he allegorizes the biblical text in detail, the Tabernacle is for him the tent made of curtains, and Aaron wears a robe according to biblical prescription. I see no reason to suppose that the "philosopher" who designed the synagogue painting had Philo's text as a guide. It is accordingly important to note that Philo himself tells us in one of the most mystical of his Temple allegories that "those who are nourished by visible food in the form of allegory also say . . ." That is, Philo is writing his allegory of the Temple and its cultus in accordance with a tradition. The tradition reappears in Josephus with such variations as to show that he also did not depend upon Philo, while Clement of Alexandria gives a very similar discussion of the matter with no apparent dependence upon either Philo or Josephus.[98] All allegorize the priest's vestments in terms of the four elements, and all agree that the two outer courts referred to the material cosmos, the inner to the world of God beyond the cosmos. Clearly in the same tradition, but by no means its source, an anomalous passage in *Numbers Rabbah* especially emphasizes the menorah as the seven planets, burning in worship of what lies beyond them, represented by the hidden Ark of the Covenant.

The painting seems to me essentially to represent this general tradition. The robes of Aaron have become the royal-priestly dress of the Parthians and Sassanians, a dress which, we saw, the Parthians thought appropriate for cosmic worship, worship in the realm of "the good in its contaminated state," the material world. By writing "Aaron" beside the priest's head, the "philosopher" seems to announce that the true cosmic priesthood sought by the gentiles presents itself in Aaron; he presides over a worship that is one with the worship which the universe itself offers to God. Man approaches it through the purification symbolized by the red heifer, but does not have to go back to the curtained Tabernacle of the wilderness, or even to the Temple in Jerusalem which succeeded it. For these, lost in a literal sense, were still available to Philo as he purified himself, and offered himself. The true oblation, Philo tells us, is the piety of a soul which is dear to God. The worship revealed to man in

98. For the passages and discussion see my *By Light, Light*, 98 f.

the cultus of Aaron seemed still available to the "philosopher" who designed this painting to show the Judaism of cosmic worship. One entered it by pulling back the veil in the outer court, joined the planets in their circles, and offered oneself on the altar. One ended with such an experience as only the Victories with their wreaths could typify.

The achievement of the crown meant to Philo saving knowledge — perpetual vision of God.[99] It indicated that he who received it was "given Anthropos," which means that he became the Anthropos or Logos.[100] Philo is not alone in this conception. The Mandaeans proclaimed: "The crown of aether light shines forth from the House of Life."[101] And the second ending of the liturgy of the dead of the Mandaean Qolasta closes with the following lines which I quote in Lidzbarski's translation:

Einen Ätherkranz errichteten sie ihr auf dem Haupte
 und führten sie in Pracht aus der Welt.
Das Leben stützte das Leben,
 das Leben fand das Seinige;
das Seinige fand das Leben,
 und meine Seele fand, was sie erhoffte
Und das Leben ist siegreich.[102]

The seventeenth Ode of Solomon begins: "I was crowned by my God: he is my living crown,"[103] and the Ode goes on to describe the mystic ascent to this culmination. In the hellenized IV Maccabees the martyrs expect to receive the crown.[104] That is, mystic Jews widely used the crown to symbolize their highest mystic achievement and immortality, so that Christians[105] found the symbol already assimilated for them by hellenized Jews.

Whether a ritual in the synagogue corresponded to this mystic setting or not, Philo would have called the whole conception represented in the painting a Mystery. I doubt that modern philologians, who wish to define "mystery" in a way to keep it from such usage, know more accurately the meaning of the term than did Philo, following Plato, himself.[106] For him it was part of the revelation of God to Moses, who in the Bible built the Tabernacle and installed Aaron in office. I cannot believe that it is by chance, then, that Moses stands at the right of this scene, himself engaged in worship along with the celestial bod-

99. *Migr.* 133–135. See *Praem.* 27.

100. *Praem.* 13–15.

101. M. Lidzbarski, *Mandäische Liturgien*, 1920, 9 (Abhandlungen der Königlichen Gesellschaft der Wissenschaften zu Göttingen, phil.-hist. Klasse, N.F., XVII, 1).

102. Ibid., 114, lines 3–6. R. Reitzenstein, *Das iranische Erlösungsmysterium*, 1921, 69.

103. Ibid., 86.

104. IV Mac. XI, 20; XIII, 4; XV, 29; XVII, 15 f.

105. I Cor. IX, 25; Rev. IV, 4, 10. I could find no such symbolism of crowns in rabbinic sources.

106. See my "Literal Mystery in Hellenistic Judaism," *Quantulacumque: Studies Presented to Kirsopp Lake*, 1931, 227–241.

ies. And again it is entirely proper that at the left Moses should again stand, this time touching the rock to give water to Israel, and that this should be so designed as to represent Israel in celestial worship as the zodiac.[107]

107. Daniélou, *Symboles*, 9–30, which appeared after the above had been set in type, adds much interesting material to my discussion but tries to connect all Jewish and Christian crowns with the Feast of Tabernacles. The Feast itself, he feels, was free of hellenistic influence.

The Judaism of Immaterial Reality:
The Ark vs. Paganism

T H E S C E N E of the miraculous well illuminated the meaning of the Temple of Aaron beside it. In the same way, I believe, the scene of the Ark of the Covenant, fig. 66, to which we now come, complements the scene of the Closed Temple.

The painting appears at first to fall into two parts, divided by the Ark, which rests upon a cart. The painting has usually been described as containing two scenes, two episodes, but we shall have reason to suppose that, although details come from various sources and passages, the painting actually gives us a single composition which is unified by the central Ark itself. At the right two idols in Persian dress lie broken on the ground, surrounded by a variety of cult objects, with an empty temple in the background. At the left two men in Persian dress guide a pair of bulls that are pulling the cart, while three men in Greek dress walk behind.

A. PAGANISM

T HE BIBLICAL INSPIRATION of both parts of the painting is obviously the incident in which the Philistine god Dagon at Ashdod collapsed before the Ark, after which the Philistines returned the Ark to Israel.[1] In that story the Philistines had captured the Ark in battle and set it up as a trophy before Dagon, only to find the god's image prostrate before the Ark on two successive mornings; the second time it had lost its head and hands, cut off on the threshold. This only began the trouble of the Philistines, who found themselves visited by calamities in all the five cities where they then tried to keep the Ark. So at the advice of their priests the Philistines built a new cart on which they put the Ark, along with five golden images of the tumors, and five others of the mice, that had been afflicting them, a golden tumor and mouse for each city. The cart was to be drawn by two milch cows that had never yet worn a yoke, and the cows were to go their own unguided way.

1. I Sam. v, 1–vi, 18.

The cows went straight in the direction of Beth-shemesh along one highway, lowing as they went; they turned neither to the right nor to the left. And the lords of the Philistines went after them as far as the border of Bethshemesh.

That the cows thus took the cart without human guidance straight back to the Jews indicated to the lords of the Philistines who followed, five in number, that they had done right in thus returning the Ark.

The Dura artist has taken elements from both these incidents of the story to say some things which the story itself by no means indicates. Details are altered quite *a piacere*, but, we shall see, with purpose. A glance at the objects strewn on the ground before the Ark at the right, for example, shows that the artist was not reconstructing the historical scene at all. The images of the two gods each look almost exactly like the painting of Adonis in the temple dedicated to him a few streets away, fig. 56. Kraeling identified and numbered the ritualistic implements for his drawing, which I reproduce in the accompanying text fig. 1:[2]

FIGURE 1

a large, wide-mouthed storage jar (no. 1), a hydria (no. 2), two shallow basins or bowls (nos. 3, 4), three small jugs (nos. 5–7), three candelabra or lampstands (nos. 8–10), two large thymiateria (nos. 11, 12), two smaller thymiateria (nos. 13, 14), and two altars (nos. 15, 16).[3]

2. From Kraeling, *Synagogue*, 101, fig. 30. 3. Ibid., 102.

No. 17, he continues, is probably a "snuff shovel," apparently a reference to the incense burners of this shape that were formerly called snuff shovels.[4] He plausibly suggests that no. 18 may be a musical instrument, and I suspect no. 17 is another.

The artist has made no attempt to orient all these objects, or the idols among them, with the empty temple. Instead, the idols lie prostrate facing the Ark, certainly not aligned with the pedestals in the shrine behind them from which they presumably have fallen. The artist seems to have had the problem of how to orient them toward the Ark and yet make them recognizable. For the latter, they had to lie face up, but had he drawn them face up with their heads toward the Ark the actual effect would have been that their backs were toward it. His solution was the only possible one, to make them lie on their backs, with their feet toward the Ark, their heads facing it. Such relation to the Ark had presumably greater importance than to show their relation to the pedestals. In this way he has succeeded very well in using the incident from I Samuel to show the collapse of paganism before the reality of Judaism, the collapse of paganism presumably as he knew it directly in Dura itself.

The empty temple at the back presents a shrine whose architrave is carried by six tall white columns with Corinthian capitals. Behind the columns a wall of yellow masonry flanks a central element consisting of a wall of lighter yellow above and the entrance below to the adyton.[5] A pair of dark yellow pilasters or columns flank the opening and carry a lintel with a pediment above it. The lintel and pediment were crudely drawn, for the earlier photographs and Gute's painting, fig. 66, show that the right corner of the pediment and the pilaster beneath it overlapped the larger white column, though they were clearly supposed to be behind it. Upon the white inner triangle of the pediment stands a multi-pointed gold rosette, probably intended to have sixteen points; superimposed upon this Gute indicates that he saw a four-point rosette. I quite agree with Kraeling's suggestion that the artist meant to represent in this design only the façade of a temple, with the columns of the portico spaced "in the arbitrary manner familiar from Roman coins to provide an unobstructed view of the interior of the cella."[6] When the Romans did this, the opening ordinarily showed a cult image,[7] though sometimes a boss seems to indicate the closed door of the adyton, a device which suggested but did not

4. See M. Avi-Yonah, "On the Problem of the Shovel as a Jewish Symbol" (in Hebrew), *BJPES,* VIII (1940), plate II, pp. 20 f.

5. Kraeling, *Synagogue,* 101, has an excellent description of the temple with interesting references.

6. See his *Synagogue,* 101, and n. 325. Kraeling does not claim that the painter used the design on Roman coins as the direct model. There is some discrepancy in the various colors reported.

7. H. Mattingly, *Coins of the Roman Empire in the British Museum,* IV, 1940, plate 9, no. 6; plate 29, no. 12 (contrast nos. 10 f., 13); plate 36, nos. 2 f., and passim. Hill, *Coins of Palestine,* plates XV, 10 f.; XVI, 6; XXVI, 5; XLI, 9 (*CBM*), where a pair of gods are in the shrine—here male and female.

reveal the sanctity of the cult object behind it.[8] Jews had elsewhere taken over the convention. They represented the Ark or the Torah shrine thus at the center between four columns on their coins of the Second Revolt,[9] and painted the façade with four columns and the closed doors over the Torah niche in the Dura synagogue itself. On the latter the closed doors have "round objects" upon them which recall the bosses of the similar closed doors on Roman coins. The adyton here, on the contrary, shows only an empty mockery, with what seems to be two pedestals and a table for the cult instruments, or for cultic use of some kind. But all hope of cult or divine presence has vanished. No Victories are here, though there was plenty of room to indicate them on the extended lintel beside the inner pediment. The artist is telling us as clearly as if in words that paganism is a mockery and empty shell. Its fatuous pretense collapses before the Shekinah of the Ark.

In representing six columns on the façade, the artist may simply have been reproducing a "cliché" familiar from Roman coins, but while such façades with images on the coins had six columns more often than any other single number, many times the design shows four or eight columns while, as we have seen, the façades of the pagan temples at Dura, as well as the Jewish façades, usually had four columns with three openings. I strongly suspect that the six columns for the pagan temple of the painting express a numerological value judgment, though this I cannot adequately defend. Philo often calls six a "perfect number,"[10] chiefly on the ground that it is the product of two and three. In the number six, however, these numbers

> have left behind the incorporeal nature of the One; for the Two is an image of matter, since like matter it can be divided and cut, while the Three symbolizes a solid body, since a solid has three dimensions (literally, is divisible in three ways).[11] . . . [Moses] intends to show that mortal and immortal things are each formed in a way corresponding to their proper numbers, mortal things, as I said, structured in a way comparable to the Six, but the happy and blessed things to the Seven.[12]

A little later he adds: "When the holy Logos, which is after the manner of the Seven, comes upon the soul, the Six is suspended, along with all the other mortal things which the Six seems to make in this way."[13] Philo did, then, know the six as a material symbol quite inferior to the seven, though he by no means consistently holds to it. That the artist may have intended to express such a con-

8. Mattingly, plate 31, no. 8; plate 32, no. 8.

9. See du Mesnil, *Peintures*, plate XIII, 1 – 6.

10. Cf. *QG* III, 38. Philo often says this. The passages are collected by Staehle, *Die Zahlenmystik bei Philon von Alexandreia*, 32 – 34.

11. Cf. *Decal.* 24 f.; *Opif.* 36; Staehle, 25.

12. *LA* I, 3 f.

13. Ibid., 16. The last phrase is corrupt textually, but the general meaning seems clear.

trast of the six with the sacred three and seven will appear more likely when we consider the details of the other half of this painting.

Before leaving the pagan half, however, we must ask more closely why the shrine was made with pedestals for two gods, and what gods the two male images prostrated before the Ark might have represented. They are almost identical. Each wears Persian dress with a coat hanging behind like a chlamys,[14] similar to the one worn by Aaron in fig. 37, and fastened by a similar brooch at the chest. Each has a sword at his side, on whose pommel the left hand quietly rests. The right hand is raised to about shoulder height, and carries a staff.[15] Du Mesnil recognized the great similarity of the fallen idols to the images of Adonis, but got into considerable difficulty when he tried to explain why there were two images. He ingeniously recalled that I Sam. v, 3 f., reports that Dagon fell before the Ark on two successive days, and on that basis he suggested confidently that the two figures represent the same god as twice fallen. To do this he had to assume that what appear to be two pedestals in the adyton are altars (though two altars lie in the debris with the gods), and that the "table" in the center actually is a bed on which the single god reclined.[16] This stretches our fancy too far. The images on the ground clearly were not couchant, like the many we know, as for example figs. 67–74,[17] but standing, like the Adonis in fig. 56. While Brown, in publishing this restored painting, was uncertain whether he should have Adonis stand on a pedestal or a globe, his Adonis, like the fallen gods of our scene, must have stood on something. I do not see how we can imagine the ones in the synagogue painting as originally doing anything else than standing on the two pedestals. In that case they must represent two distinct deities.[18] The object between the pedestals would then perhaps be a bed, but seems more likely to have been a table to hold some of the cult implements, like the table in fig. 65. From the pagan temples we should judge

14. They may possibly be wearing the candys, a cape similar to the chlamys, but with short sleeves. See Cumont, *TMM*, II, 270, fig. 113; W. Amelung in PW, III, 2207 f.

15. There was some sort of knob at the top of the staff and perhaps something on the side as Gute represented. Kraeling, *Synagogue*, 102, n. 334, suggests the possibility of a thyrsus.

16. Kraeling, *Synagogue*, 102 f., rejects du Mesnil's identification with Adonis, on the ground that this would have "introduced a type of short-range polemic into the decorations that in general appears to be alien to the rest of the work of the Synagogue artists." We are finding so many "short-range" references in the decorations that this objection has no

weight at all. On the other hand, Kraeling eagerly accepts du Mesnil's suggestion that the two figures represent a single deity.

17. See also H. Ingholt, H. Seyrig, and J. Starcky, *Recueil des tessères de Palmyre*, 1955, plate XXXVIII, fig. 773; cf. figs. 760–813 *et passim* (Institut Français d'Archéologie de Beyrouth: Bibliothèque archéologique et historique, LVIII).

18. The biblical narrative has the god broken into pieces only at the second fall, while the painting has each image damaged. It may be that the one god has lost his foot, not his hands, because the artist was here following the LXX, as Kraeling pointed out, *Synagogue*, 102, n. 335. But the artist is using the story for his own ends.

that the large hydria may either have been buried or have stood upon the floor,[19] and the candelabra, incense burners, and altars may have stood on the ground as in figs. 47 and 37.[20] That the implements include two altars, two large and two small incense burners, two large open bowls, and perhaps two musical instruments suggests further emphasis upon a double cult, though the single tall vase, the three ewers, and three tall lampstands weaken the suggestion. The implements for libation — that is, the bowls and ewers — may have stood upon the central table, or, less likely in my opinion, the table may have held the Ark during the roughly forty-eight hours it rested in the temple, as has been suggested. In all of this I make no firm decisions, except that the erect figures of the gods, or of a single god if they double for Adonis, could not have lain on a "bed." Less than certain but still by all means probable, the two images represent two gods, who stood on, but now have fallen from, the two pedestals, and between the pedestals is, accordingly, a table, like the table in the underpainting of the reredos, fig. 75.

If the two almost identical images actually represent two gods, we ask again what gods they were. Pairs of similar standing gods have appeared several times on the Palmyrene tesserae. The pairs are of course often god and goddess,[21] but by no means always. Fig. 76[22] shows Iarhibol and Aglibol, identified by inscriptions and associated respectively with the sun and moon. Since the sun and moon appear with two similar images in fig. 77,[23] I should guess that these also are the same Iarhibol and Aglibol. More often the pair of such gods are Maanou and Shaarou, and perhaps these are the deities in fig 78.[24] One broken stone, fig. 79,[25] seemed to the editors also to have had Maanou and Shaarou, as they have reconstructed it. Here they carry shields, as they usually do not, but otherwise have points in common with the fallen images in the Dura painting. Fig. 80,[26] with a god and goddess, shows the importance of the pedestal for such images.[27]

Two figures on the larger bas-relief from the Mithraeum of Dura seem also in point here, fig. 81.[28] Between the Mithra killing the bull and a person at

19. See Chapel 4 of the Temple of Adonis, in Rostovtzeff, *Dura-Europos*, VII/VIII, 140; Chapel 44, ibid., p. 141.

20. See also the instruments used in the Sacrifice of Conon at Dura.

21. For example, Ingholt, *Tessères*, plate XXV, 502, 507 f.

22. Courtesy of the Bibliothèque Nationale. Cf. Ingholt, plate VII, 119*b*.

23. Courtesy of the Bibliothèque Nationale. Cf. Ingholt, plate XXII, 417*a*.

24. From Ingholt, plate XIV, 257*a*; cf. 245–256.

25. Ibid., frontispiece, 330; cf. plate XVIII, 330.

26. Ibid., plate XLIX, 389*b*.

27. The gods in the Dura painting may be the pair Aglibol and Melakbel, to whom an altar was dedicated at Palmyra in A.D. 132 by a *marzeh*, an eastern sort of mystic thiasos: see J. G. Février, *La Religion des Palmyréniens*, 1931, 201–208, esp. 203, 206.

28. From Rostovtzeff, *Dura-Europos*, VII/VIII, plate XXX; cf. pp. 97 f., 100. It is a copy by Gute.

the extreme right in Greek dress, who from his gesture is taken to be putting incense on a burner (a point of which I am by no means sure), stand two little figures on a pedestal. One has a sword, both wear Persian dress, and the one at the left has a jewel in his hair. Both raise the right hand. Such figures would have been taken as a matter of course to be deities, if a name had not been inscribed with each of the three. Zenobius is the larger figure in the Greek robe, and Jariboles and Barnaadath are the two in Persian dress. Zenobius and Jariboles both reappear as dedicants in the inscription below, but not Barnaadath. I suspect strongly that these personal names have been written, perhaps in hopeful identification, beside figures that the members of the thiasos would have known very well to be gods with other names. The resemblance of the two on the pedestal to the two fallen gods in our synagogue painting strikes one at once. From the material to which we come next, I should guess that for local benefit, as so often in Mithraic shrines, a familiar pair of Sassanian gods have been associated with Mithra, and that the two must be understood as gods.

The Sassanian coins of the period slightly before that of the synagogue, as well as centuries later, throw additional light on the problem. Many coins of Artaxerxes I (A.D. 226–240) are designed basically like the one in fig. 82.[29] The king's head is on the obverse, and on the reverse is a collection of instruments. Two stands, with a rounded ball on each of them, perhaps loaves of bread,[30] flank an altar on a tall pedestal. The top of the altar extends slightly above a table which is before it, and fire burns on the altar. Both the altar and the table recall the similar objects in the Dura painting. The coins of Artaxerxes' successor, Shapur I (A.D. 240–271), the contemporary of the synagogue, changed the design. Of the instruments only the altar with the fire was left, and at either side was put a deity in Persian dress, one hand on a sword, the other holding a staff.[31] The tradition continued for the coins of later Sassanian monarchs, as for example the coin of Varahran I (A.D. 272–275), fig. 83.[32] In these, one figure has a radiate solar crown, the other a sphere, and from the material we have seen on the tesserae we can at least surmise that the ball is the full moon, and that the two figures represent the sun and moon. It seems inevitable that they had great importance, or that the design did, since the design continued in use, however modified, to the mid-seventh century, fig. 84.[33] I cannot

29. From de Morgan, *Numismatique de la Perse antique,* plate XLIV, 6; cf. pp. 663 f. De Morgan publishes thirty-seven of these coins of Artaxerxes I on plates XLIV–XLVI. Cf. C. Hopkins in *JAOS,* LI (1931), 129, 131.

30. De Morgan calls these "two objects in the form of vases": *Numismatique,* Text, 658.

31. Ibid., plate XLVII, 7. De Morgan publishes many of these coins of Sapor I.

32. Ibid., plate XLVIII, 8; cf. Text, p. 669.

33. Ibid., plate LXXVII, 1*b*; cf. Text, pp. 730–732. It is a coin of Purandukht (A.D. 630–631). The persistence and varieties of details of this design can easily be followed by leafing through the intermediary plates of de Morgan. See also the plates in F. D. J. Paruck, *Sasanian Coins,* 1924; Pope, *Persian Art,* IV, plates 251–254.

believe the two figures represent mere "attendants,"[34] but should guess that the two kinds of coins refer to the same cult: one showing its instruments, the other keeping only the thymiaterion in order to put in the two gods. If we combine the two, we have gods and cult implements much like the ones shown in the synagogue painting we are considering.

Nothing I have seen specifically identifies the Dura pair before the Ark, but it would appear that the artist had some definite reference in mind. The actual form of the two gods may have been copied directly from the Adonis picture at Dura, though I highly suspect this would not have been open to the public, or may have been conventional. But I firmly believe that the people of the day in Dura would have recognized them at once by their being two gods, and by their attributes.

Even though we cannot recognize the figures — as the people at Dura, Jew and gentile, probably could have done — I do not see how we can come to any conclusion but that the artist has generalized the incident of Dagon, and used it to present the Jewish belief that paganism, specifically of the Sassanian gods and cultus, collapses before the true God of the Jews, the God whose Shekinah was brought to men most vividly by the Ark of the Covenant.[35]

B. THE ARK

In DESIGNING the other half of the painting the artist seems to have used the same freedom to adapt motifs from the biblical story to express a more general conception. As du Mesnil pointed out, in the biblical narrative the Philistines put the Ark on the cart and returned it to Israel seven months after the image of Dagon had fallen down before it. The artist was painting ideas, not an historical incident, and so had no compunction in combining the two events into a single composition. If in the right half of the picture paganism collapses before the true revelation and worship of God in Judaism, the painter has taken the left part to show the glory of Judaism. The most important element in this part of the painting is the great central Ark itself; but the details of its representation should be considered only after we have studied the other elements in the composition.

The Ark rests upon two cushions, one pink and one green, as it rides upon a peculiarly shaped cart which at first sight seems to have quite broken down the artist's ability to draw. It shows only a single pair of wheels, though we can-

34. J. Allan in Pope, *Persian Art*, I, 817. This is the usual interpretation. De Morgan, p. 649, says of them that generally the prince is the figure at the right, the king at the left. He gives no reason for this identification, and I see none.

35. That is, even though I see no ground for giving names to this pair of gods, the altar, table, and pair of gods with sword and staff make me feel that this scene presents us with a body of information about the actual Sassanian cult such as we get nowhere else.

not rule out the possibility of two other wheels behind.[36] A low-banistered rail-ing runs across the front, and perhaps ran round the other three sides, a rail useless to steady its top-heavy load. At the corners are flaring pieces like the horns of an altar. They, like the railing, do not go above the cushions, and so, as drawn, had no value for holding the Ark in the wagon. In view of the num-ber symbolism we shall encounter, it may have meaning that the rails mark off seven spaces across the bottom of the Ark. The body of the cart grotesquely rests on the wheels instead of an axle. At the back runs a high frame that bears a pink canopy; whether the canopy was deep enough to cover the entire Ark I cannot tell.[37] The spokes of the wheels are carefully outlined to make them eight-point rosettes, but no shaft joins the cart to the yoke of the animals that pull it.

Identification of so crudely drawn a cart cannot be at all certain. Du Mesnil[38] thought it the funerary cart of Adonis, to which Kraeling objected,[39] and gave other parallels that seemed to him closer.[40] But no parallel yet sug-gested seems to me as close as the design on the silver plate of Sassanian origin, now at the Hermitage Museum, fig. 85.[41] This piece shows what Orbeli calls the chariot of the moon god, Mah, with the deity sitting on a couch in his cres-cent.[42] If the artist at the synagogue had some such original before him, he had to make few changes in the basic design to have an outline remarkably like that at Dura. The lower line of the pink canopy of the Dura design follows the lower line of the crescent. The arch containing the lower figure in the Sassan-ian design has by the Dura artist been made to run out practically to the edge,

36. Du Mesnil, *Peintures*, 82, restores the cart as having two wheels; Kraeling, *Syn-agogue*, 103, supposes there were four. The turning of the wheels would be impossible on a two-wheel cart, so that Kraeling's guess seems better to me. But the cart is so crudely drawn that either is possible.

37. Kraeling and du Mesnil disagree on this point also.

38. *Peintures*, 83.

39. *Synagogue*, 104, n. 343. He argued that a funerary cart would be quite inappro-priate. But funerary and royal symbolism, as we have seen repeatedly, tend to be very close, since both so often imply deification. This observation has nothing to do with iden-tifying the cart as that of Adonis, for which, I agree with Kraeling, we have not enough evi-dence.

40. Especially those in A. Alföldi, "Die Ausgestaltung des monarchischen Zeremo-

niells am römischen Kaiserhofe," *MDAI, Röm.*, XLIX (1934), 107, fig. 7, and 115, fig. 10. Also the coin of Sidon in DS, I, i, 95, fig. 136. A splendid collection of ancient wagons and chariots was assembled by P. Forrer, "Les Chars cultuels préhistoriques et leurs sur-vivances aux époques historiques," *Préhis-toire*, I (1932), 19–123; see esp. the figures on pp. 77, 81, 83. Many of these have details suggestive of the Jewish cart, as for example the chariot on a coin in honor of Agrippina, p. 76, no. 11, or the eagle under a round-topped canopy, ibid., no. 2. See also idem, "Un Char de culte," *Cahiers d'archéologie et d'histoire d'Alsace*, III (1918–21), 1195–1242.

41. From Pope, *Persian Art*, IV, plate 207B; cf. I, 736, n. 45.

42. Both figures in this design have been variously identified, according to Orbeli's notes in Pope, loc. cit. See also A. Alföldi in *La Nouvelle Clio*, I/II (1949/50), 546 f.

so that the columns, which turned the design into a temple or aedicula on a wagon, no longer appear at Dura. The Ark quite fills what was the original niche, and keeps its form. The Sassanian design has no cushions, but the floor of the wagon rests directly upon the two wheels, as in the design at Dura, and the wheels are splayed out to show the same eight-point rosettes as spokes. Further, the wagon is pulled by humped-back cattle, which Orbeli calls "four zebus, an expression of the close relation between Mah and the primeval ox." We cannot press the details too far, since there is no likelihood that the Dura artist had seen this particular Sassanian design, but coincidences have become too numerous not to suggest a common ancestor. Whether by correction of a design like this or as drawn in the original the artist was adapting, the four cattle have become two, and the position of the cattle before the cart has been made much more natural than on the plate. Both gods have entirely disappeared. But just as the synagogue as a whole was designed like the inner shrine of a pagan temple, with the Ark of the Law in the niche where a cult statue would have been, so here the Ark of the Covenant has slipped into the niche where, on the plate, a god stands. It was Orbeli who felt a relation between the bulls of the Sassanian wagon and the cosmic bull of Pahlavi tradition, a bull which we see so strategically ready for sacrifice on the door of the Closed Temple beside this scene in the synagogue. Orbeli took a long step from the four bulls of the plate to the single cosmic bull of the tradition, although perhaps there was a connection. Kraeling called the two animals pulling the cart in the synagogue "bullocks," and Gute painted what would seem to be testicles on the one animal we can see, fig. 66. The biblical text calls for cows, and du Mesnil still makes them such.[43] So far as I could see at Damascus, there is no indication of sex on the beast at all, but only a long scratch or smear that begins up on the thigh and runs down nearly to the hoof.[44]

Another departure from the biblical narrative appears in the two drivers in Persian dress who walk beside the cattle, one guiding them from the yoke, the other whipping them on. Those who opened the western prairies with covered wagons and ox teams called such drivers "bullwhackers," a term directly applicable here. Their presence surprises us, since, as we have said, the biblical narrative[45] tells that once the cows were hitched to the cart they were to go entirely without guidance, and if they went to Bethshemesh of their own accord, the Philistines would know that Yahweh had stricken them because they had

43. But he admits that they have no teats, "ce qui prête à confusion."

44. A shadow on the ground shaped like an inverted T led Kraeling to surmise that they represent roads between which the animals are carefully choosing to get to the right place in Israel. The biblical story, of course, makes considerable point of the fact that they never turned at all. If Kraeling is right, the turning would be simply another departure from biblical details; but, while I have no other suggestion, I am by no means sure that these darker patches indicate roads.

45. I Sam. vi, 8–12.

kept the Ark captive among them. The "whacking" and guiding of the cattle thus takes all point from the original story. The two drivers seem to me to come from another incident, II Samuel vi, 1 – 19, when David took the Ark to Jerusalem. On this occasion Uzzah and his brother Ahio drove the animals which pulled the cart. Ahio, according to the narrative, went ahead, and by rabbinical inference Uzzah, who shortly was killed for his impiety in touching the Ark to steady it, walked behind.[46] I cannot see how we can avoid this identification, even though it throws us into still a third incident for the painting. For the two drivers may have been introduced precisely to show that the Ark ultimately did get to Jerusalem — that is, that the artist has ideas rather than incidents in mind.

If so much in the painting has no direct source in the biblical story of the Ark with the Philistines, we have clearly no obligation to align with that story the last detail, the three men in Greek sacred dress who advance in the upper left corner behind the Ark and the drivers. Their clothing, the striped chiton and prong-marked himation so common in the synagogue, is here for two of them a light pink, while the central one is significantly marked off by a still lighter color, which seems to verge on the yellow. The biblical account specifies that five lords of the Philistines followed the Ark, and while the drivers together with the three in Greek costume make five, it is hard to believe that the two bullwhackers are to be included among these lords.[47] Who then are the three men, thus marked off in position, dress, and dignity? They seem to have intruded themselves as did the four central figures wearing similar dress in the Esther scene, fig. 36. We concluded that the four men of this scene represented heavenly intervention to save the Jews. In the scene of the anointing of David, fig. 86, the figure of Samuel in the same dress was recognizable, but the six others were a stylization of Jesse and his sons, here an arbitrary number that lost all historical reference, and again, with Samuel, represented a heavenly, or spiritual, company. We have seen Pharaoh's daughter and her attendant maidens become Aphrodite-Anahita of Iran and the three Nymphs of Greco-Roman tradition. Similarly in the scene before us the artist substituted for the five Philistines three men in the spiritual dress, walking each with his right forefinger extended, the real directors of the bullocks. What the artist is doing, as in all the paintings of the synagogue, is to use details from biblical stories to present an idea directly out of the Judaism he knew in his own time. These three men walk behind the Ark after the analogy of the five lords of the Philistines, but the three seem to me no more necessarily to represent those five Philistine lords than the two prostrate idols in Iranian dress represent the

46. *MR, Num.*, vi, 20 (ET, I, 125, 127).

47. I Sam. vi, 12, 16. The background behind the men in the original is almost white, so that apparently the garments of the three men have a slight coloration to bring them out against it. The two figures on the outside may be bearded, but I can suggest no reason that they should be.

single Dagon of Ashdod, or than the three Nymphs represent the attendant maidens of the princess, or, as we shall see, than the Ark as represented attempts to follow the biblical description of the ancient Ark.

The Ark of this painting, to which we may now well turn, resembles in general form the Ark as twice represented in other paintings. I reproduce here, text fig. 2, du Mesnil's drawing of the three.[48] In the first of these, which appeared at the door of the inner shrine of the Temple of Aaron, fig. 37, the

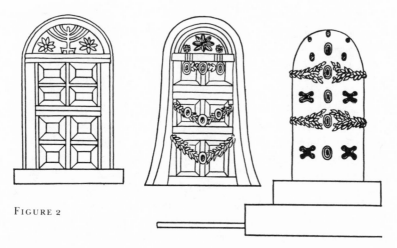

Figure 2

panel at the little rounded top holds a menorah with an eight-point rosette on either side of it.[49] For the rest of the box we have only the most severe panels, eight in all. The design on this representation of the Ark seems to have carried out the symbolism of the painting in general, that in the temple worship of the Aaronic priesthood one approached the Ark, itself veiled and mysterious, only through the planets and stars as represented primarily by the menorah. The second Ark, the one as represented in the scene with the collapse of the pagan gods, has at its rounded top a large rosette instead of a menorah. Small rosettes still flank it: but the whole has taken us at once into a symbolism of the three, on the abstract level of the rosettes, and the central member of the three has much greater importance than the other two. Below this rounded top is again the paneled box, here with six panels, two tiers of three, with a laurel garland across each pair of panels. Each of the two upper garlands carries three large jewels, the lowest garland a single jewel.[50] Against the background of threes,

48. Du Mesnil, *Peintures*, plate xxvi.

49. In the painting as finally restored the menorah disappeared except for a single arc. Gute's painting, fig. 37, and the early photographs support du Mesnil's drawing.

50. According to Gute's painting, five of the jewels are red with a black frame, and two, the bottom jewel and the one just above it, are black.

then, the seven jewels mark the Ark as belonging to the symbolism of the
seven, while the laurel garlands indicate triumph.[51] That is, the Ark in this de-
sign has its especial value spelled out in terms of the three and the seven. Like
the round-topped ark of the Law beside Moses reading the Law, fig. 34, the
round-topped Ark of the painting we are considering was covered with pink
drapery, which reminds us that although the little ark of the Law with Moses
stands on legs, which none of these objects do when represented as the Ark of
the Covenant, the three Arks of the Covenant are shaped like the little ark of
the Law with Moses, but totally unlike what anyone would have expected from
the biblical description of the ancient Ark. I can only conclude that in using the
form of the ark of the Law for the ancient Ark the artist is making a definite
identification of the two.

On the Jewish coins of the First Revolt the round-topped object stands in
the middle of a façade and has usually been taken to be the Ark of the Cove-
nant, but seems to me more likely to be the ark of the Law represented within
the façade to mark its sanctity. It was then, as now, the supreme symbol of Ju-
daism. On the face of the south bench of the earlier synagogue at Dura a sim-
ilar ark was drawn as a graffito.[52] Early Christian representations of the Ark of
the Covenant sometimes take this form, as in fig. 48 and in the Vatican Bible,
fig. 50, but usually, as here, with the cherubim added. Fig. 87[53] shows it as a
three-storied, tower-like, object. In Jewish art of the period we have seen the
Torah shrine in many forms, but on the whole it appears as a gabled structure
which seems to be the shrine in which the *aron* proper, usually but not always
round-topped, was kept and taken out for ritualistic purposes. Sometimes
the Torah shrine was shown as the whole gabled structure, sometimes as only
the round-topped aron within it.

It is clear that the form of both the ancient Ark and the shrine in the syn-
agogue had coalesced, as had the name for them, aron. For the name of this
box of the Law came to be changed in common usage from the *tebah*, or box,
as the tanaite rabbis usually called it, to the *Aron ha Kodesh*, the holy ark. The
ancient Ark had several titles, of which Ark of the Covenant was most com-
mon. The history of the change from *tebah* to the word for the older Ark is by
no means clearly attested.[54] Aron as a box was a word used for a coffin by the

51. The garland was simply an untied
wreath and was used with the same symbol-
ism.

52. What was probably a second is shown
in Kraeling, *Synagogue*, 320, no. 72.

53. From G. Swarzenski, *Die Salzburger
Malerei*, 1913, II, plate xxvi, fig. 88; cf. Text,
70. It is often a gabled structure, as in fig. 63.
Cf. the *Beatus in Apocalipsin*, Paris, Biblio-
thèque Nationale, lat. 8878, fol. 157ᵛ. The
latest study of the original form of the Ark is

M. Haran, "The Ark and the Cherubim,"
IEJ, IX (1959), 30–38, 89–94; and see
Nordström, "Water Miracles," 83–86.

54. As Goldin kindly showed me, the his-
tory of this change must be constructed or
guessed from such scattered midrashic pas-
sages that I shall not attempt to outline it. See
I. M. Casanowicz in *JE*, II, 107–109; Elbo-
gen, *Der jüdische Gottesdienst in seiner geschicht-
lichen Entwicklung*, 469–471; Krauss, *Synag.
Altert.*, 364–376, esp. 366.

early rabbis, but my colleague Goldin agrees with my suggestion that the change of name for the box of the Law from tebah to aron would seem to mark a definite sense that the Law, in or out of its box, had taken a place in Jewish religious life which Jews felt to be analogous to that of the ancient Ark. Indeed when the rabbis say why Bezalel, who made the ancient Ark, was blessed, they explain among other things, that it was for "having made an Ark unto me in which the Torah is kept," which seems to indicate that the rabbis already fully associated the two,[55] as, we shall see shortly, did Philo. To represent the ancient Ark, then, in the form of the current box of the Law had in these very years fresh poignancy and direct impact. By putting the quite recognizable aron of the synagogue in place of the ancient Aron in the inner shrine behind the sacrifice of Aaron, and by painting the menorah on it for this context, the artist declared that the Torah still offered the cosmic symbolism of Aaron's sacrifice, as well as the hope this represented of worshiping God in harmony and company with the cosmos itself. Similarly in the painting of the gods fallen before the Ark we have, I believe, a double assertion: the recollection of the power of the ancient Ark to destroy Dagon of the Philistines, and the assertion that the contemporary ark of the Law had kept its devastating power, and could (perhaps would) destroy the gods of the Sassanians. The same object protected the Jews in battle.[56] But in the painting we are now considering, we see the Ark decked with peculiar ornament, apparently because in this setting it had, as in each of the others, a peculiar value: in this case the value before which paganism crumbles. Our antecedent hypothesis is that the three men, the three rosettes at the top, and the seven jewels on the victorious laurel garlands will lead us to an interpretation of the Ark which harmonizes with the Closed Temple beside it, just as the painting of the Well of the Wilderness supplemented and shed light upon the Temple and sacrifice of Aaron. For this we use the composition of the painting as a guide to what ideas in Jewish literature may be relevant, and so seek in literature an interpretation of the ancient Ark in which three men of divine or semi-divine nature,[57] and a general interest in the number three as well as a formulation of the number seven, appear and are connected with a body of ideas primarily associated with the Ark.

In the rabbinic writings the structure of the box is described, and such miraculous powers attributed to it as that sparks went out from it which killed snakes and scorpions and burned brambles from the path of the Israelites.[58] The two cherubim on the top of it, according to an eleventh-century midrash, correspond to the two divine names of God, *Adonai*, Lord, and *Elohim*, God.[59]

55. *MR, Exod.*, L, 2, 5 (ET, 557, 561).

56. Morton Smith reminded me that according to the pre-Exilic documents the Ark contained oracles, while in the Priestly Code it contained the Law. The identification of the Ark with the box of the Law may be very old.

57. Such a character seems increasingly to be what the Greek robe indicates.

58. Ginzberg, *Legends*, III, 157 f.; VI, 64, n. 330.

59. *Midrash Tadsche*, 2. A. Wünsche, *Aus*

Ginzberg[60] says that the symbolic representation of the Ark as given by Philo "offers many points of resemblance to that of the Midrashim." I am not in a position to say what and how many such points there are, and Ginzberg does not expand this statement.

A most important detail seems to me the song to which Kraeling[61] alludes, but which I quote in Scholem's translation:

> Rejoice, rejoice acacia-[shrine]
> Stretch forth in fullness of thy majesty
> Girdled in golden embroidery
> Praised in the recesses of the palace
> Resplendent in the finest of ornaments.[62]

This is a song which the kine who pulled the Ark from the Philistines are supposed to have sung to it. I agree with Kraeling that the painter did not represent the kine as singing but did represent the Ark "covered by a veil and adorned with jewels." The word which Scholem properly renders "ornament" might well have suggested jewels to the painter, as indeed it was translated in the Soncino edition. Scholem's brilliant discussion of this song, published after Kraeling's comment had been printed, makes it clear that the verses are at least as old as the second century. Scholem argues convincingly that they came from the Maaseh Merkabah, as, he thinks, did the very similar songs of the Greater Hekhaloth which the "Living Creatures" sing to the Throne, "songs to which only the initiate could listen without endangering his life."[63]

The jeweled wrappings of the Ark have accordingly suggested the very heart of Jewish mysticism. But the song has not prepared us to find that the wrappings are Greek garlands of victory, that the jewels should be seven in number, that there should be three rosettes, or that the Ark should be accompanied by three men in the Greek robe. The little song must have had a great context in Merkabah mysticism, but that context is lost, and for the additional details of the scene we must look elsewhere. We can learn much from the Old Testament art of early Christianity, and from the writings of Philo Judaeus.

In my *By Light, Light* I discussed "The God of the Mystery," a chapter which could well be included here. I shall take considerable excerpts from it, for there I showed how for Philo the Ark supremely symbolized the nature of ultimate Reality or Deity. Philo had been much influenced by Pythagorean speculation on the relation of the number seven to that Reality, as well as by the Amesha Spentas as emanations from God.[64] He argues at length that in the

Israels Lehrhallen, 1910, V, ii, 89. The translation obscures the plain Hebrew reference to the two names.

60. *Legends*, VI, 65, n. 333.

61. *Synagogue*, 105; the song is from *BT*, *Abodah Zarah*, 24b (ET, 123 f.).

62. Scholem, *Jewish Gnosticism*, 25; cf. pp. 24–30.

63. Ibid., 27.

64. See the Greater Bundahishn, 1, 29–35 (Zaehner, *Zurvan*, 316 f.).

Ark God revealed and presented himself as the one God, who created and ruled the world through emanations, sometimes three, but in the Ark seven. These seven are the Law within the box, the mercy seat, the two cherubim, the voice that spoke to Moses from the Ark, and the Presence or the One who spoke. Reversing the order of these, Philo describes each part as a symbol. The Presence, the One who spoke, is the highest God, *to on*. From him radiate all the lower manifestations. First is the Logos of this One, which corresponds to the voice heard by Moses. From the Logos the Stream goes on out in two branches, the two cherubim, who are called the Creative Power, and the Royal, Kingly, or Ruling Power. Each of these is now in turn the source of a further emanation. The Creative Power sends forth the Merciful Power or Benevolence, the Mercy Seat, and the Royal Power sends forth the Legislative Power, the Law within the box, which is also the punishing Power. The seventh and last member of this pleroma, the one typified by the box of the ark, is the Conceptual World (*kosmos noētos*), the Platonic world of forms.

Philo's most important passage describing this schematization of God and the Stream should be quoted. He begins by explaining that the two cherubim represent the Creative and Ruling Powers of God, with the second definitely inferior to the first. So the Creative Power is equivalent also to the word "God," the Ruling Power to "Lord."[65] The cherubim are said to be of beaten gold to show by the gold that they are of the highest being (*ousia*), the pure and unmixed: that is, that their nature is divine. The craftsmanship indicates that they are form, the forms of forms, and so of a conceptual nature (*epistēmonikē phusis*).[66] These serve in the universe as the guards at its limits (*horoi*). The Creative Power is not only the Creative principle but guards the world against destruction; the Royal Power puts into it the great Law, that of Equality, which preserves the cosmic peace, since it keeps all things within their proper limitations.[67] The Powers have wings because all of them "desire and struggle for the Road up to the Father"; and their wings overshadow the parts below to indicate the guardianship of these Powers over all beneath them.[68]

From this Philo goes on to explain why the faces of the cherubim are turned toward each other, and together toward the Mercy Seat. These words of Scripture, says Philo,

> are an extremely beautiful and divine similitude. For it was proper that the Powers, the Creative and Royal, should look toward each other in contemplation of each other's beauty, and at the same time in conspiracy for the benefit of things that have come into existence. In the second place, since God, who is One, is both the Creator and King, naturally the Powers, though divided, are

65. *QE* II, 62. For Greek see Marcus, p. 253 f. Philo gives an interesting comment on the Creative Power as "God" in *Conf.* 136–138.

66. *QE* II, 63; cf. Marcus, 254.
67. *QE* II, 64, p. 254.
68. Ibid., 65; cf. Marcus, 254.

again united. For it was advantageous that they be divided in order that the one might create, the other rule. For these functions differ. And the Powers were brought together in another way by the eternal juxtaposition of the names (i.e. Lord and God) in order that the Creative Power might share in the Royal, and the Royal in the Creative. Both incline fittingly toward the Mercy Seat. For if God had not been merciful to the things which now exist, nothing would have been created through the Creative Power nor be given legal regimentation by the Royal Power.[69]

Two things have become clear from the material thus far described, first the definiteness of Philo's schematization, and second the fact that these Powers have not distinct existence but are only aspects of the single nature and activity of God. The Power of God is being visualized in its richness by discussing it in terms of Powers, but the Powers share each other's nature, and are functional distinctions of the single Power of God, not existential distinctions.

The next section discusses the meaning of the statement of God to Moses "I shall become known to thee from there."[70]

The purest and most prophetic mind receives knowledge and understanding of the Existent One (*ho ōn*) not from the Existent One himself, for the mind is not great enough to compass his magnitude, but from his primary and guardian Powers. One must be content with the fact that beams are borne from these into the soul, so that one may be able to perceive the elder and brighter by means of the secondary illumination.[71]

The solar character of the figure is at once indubitable, and the object of the whole schematization apparent. A ladder, each rung of which represents brighter illumination, is being constructed, with a mystic-metaphysical rather than cosmic-mythological objective.

Philo now goes on to give the whole scheme. In explaining the words, "I will speak to thee from above the Mercy Seat between the cherubim"[72] Philo says:

Herewith it appears first that above the Power of Mercy, the Creative Power, and every Power, is the divine Principle (*to theion*); and second that [this Principle] speaks from the very center between the Creative and Royal Powers. The mind understands this as follows:[73] The Logos of God, which is a mean,[74] leaves no void in nature, but fills all things and mediates and arbitrates between what things seem to be opposed to each other; it thus creates friendship and con-

69. *QE* ii, 66; cf. Marcus, 255.
70. Exod. xxv, 22 (LXX).
71. *QE* ii, 67; cf. Marcus, 255.
72. Exod. xxv, 22.
73. "Mental understanding" is Philo's phrase throughout the *Questions* for the mys-

tical meaning of Scripture as contrasted with the literal.
74. This concept echoes the *logos tomeus* theory which I have discussed in *Yale Classical Studies*, III (1932), 145–150.

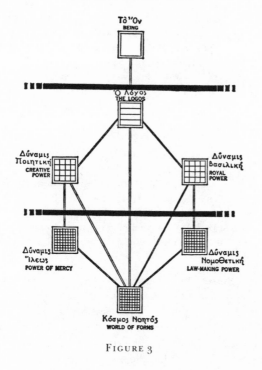

FIGURE 3

cord. For the Logos is always the cause and creator of fellowship.[75] The parts of the Ark have been severally mentioned, but we must summarize them again from the beginning if we would understand what they symbolize. And the following [elements] are symbolic: the box of the Ark, and the laws treasured within it and the Mercy Seat upon it; the Cherubim, as they are called in Chaldean, upon the Mercy Seat; the Voice or Logos above these and between them; and, above all, the Speaker. Now if any one would become able accurately to grasp the nature of these, it seems to me that captivated by their most divine beauties he should renounce all the other things men seek.

But let us consider the nature of each of these. The first is the Being more primal than the One, the Monad, or the Beginning (*archē*). Second is the Logos of the Being, the seminal substance of existing things. From the divine Logos, as from a wellspring, two Powers separate themselves. One of these is the Creative Power, through which the Artificer (*technitēs*) founded and ordered all things; this Power is called "God" [*theos*, or the Hebrew *Elohim*]. The other is the Royal Power, through which the Creator (*dēmiourgos*) rules over what has come into existence; this Power is called "Lord" [*kurios*, or the Hebrew *Adonai*]. From

75. In the first edition of this Greek fragment by Grossmann he adds "of peace," so that the line reads "cause of fellowship and creator of peace." Harris approves this, but does not put it into the text. Marcus includes the word in the text: see his pp. 115, 255.

these two Powers others have grown out. For the form of Mercy, whose name is Benefactor (*euergetis*),[76] stems off from the Creative Power, and the Law-making Power aptly called the Punitive [Power][77] stems off from the Royal Power. Below and around these is [the box of] the Ark, the symbol of the conceptual world (*kosmos noētos*).[78] But the Ark [as a whole][79] has in symbol all things established within the Holy of Holies.[80]

Philo goes on to repeat the identifications of each symbolic part or aspect of the Ark as a whole, and continues:

> The number of the things here enumerated amounts to seven, the hebdomad, [that is] the conceptual world; two kindred Powers, the Punisher and Benefactor; two others preceding this, the Creative and Royal Powers, more closely related to the Creator than to what was created; sixth the Logos; and seventh the Speaker. If you count from the top, you find the Speaker is first, the Logos second, third the Creative Power, fourth the Ruling, and then the Benefactor subtended below the Creative; sixth the Punisher under the Royal, and seventh the world of forms.[81]

Philo has indeed labored his point, and even so I have quoted only a small part of his long and repetitious exposition.[82] He describes the Ark in almost exactly the same terms in quite another treatise,[83] or alludes to it.[84] He can speak of the Powers more generally, and actually calls them in one passage "many-named."[85] But the material I have quoted is no passing allegory or momentary *jeu d'esprit*. Hidden within the Holy of Holies, he tediously explains, the Jews had the true symbol of God's nature. We must recall again that Philo definitely warned against conceiving of these as anything but aspects of God's unity. In all this Philo shows himself clearly in the intellectual tradition of Neoplatonism which made Plotinus hotly oppose the Gnostics. Teachers in both schools insisted that the supreme God or Reality has a nature which can have no immediate relation with the material world, or with man as a part of that world. Man turns to look above and beyond, but sees only manifestations of God, not God himself. In contrast to the more popular schools, however,

76. Philo clearly identifies this with the Mercy Seat in his list of symbolic aspects of the Ark as a whole.

77. This seems just as clearly to be the Law within the box of the Ark.

78. In *QE* II, 59, Philo says that the Law was put into the Ark in word, as a symbol that in deed or potency they pervade the conceptual world.

79. Philo seems throughout this passage to be using *kibōtos* now for the Ark as a whole, and now for the box only.

80. *QE* II, 68; cf. Marcus, 255 f. In revising my earlier translation of this passage I have found a number of excellent suggestions in Marcus.

81. Ibid.

82. See *QE* II, 51–68.

83. *Fug.* 100 f. This is an interruption in another long allegory in which the six cities of refuge are the Powers, and the High Priest is the Logos, *Fug.* 93–118.

84. *Heres* 166.

85. *Som.* II, 254. The number is vague, but the function identical, in *Conf.* 171 f.

Philo, like Plotinus, regarded these as powers or manifestations, in no sense personalities or a pantheon of gods.

Accordingly, even though the Ark in the synagogue painting has lost the Cherubim and become the Ark of the synagogue, and though the jewels of that Ark are not arranged in the order of Philo's description as in text figure 3, it seems much more than a chance occurrence that in this particular setting the seven jewels are arranged in groups of three, and that only here do the three rosettes appear at the top of the Ark. Philo himself had no invariable arrangement for the Powers or names for them,[86] even though he usually thought of the same three or seven, and I should not remotely suggest that the artist was working from Philo's text. I do suggest very strongly, however, that the sort of associations Philo had with the Ark as the supreme symbol of Judaism, especially expressed in terms of the three and the seven, have more relation to the Ark as here presented than does any other interpretation of the Ark I have been able to find.

C. THE THREE MEN

IMPORTANT AS PHILO has made the structure of the seven Powers with the Ark, he actually speaks more often of the three than the seven in this connection.[87] He many times brings in the three as a revelation of God.[88] But he especially found the three in the "three men" who appeared to Abraham.[89] In one treatise[90] he says that Abraham's vision of the three typified all lifting of the eye of the mind, especially as done by the prophets; that is, it is the metaphysical vision. Of the three men whom Abraham saw, the one in the middle is called Being, Philo says, which is a term not a name, for he has no name; it is a description of his type of existence. The men on either side represent one the Creative Power "God," the other the Royal Power, "Lord."

Philo bases one of his most extended allegories on Abraham's vision of three men.[91] It and its parallels would require a monograph for proper dis-

86. I quote a number of these in my *By Light, Light*, 28–30, out of one of which comes a totally different diagram.

87. For example, *Mos.* II, 96–100.

88. The Logos is the flaming sword between the two Cherubim—Powers of Eden in *Cher.* 21, 27–31; God and the two Powers are symbolized by the tetragram on the turban of the High Priest, *Mos.* II, 131 f.; it was the Powers who buried Moses, *Mos.* II, 291.

89. Gen. XVIII, 2; cf. *Abr.* 119–132, 142–146.

90. *Deo* 2–12. This highly important treatise, which also was given the title "On the Three Men Who Appeared to Abraham,"

survives only in the Armenian, published by J. B. Aucher, *Philonis Judaei Paralipomena Armena*, 1826, 613–619. Aucher's Latin translation was reprinted in the edition of Philo by M. C. E. Richter, 1828–30, VII, 409–414. For its relation to the Philonic corpus see M. Adler, "Das philonische Fragment De Deo," *MGWJ*, LXXX (1936), 165–170. Adler reviews earlier suggestions. None of them, including Adler's, seem convincing to me, but that the little fragment is genuine I see no reason to doubt at all.

91. *QG* IV, 1–22; cf. *Abr.* 107–132; *Post.* 27.

cussion. Here I can say only that from the oak of Mamre, under which Abraham saw the men, to the mystic meal they shared, and their final departure, Philo makes every detail reveal what seems to me the very core of his religion. In describing these three men as a revelation of God, Philo says that Scripture presents

> most natural things to those who are able to see, [namely] that it is reasonable for one to be three and for three to be one, for they were one by a higher principle. But when counted with the chief Powers, the Creative and Kingly, he makes the appearance of three to the human mind. For this cannot be so keen of sight that it can see him who is above the Powers that belong to him, [namely] God, distinct from anything else. For as soon as one sets eyes upon God, there also appear, together with his being, the ministering Powers, so that in place of one he makes the appearance of a triad. . . . He cannot be seen in his oneness without something [else], the chief Powers that exist immediately with him, [namely] the Creative, which is called "God," and the Kingly, which is called "Lord." . . . [Abraham] begins to see the sovereign, holy, and divine vision in such a way that the single appearance appears as a triad, and the triad as a unity.[92]

Marcus notes that of the three adjectives used here for the vision, sovereign, holy, and divine, the first and last correspond to the "Lord" and "God," so that the Holy One at the center would be God (or the Logos), in which they were united.

The great Abraham did not stop with the vision of the three, for Philo interprets Genesis XVIII, 3, to mean that Abraham's mind

> clearly forms an impression with more open eyes and more lucid vision, not roaming about nor wandering off with the triad, and being attracted thereto by quantity and plurality, but running toward the One. And he manifested himself without the Powers that belong to him, so that he saw his oneness directly before him, as he had known it earlier in the likeness of a triad.[93] But it is something great that he asks, [namely] that God shall not pass by or remove to a distance and leave his soul desolate and empty. For the limit of happiness is the presence of God, which completely fills the whole soul with his whole incorporeal and eternal light.[94]

After considerable other comment Philo returns to the essential meaning of the three:

> So that truly and properly speaking, God alone is the measure of all things both intelligible and sense-perceptible, and he in his oneness is likened to a triad because of the weakness of the beholders. For the eye of the soul, which is very lucid and bright, is dimmed before it falls upon and gazes at him who is in his

92. *QG* IV, 2. 94. *QG* IV, 4.
93. Cf. *Abr.* 131 f.

oneness without anyone else at all being seen. For just as the eyes of the body when they are weak, often come upon a double appearance from a single lamp, so also in the case of the soul's vision, it is not able to attain to the One as one, but finds it natural to receive an impression of the triad in accordance with the appearances that attend the One like ministers, [namely] the chief Powers.[95]

Lebreton,[96] a Catholic writer on the origins of the doctrine of the Trinity, was aware of these passages from the *Questions* in which the three are said to be one, but thought that their phraseology could so easily have been given a Christian coloring by the Armenian or Latin translators that he needed to mention them only in a footnote. But the same conception of the three who are one appears in Philo's other books.[97] These three, not only here but throughout Philo's writings, basically symbolize Philo's single Deity, and are at the heart of his most reserved mystic teaching. "The sacred mystic account concerning the Uncreated and his Powers must be kept secret," he says,[98] "since it is not for everyone to protect the deposit of divine rites," and he thereby directly tells us that it is the *hieros logos* of his mystery, its deepest secret, and suggests that in some way it was connected with "rites." He could not have underscored its importance more vividly.

In another discussion of the three men of Abraham, Philo goes on specifically to identify the Deity they represent with the Deity manifested by the Mercy Seat and Cherubim of the Ark: "In terms of these three men the divine oracle seems to me," says Philo, "to be explained when it pronounces: 'I will speak with thee from above from the Mercy Seat between the two Cherubim.' "[99] After this identification Philo proceeds to give the same description of the One with the Powers which the Ark always suggested to him. We cannot doubt that to Philo the two symbols, the Ark and the men, belonged together. Hardly a treatise of Philo lacks at least a reference to God and the two Powers, whether with or without the Logos.[100] He steadily visualized God in this way, and he even represents the Jews as worshiping such a Deity when he writes, for pagan Roman readers, the defense of his embassy to Gaius.[101] Indeed it is just because Philo, and apparently the group he represents, consistently thought of God in these terms that his very monotheism seemed in danger, and he had

95. Ibid., 8.

96. J. Lebreton, *Histoire du dogme de la Trinité*, 8th ed., 1927, I, 207 (Bibliothèque de théologie historique).

97. *Abr.* 119–132, 143–146.

98. *Sacr.* 59 f. The text I have translated is corrupt: see Cohn's note in the edition of L. Cohn and P. Wendland, 1896–1930, I, ad loc. Apparently Philo is saying that only a *mustēs* should be entrusted with the *hieros logos* of the rites (*orgia*) connected with the Un-

created and his Powers. Cohn reprints the text as quoted by both Clement of Alexandria and Ambrose.

99. *Deo* 5 (ed. M. Richter, VII, 411).

100. He expands the functions of the Powers very well in *Plant.* 50, 85–92; *Immut.* 3, 77–86, 109 f.; *Post.* 14–20, 167–169; *Gig.* 46 f.; *Conf.* 136 f., 175; *Cher.* 106; *Mut.* 15–24; *Mos.* ii, 238; *Abr.* 59; *Spec.* 1, 45–49, 209, 307.

101. *Legat.* 6.

to insist that God is still the One while represented in the Powers. His form of defense is extraordinary for its premonition of the Christian solution of a kindred problem.

I need hardly say that for the origins of the Trinity all this material deserves more than a footnote. When the early Church first talked of this experience of Abraham, if we may trust Justin Martyr,[102] the three consisted of God and two angels, and this "God" was a second God, or, to follow his general argument, it was the Logos, which now, in Christian hands, has become Christ. The interpretation that the three of this vision are one was continued by Augustine,[103] but of course by his time the special dignity of the One at the Center had to be specifically denied in order to harmonize the tradition with the Christian Trinity:

"The Lord appeared unto Abraham." Not one, or two, but three men appeared to him, no one of whom is said to have stood prominently above the others, no one more than the others to have shone with greater glory, or to have acted more authoritatively.[104]

Augustine obviously is refuting people who still used the verse in the way Philo and Justin Martyr did.

The older tradition of Justin Martyr and hellenized Judaism, however, by which the central one of the three men was superior to the other two, appears in the Santa Maria Maggiore mosaic of the incident,[105] where a mandorla sets off the central figure, although in the lower half of the same mosaic he is like the other two. They all three wear the sacred robe, as, of course, does Abraham. As I said above, this mosaic, so completely Philonic in its conception of the Logos and two Powers, first suggested to me that a Jewish Old Testament art must lie behind the Christian, and that the Christians in using it were, like Justin, only reinterpreting the originally Jewish iconography.

The art tradition continued. Fig. 88[106] has the three men waited upon by Abraham and Sarah at the left,[107] as shown in the sixth-century mosaic in San Vitale at Ravenna. The men in this mosaic look much like those at Santa Maria

102. *Dialogue*, 56; cf. my *Theology of Justin Martyr*, 1923, 142.

103. *Against Maximianus*, II, XXVI, 7; Migne, *PL*, XLII, 809.

104. Augustine, *On the Trinity*, II, XVIII, 34; Migne, *PL*, XLII, 868.

105. The earliest presentation of the incident, if, as I agree, Ferrua's dating is correct, appears in the new catacomb Via Latina, Rome. See Ferrua, *Via Latina*, 50, plate XXIV, 2. Here the central figure is distinguished by being slightly smaller than the other two.

They all, of course, wear the full Greek dress.

106. Cf. M. von Berchem and E. Clouzot, *Mosaïques chrétiennes*, 151 f., fig. 191; G. Bovini, *Chiese di Ravenna*, 1957, 122–124 (Musei e monumenti).

107. Sarah in her tent recalls the figures in the tents in the Dura painting of the Well of the Wilderness, fig. 47, and the person over the niche, fig. 29. This mosaic shows Abraham not yet in mystic garb, but wearing it at last at the Akedah. At Santa Maria Maggiore he clearly had it.

Maggiore, and they obviously belong to the same tradition. Comparing them, however, we see that the central figure in both mosaics sits well in front of the other two. The tradition persisted in Christian biblical illustrations, which have such importance for us that we must see at least a few of them. Fig. 89[108] shows Abraham falling at the feet of the men, with the middle one emphasized. In fig. 90[109] they are again at the table, now winged angels, with the central one exalted, a meaning made specific in fig. 91,[110] where the central figure alone wears the cruciform nimbus, and so unmistakably carries on the tradition we find in Justin Martyr against which Augustine protested. An allegory of the scene and the men, much like Philo's, clearly lies behind both the art and the early writers of Christianity, and must be taken by moderns as seriously as it was by the ancients for the origins of the Christian Trinity.[111] Indeed, so much had the "God of the three men" become itself a special description of God that in one passage of Philo God tells Moses to say to the Israelites:

> First tell them that I am "He-who-is," that they may learn the difference be-
> tween what is and what is not, and also the further lesson that no name at all
> can properly be used of me, to whom alone existence belongs. And if, in their
> natural weakness, they seek some title to use, tell them not only that I am God,
> but also the God of the three men whose names express their virtue, each of
> them the exemplar of the wisdom they have gained—Abraham by teaching,
> Isaac by nature, Jacob by practice.[112]

The important thing for Philo is that the God who is purely Existent manifests himself as "three men," though which group of three men illustrate this makes relatively little difference to him as an allegorist.

We still have no Jewish pictorial representation of Abraham and the three men, but the three men beside the Ark in the Dura painting strikingly recall the three at Santa Maria Maggiore, and indeed in all the art tradition. The resemblance became more striking when I examined closely Gute's copy of the Dura painting, and discovered that while the two outer men wear exactly the same shade of pink, the dress of the man in the center is definitely lighter. The three are generally alike, but the one at the center is marked off.

The central rosette on the round top of the Ark's face with an identical but smaller rosette on either side seems to announce similarly the conception of

108. Courtesy Vatican Museum, Rome. It is cod. vat. gr. 747, fol. 39. Cf. Wilpert, *Mosaiken und Malereien*, I, fig. 147, p. 428.

109. From the *Const. Octateuch*, plate xiv, 46.

110. Courtesy Vatican Museum, Rome; cod. vat. gr. 747, fol. 39. Cf. Wilpert, *Mosaiken und Malereien*, I, fig. 148, p. 428.

111. By the twelfth century orthodoxy has taken over entirely, and on the mosaic of Monreale nothing distinguishes the central angel at the table except that the two others look toward him. Abraham serves them a pig! See O. Demus, *The Mosaics of Norman Sicily*, 1949, plate 103.

112. *Mos.* I, 75 f.; cf. *Mut.* 11–15, where "He-who-is" again is broken down to mean the three Patriarchs.

the three whose central member dominates; and the seven jewels on the Ark now seem quite appropriate if the God of the seven who manifested himself in the ancient Ark was thought still to be the God of the ark of the Law in the synagogue. For the artist, as for Philo, the Ark and the three men belonged together. The most reasonable assumption seems to be that the three men who walk beside the Ark were originally those of Abraham's encounter with God, as well as the three great Patriarchs, the three in which the Existent manifests himself. That they should thus walk beside the Ark makes little sense in historical or biblical terms, but is completely appropriate in symbolic terms. The three cannot be the five Philistine lords. We have repeatedly found it the most natural assumption from the use of such a robe on figures which thus intrude themselves into the paintings that they represent divine intervention in the events or, when worn by biblical heroes themselves, represent human beings who have special divine power at least for this occasion. Their pointed fingers may well mean that collectively they represent deity intervening to direct the oxen back to Bethshemesh.

D. CONCLUSION

THE PAINTING we are considering elaborately presents the divine intervention that manifested itself in the miraculous power of the Ark to destroy the pagan idols, and identifies its potency as that of God and his Powers, the seven, or even more, the three, who are one. The sense of victorious power is intensified by the three laurel garlands across the face of the Ark.

Not divided into two incidents, or two halves, the picture has a unified design, all of whose details center in the Ark itself. Its power, or the power of the God of the Jews which concentrated in it, at once demolishes the pretenses of paganism and reveals itself as the mystic potency of the seven and the three. Its symbolism goes with that of the Closed Temple, for while that temple presents the mystic seven by the convention of the walls, it announces a God and a Judaism of the seven and ten which had no relation to the physical world but was a mystic and metaphysical reality. Judaism, as Philo explains it, used the seven in two ways. One was for the cosmic ascent through the seven planets, whose total exposition was in the visible cultus of the Aaronic priesthood and whose supreme symbol was the seven-branched candlestick. In contrast there was metaphysical, immaterial Judaism, whose seven were God and the Powers but whose highest revelation was of the three who are one. The chief symbols of this were the Ark, invisible in the inner sanctuary, and the vision of God given to Abraham when the three visited him. All this leads to the completely perfect ten, as contrasted with the five, the ten being the metaphysical, immaterial world, the five the physical world of the five senses.[113] The three men

113. For the five see *Abr.* 147–166.

guide the Ark away from the shambles of false religion to the mystic temple closed to ordinary men:

> For to the construct of wisdom as a whole belongs the perfect number ten, and Wisdom is the court and palace of him who rules over all as the sole really autonomous King. This dwelling house is a conceptual (*noëtos*) one.[114]

The King, Philo has just said,[115] is he who is "Tenth and alone and eternal." Properly, above these two paintings in the synagogue is the scene of the Exodus, whose meaning we shall find summarized in Philo's terms:

> We find this "ten" properly called the Passover of the soul (*to psuchikon Pascha*), the crossing from every passion and the whole realm of sense to the Tenth, which is conceptual (*noëtos*) and divine (*theios*).[116]

Philo has one passage in which he contrasts the ascent through matter with the true ascent into the immaterial world. He does this in terms of the Powers, and of gates and walls, in a way that could well have suggested our two temples:

> But this world that we can point out and see, the one discerned by sense, is, as I now know, nothing but a house of "God," in the sense of one of the Powers of the Existent, the Power which expresses his goodness. The world which he named a "house," he also described as "gate of" the real "heaven." Now what is this? The world which only intellect can perceive, framed from the eternal forms in him who was appointed in accordance with divine bounties,[117] cannot be apprehended otherwise than by [our] passing on to it from this world which we see and perceive by our senses. For, indeed, it is impossible to get an idea of another sort of existences, the incorporeals, except by making material objects our starting point. The conception of place was gained when they were at rest: that of time from their motion, and points and lines and superficies, in a word extremities (*perata*), from the robe-like exterior which covers them. Correspondingly, then, the conception of the intelligible world was gained from the one which our senses perceive: it is therefore a kind of gate into the former. For as those who desire to see our cities go in through gates, so all who wish to apprehend the unseen world are introduced to it by receiving the impression of the visible world. The world whose substance is discernible only by intellect apart from any sight whatever of shapes or figures, but only by means of the archetypal eternal form present in the world which was fashioned in accordance with the image beheld by him with no intervening shadow[118] . . . he [or it] shall be summoned when all its walls and every gate has been removed and men

114. *Cong.* 116.
115. Ibid., 105; cf. 103.
116. Ibid., 106.
117. Literally, "benefactions for support of a chorus" (*chorēgias*). I suspect that a Greek would have understood that God was the founder of the great choral rhythm of Reality, one over which the Logos presides.

118. The text is probably corrupt. See Colson's suggestions in his note to the passage, pp. 602 f.

may not catch sight of it from some outside point, but behold the unchanging beauty, as it actually is, and that sight no words can tell or express.[119]

Here is a city with walls and gates, and to penetrate the inner part is to achieve not the apocalyptic but the mystic vision. It was this, I believe, which the two paintings, of the Ark vs. paganism and of the Closed Temple, together represented.

119. *Som.* I, 185–188. The text is extremely difficult, but not so as to obscure the point of Philo's imagery for our purpose here. See Colson's note, V, 601–603. I quote substantially his translation as given with the text. The mystic approach through walls and gates made P. Wendland suspect that this was a Christian insertion from the Apocalypse. But I agree with Colson in seeing no such intrusion. Cf. *Fug.* 183.

Summary: Judaism at Dura

TO RECOVER the thinking of these Jews, I have felt all along that we must approach their paintings as nearly as possible with a *tabula rasa*, ready for any impressions. For before the discovery of the Dura synagogue in 1932 anyone would have been thought mad who suggested that Jews could have made such a place of worship. Its discovery has maddened us all, but we do not return to sanity when we force the synagogue to conform a priori to Jewish literary traditions which through the centuries had never suggested to anyone that such a building could have existed. All of our ideas of what Jews could have done have to be revised in the presence of what they did.

The Jews of Dura lived as a small minority in a frontier town of very mixed population and traditions. Syrians, Greeks, Iranians, and Romans, from the relative size of their temples, all presumably surpassed the Jews in numbers and in setting the dominant tone of the city. Some of the Jews must have become rich to have built and decorated such a synagogue. But the size of the meeting room suggests a group almost insignificant as compared with those who supported the great temples. Of this we cannot be certain, since the nearby Mithraeum was also small, and presumably a considerable part of the Roman garrison were Mithraists. Jewish synagogue worship, however, so far as we know it, was then as always a congregational affair, as Mithraism could not have been because its shrines are so universally small. Certainly the synagogue at Dura could never have housed a very large congregation. Probably, then, the Jewish group as a whole was a small one.

When the group built the synagogue, the model they first took was that of a meeting room with, I believe, an incense burner, and a side room from which those officiating brought out the scrolls, the sacred instruments of the cult. Perhaps other instruments were also carried in and out. There may or may not have been a niche for the Torah, since there was none in the earlier Palestinian synagogue, or those in Asia Minor, or, perhaps, at Hammam Lif. In this side room were benches and decorations that mark the room as probably one of cult, perhaps an inner room, where special rites were celebrated by a select company, a possibility which can neither be proved nor dismissed.[1] So far as

[1]. It has been suggested to me that the side room may have been a schoolroom. The suggestion is possible but, in my opinion, less probable than the one I am making, because

structure goes, it might have been the room for people especially "initiated" in some way, though nothing tells us that it was thus used. We do know, however, that people walked back and forth to the large assembly room so frequently as to wear down the threshold between the two rooms. In the second synagogue the assembly room was made to look as much as possible like the inner sanctuaries of the great temples, where one came through columns which made three openings, and thus approached the cult statue directly. In place of the cult statue Jews used a portable Torah shrine, but by putting it into a niche made it the place of the Real Presence, the Shekinah, in the Jewish sense of the term. For pagans and Jews alike came through these openings to the presence of God.

Just how worship was conducted in the room we have no way whatever of knowing, except as we transport over to it the information about synagogue worship which survives in rabbinical writings. Such a transportation seems to me as dangerous as it is easy. Of only one thing does the architectural form of the synagogue seem to assure us: the form so directly corresponded to the forms used to house pagan worship that, at least to me, it is inconceivable that the Jews were not fully aware of the resemblance and wanted it. In that case it is just as inconceivable that all imitation of pagan worship stopped at this point.

It may also be noted here, as Kraeling has pointed out, that the titles of the officers reproduce those used in the "organization of the Greek city states and civic and private corporations."[2] As to the functions of these officers in the Dura synagogue we know nothing. We cannot assume with him that, as he says of the "scribes," if we "knew more of their function at Dura it would merely confirm what we know of scribes elsewhere."[3] Similarly, that *kohen* here or at Qumran meant simply a person of high priestly descent is indeed a moot question, one to which, with our present evidence, we can do justice only by leaving it completely open.

The decorations of both the early and later synagogues seem to me no less conscious adaptations. Not so elaborately in the early synagogue, much more so in the second, the ceilings represented a trellis by their coffered form, while in the interstices were put an extraordinary assembly of tiles with painted symbols, many with heads of the great Female of the East. Almost all the tiles bore symbols of heavenly life. Among the heavenly symbols the leaders of the synagogue, like people in Egypt, put a few tiles on which their own names were written within wreaths, apparently to indicate, and ensure, their share in the heaven the ceiling symbolized.

When the side walls were painted, the whole idea of the trellis for a grapevine, which the coffered ceiling presented, was elaborated. The paint-

of the building's many analogies with the structure of pagan temples.

2. *Synagogue*, 333.
3. Ibid., 331.

ings were separated by bands in which a vine and grapes ran everywhere across and up and down the room, while in the corners columns were represented to support the ceiling. The whole room, that is, was so painted that those worshiping in it were enclosed in a grape arbor. Quite fittingly, then, the lowest row of paintings, conventionally but inaccurately called the dado, was devoted to Dionysiac motifs: felines, usually attacking a victim, or masks or heads, such as are commonly found in Dionysiac representations. So elaborate a framework of vine with Dionysiac motifs above and below, whatever it meant, could hardly have been made inadvertently.

Apparently before any of the other decoration of the wall, the Jews made the niche. Above it they put the basic tokens of Judaism: the menorah, the lulab and ethrog, a scene of the sacrifice of Isaac in lieu of the shofar, and a shrine with closed doors — essentially the eschatological constellation of symbols which appeared in the Catacomb Torlonia in Rome, the mosaic floor of the synagogue at Beth Alpha, and, in more or less full representation, upon innumerable lamps, gold glasses, and inscriptions from Jews of the whole world at the time. These, with the heavy shell clumsily incrusted upon the semidome of the apse of the Torah shrine below it, unite the Jews of Dura with the whole body of Judaism which created the synagogues and other monuments we have seen earlier. The Jews of Dura found their Judaism epitomized by the same symbols of their faith which Jews were using everywhere, apparently with eschatological and mystical rather than halachic reference.

The Jews at Dura did not stop their symbolization at this point, however, but went on to cover the walls with allegorized representations of biblical motifs, and thereby showed how they were reading their Bibles also. Here is the great contribution of the Dura synagogue. For of all the Jews who made this symbolic ornament, they alone give any direct evidence of their interpretation of Jewish traditions. That the Jews who made the Roman catacombs, the strangely pagan carvings and mosaics of the synagogues of Palestine and North Africa, all read their Bibles exactly as the Jews at Dura seem to have done is the last conclusion to which we should dare to leap. The Old Testament pictures at Dura, however, do show a sensitivity to, and acceptance of, Jewish mystic ideas which the symbolic vocabulary of Jews elsewhere had repeatedly suggested to us. In themselves, however, the paintings, which make an amazing midrash on the Old Testament in general, confirm our conclusions from the symbolic borrowings of Jews elsewhere in the period. Done in what was for the Roman world the Far East, they show a sensitivity not only to hellenistic symbols but also to Iranian or generally eastern ideas, which it would be extremely dangerous to impute to Jews of Rome, Priene, or even western Syria and Palestine without some direct evidence. And this evidence precisely we lack altogether.

The uniqueness of the Dura paintings, like the uniqueness of the Qumran

Scrolls, enhances their value and piques our curiosity. But our curiosity will take us nowhere if not accompanied by a mind ready to learn the utterly unexpected from such utterly unexpected new sources. If the paintings give us Jewish midrash in a strangely new form, they may well give us midrash with a strangely new content. We have been forced to begin with the paintings themselves, to try to see what the artist did with the Old Testament motifs artistically, and hence what interpretations we may presume he was trying to express.

Had we only one of these scenes, interpretation would have been indeed hazardous. With a whole roomful of them, however, or nearly so, the interpretation of one scene supports that of the others, and it is quite as though we had found a new Jewish text in the sands. How generally representative we may consider these artistic interpretations of the Old Testament motifs is a problem which must be kept quite separate from that of what the paintings themselves actually say. Here again, we have had to ignore preconceptions from literature of what Jews could have done, while we investigate what they actually did do.

They were at first content to draw a pagan tree, as the most important single design in the room, over the Torah shrine. Whether they had primarily in mind the Iranian cosmic tree or the Dionysiac vine we cannot judge. In view of the way in which we have seen hellenistic motifs mingled with Iranian, and the fact that the tree has no grapes but does have tendrils and grew at first out of a huge crater, I doubt that the artist could himself have made the distinction between tree and vine we so neatly desire. He worked in an atmosphere where identifications rather than distinctions, mingling rather than separation, ruled the thoughts of men, and the tree-vine seems to express this sense of identification of tree with vine to the point that we have called it the tree-vine. At its top he put an enthroned king in Persian dress with two Throne Guards in the Greek chiton and himation. Across the middle sat Orpheus playing to the animals, primarily to a huge lion, and at the base of the tree he put on one side a table with a banqueting cushion and bread. On the other side he put a second crater with rampant felines. The symbolism for that age could not have been more explicit, that out of the Torah shrine beneath the painting grew the tree of life and salvation which led to the supernal throne.

But the symbolism had not been sufficiently Judaized. So Jacob, blessing at first the twelve tribes, and then Ephraim and Manasseh, was put on either side of the trunk, painted over the table for bread and the crater for wine; and then the artist put the thirteen tribes in two groups beside the throne. Perhaps there were several repaintings before the design became sufficiently explicit for the artist. His care and his process in symbolization, however, have taught us far more than the perfect preservation of this painting in any one of its forms could have done. We see that if the technician who actually executed the

paintings had working models for details, he did not have a working model of this reredos as a whole. A master symbolist was developing his ideas on the spot, however many models of details he may have had. What he was trying to show was the glorification of Israel through the mystic tree-vine, whose power could also be represented as a divine love which the soul-purifying music of an Orpheus figure best symbolized. That Orpheus here was probably called David by no means changes the fact that, if for Jews the songs of David had become their Orphic Hymns, it was David's music as heavenly, saving, and mystical music, through which the artist declared Israel could be glorified. Orpheus represents him, presumably because when the man planning the design read the Psalms he allegorized them to make them express the values of the Orphic Hymns. But the painting is a triumphant assertion that Israel and its singer really offered the vine and the Song which could bring man to the supernal heights.

Who was the king at the top? Kraeling reminds us that in pagan temples the painting or statue opposite the entrance — that is, in the place corresponding to the reredos — represented the deity of the shrine. In "the synagogue," he says, "of course, the representation of the deity was excluded," and the Jews substituted "the Messianic King of the House of David" with the tribes, for the prohibited deity.[4] To reach such a conclusion Kraeling has at last quite ignored the Orpheus and the tree-vine itself, and this we cannot do. The enthroned king surrounded by the tribes in such a place reminds us much more of the Christ enthroned with the saints in heaven, so common in the apses of early Christian churches, than of any other figure in the history of art. Let me repeat that before the discovery of the synagogue all sane scholars would have agreed that "of course" no such synagogue paintings as these could have existed at all. I do not say that the person on the Throne at Dura is God, but I cannot agree that "of course" it could not be God. What I do say is that the painting did show the salvation of Israel, the ultimate value of Yahweh, if it did not represent Yahweh. I do not see how we can go any further than this, or stop short of it. Even so, such interpretation of the reredos would properly seem drastic overinterpretation if the other paintings in the room did not suggest the same underlying sort of meanings.

Flanking the reredos, indeed a part of it, stand the four portraits, two of them certainly Moses (at the bush, and on Sinai), and two probably so (Moses reading the Law as a mystic reader, and Moses ascending to the heaven of the cosmic bodies at his death). For the last Moses the painter very likely used an older figure of Abraham as he was called out to count the stars, since in the Octateuchs that incident appears very similarly represented. But with the

4. *Synagogue*, 348 f.

freedom in using traditional models which the artist or "philosopher" of the synagogue usually shows, it seems to me highly probable that the four figures all represent Moses.

The great importance of the central block of the west wall is accentuated by the fact that all the other scenes on the wall are balanced at either side with orientation toward it. On the bottom row, right, Samuel anoints David, a scene transformed from the natural presentation which supposedly lay behind the Christian representation of the incident. In Dura this design has been changed into a hieratical scene of David initiated into a holy seven. This conception of Jewish kingship is balanced on the other side by the triumph of a Jewish royalty in which Mordecai, by divine intervention, rides in triumph as the divine-royal Cavalier. On the outside, with these, the figure of Anahita-Aphrodite takes out the baby Moses and commends him to the three Nymphs for divine upbringing; balancing this Elijah restores the widow's son to life. In both scenes the Wunderkind is held up for adoration, and he lifts his hand in blessing. The baby Moses goes with the hieratical anointing of David; the baby restored by Elijah goes with the temporal glory of Mordecai. We have too little knowledge of the legends of the widow's son and his later accomplishments to make any firm conclusions, but I suspect that as the divine origin of Moses harmonizes with the mystery of the Seven with David, so the widow's son in some legend known at Dura became a person famous in Jewish dreams of dominance over the gentiles.

For above this row stands another, likewise balanced, and apparently contrasting in much the same way. Two temples are on the inside. The Temple of Aaron, at the left, is clearly derived from a stock representation of a pagan mystic shrine, but is cleverly adapted to make room for the instruments of Aaron's cult. Aaron seems to be conducting a worship which centers in the menorah, itself dedicated to the Ark of the Covenant veiled in an inner shrine, which, in turn, was topped with figures of the goddess of Victory. Indeed the menorah is painted on the Ark itself. Three doors superimposed upon the outer wall seemed a fresh and arbitrary appearance of the three doorways which have appeared so often in mystic and eschatological symbolism. The scene could no more be identified with a single biblical incident than the stone temple could be identified with the portable tent shrine of the wilderness, or than Aaron's dress as an Iranian priest could be identified with the robes specified for Aaron in the Bible. The five assisting priests, along with the five columns of the inner shrine, go with the seven branches of the menorah and the terrestrial allocation of the temple to indicate what Philo called the cosmic worship or mystery, whose type, for him, Aaron especially was. Beside this scene at the left the cosmos was again presented in worship as Moses in the checked cloth of priesthood released from the Well of the Wilderness a flow of water to the twelve tribes as the twelve signs of the zodiac. This worship also

centered in cult instruments, especially those of incense and the menorah, dedicated to a shrine of mystery at the back. It seemed not a chance that these two scenes adjoined the figure which I called Moses at his death in cosmic worship with the heavenly bodies. If it is Abraham rather than Moses who stands here, still these three scenes strikingly present the notion of a cosmic worship for and in Judaism.

Balancing these, Moses as a mystic priest reads, that is, expounds, the Law, and beside him is another temple, which I called the Closed Temple. It has the same design as the Temple of Aaron, but is still more schematized for ideological purposes. The three doors suggest that again there was an outer wall and an inner court, but the outer wall has become a series of seven walls, in seven colors, upon which the artist has superimposed an inner shrine, this time with the ten columns but again crowned with Victories. The ten takes us into a formulation of immaterial reality as the five put us into the material realm, and we recalled that the seven had as great importance in the immaterial formulation as in the cosmic. Conspicuously all cult instruments, especially the menorah, have been omitted, and the temple has no servitors, no animals for sacrifice, indeed no basis upon the earth at all. This temple seems, then, to represent the mystery of immaterial reality, an idea which the artist also expressed by putting the cosmic Bull, Gayomart with his twins, and Spandarmat, on the central doors, and Zurvan with ten rosettes and a seven-point rosette at the top, on the side doors. The greatest symbol of this immaterial mystery, according to Philo, was the Ark itself. So in the scene at the right of this, two oxen draw the Ark upon a cart, under the direction of three figures in Greek chiton and himation, an Ark with seven jewels upon it and three rosettes, along with three garlands of victory. Before this the popular pair of pagan deities of Dura and Iran collapse and lie shattered with the paraphernalia of their false cult.

That is, this scene supports the Closed Temple just as the Well of the Wilderness supports the cosmic worship of Aaron's triumph. And each pair stands above the appropriate lower pair: Aaron and the zodiac of cosmic worship and the five senses stands above the scene of earthly Jewish triumph with Mordecai; the Closed Temple and the Ark on the cart stand above the mystic kingship of David, and Moses as the divine child.

We are handicapped in the top row by having lost almost entirely the two scenes at the left. Of the outer of these only the feet of several people have survived: nothing can be identified at all. In the inner scene we can see the bottom of the throne of Solomon with two attendants. Two women approach the throne, met by a man in Persian dress, but no evaluation of such a fragment is possible, or identification of the women, since the upper part of the painting has perished. The painting which balances these at the right of the reredos shows Moses, three times presented in the grandeur of the white robe. In heroic size, and wielding the club of Heracles, he supervises the Exodus from

Egypt. The movement is again toward the center. The Israelites, consisting of two columns of soldiers, a row of twelve men in the white robe, and at the bottom a row of people wearing only the striped chiton, march out from a walled city at the right. Over its open doorway Ares, the mystic god who brings peace in the soul, stands flanked by Victories who present wreaths. Moses at the head lifts his herculean club to strike the sea before him, but the sea has already been closed by the Moses who stands at the other side holding his club out over it. Contrary to all representations of this incident, and all biblical and rabbinic sources, it is not Pharaoh with his horses, chariots, and army which perish in the sea, but the lower row of Israelites, those who wore only the chiton as they left Egypt.

The third Moses stands in the midst of a series of strips which may well represent the dry paths on which the tribes, in rabbinical legend, passed through the sea. But he holds his club down to a pool from which spring fish in amazing sprightliness, while at the back stand the armed soldiers and the twelve men in full white robes, now bearing standards which presumably marked them as the heads of the twelve tribes. The bottom row of Israelites who perished in the sea are not there at all, unless they are the fish of the pool, like the sailors turned dolphins in the Homeric Hymn to Dionysus. A divine hand blesses this last Moses and the group at the pool.

Proof texts to identify these scenes of the migration, and to guide us in their interpretation, have all failed. What the artist has painted is not the biblical story of the saving of the Israelites from Egypt and the destruction of the Egyptians, but the migration as a great purging of the Israelites themselves, precisely the basic explanation of its meaning to which Philo again and again returns. The migration cycle stands on the right side, where the other scenes take us into the immaterial mystery, and with this the migration as the artist has interpreted it harmonizes perfectly. What is the pool at the end of which Moses stands triumphant? But what is the Closed Temple immediately below?

The scenes at the right can all be read vertically as well as horizontally, in fact. All begin with the futility of material and human aspiration, above which man should rise. In the bottom and the top scenes this futility is represented by Pharaoh and his Egypt, at the center by the collapsed gods of idolatry at Dura itself. From the lowest Egypt we move left to the miracle of the birth of Moses, the chief mystagogue, then to the initiation of David into the mystic Seven. Above this we move from idolatry to the mystic Ark and its Three Men, and to the Closed Temple of the Three, Seven, and Ten, the true worship. At the top we move, purified as we go, from Egypt to the finality of the sacred tribes at the Well. I strongly suspect that the scenes at the left similarly rise in importance with their height on the wall, and that material Judaism rises from merely having the true king, and supplanting the monarchy of gentiles, to a worship in cosmic terms, and above that to some superior, probably eschato-

logical, monarch, which Solomon represents. Of course with the loss of the scenes at the top such a suggestion cannot be pressed at all.

The paintings on both sides are caught up and united in the career of Moses himself, who, on the cosmic side, climbed the mountain and brought the Law down to man on the tables, and who prayed for Israel with the whole cosmos at his death. On the other side of the reredos he came to pure Being at the burning bush, as Philo interpreted "I am that I am," and expounded for men the mystic scroll. Both aspects of Judaism, the cosmic and the immaterial, come together in the reredos itself, where by the tree-vine, and the saving music of David-Orpheus, Israel rises to be glorified at the great throne. The basis for all this is the actual Torah shrine below, with its Jewish cult instruments. The power of the Torah still can be expressed in a most primary way by the Dionysiac symbols of the dado, themselves divided into male and female to express the higher and lower types of ascent. Above the dado Israel rises but only to fulfill the dreams which Jews seem to have learned from pagans. The objective still can be stated in felines and masks, or in the tree, craters, table, Orpheus, and the Throne at the top, but can be realized only through God's revelation of himself to Jews, and it is Israel which is gathered at the Throne.

The other walls apparently only amplified this Judaism of the west wall, but we can construct no such cohesive idea of what each wall was saying, since so much of them has perished.

On the south wall a triumphant procession of the Ark seemed to suggest the celebration of the Feast of Tabernacles. Beneath it a series of Elijah scenes appeared to lead to the Elijah scene of the west wall. Since the incident of the resuscitation of the widow's son there shown belonged chronologically well back in the series, it seemed that the series as a whole was rather an afterthought, put beside Elijah with the baby to build up his status. But again, such a conclusion can only be a possibility with so much of the design of the wall as a whole entirely gone. We know on this wall that Elijah, with another great figure in the himation and chiton, visited the widow, though how the scene was interpreted we cannot say. Two further scenes show the victory of the hosts of Yahweh as they bring the snake to kill Hiel under the futile altar of Baal. Then the Three bring the fire that consumes the offering of Elijah himself, even as his assistants pour water upon it.

At the back on the east wall, Saul and his servant, Abner, sleep while David and Abishai steal the king's spear and water gourd. The dominating person in the scene, however, is a great figure of Iranian royalty on a white horse, leading a host of Iranian soldiers, all on white horses. It seemed at least worth suggesting that the figures of Saul and David have been thus subordinated to the host on white horses because here again the dominant interest lies in the white company. They may well have been the heavenly champions in a new role, coming in this form to show that they control the wars, and royalty, of Israel.

For on the last wall, under a fragmentary scene where Jacob in the great robe dreams of the heavenly ladder and the figures upon it, is a battle scene again, here with the white-horsed champion fighting the black-horsed one, while beside the fighting the Ark is carried in complete splendor, symbol of the Lord of Hosts, with the hosts (again I believe heavenly) or army guarding it. The Ark in such a scene is appropriately wrapped in garlands of triumphant ivy.

At the bottom Ezekiel begins his role as preacher to the dead bones, and, as God's own hand carries him in by the hair, he wears the Persian dress. The pieces of anatomy go through a split mountain, are reassembled, and the four winds as four Psyche figures flutter down to give them the breath of life. Then the men too are restored and appear, ten of them, in the Greek robe of glory. For the two final stages Ezekiel's own garb is changed to that of the white robe. But having accomplished his great mission, he must go back through the mountain, resume his human, Persian, dress, to be arrested at the Jewish altar by a royal figure in armor, and then beheaded.

Throughout the entire collection of paintings, one of the most consistent guides to meaning was the Greek robe of chiton and himation, with the clavi on the chitons, the forked gams on the himation. This and the relative size of the characters as presented seemed highly important clues to interpreting the scenes, for only those who appeared to be heavenly beings or the greatest saints of Judaism, mystic saviors, wear this clothing, or are painted in gigantic size.

This Greek dress seemed symbolic for the Jews, since it had been used with such symbolic cogency for centuries by the Greeks, by Greco-Egyptians, and throughout Greco-Roman Syria; and it was already beginning to be so used by Christians. The Jews had borrowed much else from the pagans, however, a whole assortment of divine figures, the tree-vine, the banqueting couch of immortality, the zodiac, the white and black horsemen, and much else. These in no cases seemed borrowed without definite relevance to the scenes in which they stood, as that Jacob lies on the couch of immortality when he blesses his sons on his death bed, and on it Elijah restores to life the widow's son.

While the theme of the synagogue as a whole might be called the celebration of the glory and power of Judaism and its God, and was conceived and planned by men intensely loyal to the Torah, those people who designed it did not understand the Torah as did the rabbis in general. Scraps stand here which also appear in rabbinic haggadah, to be sure, such as Hiel's being attacked by the snake. But in general the artist seems to have chosen biblical scenes not to represent them, but, by allegorizing them, to make them say much not remotely implicit in the texts, either as literally meant or as the rabbinic midrashim interpret them. On the other hand, the paintings can by no means be spelled out from the pages of Philo's allegories, for especially in glorifying

temporal Israel they often depart from him altogether. Kraeling astutely in-
dicated, also, that we have no trace of the creation stories, or indeed of any bib-
lical passages before the sacrifice of Isaac,[5] sections of the Bible to which Philo
paid almost major attention. This must not blind us, however, to the fact that
the artist, like Philo, presumed that the Old Testament text is to be understood
not only through its Greek translation, but through its re-evaluation in terms
of Greek philosophy and religion. Again, unlike Philo in detail but like him in
spirit, the artists have interpreted biblical tradition by using Iranian costumes
and such scenes as the duel between the white and black horsemen.

The Judaism expressed here, as Kraeling recognized, is devoted to its tra-
ditions, to its Torah, and to Jewish religious observance and tradition. This
meant to Kraeling what I have loosely been calling "rabbinical" tradition, one
which, as he says, was tending "to turn more and more away from the world
and back upon itself, concerning itself ever more exclusively with the vast body
of tradition its scholars and preachers had created for it out of their study of
the sacred book."[6] I could not imagine a better description of rabbinical
Judaism, at least as it has almost universally been understood, or a less apt
description of what we have seen in the synagogue. On the contrary, the Jews
here, while utterly devoted to their traditions and Torah, had to express what
this meant to them in a building designed to copy the inner shrine of a pagan
temple, filled with images of human beings and Greek and Iranian divinities,
and carefully designed to interpret the Torah in a way profoundly mystical.

For the Judaism that seems expressed here is a Judaism which finds its
meaning in mystic victory, a victory reached by two paths, the cosmic and the
abstractly ontological.[7] Yahweh of Hosts, or the Lord of the Powers, reveals
himself through his creation, the universe, and also through the abstract val-
ues symbolized by the ten and the seven. I suspect that the black and white
horses reflect a dualism nearer to Manichaeism, and to Iran in general, than to

5. *Synagogue*, 350.

6. *Synagogue*, 325. On p. 335 he says that
the pictures reveal also "a close contact with
both the Palestinian and Babylonian centers
of religious thought." The "close contact" is
represented only by fugitive details, the hel-
lenization by the whole structure and com-
position of the building and its designs.

7. I have not attempted to refute in de-
tail the elaborate section on "Interpretation,"
and the final judgment of the meaning of the
paintings with which Kraeling closes his *Syn-
agogue*. Without adequate consideration, he
banishes "allegorists of the school of Philo" as
having no relevance; he supposes that con-
cern for the people and their destination ex-

cludes interest in the "individual's search for
participation." He recalls that Judaism at this
time, by which he means the rabbinical writ-
ers, had fallen back upon their inner tradi-
tions, and says that this sort of Judaism ac-
counts for the paintings "fully" (p. 351); the
background is Palestinian-Babylonian hag-
gadah rather than Egyptian (p. 354). I can
only say that his conclusion is based upon
identifying scenes with biblical passages, and
painted characters with specific biblical char-
acters, in a way for which I repeatedly see no
justification, along with a systematic disre-
gard, or dismissal, of most of the pagan and
mystical elements I have pointed out.

rabbinical Judaism, dualistic as the rabbis often are. Dionysiac feeling is ramp-
ant, but it seems to me no chance that the entrance to the Closed Temple was
marked by the symbols most sacred at the time in Pahlavi Iran. The end result
might be called a new paganism enlightened by Judaism or a new Judaism
made cosmic and mystic-metaphysical by paganism. In any case, the two are
deeply interfused. The people in the synagogue, however, would passionately
have rejected the suggestion that they were presenting a new paganism, much
as such thinking has always seemed a paganizing of Judaism to halachic Jews.
I can myself see no reason that Jews who want to live by the mystic implications
they feel in their traditions should not be free to call their religious ideas and
practices Judaism; or that the historian should either belittle the mystic for-
mulation which the Dura art implies, or rule it out of Jewish history.

How typical was this Judaism for the Jews of the day, I ask again? One can-
not make a positive judgment. The "philosopher" at Dura actively combined
biblical incidents or motifs with the pagan symbols in a way we have seen even
suggested in very few other places. But we have seen loyal Jews throughout the
Roman world using pagan symbols, using most of those in the Dura paintings
and many others as well,[8] and since their being Jews implied that they were
reading their Scriptures, we must assume that in some way the Jews combined
pagan symbols with Scripture almost everywhere, whether in representation
of Scriptural scenes or not. The rabbinical writers seem the only specific group
of Jews who did not do so, since they were the only Jews of the day who in over-
whelming majority protested against it, so that I can see no reason whatever
for assuming that they established and controlled Jewish norms for all others.
The halachic rabbis alone, stripped of their own mystic traditions, cannot be
taken to represent the "historical context" of the synagogue and its paintings,
for that context must include all the material in the earlier volumes of this
series. We must indeed arrive at the meaning of the paintings "inductively
from a study of the paintings themselves,"[9] from a study of all that is in them,
and of all the Jewish art of the period.

We may well go farther than this, for the history of art itself provides a
basis for generalizing about the temper of a considerable part of Jews at this
time. Erwin Panofsky pointed out to me that we have in the synagogue an in-
ferior provincial representation of what must have been a great Jewish tradi-
tion of biblical art. If all the great sculpture of Donatello and Michelangelo had

8. It is inconceivable that even after the
publication of the first three volumes of this
series [*Jewish Symbols in the Greco-Roman Pe-
riod*], to which Kraeling refers (*Synagogue*,
342, n. 90), he should shortly, p. 345, say that
except for the synagogues of Dura and pos-
sibly Ercis, "certain tombs in North Africa,

and some sarcophagi at Rome, the decorative
material associated with Jewish monuments
is to my knowledge limited to the represen-
tation of things and does not include animate
beings."

9. Kraeling, 348.

been destroyed, he said, and only a few inferior scattered pieces of Renais-
sance sculpture survived in a remote village, any historian of art would at once
assume that what had survived reflected some great tradition of masters who
worked in the chief centers of the Renaissance. So important an innovation
over medieval sculpture would not have been made by the inept sculptors
whose work had survived.

Similarly, I agree, creative as are the ideas expressed at Dura, and active a
symbolist as I have felt the man to be who planned the paintings, he was clearly
using traditional forms and designs, though here executed by a quite unskilled
craftsman.[10] The Greek forms and dress, the tendency to a hieratic rigidity
which soon flowered as the dominant art of Byzantine tradition, can hardly
have begun with these utterly provincial paintings, done by a man or men
working as far from the great centers as Dura, paintings which were totally
destroyed, or buried, almost as soon as they were completed.

The tradition of early Christian painting reflects the original hellenistic
beginnings of this Jewish art more directly than do the Dura paintings, or the
medieval illuminations in Jewish manuscripts. The "philosopher" at Dura, or
the artist he employed with his models, used the hellenistic tradition, but shows
it already shot through with Iranian motifs. These were used as consistently
and, we can often recognize, as meaningfully, as the Greek. I find it just as hard
to believe that Samuel, or one of his collaborators at Dura, ordered the painter
to make this intermingling for the first time. The painter himself, surely not
an inventive or creative genius, drew the pagan figures with quite as great
assurance as the Greek ones. His models must have included both.

We may push the argument one step further. The Greek conventions
which the artists used to represent the biblical texts indicated that the texts
were being read with a Greek mystical understanding. But simultaneously the
artist's interpretation of the battle of Ebenezer, for example, seemed to go just
as far in using Iranian conceptions and forms to allegorize biblical incidents.
The Iranian elements were as little likely to have affected the meaning of Ju-
daism for the first time at Dura as the art conventions in which they were rep-
resented to have originated there. That the paintings at Dura somewhat
freshly restated the conceptions of an Iranian-hellenistic Judaism seemed also
reflected by the Pahlavi speaking inspectors who came and wrote their ap-
proval on the paintings. I can only conclude that in some center, of which we
have perhaps never even heard the name (as we never knew of Jews at Dura),
but perhaps at Palmyra, where Greek and Iranian traditions met and mingled,

10. Ibid., 392–398, Kraeling concludes
that the originals were written on scrolls, but
the conclusion does not follow unless one ac-
cepts his identification of the scenes. In any
case he may, of course, be right about the
scroll as the original medium of such paint-
ings.

a Judaism arose which interpreted the texts of Scripture anew in terms of the basic ideas of this mixed civilization.

That is, the art, inexpert as it is, reflects an art tradition in which Iranian and Greek forms had been mingled. Both are used for a hitherto unknown reinterpretation of Judaism. Neither the art nor the conception of Judaism would in any probability have been worked out *de novo* in the remote provincial city of Dura. Nor, we must presume, would the meeting of the two in schematized representations based upon Jewish biblical texts have occurred here for the first time.

We can conclude as the major probability only that the hellenized Jews of the West thought in general much along the lines Philo indicates (though apparently more like the "Gnostics" and "rabbinic" Maasim than Philo), and expressed these ideas in allegorical representations of biblical texts in forms from Greek art; that this art, and the ideas behind it, went East where Jews were being Iranized along with their hellenization, to the point that the Jewish art tradition in the East came to mingle Iranian art forms with the Greek as they had mingled Iranian religious ideas with the hellenistic. Of all of this we have left directly from Jews of the West only the hellenistic symbols mingled with Jewish ones. Dura shows how in the East, at least, along with this, in a much more Iranized form, but still hellenistic, Jews were declaring these interpretations in pictorial schematizations of biblical incidents. It is the most likely presumption that in the West the art of hellenized Jews reflected a widespread Judaism which likewise expressed its hellenistic interpretations of the Bible in pictorial form.

We cannot go on to assert that a single detail of our interpretations of the Dura paintings reflects a specific detail of the biblical interpretations being made at Beth Alpha, Ephesus, Hammam Lif, or Rome. But with any group except the Jews, everyone would at once have assumed that the Dura paintings give a generally typical insight into the sort of Judaism that was borrowing the pagan symbols throughout the Roman world. I cannot see that a similar conclusion is any less imperative because our literature from rabbinic Jews of the period reflects on the whole a Judaism so different from this, one which, in spite of intrusions of the Maasim, so generally protested against it.

What, basically, is the character of the Judaism thus suggested to us? To try to put it into a few words would do violence to my own impressions, and to the synagogue itself. A great difficulty inheres in verbalizing an expression of religion which its exponents have left to us only in symbols. Words are exclusive and specific, symbols inclusive and suggestive. We are dealing with a period in religion which antedated the curse which the synods and scholastics laid upon Western civilization, the curse (in many ways, of course, a blessing) of supposing that conceptions must be expressed in words of clearly specific meaning. We dispute, excommunicate, and torture to death for the sake of

words. The Catholic Church rightly saw that the destruction of its icons would cut at the roots of its very life. The verbalism of Protestants and of rabbinic Jews has been their own greatest obstacle. Words are also symbols, I know, but the word "vine" can never be a symbol as the vine itself, in nature or in representation, can be. Always what contemporary thinkers have come to distinguish as the denotative meaning of verbal expression intrudes into the pure metaphysical connotation of symbols themselves. Actually the symbol has little importance except as it takes us behind all formal thinking into a reality which perhaps we create but which simultaneously creates new forms in us. Brewster Ghiselin recently wrote that it is a question whether Goethe created Faust or Faust created Goethe.[11] Our creative metaphors create new dimensions in ourselves, whether they be the metaphors of mathematics or sculpture. We can no more paraphrase in words the metaphors of painting or music than of physics. But all our deepest expression is metaphorical.

So in trying to verbalize the Judaism which was being expressed in the Dura paintings I feel at the end much like one writing a synopsis of a play of Shakespeare, fully aware all the while that "the play's the thing." If we need annotated editions, synopses, and glossaries to understand *Hamlet* at first, we shall never really understand it until we throw all these away, and read the text as Shakespeare wrote it, or see it magnificently presented by an actor who is himself creative.

We in our generation must beware lest we suppose that in verbalizing and defining the meaning of symbols we have come better to understand them. Why does Mordecai ride a white horse; why do the hosts that guard Saul and David ride white horses; why does the champion of right ride a white horse to fight evil on a black one? Why does Samuel take David into the true kingship of the mystic Seven? Why does Anahita-Aphrodite give the baby Moses to the Nymphs? Such questions become idle with verbal answers. The objective is not to make the observer stop to consider white horses, to define their function, but to take him beyond the representation to a sense of the reality and power of justice and righteousness. As Kraeling so well says, "Reality will always be more complex than any system man can devise for comprehending it."[12]

We have from Dura one of the most remarkable documents of human history. Here men worshiped as loyal Jews, loyal to their People, to their Torah as the supreme revelation of human hopes and metaphysical reality. But while that reality was revealed in Judaism, it was not confined within Judaism, so that whatever from paganism helped make it vivid could freely be used in presenting it. Like Philo, the "philosopher" who designed these paintings saw in the Torah something so great that it was beyond the Torah as a doc-

11. In the most interesting essay with which he opens up *The Creative Process*, 1952.

12. *Synagogue*, 340.

ument, something so great that it promised material and messianic triumph,
mystical association with the universe in its worship of God, and a leaving of
Egypt to be purged of material dross and to come into the metaphysical reality
of the ultimate pool, and of the ultimate sanctuary behind the seven walls. To
the reality itself, supremely revealed by the Torah, many ancient Jews lifted
their hearts and opened their minds. We cannot understand their Judaism or
their paintings unless at least in sympathy we share in this sort of devotion to
reality ourselves.

At the end I should perhaps state a few more positive conclusions about
the Judaism which these symbols, charms, amulets, and paintings seem to me
in all probability to indicate.

Outside the circles of rabbinic teaching, as we have hitherto envisioned it,
there seem to have been a great number of Jews everywhere who had been in-
fluenced by paganism, to the point not only that, like Philo, they expressed
their religious aspirations in the language of Greek mystery and metaphysics,
but also that they found the symbolic vocabulary of later Greco-Roman art
equally suitable to their thinking. I have seen no evidence that Jews were wor-
shiping other gods than Yahweh; hence in that sense no trace of syncretism has
appeared. But there is a great deal of evidence that they ascribed to Yahweh
Helios' rulership as charioteer of the universe, such saving power as that of
Heracles and Ares, such gracious mercy as that offered by Aphrodite and the
Nymphs. Yahweh made available to men such spiritual triumph as was repre-
sented to pagans in Nike, the goddess Victory, and her crown. Yahweh seems
to have had the ferocity and glory of the lion, the bull, and the eagle, and to
have been the spurting Stream of Life. At the same time he still kept his People
together in the ancient Covenant, so that the delivery from corruption and sin
he offered in this life and the heavenly glory at his throne in the next were ori-
ented in the same Torah and in the same proof texts as those on which the tal-
mudic rabbis were basing their own Judaism. The hellenized Jews were loyal
to the People and the holy Writings, but they interpreted them more as did
Philo (mind, I do not say just as did Philo) than in the way the rabbis are now
recorded as having done in Palestine and Babylonia. Such hellenized Judaism
seems witnessed from Rome and Tunis to Mesopotamia.

If, however, one should grant that, with all the corrections of detail which
further study and discovery may reveal, such a widespread and deeply moving
Judaism actually existed, what then became of it? To this I must answer that
from direct evidence we know nothing; but it would seem that the leaders of
this Judaism from the sixth to the eighth centuries had a great change of atti-
tude. They learned Hebrew, after more than half a millennium when Hebrew
had been a dead language for all but the learned even in Palestine. As they did
so they could for the first time learn to pray in Hebrew, to read the Scriptures

in Hebrew, and to study the rabbinical writings. In addition to the Torah, the great guide of Jews became the Babylonian Talmud, with its Hebrew Mishnah and Aramaic Gemarah. At the same time, they not only stopped using the symbolic vocabulary we have been discussing, but, wherever possible, destroyed it by clipping out the offensive forms, or, as at Sardis, by laying a plain mosaic over the old floor. Christians preserved Philo and many Jewish apocalyptic books, but the medieval Jews so neglected the great mass of literature that Greek- and Iranian-speaking Jews must have produced in the whole ancient world that from Jews we have no trace of it left at all. We may still hope for a new resurrection from the sands of Egypt—after Dura, Qumram, Nag-Hammadi, and the Jewish magic of the Genizeh fragments we may hope for anything—but at present that Jewish literature is *spurlos versunken*. It remains to be seen whether medieval Jewish Cabbala, especially as set forth in the Zohar, represents a survival and amplification of this more general Jewish mysticism, or was freshly created by the influence of medieval Christian mystics, or came down from Merkabah beginnings, or, as I suspect, was in some way a mixture of all these. The specialist in any one aspect will always tend to be chiefly impressed by echoes of material he has otherwise learned to know.

In all this I must warn those who would enter this complex field that they heed the warning of Dobzhanski, the great biologist, against expecting simple solutions in complex situations. As I finish writing these volumes I can only end in the medieval fashion on a note of thanksgiving, most of all that at least I have not been beguiled into trying to offer simple solutions.

LIBRARY OF CONGRESS CATALOGING-IN-PUBLICATION DATA

GOODENOUGH, ERWIN RAMSDELL, 1893–1965.
JEWISH SYMBOLS IN THE GRECO-ROMAN PERIOD.

(BOLLINGEN SERIES)
BIBLIOGRAPHY: P.
INCLUDES INDEX.
1. PALESTINE—ANTIQUITIES. 2. JEWS—ANTIQUITIES.
3. JEWISH ART AND SYMBOLISM. 4. JEWS—CIVILIZATION—GREEK
INFLUENCES. 5. SYNAGOGUES—SYRIA—DURA-EUROPOS (ANCIENT CITY)
6. DURA-EUROPOS (ANCIENT CITY) I. NEUSNER,
JACOB, 1932– . II. TITLE. III. SERIES.
DS111.G65 1988 933 88-5857
ISBN 0-691-09967-7

ILLUSTRATIONS

ILLUSTRATIONS

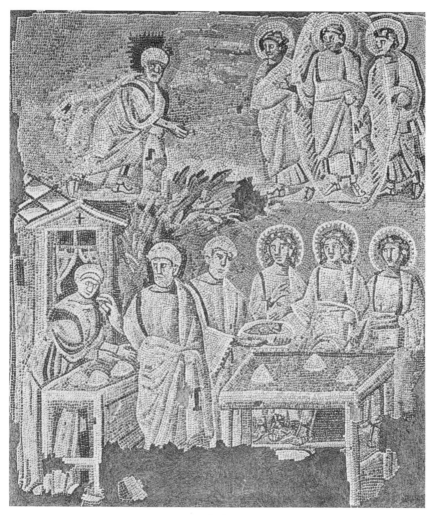

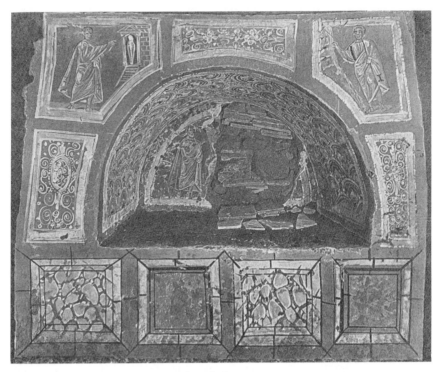

[2]

[3]

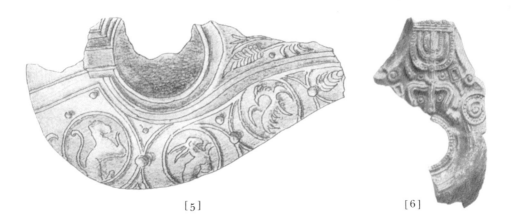

[5]

[6]

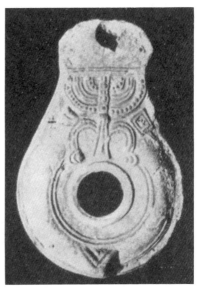

[7]

[8]

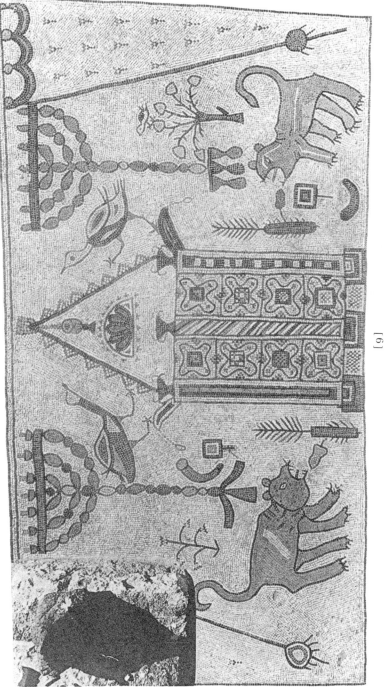

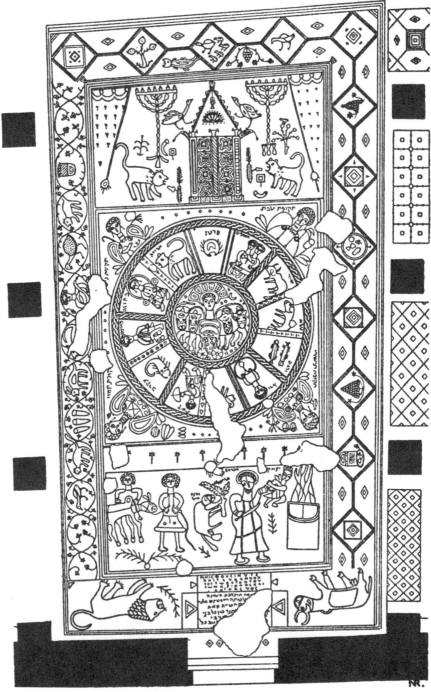

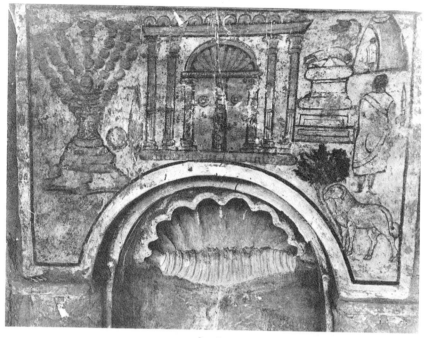

[11]

[12]

[13]

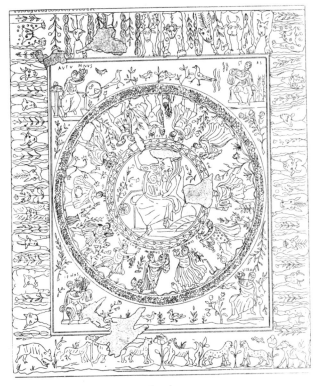

[14]

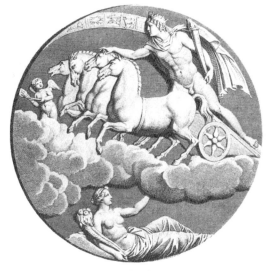

[15]

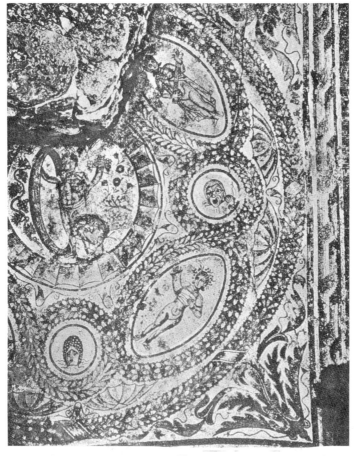

[16]

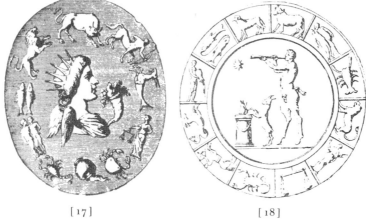

[17] [18]

[19]

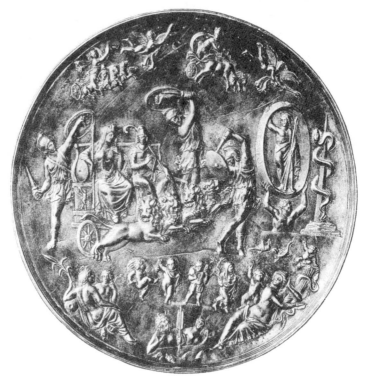

[20]

[21]

[22]

[23]

[24]

[25]

[26]

[27]

[28]

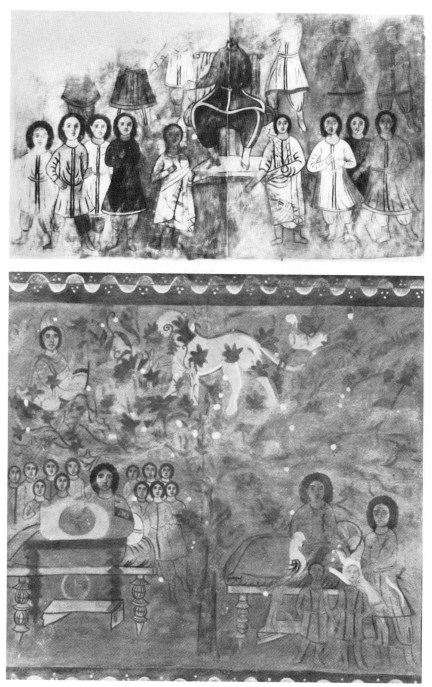

[30]

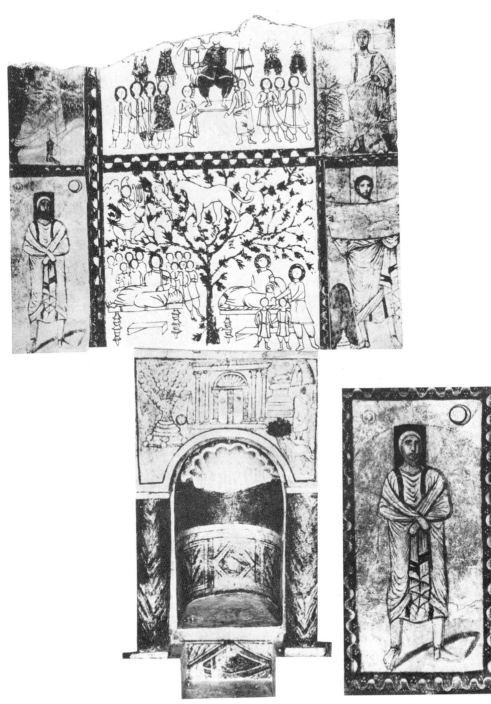

[31]

[32]

[33]

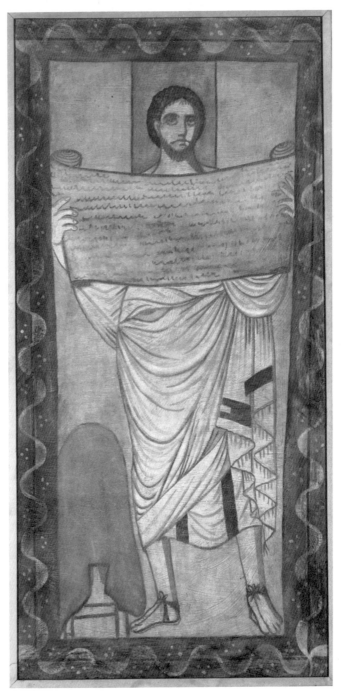

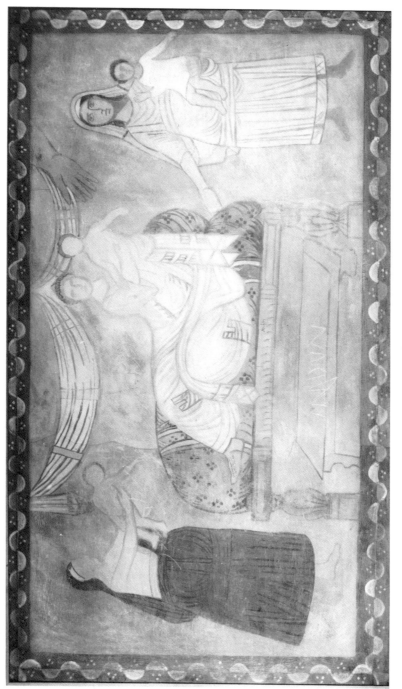

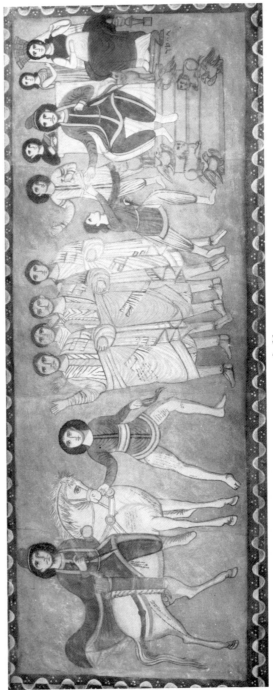

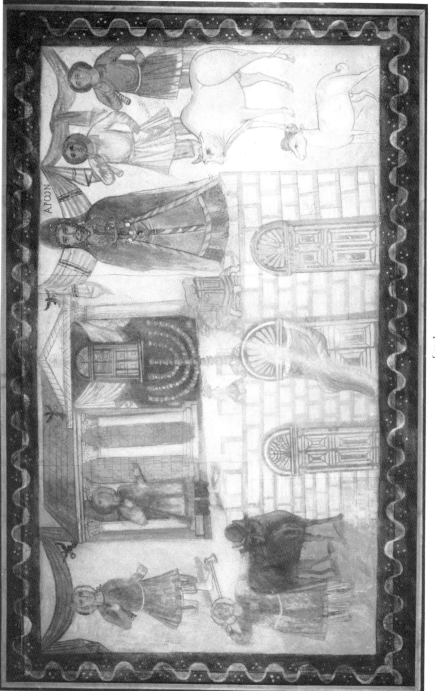

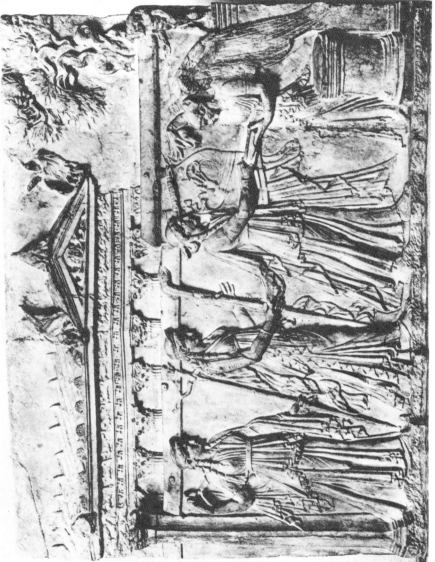

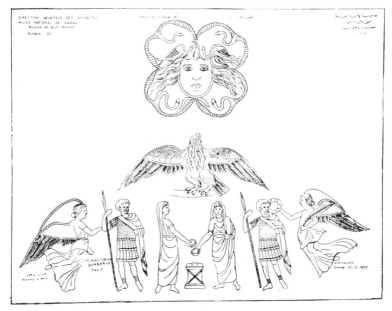

[40]

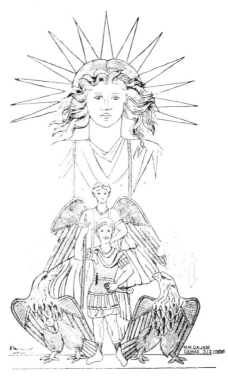

[41]

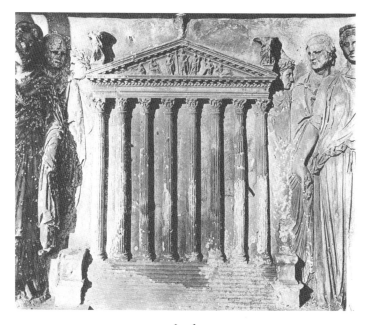

[42]

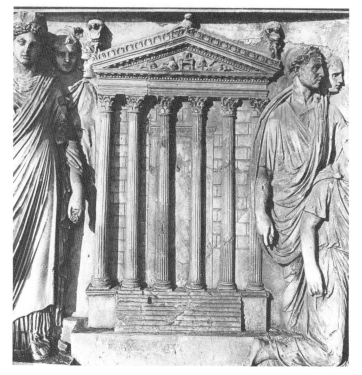

[43]

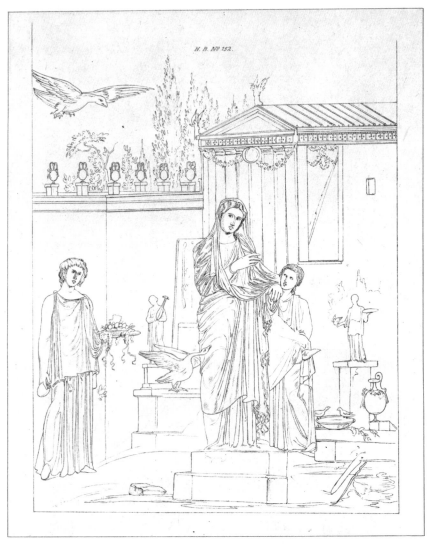

H. B. Nº 152.

[45]

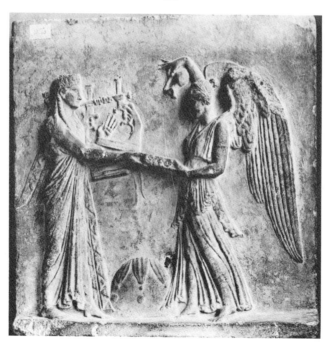

[46]

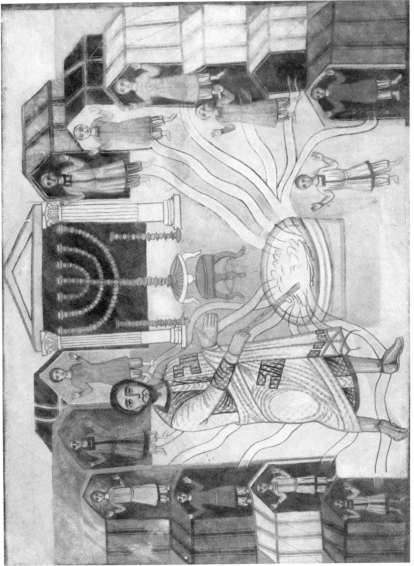

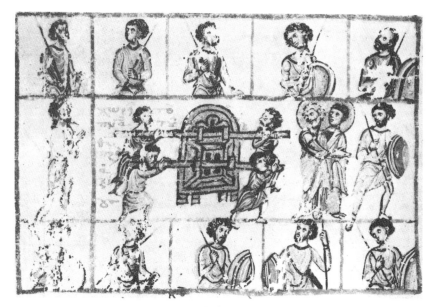

[48]

[49]

[50]

APωN

[51]

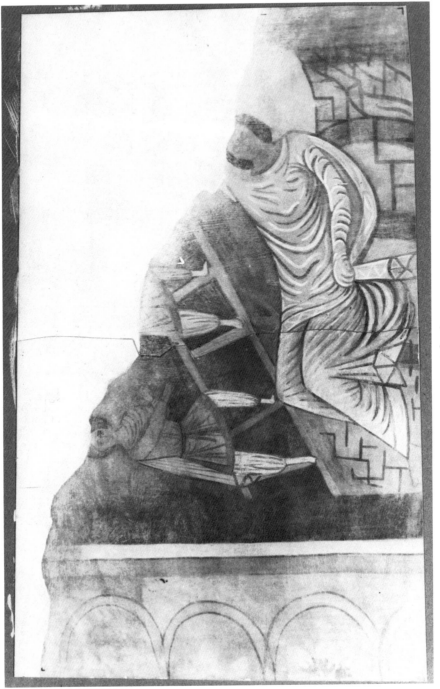

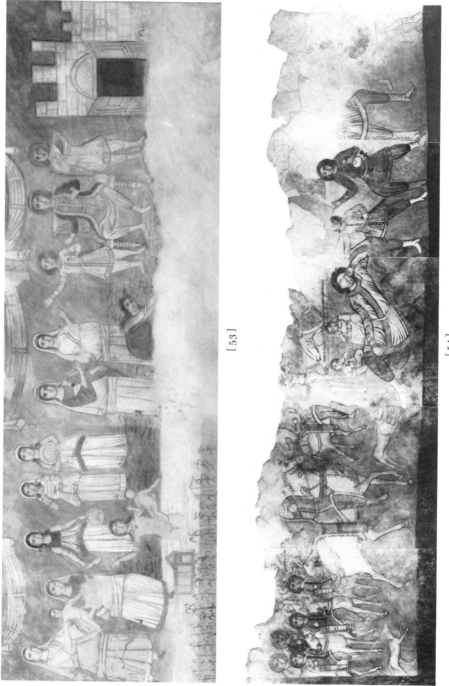

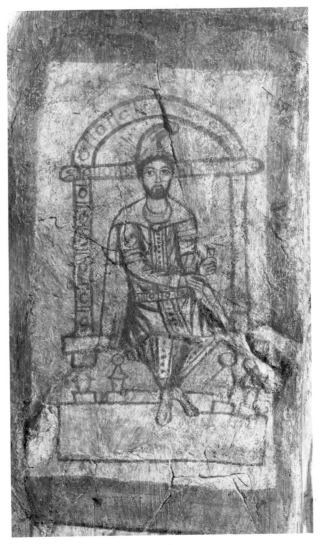

[55]

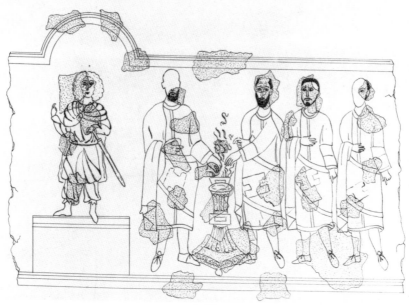

[56]

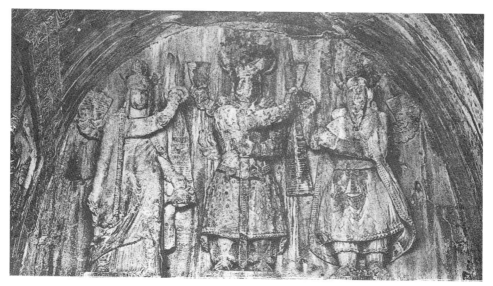

[57]

[58] [59]

[60]

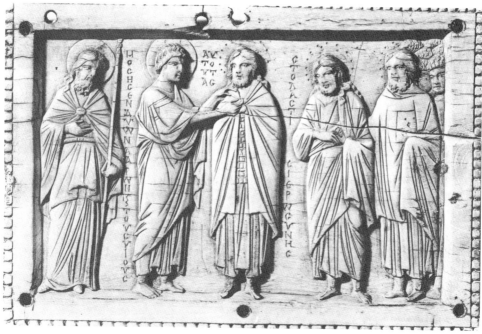

[61]

[62]

[63]

[64]

[65]

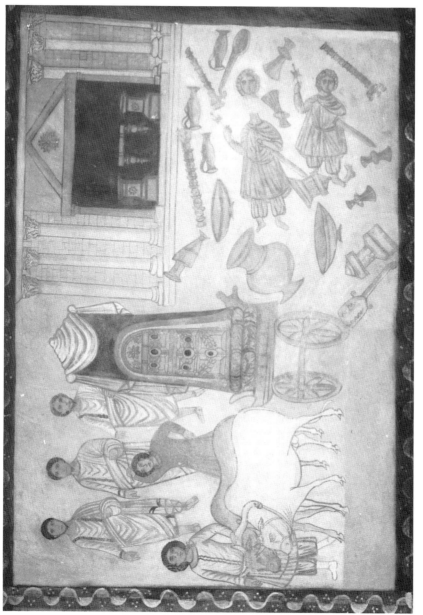

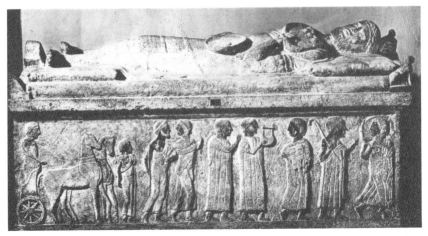

[67]

[68]

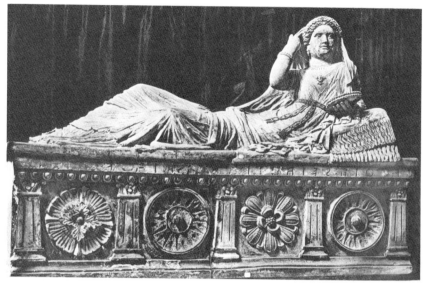

[69]

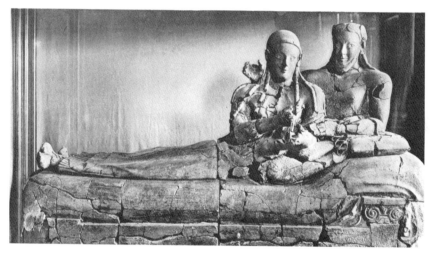

[70]

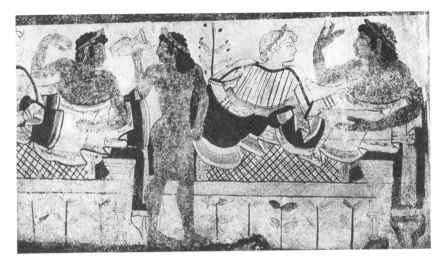

[71]

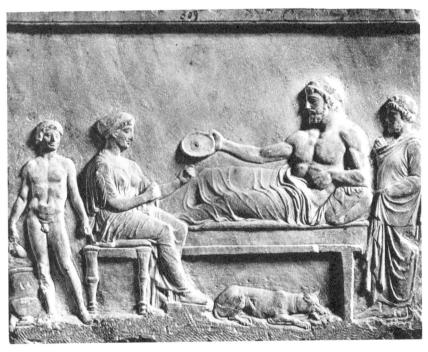

[72]

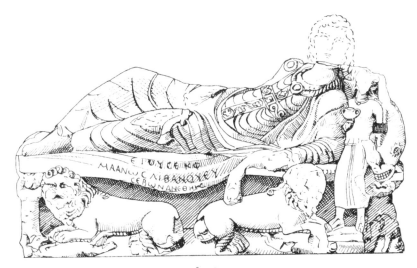

[73]

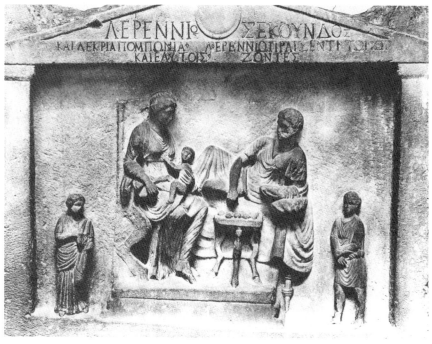

[74]

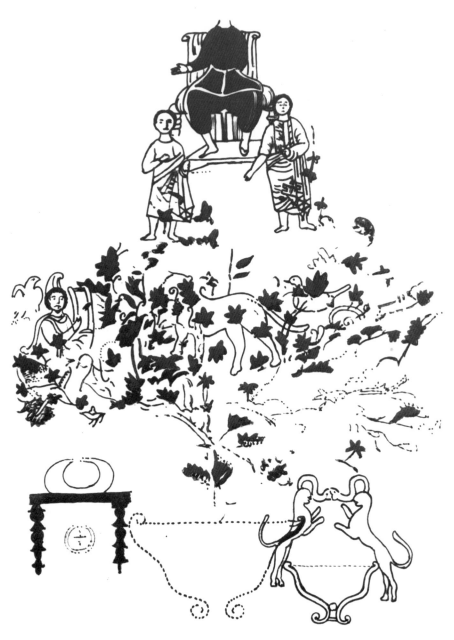

[76]

[77]

[79]

[78]

[80]

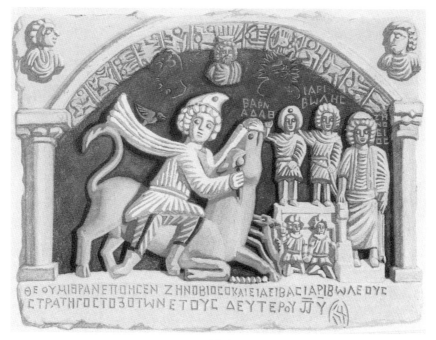

[81]

[82]

[84]

[83]

[85]

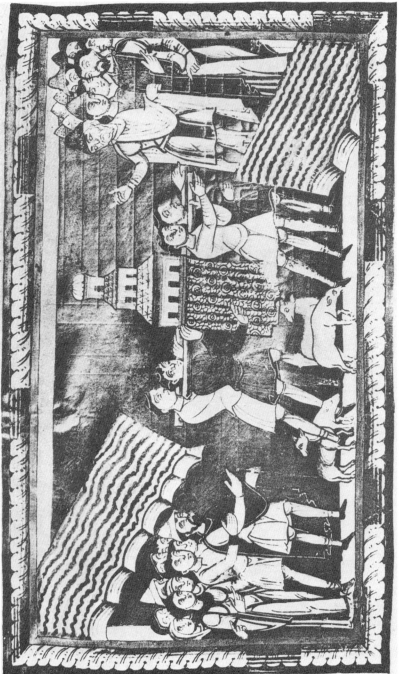

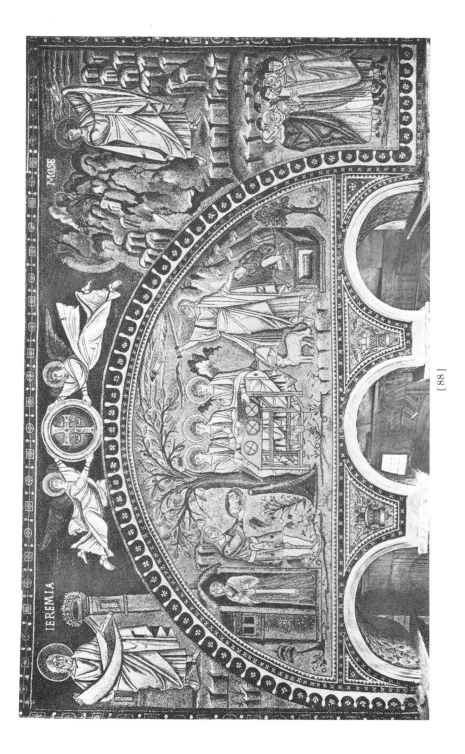

[89]

[90]

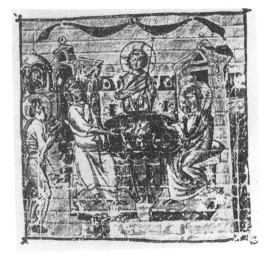

[91]